UNSETTLED VISIONS

OBJECTS / HISTORIES:

Critical Perspectives on Art, Material Culture, and Representation

A series edited by Nicholas Thomas

PUBLISHED WITH THE ASSISTANCE OF THE GETTY FOUNDATION

Margo Machida

UNSETTLED VISIONS

contemporary

Asian American artists

and the social imaginary

DUKE UNIVERSITY PRESS DURHAM AND LONDON 2008

© 2008 Duke University Press

All rights reserved

Printed in Italy on acid-free paper ∞

Designed by C. H. Westmoreland

Typeset in The Sans by Tseng Information Systems, Inc.

Library of Congress Cataloging-in-Publication Data

appear on the last printed page of this book.

This is dedicated
to the memory of my father,
MICHAEL SEIJI MACHIDA

CONTENTS

ILLUSTRATIONS

PREFACE

My involvement with questions of visuality and representation began in the mid-1970s, while I was working in the South Bronx—at that time one of the most economically blighted areas of New York City. I was employed by a social service agency, while simultaneously pursuing studies in creative writing and psychology and undergoing training to become a psychotherapist. In this job, I offered counseling to individuals (primarily African Americans and Latinos) who were remanded to the agency by the court system as an alternative to incarceration. During our meetings, these clients would relate harrowing stories of their daily struggles to survive in situations where violence, drug abuse, illness, and chronic poverty were commonplace. Having come from a rural town in Hawai'i only six years earlier, my experiences had little equipped me to understand the stark circumstances in which many in the South Bronx spent their lives.

It was in those years that I first drew upon visual media to engage with the people, places, and situations I encountered. I took classes in photography and found early inspiration in the Depression-era documentary work of Dorothea Lange, as well as the gritty New York street scenes of Weegee. Some of my clients would invite me into their homes to photograph families and friends. Seeing the camera, even strangers approached me to take their pictures during my walks in the area. As I now understand it, being photographed provided a means of personal empowerment—a platform for self-narrativization and presentation that endowed them with a sense of greater importance, as significant subjects for attention and documentation. Indeed, the Korean American artist Yong Soon Min recently noted, in writing about her project on Asian migrant labor in South Korea, that the presence of a camera itself "encouraged most of the interviewees to be more open and generous, by giving them a sense of responsibility and purpose in going on record."[1]

1. Min, "Transnationalism from Below," 6.

One of my most memorable encounters was with a tall, African American woman who had been sitting on her front porch. Catching sight of me, she ran into the house, re-emerging in an outfit made of leather straps that encircled her body and were pulled taut with metal rivets. She first posed dramatically atop her stoop in this skimpy costume and then gleefully made her way down the stairs, proudly posturing and twisting at each step like a fashion model. Later, I showed this photograph to a friend, an African American male artist; he reacted with considerable acrimony at what he perceived to be a derogatory image. After all these years, I still hear his angry words: "Who are you to show this black woman like that? What do you think you're doing?" While I had naïvely failed to anticipate how such an image might be received, I had not sought to denigrate this woman; indeed, this is how she chose to represent herself. Yet, as I discovered, simply presenting an image is not in itself sufficient to convey the meaning or intentions behind it.

Over the next decade, I studied art full time and began to pursue a career as a painter, exhibiting my work in alternative spaces, commercial galleries, and museums throughout the 1980s and early 1990s. Gradually I also published articles on fellow artists of Asian heritage and organized exhibitions featuring their work. In 1987–1988, I was invited to serve as critic-in-residence by a Washington, D.C.–based arts organization, where I wrote an exhibition essay on a local Korean American artist. The artist's multimedia work incorporated cultural and historical references to his heritage that I had difficulty decoding. Rather than simply impose my preconceptions, I engaged in dialogue with the artist to better grasp his conceptual system and intentions; this was my first extended use of orality as a means of interpreting art. The following year, I was asked to provide written commentary for an exhibition of abstract sculptures by three Japanese-born artists on display at a community gallery in Brooklyn Heights. Initially, I thought that they were working within the conventions and intellectual trajectory of 1970s Western minimalism; however, our interviews soon revealed that their sensibilities were informed by conceptual currents within Japanese modernism, including Mono-ha (School of the Object), a radical art movement of the 1960s. Once again, collaborative inquiry with the artists played a vital role in my interpretive process.

As a seventeen-year-old from Hilo, Hawai'i, who had never been on the mainland, my entry into New York City in the late 1960s to attend university

was jolting. Soon after settling into my dormitory, I participated in a campus protest march, as well as a Black Panther Party rally in which Eldridge Cleaver exhorted students of color to join together in opposing white supremacy. The electrifying sight of groups like the Panthers and the Young Lords vividly reinforced the idea of race as a source of strength and shared purpose. This period of enormous social and political conflict coincided with seismic shifts in the ethnic, cultural, and political geography of the United States and also saw the beginning of a wave of phenomenal growth in the Asian diasporic communities, following the removal of restrictive immigration quotas. Moreover, having been raised in the only state in the nation with an Asian majority population, I suddenly found myself cast as a minority for the first time. It brought compelling issues of identification, affiliation, and place—in particular, my position as an American-born Japanese woman in the United States—to the foreground and spurred my continuing interest in the phenomenon and effects of travel and migration, whether within or between nations.

My intellectual and ethical commitment to linking individual art-making practices and real-world conditions through productive dialogue—an orientation that valorizes Asian American artists' positions as knowing social agents by directly engaging them in articulating the standpoints that give rise to their creative production—grew out of my subsequent involvement with the Asian American art movement beginning in the late 1970s. It was through projects with community arts groups and alternative art spaces (as well as the influence of my counseling background) that I began to develop the methods that would become central to my scholarship, in part because many artists I met were first-generation immigrants from East and Southeast Asia. Seeking to decipher how these artists made meaning of their lives, and how they understood the world and their positionings within it through the lens of artistic production, these early conversations would be decisive in leading me to look at artists as primary sources and coproducers of information and as guides in suggesting the directions my research would ultimately take.

At the time, I was also living in a working loft in New York's Chinatown, after completing graduate studies in studio art. Around the corner was Basement Workshop, one of the pioneering Asian American community arts organizations on the East Coast. Its members were the first Asian Americans of my generation that I had met who were seriously involved in

the arts and who were actively exhibiting and publishing their work. Many were children of working-class immigrants, and often the first to go to college in their families. The political activism of these artists, writers, and curators, and their efforts to build the nascent field of ethnic studies, had inspired them to return to their local roots in their search for ways that the arts could give expression to their communities' histories and experiences. Their approach to art, formed in the matrix of U.S. multiculturalism, the community arts movement, feminism, and third world politics, regarded it as a means of collectively "coming to voice" for people who had long been disenfranchised and subjected to systemic discrimination. Seeking to confer recognition and a place in the cultural record to expressions emerging from constituencies whose situated knowledges, images, and expressions were largely unrecognized by the society at large, these cultural activists looked upon art as a tangible means to assert lived, street-level realities, as well as the historical struggles and cultural heritages of their groups.

Especially influential was their integrative view of the artist as a social actor, whose role was not simply to produce work but also to act as a theorist, educator, and organizer. This vision inspired me to begin curating small, thematic exhibitions featuring fellow Asian American artists. The passion of these calls for collective expression and empowerment, as well as for resistance and social justice, likewise inflects my view of art as an epistemic asset for minoritized groups as they seek to more fully apprehend the conditions and the experiences they may share, and hence to envisage new cultural paradigms and forms of affiliation.

By the late 1980s, a Rockefeller Foundation humanities fellowship provided me with the means to conduct in-depth research with a greater number of Asian American artists across the Northeast. As a result, my projects increasingly intersected with the museum world and academe. 1990 was a pivotal year. Building on the information emerging from my investigations, I designed and taught one of the first college-level courses on Asian American art history. I also cofounded Godzilla, a loose-knit group which brought together American and foreign-born artists, critics, and curators. That same year I contributed the essay "Seeing Yellow" to the catalogue of "The Decade Show: Frameworks of Identity in the 1980s," a sprawling exhibition co-organized by the New Museum of Contemporary Art, the Museum of Contemporary Hispanic Art, and The Studio Museum in Harlem.

In the early 1990s, I was invited to curate "Asia/America: Identities in Con-

temporary Asian American Art" (1994) for the Asia Society Galleries in New York—a groundbreaking thematic group exhibition featuring immigrant and refugee artists. As part of the curatorial process, the "Asia/America" project provided valuable institutional support that extended the scope of my inquiries and my contacts with artists to new corners of the nation. In turn, the substantial research and writing required for this undertaking led me to return to school for a doctorate in American Studies.

Those dialogues with Asian American artists across the United States produced a sizeable body of raw transcripts, spurring me to develop "oral hermeneutics," the comparative analytical approach that underlies my writing on Asian American art. What distinguishes this mode of inquiry, and underpins the resulting writing, are the highly detailed and sustained recorded conversations I initiate with artist/producers for the purpose of reading specific works of art. Through such an interpretive strategy I endeavor to make more accessible the sweep of perspectives and feelings that animate these artists. When their works are placed in the public sphere, these images, together with the producers' insights, have the potential to act as both a mirror and a critical lens through which Asian Americans and others in this society can more clearly and forcefully apprehend the times we share.

This significant undertaking enabled me to identify the larger social themes and orientations that connect this art across the particularities that define individuals' lives and preoccupations as artists. Conversely, the many discontinuities and conflicting positions articulated in this process allowed for a more acute recognition of the problems inherent in any project that might seek to present Asians in the United States as a unitary or static group, or to subsume them within any singular agenda or point of view.

To better envision the contours of the enormously complicated and continually expanding field of Asian American cultural production, I conceive my ongoing project as comprising acts of engaged criticism, not simply with works of art construed as anonymous texts, or with other critical interpretations, but with producers themselves. Since I pay particular attention to art in which matters of social identification and affiliation are central (and to what their creators have had to say about those pieces), my interpretive orientation has necessarily become increasingly hybrid, as it bridges diverse perspectives from domains and practices with often quite different imperatives—cultural activism, the inner imaginative lives of artists,

and the various academic approaches brought to bear in inquiring into and contextualizing their work. The intellectual and ideological climate, especially in critiques of cultural nationalism and essentialism, has also shifted substantially since this work began. Not only has the significance of the subjective in the creative process been de-emphasized, but with growing doubt over the primacies and fixed positions on which prior claims of collectivity were based, appeals to identity and community, and, indeed, the very notion of common cause among Asians in the United States, have been sharply interrogated. Embracing relativism, indeterminacy, and a performative construction of the self, identity, and culture, many artists and critics today instead invoke postidentitarian rhetorics to signal a perceived rupture with any form of politics based on strong assertions of otherness.

Moreover, with matters of cross- and intracultural mediation becoming increasingly prominent features in contemporary art, it is also important to consider the broader context in which cultural identification and positioning are significant for many in today's postcolonial and postcommunist world. In this era of heightened global ferment, the most fundamental frameworks upon which identities and identity politics are constructed—involving a sense of affiliation with traditional notions of collectivity—are increasingly being destabilized and challenged. With people crossing and recrossing porous borders, their subject positions are ever more complicated, shaped by the influence of older nation-states and societies, as well as by regions, locales, and newly emergent political entities and movements for change.

Although much has certainly changed over the intervening years, from the vantage point of the present the critical insights triggered by my African American friend's sharp response remain meaningful to my work as a critic and scholar. They ultimately led to my interest in taking into account the intentions of the producer—the ways in which artists understand their actions and their relationships to the work they make—and underlie many of the questions that continue to engage me in writing about art and artists. Taken together, these experiences provided important realizations about the relations of power that lay behind any act of depiction, as well as the challenges and limitations inherent in interpretation—whether it involves representations of minoritized ethnic or racialized groups whose images are already overdetermined in this culture, or images produced by artists of non-Western heritage circulating in the West.

ACKNOWLEDGMENTS

Many people contributed significantly to the gestation and realization of this project, which in itself has been a long-term dialogic effort. Since this book began its life as a dissertation, I first want to acknowledge my debt to the American Studies Department (now the Center for the Americas) at the State University of New York at Buffalo, and to Michael Frisch, Elizabeth Kennedy, Jolene Rickard, and the late Lawrence Chisolm for providing means to theorize the role of orality in producing social knowledge and to conceptualize its usefulness in interpreting visual art. I also want to recognize the intellectual community at New York University's Asian/ Pacific/ American Studies Program and Institute. Particular gratitude goes to John Kuo Wei Tchen for his guidance in formulating my research at many critical junctures, especially in helping me to think through the concept of dialogism that has been so pivotal to my work. Likewise, I am indebted to Lok Siu for her generous advice and collegial support, and to Angel Shaw for all our discussions of art, life, teaching, and cultural politics. In addition, I wish to thank Gary Y. Okihiro at Columbia University, whose incisive comments on the shape and historical framing of this manuscript were unfailingly helpful. My gratitude also goes to Franklin Odo at the Smithsonian Institution Asian Pacific American Studies Program for providing important opportunities to present my scholarship.

At the University of Connecticut, I want to acknowledge many colleagues whose interest in my work has been greatly appreciated: Roger Buckley and Bandana Purkayastha at the Asian American Studies Institute; Dean David Woods at the School of Fine Arts; and the faculty of the Department of Art and Art History, in particular Judith Thorpe and Anne D'Alleva.

A special thanks is due to Moira Roth, whose intellectual generosity, deep commitment to feminist scholarship and artist-centered inquiry, and passionate efforts to challenge the Eurocentric biases of art history have meant so much to me. Likewise, I owe a great deal to the work of Lucy Lip-

pard, whose book *Mixed Blessings* stands as an ambitious effort to foment a wide-ranging multiculturalist dialogue in the arts.

Within the Asian American arts community in New York, I must foremost thank Fay Chiang. It was she who first encouraged me to begin writing about Asian American art and to believe that I had something significant to contribute. I am also grateful to Ken Chu and Bing Lee, with whom I co-founded Godzilla: Asian American Art Network. The tremendous ground-swell of interest in Godzilla reinforced my belief in the need for such dia-logic spaces. My thanks as well to Vishakha N. Desai at the Asia Society; by giving me the opportunity to curate "Asia/America: Identities in Contempo-rary Asian American Art," she enabled me to do foundational research on artists across the United States.

None of this would have been possible, of course, without the gener-ous support of The Rockefeller Foundation, and in particular, Tomás Ybarra-Frausto and Lynn Szwaja in the Creativity and Culture program. I am grate-ful for their steadfast commitment to supporting this research on Asian American art.

I also want to express my enormous gratitude to Ken Wissoker, my editor at Duke University Press, for his ongoing support, guidance, and patience throughout the long process of bringing this book to fruition.

My greatest debt, however, is to the artists, without whose generosity in sharing their thoughts and experiences over many years this work could not have been done. Their interest and support continue to deepen my commit-ment to this research, which is renewed with each conversation we share.

Some sections from the individual chapters have previously been pub-lished in different versions. I would like to thank the publishers for granting permission to reprint this material. They include excerpts from the follow-ing exhibition catalogues: "Reframing Asian America," in *One Way or An-other: Asian American Art Now* (New York: The Asia Society, 2006); "Cultur-alist Conceptualism and the Art of Ming Fay," in *Transcultural New Jersey: Diverse Artists Shaping Culture and Communities* (New Brunswick: Rutgers Office for Intercultural Initiatives / Jane Voorhees Zimmerli Art Museum, Rutgers, The State University of New Jersey, 2005); "The World as Home," in *Zarina: Mapping a Life, 1991–2001* (Oakland: Mills College Art Museum, 2001); and "Out of Asia: Negotiating Asian Identities in America," in *Asia/America: Identities in Contemporary Asian American Art* (New York: The Asia Society Galleries and The New Press, 1994).

Art, Asian America, and the Social Imaginary

a poetics of positionality

The recent past has witnessed an explosive growth in Asian American cultural production, prompting the proclamation of a "Harlem Renaissance–like era" in the arts.[1] Beginning in the 1990s, an unprecedented number of group exhibitions organized by U.S.-based art museums, arts organizations, and university galleries specifically foregrounded work by Asian American artists.[2] Likewise, individual Asian American artists have increasingly been the subjects of important one-person exhibitions.

At the same time, there has been a marked upsurge of interest in Asian American art as a nexus for new art-historical writing and cultural criticism. Established Asian American scholars are now bringing their insights to bear on visual art.[3] New generations of art historians and scholars in other disciplines are enriching this expanding and multivalent dialogue with critical perspectives from postmodernist, psychoanalytic, and postcolonial theory, as well as from literary, film, and performance studies. Such views inform exhibitions like "One Way or Another: Asian American Art Now," which was mounted by the Asia Society in 2006 to profile works by younger generations of artists and to assess what has changed in the dozen years since it presented "Asia/America: Identities in Contemporary Asian American Art." A number of foreign-born Asian scholars and curators are also applying comparative transcultural approaches that link works produced in the Asian diasporas with contemporary works from their cultures of origin.[4]

An index of the changing status of this field is the recently published *Encyclopedia of Asian American Artists* (2007). Books and book chapters, exhibition catalogues, major monographs, and special issues of academic journals are appearing, devoted to individual artists past and present: Ruth Asawa, Theresa Hak Kyung Cha, Hideo Date, Yun Gee, Charles Higa, Michael Joo, Byron Kim, Shigeko Kubota, Maya Lin, Hung Liu, Long Nguyen, Isamu Noguchi, Chiura Obata, Manuel Ocampo, Miné Okubo, Yoko Ono, Nam June

Paik, Paul Pfeiffer, Roger Shimomura, Shahzia Sikander, Henry Sugimoto, Masami Teraoka, George Tsutakawa, Florence Oy Wong, Martin Wong, and Bruce and Norman Yonemoto, among others. Key collections of critical writing on Asian American art have also been published, among them Alice Yang's influential work, *Why Asia?* (1998), and the 2003 volume of essays *Fresh Talk / Daring Gazes: Conversations on Asian American Art*, which I co-edited with Elaine H. Kim and Sharon Mizota. There are also interpretive writings grounded in dialogic engagements between scholars and visual artists, like the art historian Moira Roth's ongoing exchange with the Vietnamese artist Dinh Q. Lê.[5] Moreover, there are ambitious regional art history projects in progress, such as the California Asian American Artists Biographical Survey (CAAABS), which has done foundational research and documentation on West Coast artists in the last decade, in partnership with the Smithsonian Institution's Archives of American Art.[6]

What emerges from this quick review is a sense of the growing intellectual breadth of current writing on Asian American art, as well as the ethnic and generational diversity of its scholars. Together, these intersecting lines of inquiry begin to construct a matrix of contextual interpretation for this evolving field.

The mounting attention being directed toward Asian American art represents an important shift in what formerly had been a largely overlooked area of study. Elaine H. Kim speculates that, in contrast to scholarship on expressive media such as literature, film, and the performing arts, as well as on popular culture, the paucity of serious writing on visual art by Asian Americanist scholars results from conditions specific to the genesis and ideological roots of Asian American studies.[7] Besides the fact that the historical focus of Asian American studies has been on the West Coast (whereas the eastern seaboard is the larger locus of artistic and critical activity), she notes that many of these scholars find visual culture and visuality itself highly suspect because it has long been recognized as a tool of suppression and stereotyping for Asians in this nation. Equally problematic is the history of the entrenched elitism and exclusionary practices of the art world, especially in regard to artists of color. Kim likewise reminds us that whereas the institutionalization of Asian American literature in the academy occurred before the debates about identity politics, this is not the case for visual art. Indeed, by the time Asian American art began to gain momentum as a field, it ran afoul of the highly polarized cultural and intel-

lectual climate of the 1980s and 1990s in which domestic expressions of ethnicized and racialized identifications and social affiliations were being strongly challenged. In view of this contentious history, the renewed interest in this area, and its growing incorporation in present-day art historical and critical discourse, is all the more noteworthy.

The primary focus of this book is on work produced in the 1990s, a pivotal moment in Asian American art during which no single discourse or ideological shift proved decisive. Many Asian American artists, despite a growing disquietude with conceptions of identity, took on issues of self- and social identification during the course of that decade, even as they sought to move beyond the more circumscribed race- and ethnic-based domestic agendas of previous years. Not only are these artists compelling for their own sake, but for younger Asian Americans working today their efforts remain resonant as both touchstone and foil in approaching changing circumstances and unresolved social issues.

Drawing on representative work, I have chosen three wide-ranging themes around which to organize the artist-focused chapters that engage Asian American perceptions of othering, social memory and trauma, and migration and relationships to place—subjects that often aroused the attention of artists during the period.[8] Because the art object lies at the core of this research, each chapter is built around individual case studies of artists whose work follows these lines of inquiry. Since the issues under discussion often overlap, these chapters were conceived as semi-independent essays, a move that allows for the examination and comparison of the pieces grouped under each theme from a different angle.

Asian America in Flux

The imaginative efforts of Asian American artists, by consciously and unconsciously giving voice to the impact of larger social and political conditions on personal and communal experience, bestow tangible shape and texture to the Asian presence in the United States. Indeed, the flourishing of Asian American visual arts over the past few decades has emerged out of vast economic and social shifts within the United States. In the wake of the abolition of highly restrictive federal immigration laws in 1965, and the inextricable intertwining of the financial and political fortunes of Asian nations

and the United States, Asian America would be thoroughly reordered.[9] This study grows out of and acknowledges this period of enormous transformation, as the contours of Asian America were being dramatically reconfigured by the explosive growth of new immigration.[10]

As immigrants came to substantially outnumber the U.S.-born generations, Asian America itself became a vast "contact zone" where the newly arrived from all parts of Asia and from various Asian diasporas converged (and sometimes collided) with one another, with American-born Asians, and with the society at large.[11] In these encounters, both groups were affected by the productive tensions, repositionings, and imaginative self-representations found in the shifting intersections of diverse Asian heritages, histories, and cultures. Amid this growing internationalized circulation, migration could no longer be viewed mainly as a one-way street culminating in inevitable assimilation. As relatively inexpensive air transportation and access to powerful communications and media technologies made it possible for migrants to more easily travel back and forth between their many points of origin and the United States and also to maintain strong ongoing connections to distant homelands, migration became a more mutable phenomenon. Multiple migrations from or through different Asian diasporic communities around the world further challenged longstanding conceptions of Asian American history, which previously had been framed as narratives of passage to this country from originating points in Asia. The pluralized backgrounds and sensibilities, for instance, of ethnic Indians from South Africa and Trinidad, or ethnic Chinese from Vietnam, Mexico, Jamaica, and Panama, would further complicate understandings of Asian American identification based on ethnicized or racialized categories alone.

In light of these developments, much has certainly changed since I first became involved with the community arts movement. At that time, its members were usually American-born second- and third-generation East Asians who found commonalities in their experiences of being raised in this country and often in their struggles with institutionalized discrimination, racism, and ethnic stereotyping. The post-1965 Asian influx, however, would introduce new transnational perspectives and differing priorities into the Asian American environment over the succeeding decades. Increasingly, these encounters would serve to unsettle and relativize the issues of identity politics and multiculturalism that had preoccupied my generation of baby boomers. Although domestic issues usually held greater significance

for long-term residents, newly arrived immigrants often had little knowledge of Asian American histories or prior struggles for civil rights and thus found little incentive to engage in the causes of local cultural politics.

By the 1990s, the decade during which the primary research for this book was conducted, not only had the Asian immigrant population far outstripped that of the American-born, but the circulation and expanding presence of foreign-born Asian artists and intellectuals (including a major wave from mainland China) also began to have a significant impact on the American art world and the Asian American arts communities. As the concerns of these new migrants, as well as of émigrés—some of whom were living in the United States for extended periods—were being keenly felt by artists, scholars, and cultural activists alike, I was spurred to find fresh ways to engage with the changing domestic situation. Seeking to gauge the effects of these sweeping developments as they played out in individual expressive endeavors, the trajectory of my curatorial practices, and related research and scholarship, followed my efforts to stimulate open-ended dialogue with these foreign-born artists. One result was the Asia Society's "Asia/America" exhibition.

This study enfolds and extends the scope of my work with U.S.- and foreign-born artists by examining how Asians from both groups have framed their encounters with American (and Western) societies through their art during the 1990s. Yet, as a product of its historical moment, and reflecting the demographics and formative developments of that period, the majority of the artists under discussion are foreign-born—most coming to this country as adults, although one did arrive as a young child. Meanwhile, even as Asian American art scholarship and criticism advance, changes are occurring with astonishing rapidity.

Alongside the ongoing impact of this fresh demographic fluidity on the social and cultural fabric of the Asian American communities, the concerns of the latest generations, including the children of the Asian immigrants who began arriving in the mid-1960s, were increasingly feeding into this continually evolving conversation.[12] By the 1990s, the efforts of younger Asian American artists (and critics and scholars) to stake out fresh positions that distinguished them from the identity politics commonly associated with the art of the 1970s and 1980s were already very much in evidence. Reflecting the dynamic of this rapidly changing environment, even when Asian American artists concern themselves with questions of identification,

difference, and representation, they tend to adopt more oblique and less directly confrontational approaches. Consequently, any study initiated today would necessarily find itself engaged with a somewhat different array of artistic and critical questions.

No matter how equivocal the current views of younger artists might be, their concerns and visualizing strategies nevertheless owe a debt to the efforts of their predecessors. Moreover, expressions of common origins, history, culture, familial ties, community, and place still provide a point of departure for many Asian American artists. There is considerable merit, therefore, in conceiving today's complex intellectual currents in terms of a continuum rather than as a stark rupture within Asian American discourse in the arts—thereby recognizing what has always been a heterogeneous and unruly conversation marked as much by multiple perspectives and cultural crossbreeding as by contention and contradiction.

Art as Expressive Capital

The title of this introduction couples references to a poetics of positionality and the social imaginary in order to underscore the significance of subjectivity as a valid source of knowledge about one's condition and place in the world, in an ongoing process of positioning oneself and being positioned by the society or societies in which one lives. It further recognizes that through their impact on the social imaginary—the ways in which ordinary people understand their lives and historical moment—the interventions of public figures like artists have a potentiating effect on larger social consciousness.[13] Indeed, once their works and ideas are placed in the civic sphere, artists can be seen to function as public intellectuals who provide unique insights into larger events by holding up a critical mirror to their society.[14]

The symbolic assertion of presence through strategic acts of visual representation (ranging from critiques of dominant culture to alternative expressions of a polycentric public sphere) can provide a previously neglected people with a powerful claim to place in a society where their images are not the norm. Building on the notion of "cultural capital"—referring to those non-economic resources, such as education and social status, that enable individuals to function effectively within a culture—visual art likewise furnishes *expressive capital*, a form of capital that adds greatly to a

society's repertoire of collective responses to its moment and place in the world.[15] In constructing symbolic cartographies of who we are at specific historical junctures, formulated through a continuously evolving vocabulary of motifs, themes, images, and media, visual art enables us to better envision and convey experiences in common, often beyond the resources offered by everyday interactions.

Art functions as expressive capital for a group or culture by articulating or reinforcing "structures of feeling"; in other words, by giving expression—narrative, performative, visual, musical—to forms of social consciousness.[16] The arts provide cognitive structures that serve to organize incipient forms of consciousness emerging from people's lived, affective negotiation of their times. Once recorded, these structures of meaning can be compared and generalized. In similar fashion, visual art can be seen to produce heuristic templates of its times, as it distills and synthesizes the raw, often inchoate ideas, events, and struggles of its moment into wide-ranging bodies of images and symbols. Indeed, certain works of art associated with a particular historical era or cultural setting become identified as emblematic. For instance, although Pablo Picasso's *Guernica* (1937) was inspired by a specific event in the first half of the twentieth century, it has since served as a widely recognized visual trope for the horrors of modern aerial warfare. In a similar fashion, one of the most reproduced and familiar depictions of Americana, Grant Wood's painting *American Gothic* (1930), is often perceived as iconic of this culture's vision of itself and its ethos. *Resident Alien* (1988), a painting by the first-generation Chinese American artist Hung Liu that is based on her INS green card, has come to have much the same resonance for many Asian Americans.

The role of recorded structures in making previously unarticulated experiences available to public discourse also suggests the significance of curatorial, critical, journalistic, and academic intervention in codifying emergent expressions of social consciousness in the arts. By gathering together disparate bodies of contemporary visual production in exhibitions, catalogues, and brochures, in reviews and criticism, and in scholarship, and identifying them as discourses-in-formation, this multifaceted process provides frameworks and concepts that enable artists and their audiences alike to recognize their own concerns, understandings, and experiences as part of a larger social conversation. This point is aptly demonstrated by the comment of one participating artist in "Asia/America" who spoke of "walking through

an old familiar neighborhood" upon first seeing the newly installed exhibition.[17]

Yet how *do* the nascent structures of feeling and situated knowledges embedded in works of visual art become accessible, and hence useful, to wider public consciousness? Unlike text-based narrative forms like literature or drama, the symbologies of visual art remain largely opaque to many viewers—perhaps with the exception of certain types of illustrative or didactic works. Unless the artist is present to explain her or his work, strategic acts of interpretation are needed to form bridges that bring those subjectivities forward in the social imaginary.

Oral Hermeneutics and Visual Art

My formulation of "Asian American art" grows out of dialogue with the artists themselves about the work they produce. As an artist and arts activist, I have come to view interpretation as a collaborative act in which access to living artists offers unique opportunities for direct inquiry about the ideas and circumstances that drive their visualizing practices, bodies of iconography, symbolic systems, and uses of media. This hands-on stance, which approaches art as an open-ended epistemic project and which presumes that artistic activity cannot be divorced from social and cultural contexts, grew directly out of pragmatic concerns posed by my cross-ethnic and intercultural research, since the meanings embedded in such work are scarcely transparent.[18] Aiming to achieve something appreciably different in the construction of meaning that can result from jointly generating knowledge with producers of art, I have developed "oral hermeneutics," an exploratory form of dialogic engagement that seeks to share interpretive authority[19] with artists by linking the use of oral history methods with a hermeneutical orientation toward textual interpretation.[20] This use of orality as an investigative tool is grounded in an ongoing commitment to bringing forward the situated processes of meaning making that give rise to their work. My purpose, however, is not to simply reproduce or unproblematically endorse artists' understandings and positions on their own terms, but rather to use the meanings that they attribute to their work as primary source material for comparative analysis and interpretation within larger framings and circuits of inquiry. Accordingly, I will conditionally incorporate lines of critical

inquiry and argumentation that may postdate or not be organic to how an artist originally conceived or sought to position their work, if they bear significantly on how the artist's endeavors can be more broadly understood and situated. When augmented with a critically engaged understanding of contemporary signifying practices, techniques, and theoretical arguments specific to the visual arts, oral hermeneutics yields a type of information that cannot be readily obtained through secondary sources.

I assume that a work of art—as "an intentional manifestation of mind"— embodies a deliberate discursive act by a knowing subject in response to specific conditions and experiences.[21] To that end, I conduct and audio-tape multiple interviews—both face-to-face and via telephone—with artists as a means to elucidate the intricate connections (cultural, historical, and personal) between their backgrounds, life trajectories, inner lives, and art making. I am then able to analyze the transcribed conversations, relate them to other texts, and bring forward common themes that emerge in connecting the work of various artists to one another. Such a worldly, dialogue-based orientation bears a resemblance to the use of observant participation in ethnography as a means of enabling "shared intersubjectivity" across cultural difference and corresponds to the expressive model of culture offered by communications theory, in which the object of analysis is to understand art's "expressive logics" in enabling individuals to make connections to the world and to other people.[22] This technique has had particular relevance in my contacts with foreign-born artists, who often may draw on a repertoire of differing cultural and historical references and expectations that cannot be adequately understood without detailed interrogation of the artist's intended meanings.

Placing orality and dialogue as the centerpiece of the hermeneutical method (usually associated with text-based practices of interpretation, reflecting its origins in biblical exegesis and ancient literary studies) and directly involving artists in the production of textual meaning adds another dimension to efforts by scholars and critics to extend the insights of hermeneutics to analyses of the visual arts and visual culture.[23] By acknowledging the reciprocal contributions of the author and the reader, we are better able to examine the multiple sites in which meaning is produced. Yet even among theorists who believe it is possible and meaningful to reconstitute aspects of the author's sensibilities and worldview through close analysis of a text, it is generally accepted as axiomatic that the text itself exists as

an autonomous entity.[24] Oral hermeneutics provides a powerful alternative by positing a dialogic model of interpretation.[25] Thus, from my perspective, the ontological significance of the text/work of art lies expressly in its ability to illuminate and interrogate specific propositions about our self-understanding. Stressing the centrality of personal experience, such a critical stance insists on the recognition of the interpreter's biases in all acts of interpretation, through which that point of view is continually tested and transformed by new information in interactive interplay between reader and text, self and other.[26]

Although I emphasize the significance of paying attention to issues of authorial meaning in interpretation, the primary intent of this book is not to contend directly with the complex theoretical stances underpinning these debates, nor to foreground or render transparent the many problems and struggles associated with "reading" works of art in dialogue with the author/artist.[27] Instead, I regard the oral hermeneutical approach as a productive tool to explicate and compare the work of a range of living artists of Asian heritages, rather than conceiving the process and its methodology itself as the centerpiece of my analysis—which would necessarily constitute a very different type of project.

Selecting the Artists and the Work

This book focuses on selected works by ten artists, the majority of whom are foreign born, mirroring contemporary demographics. It is equally divided between women (Kristine Aono, Tomie Arai, Yong Soon Min, Hanh Thi Pham, and Zarina) and men (Y. David Chung, Allan deSouza, Ming Fay, Marlon Fuentes, and Pipo Nguyen-duy). The Asian groups included in this study reflect the composition of the population of Asian America during the 1990s and thus include artists of Chinese, Filipino, Asian Indian, Vietnamese, Korean, and Japanese ethnic backgrounds.[28] A number are voluntary immigrants. Some are refugees and migrants from countries divided by war and civil unrest, whose entry into the United States has typically been associated with trauma and forced displacement. Others have grown up in European colonial spheres in Asia, Africa, and the Pacific, traveled to the imperial metropoles, and subsequently come to this country as multiple migrants on a transnational circuit. Still others are third-generation Asian

Americans who were born and raised in this nation, for whom defining events like the Japanese American internment in World War II continue to bracket the living memories of their families and communities.

Seven of the ten artists represented in this book are based in New York and Los Angeles, cities that, in addition to being primary sites of Asian immigration, are home to major art museums and centers for commercial film and television production. Like other global cities such as Paris, Tokyo, and London, these expansive urban hubs are magnets for the international art market and visual artists, including growing numbers from East, Southeast, and South Asia, as well as Asian diasporas worldwide.[29] Perhaps the most salient feature of the works discussed in this book is their interrelational orientation as these Asian American artists situate themselves in relation to other cultures, histories, people, and discourses. These sensibilities, often tacking back and forth between the local and the global, resonate with the dramatic realignments and population shifts in today's postcolonial and postcommunist world, where the most fundamental frameworks upon which identities and identity politics are premised are increasingly being destabilized and recast.

The concerns of the featured artists do not exist in isolation, nor are they unique to Asian Americans; there are comparable developments in the ideas and practices of other nonwhite and minoritized artists both in and outside of the United States, with which they are generally conversant. Like their contemporaries, Asian American visual artists today embrace virtually every medium, including live and recorded performance, video, film, text-based and book art, body art, computer graphics, and the Internet. For the purposes of this book, however, I have chiefly concentrated on artists working in the media of painting, sculpture, photography, printmaking and graphics, mural art, and multimedia installations.[30] It must be emphasized that the choice of which artists to include was ultimately based on the content and significance of their work and not on ethnicity or gender alone. The selected works are not meant to offer a comprehensive view of Asian American art in the 1990s or to represent the artists' entire oeuvre or the breadth of their concerns; rather, they were chosen for their relevance to the particular themes that I examine. Since artistic intent is not construed as the sole determinant of meaning, I sought to connect each artist's work to various contemporary intellectual currents with which it intersects, among them diasporic, postcolonial, queer, trauma, and urban studies, as well as ethnog-

raphy, feminist and social art history, cultural geography, world history and world systems analysis, the politics of representation, and psychoanalytic-based approaches to issues of difference.

While sometimes influenced by similar experiences, circumstances, and social conditions, the selected artists—many academically trained, some cultural theorists in their own right, and others emerging via community activism and propelled by the idealism of the 1960s and 1970s—employ quite different representational and critical strategies that range from politicized, didactic, interrogatory, and frequently deconstructive critical postures to very personal, poetic, and idiosyncratic expressions. Accordingly, their work is not necessarily unified by any style, aesthetic sensibility, or common approach to art making, nor do they share a particular viewpoint or belief system. This arrangement is consonant with my premise that no single narrative, political, or intellectual alignment could (or should) enfold or conceptualize the highly varied cultural production of Asian America.

Despite their many differences and separate life trajectories, these artists are conjoined by a shared presence in the United States and are compelled to contend with how they are positioned as Asians in their various encounters in this social and political landscape. Thus, for all the artists under discussion, Asianness (however conceived) has been a source of meaning in dealing with their complicated relationships with the United States and its ambivalent national memory, with the issues of representation and with the global impact of Western culture, and with one another. Their selected works are connected both by a strong sense of historical consciousness and by an abiding need to come to terms with an Asian heritage, however uncertain or even contentious an artist's attitude toward that heritage might be. Though they may critically question or look to reconceptualize them, what these artists likewise make plain are the continuities (rather than the ruptures) between some of the polycentric ideas that informed multiculturalist art of the 1970s and 1980s and present-day cultural production that deals with how questions of identification, position, affiliation, and place are reconfiguring today's increasingly multicentered world.

The artworks and artists in this book originally came to my attention through a variety of means, including recommendations from other curators, artists, and scholars, as well as my ongoing research and visits to galleries, museums, and cultural organizations across the country. In my initial

meetings with the artists I begin by clearly spelling out my interests as a researcher and the interpretive framework in which their works would be cast. While appeals to Asian American conceptions of identity, selfhood, and belonging may be languishing or even be extinguished in the minds of some artists under the pressures of intellectual and political opposition, they have remained vital for others. Obviously, those who strongly object to being placed in any context that would highlight aspects of their nationality, ethnicity, race, cultural background, or even personal biography are not appropriate candidates for this type of research. Accordingly, from the very beginning the interview process becomes an important means of eliciting and clarifying the ways in which each artist chooses to define her or himself. For instance, do the artists primarily identify themselves by a national cultural heritage? Or do broader Western ethnic and racialized conceptions of being Asian or Asian American also hold meaning for them? Negotiating such positions and affiliations is therefore critical to every discussion, allowing us to mutually establish the nature of the playing field as well as the ground rules with which we will proceed.

Structuring the Book

This book is assembled around a core of three thematic chapters that broadly look at various positions of identification and affiliation, as well as of resistance and critique, marking these artists' engagement with U.S. society and with Western culture more generally. Its structure reflects my interest in identifying points of connection, however situational or provisional, by grouping together works that address similar subjects that point to significant convergences in artists' responses to their historical moment, social conditions, and everyday realities.

Each chapter contains a précis of certain key issues, along with biographical and historical information that provides a broader context for the artists' interests and concerns. My concluding commentary links the work of these particular artists to wider contemporary currents in the visual arts. Chapter 1 reviews vexed questions of identification, subject formation, and domestic identity politics, as well as intellectual and on-the-ground controversies about the significance of culture, ethnicity, and race and racial-

ization in the arts, with a particular focus on how those issues are being addressed in Asian American art and cultural criticism.

The subsequent thematic chapters are arranged according to larger social and discursive structures that frame the Asian presence in the West. Chapter 2 examines the social construction of difference, and in particular the ways that people of Asian descent find themselves enmeshed, to differing degrees, within the highly elaborated visual representations of Orientalism, primitivism, and racialized stereotyping that have become normalized in this culture. Chapter 3 focuses on social memory and trauma as an organizing principle, examining how artists contend with the historical legacy of intense social and psychological rupture that has deeply imprinted the sensibilities and lives of different Asian American groups. Apart from the fracturing of communities and families caused by discriminatory anti-Asian immigration laws, by racism, and by the uprooting and displacement that are part of migration itself, warfare between Asian nations and the United States in the twentieth century has undeniably had a powerful effect. Chapter 4 provides insights into the continually realigning relationships within and between Asian diasporic communities, in both the U.S. domestic realm and abroad, by investigating intertwined visual narratives of migration, mixing, and place. Here matters of place and conceptions of home—and in particular sites and routes of contact between peoples and cultures—are brought into focus.

The epilogue brings the discussion full circle to revisit the central premise of heterogeneity within Asian America—conceived in regard to the multivalent nature of these artists' claims and disputes as social, cultural, historical, and political subjects. In addition, it points toward the larger implications of such discourses of identification in imagining, visualizing, and asserting new forms of affiliation and citizenship among and across groups, in a broadly conceived and deliberately fluid dialogical formulation which I term "communities of cultural imagination."

This book provides a selective and necessarily partial view of a more complex and far larger history of the decades under discussion. The primary contribution of this developmental, bottom-up research methodology is to offer the kind of relational and textured insights based on an accumulation of detail about individual subjectivities that systemic analyses and generalized theoretical conceptions of localism, regionalism, globalization, and

transculturation do not commonly seek to provide. As part of a shared body of information about the present moment, and the ways we constitute our positions and relationships within it, these observations suggest the vista of constructive possibilities waiting to be explored in this maturing conversation on Asian American art, visual culture, and the social imaginary.

A Play of Positionalities

reconsidering identification

This book takes it as axiomatic that contemporary identifications and affiliations are complex, multidimensional, and fluid—a continually evolving play of positions constituted through and derived from transactions with language, art, customs, ideas, politics, spirituality, and history. Identities are aptly described as names for the divergent ways we are positioned both by and within accounts of bygone times.[1] Simultaneously mediated by tradition and change, interpellated by operations of power, and increasingly shaped by the imperatives of a globally dispersed yet ever more integrated world economy, such positionings index the continuum of circumstances, experiences, and narratives by which individuals and groups both make and take meaning from their times, their journeys around the planet, and the places in which they live.

For my purposes, a positional framework needs to be expansive and open ended, providing a context for grounded inquiry and ongoing dialogue. At the heart of my investigation is the question of how artists of Asian heritage, whether foreign or U.S. born, conceptualize the world and position themselves as cultural and historical subjects through the symbolic languages and media of visual art. This approach to positionality must be responsive to the contingent, shifting, and frequently ambivalent nature of social and personal identities in a multiply determined world, and to new ideas emerging from arenas of intellectual discourse. It should also allow scope for acknowledging the realms of the emotive and affective, including the nuances and richness of collective imaginings. It should recognize the need for belonging, stability, continuity, and origins, and the impact of individual standpoint and agency on both the artistic imagination and the cultural record. Although not in itself a theory, the critical resonances and antireductionist implications of positionality make it a robust device for exploring and mapping visual art and artistic practices informed by a poetics of self- and collective identification. Positionality also takes into

account the self-conscious, and at times quite idiosyncratic, subjectivities through which it is given expression. The term likewise seeks to denote and acknowledge the significant shifts that have occurred in the demography and cultural politics of Asian America over the last four decades, which in turn helps to trace and contextualize the artworks and concerns of the artists in this study.

Since the 1970s, the term *positionality* has been used to frame a spectrum of social critiques that point to the situatedness of our knowledge of and actions in the world, which are intertwined with different places, shifting contexts, and unequal access to power and resources—including expressive resources made available through educational, gender, and class privilege, among other factors that are pithily referred to as "positions of enunciation."[2] This move to rigorously scrutinize the epistemic, material, and discursive positionings of oneself and of others, and to grapple with realms of difference within and between groups, has had transformative effects in the academy and on post-1960s social movements more generally. One thinks, for instance, of the foundational challenge posed in the 1980s by the critique of hegemonic Western feminisms that would take "woman" as a naturalized category of analysis, thereby assuming the homogeneity of women as a group.[3] In a similar spirit, this project (and the decade of research during the 1990s on which it is primarily based) insists on the recognition and careful elucidation of different positions articulated by artists of Asian background through their work—ranging from strong assertions of ethnic heritage and community, and unifying cultural symbols, to deconstructive critiques and antiessentialist postures.

The political space of the nation that Asians negotiate is usefully framed as simultaneously "juridically legislated, territorially situated, and culturally embodied."[4] While each of these realms must be considered, the arena of national culture is where individuals are politically constituted as "Americans."[5] Although Asians have historically been positioned, both legally and culturally, as outsiders to the United States, this position can be conceived as generative, in that the Asian American presence disrupts and challenges dominant representations of a unified, homogenous nation-state. Rather than entailing the recovery of some originary or essential social categories, such an evocation of Asian American culture as a productive site of alterity—one that is not simply imposed from without but also continuously constructed from within—meshes with and helps to contextualize

the various strategies of agency and cultural intervention with which the artists in this study are actively engaged.

Matters of identity, identification, and affiliation continue to galvanize many Asian American artists, despite the prevalence of contemporary discourses that would discount the validity of such conceptions.[6] Continued attention to positions based on social identification is motivated not only by the desire to retain cultural and political agency, and by the necessities of resistance against an ascribed status, but by the fact that identity is generally deemed foundational as a source of meaning.[7] Indeed, the quest for larger identifications and affiliations is integral to the quintessentially human activity of trying to make sense of the world and our place within it. For example, the Filipino American artist and filmmaker Marlon Fuentes remarks, "I've been using my art in trying to create stakeposts or outposts, kind of an orientating device. . . . The images that I've been making are a way of reconciling myself to my own past as well as my own culture."[8] That "orientating device" can draw on many elements for its imaginative constructions, each feeding into the ever more prolific and diverse production of Asian Americans in the arts. Alongside ancestry, culture, geography, history, and nationality, identities are constructed from multiple sources, including collective memory, class, caste, and gender hierarchies, apparatuses of power, ideological and religious beliefs, cultural conventions and expressions (including literary, artistic, musical, and culinary), and personal longings and fantasies.[9]

Visual vocabularies arising from an ongoing search for self- and collective definition constitute what I term "iconographies of presence," which Asian American artists use in their work to invoke cultural commonalities and kindred histories in symbolically claiming a place for themselves in the social imaginary of the West. Whether in manifesting the sensibilities and struggles of Asians in U.S. society, or in aiming to transform from within the discourses and practices of Western art, such themes have the capacity to connect Asians in the United States to one another, and to communities of color both in the United States and abroad. By also introducing visual idioms, symbolic systems, and frameworks of reference from non-Western contexts or heritages (no matter how "modern" or hybrid), these artists broaden discourse and potentially expand the imaginative capacity to envision the world in more-complex terms as we must decipher the "image banks" of other cultures—including those within our national borders.[10]

In the process, questions are raised about the possibility of alternate commonalities and expressive conventions among peoples and cultures that are not necessarily conceived through, or directed toward, a nation's dominant culture. Moreover, since the visual tradition of a culture gives tangible form to the ways in which it sees itself and its worth in relation to other cultures, the significance of contemporary visual art in a globalized environment is not simply reducible to "formalist notions of aesthetic presence" or distancing abstractions like the autonomy of the art object.[11]

While a shared heritage hardly means that a group speaks with a single voice, in light of the West's history of efforts to subdue and control others, the concept of a group possessing its own expressive capital can be extraordinarily meaningful to those historically denied access to adequate means of self- and collective representation. Contrary to expectations, such lines of inquiry do not inevitably encourage cultural polarization and division in their attempts to invoke and project the images and voices of cultural identities long denied, appropriated, or relegated to the margins. Rather, works by Asian American artists, as well as other artists of color, can help to instigate a re-examination of how U.S. culture is conceived by pointing equally to ever-growing realms of difference and plurality and to new possibilities of achieving knowledge and understanding across difference. Likewise, they move us to consider how such art has typically been positioned in art historical and critical discourses, which in turn calls into question the limited canonical grounds on which art (and the artists who produced it) have often been assigned value and place in the social imaginary.

Following a roughly chronological trajectory, in this chapter I review significant developments and tensions that have arisen around conceptions of Asian American art, and issues of identity and identification more generally. Drawing on recent writings by curators, artists, critics, and academics, I consider various pivotal moments, social and intellectual crosscurrents, contestatory methodologies, critiques, and responses that bear upon this contemporary cultural production, as well as on its circulation and valorization within the sphere of the United States and its prevailing "ethnoracial moral order."[12] Although hardly comprehensive, this review nevertheless draws attention to certain salient and often convergent issues in Asian American communities, the U.S. art world, and the academy, while also offering a sampling of views on a swiftly changing milieu in which many are both participants and interpreters. Intended to be accessible to a nonspecialist

readership, the remarks in this chapter are organized in sections that are broadly reflective of major sites in which the meanings of contemporary Asian American art have been constituted: identity politics, the community arts movement, and multiculturalism; globalization, localism, and the U.S. art world; and critical theory and articulations of difference. Throughout, the intent is to open up new spaces for critical discourse, by suggesting ways in which prior conceptions of multiculturalism, identity, and Asian American–ness can be fruitfully reconsidered and revitalized as part of a more heterogeneous array of cultural and critical practices—even if the disputes surrounding them can never be entirely resolved.[13]

Setting the Stage

The growth of migration and the impact of accelerated transnational interchange, mutual redefinition, and hybridization are evident in various Asian American communities, transforming contemporary political, cultural, material, and intellectual life. In this volatile terrain where the global and local converge, and interculturality and polyculturalism have become bywords, social and cultural identification is continuously being reconstituted—especially as the United States increasingly turns its gaze toward Asia, with the rise of the Pacific Rim as a major economic, political, and cultural zone.

Although questions of social identity and identification are compelling concerns for many in the twenty-first century, major alterations to the Asian American environment have particularly galvanized artists, writers, and scholars to vigorously question how they are defined and define themselves as individuals and groups—including notions of who, in the U.S. context, is recognized as Asian and who is not. With the emergence, moreover, of conceptions of multiculturalism in the 1980s, and the resultant backlash against these initiatives in the domestic sphere, much public controversy has centered on the potential divisiveness of difference as a defining concept—tensions reflected in ongoing debates about the significance of ethnicity, race, and non-Western cultural expressions in the arts. In this highly charged climate, artists, curators, critics, and scholars must deal with the pressures of a political and discursive environment in which art that asserts cultural and/or racialized difference—especially when it takes an overtly critical stance on domestic politics—is often dismissed.

At the same time, the advent of critical theory and the subsequent development of cultural and American studies inaugurated a significant trend toward rethinking the paradigms that informed ethnic studies and race/identity politics both in the United States and abroad.[14] Moving away from pluralism and multiculturalism, the focus shifted instead to how individuals and groups are privileged or marginalized by the ways in which a culture's dominant institutions construct, dictate, and enforce conceptions of truth and normalcy. One of the effects of these intellectual developments has been a heightened awareness, among artists, of the politics of representation and the role of visual culture in the construction of social identifications. The most fundamental notions of how individual and collective identities are conceived and constituted have been challenged on political, theoretical, and cultural grounds and remain a matter for sharp debate within both mainstream and alternative circles in the United States. As the terms by which a sense of Asian identification were understood and validated in this society were increasingly contested and destabilized, the expression "Asian American" itself—seen by some critics as an outworn label denoting a generalized Other—became one with which growing numbers found fault.

As a result of the convergence, in the 1990s, of postmodern critical currents and the often-envenomed rhetorics generated by the "culture wars," issues of difference, identity, and diversity in the United States are today commonly conflated with extreme forms of ethnic and racial separatism, radical counterassertions of non-Western and indigenous cultural superiority and primacy, and "victim politics."[15] Symptomatic of these developments is an often-quoted 1995 essay that expresses resentment toward artists who are perceived as manipulating or pressuring audiences into feeling sorry for them by making their "victimhood" the centerpiece of their work—an approach that allegedly puts such work literally "beyond criticism."[16] The stark term "victim art" continues to resonate today, as it has been invoked to denigrate various types of politicized work, suggesting that these narratives of identity, hardship, and struggle are defined *solely* by appeals to recognize the pain, violence, and defamation inflicted on the artists' respective groups.

Aside from the foregoing types of criticism, which have come to dominate public discourse, attempts to enfold different populations under the

rubrics of "Asian," "Asian American," or "Asian and Pacific Islander" have also met with intense scrutiny from various ethnic communities. Such attitudes reflect larger intertwined debates, within and between Asian communities, regarding which peoples and cultures are perceived as Asian in the national imaginary, how different Asian groups define what is Asian in this society, and how those groups choose to define themselves.

Given the polarizing impact of such a discordant intellectual and political climate, even those in the American art world who *do* find conceptions of who "we" are and with whom we ought to identify meaningful neverthe-less feel a deep ambivalence and discomfort in recognizing that aspects of these discourses and their representations can indeed be problematic. As a result, many contemporary critics are inclined to equate any interest in cultural specificity with cultural essentialism and cultural nationalism. In treading through such a dense political and intellectual minefield, artists and scholars alike find themselves subjected to competing and often over-lapping pressures from various quarters of the art world and the academy, as well as from a host of Asian American groups and individuals with dif-fering and sometimes antagonistic agendas.

Dynamic claims and counterclaims to identification and membership in various collectivities have given rise to a broad range of symbolic repertoires and strategies of representation that artists enlist to visualize their rela-tionships to Asian heritages and cultural practices, the overseas journeys, sites, and internal circulation of historic and contemporary Asian commu-nities, as well as their interactions within and with other groups (Asian and otherwise) both in the United States and abroad. In my experience, themes of identity and identification—while multifaceted, often inter-twined, and mediated by personal and historical memory—form strands that tend to broadly coalesce around two imaginative armatures. The first entails spatiotemporal tropes of travel and place, and the second concerns signs and assertions of an Asian presence in the world. Akin to the form of transitive consciousnesses described as "dwelling-in-travel," the first approach acknowledges the importance of space/place as a locus of per-sonal and communal identification.[17] Often spanning deep histories and far-flung geographies, it embodies the variant means by which diasporic artists draw on and combine images of home, community, and trajecto-ries of movement. Following a formulation of the historical notion of space

as comprised of three coordinates—perceived space, conceived space, and lived space—such art may employ polychronic references that collapse and juxtapose the present and the past.[18]

Capable of making multiple and complex connections between the body and society, the other schema foregrounds Asian bodies as a primary device. In such imaginative approaches, bodily imagery (commonly employing self-representation) provides an animate shorthand for artists' engagement with wider social, cultural, and historical issues. Closely tying together individual and collective experience, the body serves as a sign and a metaphor of presence and physical engagement, as a focal point and scrim for social and historical texts, and as a resonant manifestation of the artist as a performing subject.

An approach that links subject formation and the transaction of difference is offered in writings on Latino queer performance art. Employing conceptions of identification, counteridentification, and disidentification, this literature provides useful insights into the different mechanisms by which artists from marginalized groups claim agency as social actors in relation to dominant ideologies—while also speaking to specific conditions that inspire this work.[19] Disidentification, in contrast to identification, enables artists to contest and transcend stereotypic imagery and roles by appropriating and reinhabiting them for their own purposes. Defined as about neither identification nor counteridentification, disidentification is a means of working simultaneously within, and in opposition to, the conventions and expectations of a particular artistic form.[20] Such a model is used to gesture toward the subversive falsification and symbolic reconstruction of the cultural record, alongside other purpose-driven interventions adopted by artists to counter and disrupt stereotypic and at times demonizing representations of Latinos.

A salient feature of much American contemporary art is its interrelational and polycentric orientation, as artists from diverse backgrounds increasingly situate themselves in relation to other discourses, histories, cultures, and peoples, while also affirming continuities with their own heritages. This builds on the concept of the "multiple viewpoints" generated by diasporas, in which diasporic images are inherently intertextual and intervisual.[21] Rather than simply iterating social relations as they exist, art concerned with symbolic negotiations of position and presence, to borrow a phrase, "search[es] for a forward-looking, transcultural and transitive place from

which to look and be seen."[22] In a world of multiple affiliations in flux, the creative use of symbolism, language, history, and myth allows the artist to reimagine and renegotiate conceptions of selfhood formed in relation to group identifications on both the local and global levels. By offering compelling imagery and forms to frame and represent these experiences, such works attest to the ways that cultures and consciousness are continuously transformed through the interaction of difference. Considerations of complex cultural standpoints and the politics of identification in the visual arts, therefore, can indeed be capacious, revealing the strands of social and cultural interactions that shape contemporary artistic consciousness.

Identity Politics, the Community Arts Movement, and Multiculturalism

Multiculturalism, identity politics, and the associated community arts movement of the 1960s and 1970s have had a major impact on extant discourses about what constitutes Asian American art. For Asians in the United States, the arts have historically played a dynamic role in framing and reframing diverse histories and experiences, in the process of defining and articulating a sense of place (and self) in the contemporary world. In this period, an Asian American political and social consciousness emerged among many visual artists, who made a deliberate effort, through thought and practice, to use the power of art and visual culture to enunciate an imaginative identification with a panethnic conception of Asian commonality. The legacy of this attempt to evoke and develop a sense of community centered on the cultural imagination would for many years strongly inform the ways in which Asian American art was framed, presented, and interpreted.

These two decades were an extraordinarily combative era, with profound consequences that, for good or ill, continue to resonate in present-day discourse and expectations. Even as ever-larger numbers of Americans were being drafted to fight in Asia, on the domestic front the Johnson administration initiated a sweeping reform program known as The Great Society (1964–1968). Alongside a vast expansion in funding for new social programs, considerable sums were allocated for the arts. With the escalation of the war in Vietnam, and exacerbated by the assassination of Reverend Martin Luther King Jr. in 1968, the United States was increasingly torn by

strife, leading to mass disorder and race riots that required military intervention to suppress. The civil rights movement steadily gathered momentum, cities across the nation became the nexus of an alienated youth-based counterculture, and antiwar demonstrations grew in intensity and influence. The rise of activist protest and identity movements—antiwar, third world liberation, Asian American, Native American, African American, Chicano, feminist, gay and lesbian—heightened ethnic and cultural awareness and provided fertile ground for collective action, as well as engaged criticism, politically inspired cultural production, and aestheticized politics.

Identity Politics

During these years, university students increasingly militated for greater academic freedom and control over curricula and institutional policies, even as a new radical activism emerged in the U.S. academy that began to pose foundational challenges to long-held conceptions of American culture and history. It was in the universities that, influenced by anticolonial struggles and by the Black Power movement, a generation of Asian American artists first encountered ideas of ethnic pride and third world solidarity. For many of us who came of age in this period, visions of social transformation would continue to guide the course of our creative and private lives.

With the establishment of ethnic studies departments across the country, activist scholars in the academy published the first critical writings that sought to articulate constituent elements of a distinctly Asian American culture. This conviction arose out of a perception that despite differences in background, Asian groups shared common histories of struggles to establish themselves in this nation in the face of discrimination, racism, and economic exploitation. While a concern with issues of identification and heritage is not unique to this generation of Asian artists and intellectuals, it is the conscious quest to construct a panethnic, "Asian American" space that makes this era so distinctive. Throughout the 1970s, matters of identification, and self- and collective representation, increasingly came to the forefront in Asian American scholarship and artistic production. Being able to assert a collective sociopolitical identity was considered a prerequisite for attaining political power, leading the movement to find means of institutionalizing itself by creating viable "counter-institutions."[23] Activists pushed for the establishment of courses and programs in Asian American studies, while at the same time they considered it their responsibility to

work toward changing conditions in the immigrant communities, where many faced ongoing hardship and discrimination. This spurred them to form local organizations, including social service agencies and cultural groups, to serve the ongoing needs of the Asian ethnic enclaves.[24]

The Community Arts Movement

A number of grassroots organizations were established during this period by loose associations of artists, writers, college students, and cultural activists and played a foundational role in the Asian American community arts movement. Among the more influential were the Basement Workshop, in New York, and the Kearny Street Workshop and Japantown Art and Media Workshop, both located in San Francisco.[25] These pioneering groups, each with a strong visual arts component, sought to combine a community-based activism with a broader social and cultural mission in trying to create the foundations for an "Asian American" culture. Besides acting as incubators for new generations of artists, and generating a significant body of documentation and critical writing on Asian American visual artists and issues, such community arts organizations have typically served as an interface with the majority culture, making the art and ideas visible and intelligible to wider audiences. Their activities, while focused on Asian Americans, demonstrated a commitment to maintaining ongoing relations with other communities of color. Influenced by conceptions of a developing third world consciousness, many of these links were formed around individuals who sought to work across communities, rather than through institutional ties. On both ideological grounds and through a common interest in allied visual traditions, some of the exhibitions, journals, and anthologies from that period provided a venue for related work by African American, Native American, and Latino artists.

Although individuals came to the community arts movement from different trajectories, most shared a common trait: their work emerged as an organic response to the world around them. In reply to the challenges of the period, and to make manifest the nature of their lived experience and beliefs, the artists employed a visual vocabulary that drew equally upon local sites and people that shaped their imaginative consciousness, and on motifs and references associated with their ethnic and cultural heritage. Commonly taking the form of large-scale public murals or silk-screened posters, prints, and book illustrations, and seeking to convey a staunch sense of

intercommunity solidarity, the approach of many of these artists was often overtly political and pragmatic in its intention; that is, their work sought to impart messages that could be readily apprehended by the broadest possible audience. With subjects like commonalities among people of color, women's liberation, resistance to racism and oppression, labor and immigration histories, and the destructive impact of urban gentrification resulting in the displacement of ethnic minority, poor, and working people, their art usually reflected radical and ethnic agendas.

At the same time, there emerged a body of art related to the Asian presence in America that was primarily introspective, associative, and often nonrepresentational—its relation to ethnicity and heritage envisioned through a more formal or a far more personal, idiosyncratic lens. The Filipino American painter and mixed-media artist Carlos Villa, for example, often combined these tendencies. He intentionally made use of materials, idioms, systems of meaning, and art-making practices that he associated with non-Western cultures, even as he was fully cognizant of contemporary art-world concerns, including Western modernism and its legacies of abstraction and conceptualism.

Fundamental to the Asian American movement was a belief that there is a "communal consciousness and a unique culture that is . . . Asian American" arising from common experiences and histories as Asians in the United States.[26] Like many members of their generation, the California-born artist Jim Dong and the East Coast poet and cultural activist Fay Chiang—both prominent members of the community arts movement—concerned themselves with the articulation of an Asian American identity. Dong notes that mainstream visual art and the popular media of the period simply "didn't reflect my own politics and [those of] people I knew."[27] Prior to Kearny Street, no institutional frameworks existed in San Francisco that were receptive to the development of an alternate Asian American visual culture, particularly one overtly informed by activist sensibilities, and established Chinatown organizations offered little for visual artists. According to Chiang, a former director of Basement Workshop: "Many like myself had been active in movements growing out of the ferment of the 1960s. . . . But now we gathered at Basement for a different purpose—to create artistic and literary expressions about the identity issue we were all grappling with: what did it mean to be Asian American?"[28]

The multiple practices of artists affiliated with these institutions pointed

to a more integrative way of thinking about the role of the artist as social actor and instigator of change—as well as to how much can be accomplished through informal networks of friendship and common interest. The term "community cultural development" was later advanced to describe the work of "artist-organizers" who share a collaborative orientation by working with others toward social change.[29] Taking an expansive view of culture as encompassing the totality of "signs, beliefs, artifacts, social arrangements, and customs" that comprise human existence, the proponents of community cultural development would contend that their real medium was not the form their art had assumed, but culture itself.[30] Certainly, a compelling insight that emerged from the activism of the 1960s and 1970s is the realization that cultural work and artistic practice can be very broadly conceived.

Related to these activists' efforts to envision a distinct Asian American culture was the articulation of a definitive Asian American aesthetic and, by extension, something that could rightfully be called "Asian American art." Yet attempts to group individuals with very different artistic and intellectual agendas (as well as different heritages) together on the basis of ethnicity alone proved to be highly problematic. In the ensuing debates (which continue to this day), two issues of definition regularly resurface. One is the perennial question about whether the term *Asian American art* refers to the background of the maker (that is, any art made by someone of Asian descent living in the United States can be called Asian American art) or instead refers to a particular subject matter (that is, work that directly addresses some aspect of Asian American experience or has specific social and political content). Not surprisingly, there is a wide spectrum of opinion about how—or if—Asian American art or an Asian American aesthetic should be defined, ranging from prescriptive formulations primarily inflected by leftist political positions to deconstructive critiques of the term itself.

During the early years of the Asian American movement there prevailed a highly politicized approach to cultural development that was strongly influenced by writings such as Mao Tse-tung's "Talks at the Yenan Forum on Literature and Art" (1942). This doctrinaire direction stressed the artist's "moral responsibility" to produce work of social and political relevance to their community.[31] Its advocates view Asian American art as a collective body of folk and art traditions emanating from within the community, which is above all identified as the Asian American working class.[32]

Multiculturalism

The United States has never been a monoculture; its history and culture are both complex and fashioned from the collective memories of many strands, indigenous and immigrant alike. Each group entering the social and political space of the nation recasts and contests its public culture on various levels, from the smallest details of daily encounters between peoples and lifeways to the larger intellectual and political realms. The visual arts provide a dynamic focal point to elicit the accumulated cultural and historical knowledge of a group, while also constituting and projecting its representations into the contemporary civic sphere. As a manifestation of who we are at a particular moment, the arts do not merely reflect, but are indispensable to the shaping of, complex understandings of specific historic periods.

Few people in the United States are so insulated, isolated, or privileged that they have never negotiated the complexities of difference or the benefits and tensions of living in relation to multiple Others. In a continuously evolving and heterogeneous society, concerns articulated by artists of non-Western heritage are integral to enlarging the country's most fundamental visions of itself, its ethos, and its collective character. Rather than stigmatizing and pigeonholing issues of racialization and ethnicization, as if they were automatically divisive and of interest only to a few, we must recognize that we live in a diverse society, in which all our identities are, for better or worse, mutually constructed. In this sense, artists who use their work as a platform to address the intricacies of ethnic and racial formation, identification, and association in a multicultural society are articulating something fundamental to the concept of what it is to be an American.

It would seem, however, that the term *multiculturalism* has assumed iconic proportions since its origins in local antiracist efforts of the 1970s that sought to benefit minority students by having public school education in this nation acknowledge cultural diversity.[33] With its roots in liberal conceptions of cultural pluralism, and reaching its discursive and institutional apex in the 1990s, today its very usage invokes a set of highly elaborated responses honed by decades of contention and debate. Works of art and cultural expressions framed under the rubrics of identity and multiculturalism are often perceived in highly circumscribed, stereotypic ways by contemporary commentators and the general public alike. Rather than attempting to inquire into their meanings, many tend to reject such

work out of hand. Some dismiss multiculturalism as a once-fashionable adjunct of identity politics that was ultimately suborned by mainstream institutional efforts to flatten and manage cultural difference in the United States. Since it is commonly perceived to be an ideological stalking horse for anti-Westernism (or anti-Americanism) rather than a description of a society made up of multiple perspectives and peoples from different lands, it has often provided a symbolic battleground for other issues in public life. The institutional application of diversity policies to social and educational policy on the national scale, moreover, introduced a hard-edged political dimension to this debate that continues to the present day. Appeals to ethnic and racial particularism are now commonly viewed as posing a danger to the cohesiveness of the social fabric by encouraging civic disunity. Consequently, many now see the contest over multiculturalism as having to do with which competing interest groups will prevail in shaping social policy, whether in government, education, or the arts.[34]

Yet multiculturalism can be a quite nuanced and malleable concept. It has found many uses beyond racial quotas and resource allocation and has meant a variety of things to different groups in the United States, to say nothing of how it has come to be applied in other national and cultural contexts around the world. Space does not permit an extended discussion of the range of criticism and counterpositions in this complex social and political conversation, except to observe that characterizations of multiculturalism and identity politics as little more than the bashing of Western history and cultural values or as a struggle between victims and oppressors are, in themselves, highly reductive. In fact, to accept cultural and ethnic specificity and the sense of belonging it engenders is not automatically to be an essentialist or to support static notions of identity.

By embodying the multidimensional contributions of diverse groups in a society, conceptions of identification expressly include culture, language, nationality, place, class, gender, and a host of other issues that conceivably could be addressed under its auspices. Indeed, it could equally be said that arguments positing identity as a monolithic and disciplinary construct simply create other essences; to put it another way, they tend to *essentialize identity* as an ontological and epistemological category. Insisting that essentialism is inherently reactionary, and thus proceeding as if it is comprised of some essence, is, moreover, to tacitly acquiesce in essentialism.[35] The notion of "strategic essentialism," which distinguishes between actively deploying

essentialism and unthinkingly clinging to it, has been invoked to contend that in any multicultural struggle, the need to allow for "communities of identification" remains vital, whether or not such communities are unitary, coherent, or somewhat a product of the imagination.[36] Along parallel lines, radical intellectual approaches in which identity and experience are held to be nothing but constructions of language can be see to function as the "dubious opposites of essentialism."[37]

At the same time that Asian American artists are negotiating the vexed, yet significant, issues surrounding social and cultural identification, they must simultaneously manage the pressures of an art world in which work addressing issues of identity is associated with a "politics of victimization" and a coercive political correctness—or, conversely, with complicity in re-legitimizing unstable ethnic and racial categories that uphold the majority culture's order of knowledge. Although multiculturalist agendas may induce some artists of color to create art that is accepted because of what is described as an "inclusion by virtue of othering," it is also true that many artists have become reluctant to engage in particular practices or discourses for fear that their art will be seen only through the lens of their race or ethnicity.[38] While few contest the value of providing exposure to artists who happen to be Asian American, exhibitions or interpretive writings that address an artist's ethnicity or background are often criticized for, among many other things, being self-marginalizing, trendy, naïve, essentializing, exoticizing, or trivial; encouraging tribalism; variously emphasizing biography, sociology, or politics at the expense of aesthetics; lacking quality or intellectual merit; dwelling on past wrongs and mistreatment; conflating the experiences of Asians with very different origins; perpetuating imposed categorizations such as race as the primary basis of identity; even, at the extreme, for encouraging a resurgent nationalism that perpetuates global conflict by emphasizing ethnic and racial difference.

One measure of these attitudes can be found in the overwhelmingly negative critical reception of the 1993 Whitney Biennial, a national showcase for new artistic talent organized by the Whitney Museum of American Art in New York, in both the popular and arts presses. Departing from the ecumenical stance of past biennials, this exhibition explicitly focused on politically oriented works by contemporary artists that addressed issues of racism, ethnic identity, multiculturalism, sexuality, and gender. A large percentage of the artists featured were from marginalized communi-

ties, including African Americans, Latinos, and Asians, as well as gays and women.[39]

The tenor of the critical responses to this biennial is instructive, as it reflects attitudes that continue to cut across a wide ideological swath in the art world, against any type of work or show associated with identity politics. One critic bemoaned the idea that "this semi-literate display of psychopathology and radical sloganeering can be held up as 'a survey of the most outstanding and challenging American art produced during the past two years.'"[40] Other reviewers complained of feeling "battered by condescension" due to the moralizing tone of the exhibition, or were put off by a perceived trend to downgrade "art to the role of social work or therapy" and to "reduce contemporary social issues to a politics of identity [that] . . . offer[s] instead a simplistic model of society as a battle between victims and oppressors."[41] Despite a sympathetic commentator's considerable reservations about the biennial, this negative reception to work by artists from marginalized groups served as a "painful 'wake-up' call" by underscoring the extent to which the biases of the dominant white majority still prevail in U.S. art-world politics.[42]

These reactions followed a pattern already set by 1990, with the contentious response to the "Decade Show: Frameworks of Identity in the 1980s" mounted by the New Museum of Contemporary Art, the Studio Museum in Harlem, and the Museum of Contemporary Hispanic Art. They would be heard again in 1994 with the controversies surrounding "Black Male: Representations of Masculinity in Contemporary American Art," "Bad Girls," and "Asia/America: Identities in Contemporary Asian American Art," three other exhibitions revolving around identity that were also held in New York museums. Even as these shows were decried for being of marginal interest to audiences, for perpetuating stereotypes and rhetorics of victimization, and for endorsing negative views of American culture, there were viewers who found validation for their own experiences in the art.

An interesting counterpoint can be found in the more nuanced reaction of an Asian American artist to the "Asia/America" exhibition, which highlighted works by foreign-born Asian artists living in the United States. Seeking to penetrate the surface of what could too easily be dismissed as another identity-politics show, the artist argues, "It would be . . . simple to judge too quickly from the exhibition's title . . . which deceptively echoes the binaristic logic of East meets West multiculturalism. Actually, though, the

work in the exhibition doesn't emphasize identity politics in the national context so much as what [the] curator . . . refers to as a 'transnational cultural terrain.' [It] probes not the issue of race, but the cultural self, the layering of psychic trajectories that follows the geographic wanderings, which are a fact of life for increasing numbers of non-Westerners."[43] Through relating personal experience as a viewer, these comments also point to the potential of such projects to open up new lines of identification: "Entering this space . . . I felt myself relieved of my racial self. . . . I felt utterly at home, where my experience negotiating the contradictions of existence in a meat-and-potatoes kind of town was not an anomaly, but a fit subject for art."[44] As these remarks suggest, rather than fixing artists within monolithic discourses of race and ethnicity, such projects can actually have the opposite effect, by creating a physical and intellectual space that illuminates and encourages a heterogeneous play of positionalities.

Alice Yang notes the tendency in the mainstream and popular press to "misunderstand, ignore, or stereotype" the expressions of Asian American artists.[45] Referring to assessments of the "Asia/America" exhibition that appeared when it first opened in the Asia Society Galleries (now the Asia Society and Museum) in New York, she quotes one critic's off-putting contention: "The migrants tell of loneliness, sleeping on floors, working at dull jobs, learning that nobody cares. Sounds familiar, doesn't it? I could sympathize, and I do, but what did they expect?" To this reviewer, Yang replies, "There is a sense of latent hostility . . . 'Go home if you don't like this country,' she seems to imply."[46]

Aside from flattening the significant differences and complexity of the transcultural art in this wide-ranging exhibition to a single theme, and thus rendering it one dimensional, on a fundamental level these remarks can be understood in terms of a guest/host paradigm that has frequently been invoked to counter the nonwhite immigrant presence in this country, and which deeply inflects American narratives about national identity, self, and Other. In this, Asians are perceived as the perpetual guests (some of whom have clearly overstayed their welcome), whereas Anglo Americans are implicitly cast as beleaguered, sorely abused hosts. As befits the proper behavior of visitors in another's home, Asians are expected to act beholden to their gracious hosts and certainly not to criticize them or make excessive demands, which would constitute a breach in the social contract. Moreover, as guests, they are required to play by the house rules; if they are not pre-

pared to do so, then, as the statement suggests, they shouldn't be here in the first place.

Articulations of Difference and a Changing Intellectual Context

With the cumulative impact of postmodernism, poststructuralism, critical theory, and cultural studies on cultural politics, intellectual life, and the arts since the 1980s, naturalized, seemingly fixed discourses of identification have been sharply interrogated. Emerging from a multifaceted array of arguments and fields of study (postcolonial, subaltern, critical race, women's, queer, performative, legal, ethical, and so on), and often infused with the languages and practices of the feminist academy, Marxism, and Freudian and Lacanian psychoanalysis, these theoretical currents have reconceived identities as socially constructed texts that are fashioned through the process of their own writing. No longer considered "true" and fixed representations, identity categories such as ethnicity, race, nation, and gender were destabilized, along with unitary conceptions of the self, and seen instead as temporary, shifting, multidimensional, and discontinuous. In light of these ideas, the politics of identity increasingly refocused on the asymmetries of power behind discourse in sustaining structures of domination and dependence—and on who is privileged to select and valorize the narratives and visual images by which a society's culture is transmitted. As master narratives came to be viewed by many in the American academy and the arts as having little or no credibility, any project that brought forward conceptions of identity and identification, especially those seeking to transcend the realm of the personal and the private, became a potentially incendiary one.

A similar ideological sea change took place in Britain during this period, moving from a "struggle over the relations of representation, to a *politics of representation* itself."[47] This pronounced shift resulted from the encounter between critical cultural theories and local conceptions of "black" cultural politics that attempted to unify marginalized Afro-Caribbean and South Asian communities around a common notion of blackness. Influenced by a central tenet of postmodernist theory—that language is constitutive, and not descriptive, of human reality—it was no longer seen as sufficient for blacks simply to gain access to representation and to substitute positive

images for the negative ones in dominant culture. Rather, the very construction of identity required critical reexamination. Instead of perpetuating the existing terms by which race and ethnicity are discussed, emphasis was placed on understanding the formation of race as a social process—recognizing how its meaning is constructed within certain regimes of representation.[48] By framing it as a discourse rather than a naturalized fact associated with particular groups, the presumption was that race could be de-essentialized. In the United States, race was increasingly spoken of as a "dangerous trope" that inscribes "ultimate, irreducible difference" between cultures and peoples.[49] Through its use, it was argued that we actually "*will* this sense of *natural* difference into our formulations" and perpetuate this term through a "pernicious act of language."[50] The concept of race was viewed as a form of "epistemic violence" perpetrated in discourses of the Other.[51]

This move toward social constructionist analyses, and an accompanying focus on the dynamics of power and on the discursive mechanisms of representation themselves in producing identities, also proved to be highly influential among a number of Asian American cultural critics and artists during the 1980s. Swayed by these lines of reasoning, they had begun to express misgivings about the perceived limitations of labeling contemporary art according to ethnicity. Seeking to advance beyond a perceived normative aesthetic, some artists and filmmakers began to practice a "politics of form," conceiving the nonconventional manipulation of a work's medium and structure as an inherently political act. Many cite the influence of the filmmaker and writer Trinh T. Minh-ha, who took the discursive theories of poststructuralism and the analytical tools of deconstruction and extended them to analyze colonial and postcolonial relationships between the West and its Others. Observing that the postcolonial subject must be constantly vigilant about efforts to suborn her/him to any single overarching discourse of identification—and influenced by the role of binary oppositions in Western thought and action—Trinh sought to dismantle the center/margin binarism that she regards as endemic to Western discourse. As Trinh, who was born in Vietnam, relates, American audiences actually demand that she speak about and highlight her difference as an Asian woman, to the point that "no uprooted person is invited to participate [in these discourses] . . . unless s/he . . . paints her/himself thick with authenticity."[52] Resisting those who might try to box her in, she asserts that a feminist must consciously

work on two fronts simultaneously, by insisting on difference while "unsettling every definition of woman arrived at."[53] Deliberately decentering and exposing the object/subject relationship devised and imposed by dominant regimes of representation thus became, for her, a potent form of oppositionality. Strategies of resistance such as Trinh Minh-ha's have set an important precedent for successive generations of academically trained Asian American artists.

Mindful of the ways that identity had virtually become a new canon for many minoritized artists, by the 1990s younger Asian American artists and writers would increasingly question whether the language and social agendas of identity politics and the community arts movement were meaningful in framing their cultural production or instead simply delimited discourse and forced artists and their work into racialized or ideologically driven straitjackets. Resistant to being labeled as Asian American artists, they came to feel that frameworks like "Asian American art" threatened to consign them to an ethnic ghetto in which they were cast in the role of the native informant and to filter their art primarily through the lens of race and autobiography.[54] Focused on relations of power (and sternly warning against complicity in maintaining the sociocultural status quo), such arguments were often pitched in a supercharged politicized rhetoric that yielded little ground for disagreement or even neutrality.

Under the impact of these challenges, it was increasingly accepted that group exhibitions organized on the basis of the maker's social and cultural identifications and affiliations (or a generic Asianness / Asian American–ness) were to be equated with a confining essentialism. Exemplifying this critical turn in the Asian American intellectual, cultural, and political landscape are the 1993 remarks of the artist Ayisha Abraham. Critiquing ethnic-based exhibitions for not accounting for how a "sense of identity can so easily shift," she maintains that the use of a generic (i.e., monolithic or culturally based) Asian identity, apart from positioning the artist in opposition to the dominant culture, is ultimately uninformative.[55] By the late 1990s, Alice Yang would assert that curatorial practices which frame Asian American identities as a negation of, or as a more "authentic" corrective to, mainstream norms and stereotypes tend to simply "reinscribe difference in the effort to circumvent it."[56] Yang maintained instead that the task should be to decenter the category of race itself by shifting the emphasis to reveal the multiple components of identity that shape artistic practice, including

issues of nationality, culture, religion, class, and sexuality. More recently, in 2003, the video artist Paul Pfeiffer drew a parallel between identity politics and consumer culture, likening the foregrounding of (group) identity to a type of commodification in which artists are encouraged to sell themselves by "act[ing] as ambassadors of their identities."[57] Given the tenor of the times, even among institutions devoted to featuring particular racialized groups, there were efforts to disengage from prior rhetorics of race and identity politics. For instance, Thelma Golden, the current director at the Studio Museum in Harlem, has advocated for a "post-black" art, reflecting the attitudes of younger artists who challenge extant constructions of blackness.[58]

Putting aside critical claims that identity categories are overdetermined, that they have no firm basis in discourse (since nothing ultimately does), or even, from a different trajectory, that postidentitarian understandings are themselves incapable of escaping essentializing moves, the use of overly purist and militantly polemical devices in portraying identities and social collectivity in starkly dichotomous terms presents a "false dilemma."[59] When restricted to these polarities, we must either accept seemingly flawed and destructive uses of social identification—reductivism, literalism, special pleading, nativism, racism, and so on—or be compelled to virtually will it out of existence by categorically denying its meaningfulness altogether. From the perspective of the political arena alone, it would be hard to conceive of any form of movement politics (indeed, of practically any effective politics) capable of gathering people together to effect change without providing some sense of "a particularized, essentialized cohesiveness."[60] While an influential scholar embraces the "expansive vision" that emerged following the identity-destabilizing debates of the 1980s and 1990s, she nevertheless now argues against the easy abandonment of "the language of gender or race."[61] Extending that contention to a defense of the continued political and intellectual deployment of both identity categories, this commentator cites ongoing efforts to counter the hard-won gains of affirmative action and abortion rights, as well as a postmodern intellectual atmosphere that "for sometimes dubious gain" permits the leveling of distinctions.[62]

It is impossible, in this short discussion, to do justice to the density, complexity, and range of such arguments, or to review every new conjecture in these areas. Suffice it to say, these intellectual developments continue to extend themselves along many avenues, and—with their deep commit-

ment to oppositionality, defiance, and the subversion of conventional expectations—they are providing many Asian American artists, critics, and scholars with important analytical tools and a well-articulated language to voice their challenges to the constructions of difference within which they find themselves and their work positioned. Moreover, they do yield useful insights and framing devices, allowing us to conceive of Asianness in the American context not simply in terms of racialization but rather as a variegate and mutable set of historically formed relationships to the dominant culture that both are imposed and constitute primary sites of symbolic intervention. Yet, the predictability of the current debate about identity, now frozen in the often-conflicting agendas of discourses swayed by postmodern ideas and identity politics, is incapable of furthering discussion.[63] Rather than following this well-worn track, it might instead be more useful for critical thinkers to focus on the specific, real-world contexts and analytic approaches by which social and cultural identification and their expressions are actually being framed.

Globalization, Localism, and the Domestic Art World

Even as critical voices were pressing either for the recognition of ethnic and national specificity, or for its denial altogether, the Asian American environment shifted significantly over the decades following the passage of the Immigration Act of 1965. The impact of the explosive growth in new immigration from all parts of Asia, as well as spreading globalization and changing patterns of settlement, irrevocably transformed the Asian situation in the United States. Older communities expanded substantially, and new communities were established in regions and towns across the nation that lacked a prior history of Asian immigrant settlement. Foreign-born Asian artists, moreover, have since become an ever-more-influential presence. In art capitals like New York, unprecedented numbers of Asian artists began to circulate as educated elites and professionals bent on establishing mainstream careers, leading to an upswing of interest in contemporary Asian art, including a number of ambitious museum-level exhibitions. For instance, the Guggenheim Museum and the San Francisco Museum of Modern Art, as part of an international collaboration, presented the traveling exhibition "Japanese Art after 1945: Scream Against the Sky" (1994–95). Likewise, the

Asia Society and Museum in New York mounted three major shows: "Contemporary Art in Asia: Traditions/Tensions" (1996), "Inside Out: New Chinese Art" (1998), and "Edge of Desire: Recent Art in India" (2005).

Yet, the newly arrived Asian artists often have little initial knowledge of, or identification with, the histories or struggles that have shaped Asian American cultural politics. Moreover, individuals with cosmopolitan or transnational aspirations might have less inclination or incentive to involve themselves in the domestic realm and its politics, nor would they necessarily come in more than casual contact with local artists or Asian American arts communities, unless there are strategic efforts to stimulate dialogue between them.[64] Asian American identity politics has traditionally emphasized the importance of claiming a place in the nation and has invoked the rhetorics of territory, home, and belonging to counter past histories of exclusion and discrimination. However, those who were part of this surging new immigration introduced very different perspectives and formulations of identification into the cultural discourses of Asian America. These divergent positions were underscored in a 1991 conference entitled "Defining Our Culture(s), Our Selves," organized by the Asian American Arts Alliance in New York, in which the question "Is there an Asian American aesthetics?" drew decidedly mixed responses. For artists and cultural producers who have undergone the multiple displacements of migration, the notion of a distinguishing aesthetics is not necessarily associated with place or fixity, but rather with movement, flow, fragmentation, and multiple points of connection. In that conference, one leading participant asserted, "An 'aesthetics of dislocation' is one component of an Asian American aesthetics. The other is that we have all come under the sign of America."[65]

Reflecting the varied transnational and diasporic positions, the discontinuities between the domestic and diasporic can be quite pronounced. Many among the foreign-born have an uneasy relationship with the American-born, since it is not uncommon for them to feel that Asian American social and political conceptions do not reflect their interests, or the reality in their home countries, where they would instead self-identify and be identified in terms of a specific national, cultural, religious, and linguistic affiliation, rather than as "Asian." They may see little reason to embrace an Asian American identity, which they may regard (if they regard it at all) as a historical artifact that arose through earlier needs to form political alliances across

ethnic lines. Others view the entire notion of being Asian or Asian American as a racialized imposition constructed and reinforced by Western culture. They challenge the very idea of "Asia" as artificial, an imposed geopolitical fiction deeply rooted in European history and its geographical conventions of naming.[66] Indeed, a major problem with the term *Asian American* is that even though many immigrants have settled here from various regions of Asia—a vast landmass stretching from within a few miles of the northwest coast of Alaska to the eastern Mediterranean—among most Americans, the commonly accepted notion of who is "Asian" remains limited to peoples from East or Southeast Asia and the Philippines. (In Britain, by contrast, "Asian" usually refers to South Asians.) Unlike the ancient and extensive history of European engagement, until recently both the zone of U.S. involvement and the bulk of migration from Asia were centered on the Pacific Rim. Now, especially with the ever more visible and dynamic presence of migrants from South, West, and Central Asia, that situation is rapidly changing, and fields like Asian American studies are vigorously being pressed to examine their bias toward East Asian history and culture.

With expanding globalization, moreover, growing numbers of scholars contend that the very notion of national and cultural boundaries is being permanently eroded. Asserting that modern identities are increasingly fluid, some decry as polarizing what they perceive to be limiting notions that would constrain or fix identity based on static criteria of ethnicity or national origin.[67] The phenomenon of globalization has helped shift Asian American studies and cultural criticism away from the U.S. environment to a focus on wider regional (Pacific, hemispheric, etc.) and international realms.[68] According to one commentator, we are witnessing a complex process of "denationalization" in which prior models of identity politics are giving way to a diasporic perspective that positions Asian Americans as "one element in the global scattering of peoples of Asian origin."[69]

Likewise, the claim is made that the boundaries of Asian American history need to be reconceptualized in relation to the international circulation of labor that brought Asians together with blacks, Latinos, and various indigenous peoples.[70] Along these lines, another scholar envisions intersections between Latin American studies, Caribbean studies, and Asian American studies, by pointing to the historical links between the decline of the slave trade and the rise of the coolie trade in countries like Peru and Cuba.[71]

Parallel developments can be seen in cultural studies and postcolonial studies. For example, it is argued that the nationalistic focus of both British and African American cultural studies stands in opposition to a larger, more complex geographical and social formation such as "the black Atlantic."[72] Rather than focusing on the modern nation-state, here the Atlantic Ocean itself become a unit of analysis as a "system of cultural exchange" that brings together peoples of the Caribbean, Europe, and the Americas in a far-reaching study of the black diaspora.[73]

On the move are countless migrants, refugees, exiles, tourists, and entrepreneurs, as well as professionals, academics, and intellectuals; the effects of globalization and cosmopolitanism in the United States are numerous, ongoing, and complicated to decipher. Even as global circulation breaks down borders, loosens the bonds of place and heritage that traditionally define identity, and emphasizes the play of difference, it also opens up fresh possibilities for connection. The very experience of displacement binds peoples in the diaspora and makes possible new identifications and "multiple anchorages" based on a common presence in a new society, in which artists' works are accordingly "refracted against that of each other."[74] From this vantage point, "Asian American" can itself be understood as a new kind of ethnicity.

The presence of Asian artists in the globalized art scene has triggered a groundswell of new writing from Western scholars of Asian art, who find their knowledge of the languages, cultures, and histories of these artists' countries of origin affords an entryway into the field of contemporary art. Likewise, foreign-born Asian art scholars and critics in this country are particularly well placed to situate contemporary artists in their wider contexts, as they are familiar with both the homelands and the U.S. environment in which these artists circulate. Specialized publications such as *ArtAsiaPacific* and *Asian Art News* follow these latest trends. Many possibilities exist for those with the skills and institutional connections to ply these international waters.

With the enlargement of the art world's geographic reach, curators, critics, and collectors now regularly travel the globe in pursuit of the latest developments.[75] Alongside the increased mobility of this host of new global actors, many artists can also be found wandering these transnational corridors. Like cultural nomads, they circulate through a series of transitory

milieus—a cosmopolitan circuit of museums, university venues, commercial galleries, festivals, art fairs, nonprofit and alternative art spaces, and paid residencies. Such a description of the changing international art scene brings to mind an evocative observation about contemporary Asian immigrants who have come to "regard the U.S. as simply one of many possible places to exercise their portable capital and portable skills."[76]

Some artists have become fixtures in the international biennials that have proliferated since the 1980s, beginning with the controversial "Magiciens de la Terre" (1989) at the Pompidou Center in Paris, advertised as the first effort to present a truly global art exhibition.[77] Organized in art capitals around the world, these blockbuster exhibitions have contributed to the reconfiguration of global aesthetic and critical discourses, even as they have become increasingly packaged, institutionalized, and a primary means by which art is consumed and artists gain international reputations. While in the past they were mainly held in Western metropoles, this situation has changed significantly since the 1990s. In Asia alone, there have been biennials and triennials staged in Gwangju and Pusan, South Korea; Jakarta, Indonesia; Taipei, Taiwan; Yokohama and Fukuoka, Japan; Singapore; Istanbul, Turkey; and Sharjah, United Arab Emirates; as well as in the People's Republic of China (Beijing, Shanghai, Chengdu, and Guangzhou).

In no small part due to their attractiveness to local power brokers as vehicles to promote commercial development and attract tourism, these thematic showcases have been enormously influential in establishing the Asian Pacific region as a vital center for contemporary art. Beyond providing high-profile venues in which a large proportion of the exhibited work represents the efforts of Asian and Pacific artists, by bringing in "significant international art and artists" these events also foster the emergence of regional contemporary art and the formation of new museums committed to the subject.[78] Although Asian American artists are not usually featured in these exhibitions as such, the 2002 Gwangju Biennial included a section that showcased Korean Americans alongside their contemporaries from Korean diasporas around the world.[79] Furthermore, increasing attention has turned to the Pacific realm, where the Queensland Art Gallery in Brisbane, Australia, organized the Fifth Asia-Pacific Triennial in 2006. This triennial brings together artists from South, Southeast, and East Asia, as well as Australia and the Pacific Islands.

Globalization, Diaspora, and Differing Frames of Reference

The processes of globalization can be seen as productive of diasporic communities and identities. The idea of diaspora in turn, as a transnational politics of dislocation engendered by relocation and resettlement, allows for distinct identifications that transcend local notions of "hyphenated" identity. Emphasizing mobility and border-crossing over stasis, the terms such as *diaspora* and *cosmopolitanism* that have gained greater currency with contemporary globalization draw attention to complex Asian subject positions that circulate among multiple locations in different nation-states, among which the United States might be only one point of focus on an ongoing journey. Amid the continual movement of people across national boundaries, *diaspora* itself is an "inevitably plural noun" whose parameters are best viewed within larger global frameworks.[80] Marked by hybridity and continual renewal, the diasporic condition generates intrinsically multiple perspectives in visual art.[81] In this "polycentric vision," which proceeds from dialogic interaction, the realm of the visual functions as a principle interface "between individuals and communities and cultures."[82]

Apart from the numerous challenges that the work of foreign-born Asian artists offers to Western interpreters, it is interesting to note how the differing frames of reference they bring have also served to relativize Asian American critical discourses in the visual arts. This fact was brought home to me during the spring 2000 visit of the Chinese avant-garde performance artist Zhang Huan to my course on contemporary Asian and Asian American art at New York University. Zhang is known for using his body in scenarios that often push the limits of physical abuse. The artist came to New York in 1998 as a participant in the Asia Society's "Inside Out" exhibition and has remained in this country ever since. The class viewed a videotape of performances by the artist, including the well-known *Pilgrimage—Wind and Water in New York* done at P.S.1 Contemporary Arts Center (now an affiliate of the Museum of Modern Art) in conjunction with "Inside Out." Accompanied by recorded chanting and instrumental music, Zhang slowly entered the museum courtyard. With his head shaved and sporting fire-red silk trousers, the artist performed a ritual associated with Tibetan Buddhism. First prostrating himself full length, he slid forward over rough stones along the length of a gravel path, rising periodically to clap his hands together above his head. The process was slowly repeated until

the artist stopped before a traditional Chinese bed placed at the foot of stairs leading to the museum, on which rested a "mattress" fashioned from slabs of ice. Tethered to the bed was a pack of barking dogs, their owners sitting nearby. Stripping naked, Zhang lay face down on the ice while the crowd looked on entranced, many jockeying for position to photograph and videotape the event. After several minutes, the artist slowly rose to silently retrace his way out of the arena.

Following the viewing of Zhang's performance on videotape, one student inquired, through a translator, whether the artist thought his work might play into and reinforce among Western viewers exoticized, Orientalist notions of Asian cultures. The artist appeared puzzled by the question and found it difficult to respond, as that issue appeared to be outside the realm of his consideration. Although this reaction may simply be reflective of this individual's standpoint, or the difficulties presented by language barriers, it also can suggest a larger dynamic. Whereas (counter)Orientalism has been a major axis of critique for Asians in this country, it does not necessarily occupy the same strategic position for artists coming from non-Western societies. Similarly, as was observed about the encounters between artists in "Across the Pacific," a 1993 exhibition of both contemporary Korean and Korean American art held in New York at the Queens Museum, Koreans simply could not understand why their U.S. counterparts were so concerned with race as an issue, as it was not a question in a fairly homogeneous society like theirs.[83] Such verbal exchanges demonstrate, on a local level, how engaging with foreign-born artists can sharpen one's awareness of the situated nature of Asian American cultural criticism within the Western frame, as well as of the particular conditions and historical relations between groups within the nation-state.

While it is important to avoid exoticizing such works of art, given that contemporary Asian artists are, for the most part, well aware of Western art and ideas, it is equally necessary to recognize cultural difference. As a contemporary curator from Thailand argues, modern Asian societies are actively grappling with Western cultural influences and ideas; however, they still do so from their own standpoints. He queries whether in doing so, the local meanings of terms like *multiculturalism* or *multiple identities* translate accurately "when applied to specific points in non-western contexts."[84] Indeed, as with all transactions between cultures, modernity, postmodernity, and hybridity are not everywhere the same; they are transmitted and

refracted through different lenses, and translated and expressed in specific ways in different places for different purposes. These complex issues were eloquently alluded to by Homi Bhabha in a 1998 conversation about Asian diasporic art with artist Shahzia Sikander: "Suppose we don't want an exoticism. We don't want an orientalism. . . . What must I know? . . . What must I be as a citizen spectator?"[85]

The U.S. Arts Environment and the Displacement of the Domestic

At the same time, it is equally necessary to recognize that migration involves not only movement but also the negotiation of relationships with new social and cultural environments. Upon entering the sphere of the United States, whether as travelers, voluntary migrants, or refugees, Asian artists often find themselves having to contend with the local politics of place, including the historically embedded experiences, politically determined status, and both racialized and Orientalized representations to which they become heir by simply crossing its borders. In this, bodies definitely continue to matter.[86] Despite contemporary efforts to reimagine the conventional meanings imputed to the human body, Americans' attitudes about physical appearance remain profoundly shaped by a long history of racial categorization and control. Whatever their background, in the United States people of Asian descent are typically marked by their physiognomy as inherently foreign or Other. In this context, cultural identification—no matter how partial, mediated, or multidimensional—can become a defining force in a diasporic Asian artist's work.

While fully recognizing the productive possibilities of the new transcultural formulations, we must also acknowledge that one of the potential hazards is the tendency to create broadly drawn dichotomies in which a focus on the local/national is posited as "essentially" narrow, territory-based, and reactionary, and the global/transnational as expansive, cosmopolitan, and enlightened. Indeed, the ever more popular use of terms like *postnational* indicates the direction of recent critical thought. Some scholars, however, offer important counterpoints to this trend. For example, even as one author problematizes cultural nationalism, she cautions against an uncritical adoption of "denationalization" as the next, more advanced phase of Asian American studies. In this view, the political exigencies that originally gave rise to Asian American cultural criticism are not yet so fully realized as to be unequivocally abandoned.[87] To play down or to delegitimize a focus on

the domestic is also potentially to depoliticize one's analysis, by not dealing with the specific conditions (such as race relations, class conflicts, anti-immigrant sentiment, and labor exploitation) that shaped Asians' histories in the United States. Rather than advocating for some single, overarching model, she proposes the idea of coexisting "modes" of Asian American subjectivity, in which the domestic and diasporic modes operate simultaneously.

Such a conception provides a means to bypass the struggle over which lens is the most meaningful to use in framing contemporary Asian/Asian American experience. Following a parallel route, the claim is made for the recognition of a "rooted cosmopolitanism."[88] By allowing for a coextensive sense of self-identification with both the local and the global, such lines of analysis open pathways for more synthetic approaches. Others emphasize hybridity and prefer to focus on conceptions of new multinational syntheses emerging through the blending of cultures. Some foresee an emergent "cosmopolitan solidarity" and a "planetary humanism," in which the changed status of the former colonial powers and the swelling ranks of postcolonial migrants allow for more productive possibilities through encounters with difference. Citing current developments in urban areas in Britain and in postcolonial cities around the world, one cultural critic notes the spontaneous emergence of local "convivial cultures" not based on conceptions of race or traditional forms of community, but instead arising organically among diverse groups from everyday "processes of cohabitation and interaction."[89]

Certainly, from the standpoint of my research with artists in the United States, it is virtually impossible (especially with the foreign born) to discuss their work and concerns without situating them within an ongoing local/global conversation that includes recent historical events in Asia, as well as in the tangled legacy of interactions between Western nations and their homelands. At the same time, from an Americanist (rather than an Asianist) perspective, my chief interest is in apprehending how those globalized events play out in the domestic context, and how local conditions likewise contribute to shaping the experiences and art of Asians in this society.

How, for example, is it possible to understand the perspectives of Japanese American artists whose families were interned during World War II, without examining the nature of U.S.-Japanese relations and the perceived threat that Japan, as a rising world power, posed to the West? Along with

the international state of affairs at the time, one must account for the local factors that resulted in the selective removal of Japanese Americans from the national body politic—including historical precedents in the forcible containment of Native Americans in restricted zones set up and managed by the federal government, and the convergence of Orientalist notions of Asians as the West's (unassimilable) Others with the pressures of domestic racism and institutionalized anti-Asian exclusionism. Thus, the relationship between the two spheres can be understood as symbiotic, and the domestic realm must be recognized as an equally legitimate locus of study, with its own characteristics and internal currents. Through grounded inquiry into the particularities of individual lives and sensibilities, as formulated in their expressive works, details of how individuals and groups navigate this intricate, multileveled interplay between the domestic and global are vividly and compellingly revealed.

In view of the dynamics of contemporary globalization, another significant problem raised by the intersection of "Asian Asians" and Asian Americans in the U.S. art world is that of authenticity: that is, who among them will come under criticism in both the West and in their homelands for not being the "real" (and therefore the most significant and authoritative) Asian. Despite providing models of transnational expansiveness, matters of cultural identification and authenticity can seem quite complicated for Asian diasporic artists—especially those whose sense of cultural identification is variously constituted in relation to several colonial, postcolonial, and Western national spheres. Allan deSouza, for example, was born under British colonialism in Africa of parents who originated in Goa, an enclave on the west coast of India long dominated by Portugal. Primarily brought up in England, he and his family have spent time in different Western and colonized societies, a condition he refers to as being "twice Westernized." DeSouza maintains that despite differing conceptions of Asian authenticity, critics in India and the West view his art as Western because it does not display the evident traces of Asianness that would distinguish it as sufficiently authentic Asian art.

With artists from contemporary Asian societies in their midst, questions like these have also been a concern for a number of American-born artists who must decide how they will position themselves in relation to distant Asian heritages, and to what extent they will or can claim Asianness. These intricate cultural entanglements, as well as changing social affilia-

tions and alignments, have in turn become a significant issue in their art making. While some strongly envision themselves as part of a continuing Asian legacy, others entirely reject the very notion of authenticity and the pressure to manifest it through their work. Still others, like the second-generation photographer Mimi Young, use their very distance from an originary culture as a space for inquiry. Focusing on curios selected from Chinatown souvenir shops, in the 1995 *Untitled (flip side)* series Young minutely examines these commercial objects to tease out her associations to a Chinese heritage. Such positions both suggest the transnational or diasporic as a locus of identification in itself and reflect the multiple identifications, affiliations, and decentralized perspectives that make it especially complex for such artists to locate themselves in relation to the American (or Asian American) social and cultural environment.

Amid the continued outpouring of institutional, curatorial, and critical attention for contemporary Asian art, some Asian Americans find it disquieting that their work and concerns might once again be overlooked by the mainstream. Given the currency of "neither here nor there" rhetorics of globalization, diaspora, cosmopolitanism, and nomadism, such extraterritorial frameworks have the capacity to displace the language and possibly even the limited gains of domestic multiculturalism. As the art world tends to echo aspects of the larger society, many in the mainstream may find it easier (and probably more appealing) to deal with artists who address issues and problems that occur elsewhere, rather than confronting alternative cultural programs and the troubling realities that arise in their own home.

The differing reception of Asian and Asian American art may, among other things, also be attributed to a form of culturalist bias. It is acceptable and even encouraged to be interested in other cultures, a quality that marks one as a person of sophistication and intellectual curiosity, with a prescient awareness of the skills and knowledge needed to negotiate a world in which Asian nations (and newly rich elites) are emerging as global economic and political forces. By comparison, Asian American art, especially when it addresses issues of identification, is associated with all-too-familiar, close-at-hand, and seemingly intractable problems linked to domestic race politics. Those who have been here for generations are chiefly perceived in a *racialized*, rather than a *culturalist*, context: yet another minoritized group clamoring for recognition. Asian Americans are thus positioned as aberrant

critics from within, launching their attacks against the dominant society from inside its very borders—and in the process, often being greeted with unease and even outright hostility. As an Asian contemporary art critic aptly remarks, many Americans may prefer to maintain a distance from the "bitter reality" of difference close to home, choosing instead to comfortably consume "sensual and serene images" of a far-away, exotic Asia offered in films like Bernardo Bertolucci's *Little Buddha*.[90]

The racialization of Asian American art and its association with minoritarian politics were underscored by my experiences in helping to arrange the national tour for the exhibition "Asia/America." In approaching various museums across the country, I found that one common response was that such a show would be of marginal or no interest to their constituencies, who were not Asian American. The supposition, of course, was that the issues addressed by these artists could be meaningful only to other Asian Americans—despite the fact that the exhibition addressed matters of diasporic journeys, displacement, migration, border crossing, hybridity and cultural difference, race relations, and historical connections between the United States and Asia, as well as a host of other concerns that could potentially affect everyone. Apparently, however, framing those issues through an Asian American lens continues to be regarded as parochial. Whereas the Asian artists represented in such shows as "Traditions/Tensions" may be actively critical of the politics in their homelands, these issues are still somewhat distant and, in the minds of most Americans, do not directly implicate them to the same degree. This is very different from the politics they must negotiate every day, face to face, in their interactions with minorities on the streets, in their workplaces, and in their communities. Given the level of fatigue and resentment toward multiculturalism and identity politics that already exists in the arts and in the larger society, it is no wonder that overseas artists—even those who are dealing with critiques of Western modernization, anticolonialism, and changing identities in Asia—appear to offer fresh and relatively unencumbered vistas for many in the West.

On the other hand, swelling migration and globalization—alongside shifts in critical awareness and efforts to reframe Asian American cultural production through both artistic and curatorial practices—catalyzed the formation of new kinds of domestic arts organizations, such as the New York-based Godzilla: Asian American Art Network. Formed in 1990, this loosely structured, grassroots group of independent artists, writers, and

curators brought together the U.S. and the foreign born and would inspire the later offshoots Godzilla West and Godzookie. Whereas arts groups that arose in conjunction with the 1970s Asian American movement were for the most part ethnic specific and rooted in long-established urban enclaves such as the Chinatowns and Japantowns, Godzilla's founders recognized that the rapid influx from all parts of Asia demanded a new type of pan-Asian organization. They sought to create a forum and space for collective action, in which Asians raised in this nation and the newly arrived from Asia and Asian diasporas around the world could associate and participate equally, based on ongoing dialogue and acceptance of difference. From its inception, therefore, Godzilla was conceived as not being anchored in any single ethnic group, community, cultural-political agenda, or point of view. One former member—who would become the senior curator of art at the Japanese American National Museum in Los Angeles—remarked that, due to its open structure and willingness to accommodate many different approaches to identity as well as critique, Godzilla was "even more radical in its concept of an Asian American arts practice than I understood at the time."[91]

Although it was centered in New York, Godzilla functioned both as an interface and umbrella, fostering information exchange, mutual support, documentation, and networking between Asian American and Asian diasporic visual artists across the country. Its members participated in many gatherings and public forums, and produced a newsletter that included national listings of shows by both Asian American and Asian artists. A number of projects were also initiated or inspired by individuals and groups connected to Godzilla, including the collaboratively organized "The Curio Shop" held at New York's Artists Space in 1993. Featuring forty-eight artists working in a variety of media, the show explored the ways in which commodification, economic exchange, and local tourism in Asian American urban enclaves have served to reinforce distorted and static notions of cultural authenticity.

Godzilla also contested the practices and expectations of mainstream institutions. In 1991, for example, Godzilla published an open letter that challenged the lack of representation of Asian Americans in that year's Whitney Biennial (aside from its film and video programming). Noting that no individual Asian Americans were featured in painting, sculpture, or photography, and that such exclusion reflected a long-standing pattern, members

of Godzilla subsequently met with the director of the Whitney Museum of American Art to discuss their concerns. Over its decade-long existence, Godzilla managed to attract a significant membership, become influential in the U.S. sphere, and even receive attention from abroad. The wider impact of Godzilla's ecumenical example can be perceived in a show like "Uncommon Traits: Re/Locating Asia" (1997–1998), which brought together Asian artists from North American diasporas—Americans and Canadians—under the umbrella of transmigration and shared transcultural circumstances.[92] However, by the very nature of its diverse constituencies and informal organization, this group remained fraught with tensions arising from differences of nationality, culture, generation, language, and sexuality, as well as, paradoxically, from a growing divisiveness over what it meant to be identified by the seemingly monolithic labels *Asian* and *Asian American*.

Despite the considerable breadth and diversity of Asian American art during this period—in which Asian American artists, like their non-Asian contemporaries, produced work in every medium, genre, style, and subject matter—the subject of identity remains closely associated with art and exhibitions of the 1980s and early 1990s. In this vein, "One Way or Another: Asian American Art Now," a group show which opened at the Asia Society in the early fall of 2006, is largely framed in a now/then paradigm premised on recognizing an accelerated shift toward a sense of being in an open-ended, postidentity world as witnessed in the questions, sensibilities, and expressions of a younger generation. The seventeen foreign- and U.S.-born artists featured in "One Way or Another," all born between 1966 and 1980, came of age in this country amid the dramatic transformations of the post-1965 era, and, as the curators assert, primarily view themselves as American. Whereas the civil rights movement and major military conflicts in the twentieth century involving Asian nations and the United States are within the living memories (and often in the personal experience) of earlier generations, for the younger artists, such pivotal domestic and overseas events are comparatively distant from their immediate lives.

Yet, to take part in an exhibition like "One Way or Another," artists must still consent to being identified within an Asian-specific context. Moreover, what may distinguish many in the current generation of Asian American artists is not their thorough rejection and supplanting of earlier discourse, but rather the degree to which the concerns and efforts of the previous generation during the 1990s—alongside a grab bag of other cultural and

life-based personal choices—have been thoroughly integrated into their intellectual, emotive, and aesthetic repertoires and are therefore being manifested in less overt, even offhand, ways. As one critic comments, "One Way or Another" suggests that "identity is one of many factors that all artists express and then some—especially those who are nonwhite and/or nonmale—consciously address in ways that have always been hard to characterize . . . [here] issues of identity shape-shift wildly and sometimes drop entirely from sight."[93]

Even as the art in "One Way or Another" endeavors to downplay and deflect sociocultural identification, the influence of the artists' Asian backgrounds remains evident. The same, moreover, applies to the curators' catalogue essays. In spite of their considerable ambivalence, and an emphasis on evocations of internally divided, unstable, and diffuse identities favored in more recent artistic production, the curators are impelled to discuss their relationships to Asian American history and identitarian issues in visual art to a notable degree. Among the artists, Asianness, albeit in subtle and inferential ways, still confers a means for this younger generation to invoke collective histories, to view and engage with American society, and to tap into a wellspring of diverse cultural and art-historical source material. For example, Michael Arcega references discourses of cultural globalization via the role of Spanish colonialism in shaping Filipino history and culture, through the galleon trade that long linked the land of his birth to far-flung Spanish possessions in the Americas, as well as to East Asia and Europe. Binh Danh's delicate, ghostly photographic images printed on tropical leaves depicting U.S. military casualties of the war in Vietnam testify to the haunting legacy of violence and bloodshed that still seems to permeate the very soil and vegetation of his homeland. Others, like Jiha Moon, take a hybrid culturalist approach through paintings that synthesize Asian and Western stylistic and art-historical references. Among her quotations, Moon cites *10,000 Ugly Ink Dots*, a relatively abstract ink brushwork by the Ming dynasty (1368–1644) artist Shitao. Similarly, the sculptor Anna Hoy appropriates idioms and forms from Chinese and Japanese culture, such as the traditional Chinese scholar's stone, and blends them with contemporary industrial materials and influences drawn from Western modernism.

Indeed, even as a number of recent exhibitions have moved to stake out fresh positions for an emergent generation of plural-minded Asian American artists, it should come as no surprise that these efforts are as likely to

echo and extend the endeavors of their predecessors as they are to point away from or complicate them. Among them are two multimedia projects: Centre A in Vancouver's "Charlie Don't Surf: 4 Vietnamese American Artists" (2005), and "Pirated: A Post Asian Perspective" (2005) at San Francisco's Kearny Street Workshop. Viet Le, the curator of "Charlie Don't Surf," reflects that for younger Vietnamese like himself, the difficult years of war and its aftermath are often little more than an imaginative reconstruction devised chiefly through traces from film, video, and television images, alongside poignant family photographs and stories.[94] Nevertheless the show's re-articulations of that legacy provide a locus for fresh and provocative imaginings by successive generations of artists. Taking global and cultural piracy as their theme, the curators of "Pirated" address how material and symbolic goods are continually appropriated and manipulated by global elites, ranging from European colonialists to the World Trade Organization and the World Bank. Their invocation of "post-Asian" echoes rhetorics of "post-black" art, while simultaneously seeking to solidly situate the exhibition in an Asian American landscape.[95]

Identity and Identification as Markers of Change

Much as the "Orient" is viewed as a constantly fluctuating product of the Western imagination and its varying projects and desires, Asian American-ness is a *positioning*, or, as it is also phrased, a "process of subjectification," and does not in itself constitute some stable or self-identical status.[96] It goes without saying, moreover, that every exhibition of art by Asian Americans is inevitably a partial view of a particular time and place that provides a selective cross-section of that larger body of work. Since artistic and intellectual discourse will always move on—sometimes proceeding in unexpected directions—it is incumbent on artists and cultural critics alike to have an endlessly questioning resolve and the expressive freedom to continually rethink the accepted wisdom in this arena. Speculating whether putting forward such a suggestion might make her "a traitor of the age of (post)structuralism," a leading feminist intellectual speaks of "reopen[ing] the questions of subjectivity, materiality, discursivity, knowledge, to reflect on the *post* of post humanity . . . and reinstall uncertainty . . . starting with the cultural and its many 'turns.'"[97] Indeed, the prospect of a new "post

post-identity" politics has also been raised to gesture to arguments that test both the critical limits of identity politics and the strategic postidentitarian disavowals of identity and the refusal to be named.[98]

Having acknowledged some of the contradictory and competing currents running through issues of identification and affiliation within present Asian American cultural discourse, I do not want to suggest that the ideas and goals that fueled Asian American cultural activism have become exhausted or stripped of their power. Since Asians in this nation do not live in a vacuum, there are activists who continue to maintain that to deconstruct or to abandon the notion of Asian American–ness is politically self-destructive, because it would serve to dilute the hard-won pan-Asian intercommunity base that emerged during the shared struggles of the civil rights and antiwar movements, as well as more recent coalition politics. Nor would many Asian American artists working today necessarily argue that strategies of collective assertion are no longer needed in the arts arena.

This is not to manufacture consent for a vision based solely on experiences of suffering and victimization (or conversely, on some extravagant celebratory stance). Rather, for all their differences and ambivalence, Asians in the United States still have much in common in recognizing both the accumulated histories of migration, struggle, and survival in their communities, and the contemporary experiences shared within groups and across ethnic lines. Whether they choose them or not, certain postures are thrust upon Asians in the American context, as they are enfolded within the highly elaborated system of representations and beliefs about Asians and things Asian associated with Orientalism in the West. Moreover, despite intellectual assertions of hybridity and fluid, socially constructed identities, the majority of Americans still accept the perceived imprints of racial and ethnic ancestry as natural markers of identity. In view of the obstacles that Asians have confronted in the past and continue to encounter in claiming a place and equal treatment for themselves in the United States, calls to dispense with terms like *Asian American* are not unanimous.[99]

Ultimately, while all artists are called to respond to the aesthetic, cultural, and political imperatives of their times, and it is understandable that groups long objectified by discourses of race and racism desire to claim new positions in order to extricate themselves from these strictures, it is equally important not to rush to dismantle the very experiential and intellectual ground on which cultural activism and visions of collectivity within minori-

tized communities have been built. Whereas constructions of group iden-
tity can indeed be limiting and employed to quite oppressive and deadly
ends, it is also evident that the sense of solidarity provided by assertions of
pride has helped to rebuild the self-esteem of racialized and marginalized
groups (albeit in sometimes wishful and sentimental ways).

To many groups—especially those who have been denied or denigrated—
identity-based expressions of culture have been the foundation for both
political action and resistance against accommodation and erasure. As a
number of artists, critics, and scholars continue to point out, the problems
of discrimination, stereotyping, and indifference from the mainstream have
not abated. According to Yong Soon Min, "In a racially obsessed and de-
termined culture such as our own . . . I could never forget nor would I be
permitted to forget that I am Asian. . . . I'm not sure that this is a problem. I
think that it's better to have a heightened sensitivity to difference than to
cast a blind eye. This notion of a colorblind culture is a fantasy about a time
and place that never existed."[100] Much as bell hooks suggests, there may
be something more primary in play: when assertions of difference do not
reflect the interests of the majority, they can variously engender incompre-
hension, indifference, resentment, active resistance, or even outright rejec-
tion. Clearly, a great deal is thought to be at stake for everyone involved.
Before we categorically discard identity politics as narrow, divisive, and a
thing of the past—and begin heralding a new postidentity era—it is nec-
essary to closely examine the basis of those assertions in order to be aware
of whose larger interests are being served and of what might be sacrificed
in the process. Especially after 9/11, if we can learn anything constructive
from the passionate backlash against multiculturalism, it is how fragile the
gains made for minoritized communities under its aegis can be, and how
keenly the resentment against their assertions of difference is felt by many
critics. Whatever one's conviction, it is noteworthy that the often-contested
theme of identity/identification remains a marker against which change
continues to be measured—suggesting the lingering impact of these de-
bates in shaping successive generations' concerns and reactions.

Othering

2

primitivism, orientalism, and stereotyping

With the disintegration of global empires in the post–World War II era, the views of formerly colonized peoples increasingly found expression in the international arena. As this new "plurality of emergent subjects"—now in charge of their own narratives—began to assert their interests, the West could no longer expect to go unchallenged when framing its conventions as universal, or casually speaking for the Other.[1] Over the last five decades, which have witnessed the domestic rise of the civil rights, antiwar, feminist, and community arts movements, the visual arts have likewise served as a site of resistance through which Asian Americans (as well as Native Americans, Latinos, and African Americans) sought to publicly expose, name, and deconstruct the ways that Western master narratives and their attendant institutionalized practices have shaped the lives, consciousness, and conditions of many in their communities.[2]

The West's Others · orientalism and primitivism in the Western imagination

As nonwhite minorities living in a predominantly Western, European-derived society, Asian American peoples and cultures remain framed in the Western imagination by Orientalism and primitivism. These powerful, inter-related tropes evolved and expanded over centuries to accommodate the shifting needs of the many peoples and cultures that came to define themselves as the West. The Orient has historically been both the West's most powerful cultural contestant and a primary source of extraordinary wealth and knowledge. Accordingly, it not only has been a centuries-old focus of fantasy, fear, and desire but, in providing the West with its most ancient and persistent imagery of Otherness, has long acted as a mirror against which the West envisioned and reinforced its collective sense of self.[3] Yet the Ori-

ent, whose imagined physical contours have fluctuated wildly throughout history, has never adhered to the continental boundaries of Europe and Asia now inscribed in the maps and books of its geographic tradition. The use of the term Orient, therefore, does not correspond to any geographic reality whose stability could be taken as a "natural fact."[4] Instead, based on changing Western perceptions of where their cultural spheres ended and Oriental ones began, the Orient remains a wide-ranging, imaginary terrain with a particular historical, intellectual, and imagistic provenance in Europe.

It is contended, moreover, that a discourse like Orientalism is more than just a system for envisioning and representing the Other. Edward Said describes Orientalism as a Western "corporate institution" enfolding a broad swath of practices and discourses historically tied to the West's exercise of power, which is aimed at "dominating, restructuring, and having authority over the Orient."[5] Within this tightly bounded conceptual system, which served—often quite openly—to support and justify the subjugation of non-Western societies under a voracious political and economic imperialism, whole cultures and peoples were rendered voiceless, reduced to a highly circumscribed set of features. In contrast to the dynamism of the modern West, they were fixed forever in time as examples of the survival of something primordial in the human psyche, something that "had to be left behind."[6]

Said deduces that because of the accumulation of essences and oppositional distinctions—European civilization versus Oriental decadence, European dynamism versus Oriental backwardness, European creativity versus Oriental mimicry—Orientalism has become so internalized and corrosive that the West has come to take its superiority for granted. Not only does a discursive formation like Orientalism allow many Westerners to feel unquestioningly that their cultures, policies, ethics, and aesthetics are absolutely different and inherently superior to those of the Other, but by dehumanizing the Orient as the antitype of the West—as a zone of barbarism, irrationality, and cultural inferiority—it ensures that non-Western peoples are condemned for not quite living up to "human" or "civilized" standards, making acts of aggression against them far less objectionable. Indeed, so resilient are these myths and illusions that they continue to resonate in Western art, literature, and music, in popular culture, the academy, commerce, foreign policy, and, just as significantly, in the imagination of non-Western peoples themselves.

Orientalism may, in fact, be the oldest Western master narrative of Otherness, the prototype for all subsequent Western perceptions of the Other, including that of Native Americans, blacks, and every other nonwhite group in this nation.[7] Similarly, the genealogy of images of the devil, hell, and other monsters in human form has been located in a long-standing European infatuation with the "marvels of the east," both exotic and grotesque.[8] These extravagant visual conventions are traceable to Greek travelers in ancient India; they prevailed throughout the European global expansion in the fifteenth and sixteenth centuries and continued to shape the views of Western travelers in South Asia as late as the 1790s. This sort of imagery has supplied Western art and popular culture with the symbolic means to depict evil, the irrational, and the Other.[9]

Although space does not permit a fuller examination of efforts to mark out the evolution of such outlandish and often otherworldly European images of the Orient, these accounts illuminate the profoundly contradictory and conflicted attitudes that Europeans have had toward Asia and things Asian, a tendency that, in a host of malleable, shifting guises, continues to this day. On one side is the trope of Asiatic inferiority and strangeness, foregrounding barbarism, primitivism, exoticism, decadence, effeminacy, immorality, and a lack of imagination.[10] On the other side, as reflected in the substantial body of ancient Greek literature evoking conflict with Asians, there is an equally powerful trope, centered on a long eventful history of struggle and competition—military, economic, and cultural—with an Orient that was uneasily perceived as the probable wellspring of much of European civilization and languages.[11] All such convictions, moreover, were accompanied by a notion that—unlike Westerners, who were multiform, differentiated, and complex individuals—Asians were all of a piece, homogeneous, and therefore fundamentally alike, both in body and mind.

Whereas Said's far-reaching theoretical argument strives to delineate the underlying mechanisms of Orientalism, and continuities have been identified between Orientalist and primitivist discourses, Marianna Torgovnick delves into the particular ways in which primitivism has been played out in an array of Western conversations, including art history. Here, the Western notion of the primitive is seen an infinitely pliable construct that merges fiction, fact, and myth, and that has often had little correspondence to any specific premodern culture. Once applied to prehistoric European, Greek, and Roman societies, its meaning in art history has shifted greatly over

time, variously describing ancient art, non-Western courtly art such as that of the Chinese and Aztecs, and "tribal" art.[12] Since the 1920s, the scope of primitivism has been increasingly limited to a notion of the "tribal" and commonly applied to traditional arts produced by groups like Native Americans, Eskimos, Africans, and Pacific Islanders.

In this accounting of the primary tropes of the primitive, it is apparent that many have counterparts in Orientalist discourses, including ones that assert that primitives, being free from civilized constraints and possessed of unique connections to nature, are embodiments of our untamed, libidinal, childlike, and violent selves.[13] Following such a model, it could likewise be observed that Asian groups, like other primitivized peoples, are commonly seen to possess certain traits: a special, balanced relationship with the natural world; arcane, supernatural knowledge, whether as martial arts masters, gurus, shamans, or spiritual guides; and unchanging, timeless cultures fully steeped in ancient traditions and lifeways. Through these discourses, Asians as well as other minoritized groups are often set apart in the Western imagination in fairly similar ways.

However, while Asians are certainly framed within many of the traditional tropes of primitivism, unlike most other non-Western peoples, they have not been exclusively viewed through such a lens. Whereas primitivism positions the Other as culturally and socially inferior to the West, Orientalism suggests a more complex and mutable array of relationships, one explicitly based on a hierarchy of civilizations and "high culture" achievements that potentially allows for a measure of parity. Indeed, from the early twentieth century on, Westerners increasingly made substantial distinctions between non-Western literate and courtly societies (such as those of China and Japan) that had "produced cultures recognizable in the West," and those that were understood as inherently primitive.[14]

These shifting attitudes, at least among Western elites, should be viewed against the background of events in East Asia during the early decades of the twentieth century. In the 1905 Russo-Japanese War this period witnessed, for the first time in modern history, the defeat of a European power by a non-European one. In China, rising calls were heard for modernization following the model of Japan's rapid adoption of Western technologies. These East Asian societies began to be viewed (somewhat uneasily) not only as possible alternative civilizations but also as eventual competitors for global dominance. To the extent that Asia was seen as an active threat to

European and European American hegemony, fears of Oriental competition gave rise to the still-potent trope of the Yellow Peril, whose roots run deep in the Western psyche.[15]

The Yellow Peril finds one of its most enduring and evocative expressions in the character of the evil Chinese genius Fu Manchu, created in 1913 by the British author Sax Rohmer one year after China threw off centuries of feudal rule and declared itself a republic.[16] Bent on world domination, Fu, who supposedly sought to emulate Genghis Khan's vast conquests across Asia and Europe in the thirteenth century, is portrayed as uniting the hordes of Asia to overrun the West. Depicted in numerous books and films as primitive and sadistic, and often invoking occult mystical practices, Fu was also educated in both Europe and America; he thus could also exploit Western scientific knowledge and technology. In the figure of Fu Manchu, Sax Rohmer made manifest largely unarticulated fears of a modern yellow horde bent on Western conquest that could concurrently master Western knowledge and draw upon mysterious Oriental powers.[17] Together, these elements constitute the essence of the Yellow Peril.[18]

Such a characterization suggests that Asians can be both Prospero and Caliban, possessors of knowledge as well as aggression and unbounded appetite, making them doubly formidable adversaries. Whereas Native Americans and African Americans could offer a physical peril to Western primacy, Asians were perceived as threats to both mind and body.[19] Because most Westerners believed that savagery and barbarism would inevitably be vanquished and supplanted by civilization, their fear of primitivized peoples chiefly remained limited to bodily harm and the destruction of property. Such dread hardly approached the level of disquietude inspired by a potential adversary who might have the means, knowledge, and ability to supplant or actually defeat the West. Indeed, in American conflicts with East and Southeast Asian nations during this century (World War II, Korea, Vietnam) such double-edged attitudes came to the fore in print and film propaganda. For example, Japanese soldiers were depicted both as relentless, brutal, almost superhuman foes and as gun-toting apes and bucktoothed, near-blind pygmies jabbering away in pidgin English.

At the same time, it is vital to distinguish between Western discourses concerned with elites and elite culture that could recognize and accept Asian millennial societies as potentially civilized by virtue of their wealth, refinement, and high culture, and the ways in which the vast majority of

Asians—both those in lands dominated or colonized by the West and those who initially came to this country as laborers—were usually regarded and treated by the dominant society. In the United States, Asian immigrants, like the white lower classes, women, blacks, Latinos, and Native Americans, were generally seen as childishly ignorant, inherently less intelligent, and even subhuman, especially in comparison to Caucasian males. Commonly associated with squalor and pestilence, as well as with profligacy, immorality, and social deviance (as evidenced by their supposedly greater tendency toward insanity, criminality, alcoholism, drug addiction, and sexual depravity), in the nineteenth century these groups were often considered prime candidates for the social regulation that was propounded by new ideas emerging from social Darwinism, physical and cultural anthropology, and, ultimately, in the twentieth century, eugenics.

For Asian migrants to the West, such primitivist notions have been endlessly elaborated, especially in relation to zones of contact, public spaces where Asians and non-Asians interact. Chinatowns, in particular, have been mythologized in innumerable pulp novels and films as a "downtown, unclean zone of opium dens, gambling parlors, rats, underground tunnels, filth, and disease."[20] In such a schema, the cityscape takes on the attributes of the bodily self writ large; hence, in sharp contrast to the rational order of the white, Protestant uptown "mind," the taboo area of Chinatown represents, for the dominant culture, the "bowels" and "genitals" of the American city. Thus, as an aspect of the trope of the Orient itself, Chinatown becomes the local site of Westerners' repulsion and voyeuristic fascination. In light of this recent history, and of earlier Orientalist notions of Asia as the source of undifferentiated hordes, it is not difficult to understand why Chinese immigrants to America would be compared to swarming rats by a nativist press and a white-dominated labor movement that strove mightily to prevent further migration, even militating to remove those already here.

Once they enter or are born into the sphere of the West, people of Asian descent—irrespective of background, class, or generational status—continue to find themselves enmeshed, to differing degrees, in these interrelated discourses of primitivism and Orientalism that have been so extensively elaborated in the Western imagination. Despite a long history of U.S. involvement with different Asian nations, many Americans still misperceive Asians, regardless of nationality, as members of a monolithic "Oriental" culture. In this unfortunate and generally unquestioned distortion, there exists

an underlying mythologizing principle, which can best be summarized as "race indicates culture."[21] Typically marked by their skin color and features as foreign or Other, Asians have been subjects of continuous stereotyping in political cartoons, films, and printed media since substantial numbers—initially Chinese—began arriving in the mid-1800s.

America's mass media project the society's unconscious struggles and its visions of itself, including its position in relation to the rest of the world—both white and nonwhite.[22] Even the most cursory glance at existing images makes it plain that Asians, like other ethnic minorities, have often been reduced to a limited number of stereotypes that the majority culture finds manageable or recognizable. While it is true that the phenomenon of stereotyping can be found in all societies, the critical issue for minoritized groups lies in unequal access to the dominant means of representation. To the degree that people of color still have comparatively little power over how they are named and depicted in the dominant culture, the corrosive influence of extant stereotypes will continue to have an impact.[23]

At the simplest level, the prevalent stereotypes of Asians in popular culture can be broken into dual categories: an unassimilable, evil, deceitful, cunning, and aggressive yellow horde; and assimilable Asians who are modest, respectful, helpful to Americans, and who sometimes even sacrifice their lives for them. This latter variety includes innumerable variations on the Asian sidekick role, who often replaced Native Americans and blacks as servants and helpers. Such Asian stereotypes have been broadly disseminated through newspapers, magazines, literature, comics, and theater—and later through radio, film, and television. While some Asian characters, like the wise and aphorism-spouting Chinese detective Charlie Chan (who first appeared in the 1920s) are now considered laughable and campy, it can be argued that all stereotypes can be damaging insofar as they condition generations of Americans to view Asians as exotic, different, not like "us"—and by extension, either inhuman or not fully human. Because they are convenient and constantly repeated, they quickly become normalized, absorbed into popular consciousness, and read back into the texture of life. To the extent that some in this country rely on such media for their information and form their expectations based on this sort of imagery, they can indeed exert a powerful influence.

Drawing on analytical and critical tools offered by critical theory, race politics, and postcolonial discourse, the four artists in this discussion—Mar-

lon Fuentes, Allan deSouza, Pipo Nguyen-duy, and Tomie Arai—mount various interventions aimed at interrogating these mechanisms of representation and visual display. In contrast to the repertoire of fictive and distorted images by which their peoples and cultures have often been depicted, the surety and clarity of their art asserts a contestatory presence moored in the specificities of personal and collective history, and contemporary Asian American experience, that allows for a more intricate understanding of the long-standing entanglement of Asians in the Western imagination.

Marlon Fuentes · ethnography and primitivism— the "other" speaks back

Marlon Fuentes, a Philippine-born photographer, filmmaker, and conceptual artist, arrived in the United States in 1974 as a twenty-year-old, eventually settling in California. He comes from a nation with long-standing connections to the Americas through common histories of Spanish domination. In the wake of fifteenth- and sixteenth-century European voyagers seeking ocean routes to East and South Asia, the Philippines and California found themselves (beginning in 1521 and 1542, respectively) under the centuries-long sway of Spain, only to be absorbed and doubly colonized in turn (a situation that could best be described as serial colonialism) by a United States expanding ever westward in the nineteenth century.

Fuentes was born in Manila in 1954; his youth was marked not only by economic hardship (owing to his father's early death) but also by the rise of Ferdinand Marcos, an elected leader who assumed dictatorial powers. In the late 1960s, while photographing an anti-Marcos demonstration for his high school newspaper, Fuentes witnessed the gruesome death of a close friend at the hands of the military. Following this traumatic event, he began to pursue writing and photography as a way of coming to grips with a situation in which politically motivated violence was always close at hand. Because his family disapproved of his interest in art, Fuentes was, by necessity, initially self-taught. Although the Filipino firm in which Fuentes worked after college sent him to the United States to further his education, it would take several years before he found the emotional freedom to enroll in photography classes. The longer the artist remained in the United

States, the more aware he was of how distanced he had become from his homeland. Wrestling with feelings of cultural instability, Fuentes came to view his growing involvement in art making primarily as a means to confront the "internal schizoidness of carrying the cultural baggage of East and West."[24]

Born in the decade after the Philippines officially acquired independence in 1946, Fuentes is, like many people whose countries achieved nationhood after World War II, deeply immersed in issues of postcoloniality. Like others of his generation, he is concerned with what it means to be Filipino in the wake of centuries of religious conversion, cultural collision, cross-fertilization, and miscegenation among indigenous peoples, Spaniards, and others (primarily Chinese) that have produced a creolized, hybrid society. Underneath the multiple overlays of imported customs, beliefs, and languages, there is no single "authentic" preconquest Filipino identity that one can call on in this Asian Pacific territory forcefully consolidated out of numerous distinct island cultures. As Fuentes remarks, attempting to untangle the braided strands comprising such a cultural crazy quilt would be the equivalent of "unscrambling an egg."[25] Further, as a diasporic Filipino who now lives in one of the nations that colonized his homeland, he finds himself unable to draw on a single, overarching narrative that would provide a solid point of reference. As a result, to paraphrase the artist, he finds it necessary to improvise, or "cobble together," a provisional contemporary Filipino identity he can take as his own. In constructing such an identity, Fuentes is centrally concerned with revisualizing the past in relation to its effects on the present. His earliest art photography focused on evidence of the historical scars of oppression (whether Spanish, American, or Japanese) on the Filipino psyche, as well as on the postcolonial repression he witnessed under the regime of former president Ferdinand Marcos.

In the 1980s, after a decade in the United States, Fuentes began to examine and to (re)establish connections with his heritage. He decided that the way to best summon that hybrid world was to become his "own personal shaman," using photography as a ritual to relive those memories.[26] In the extensive *Circle of Fear* series (1981–1991) of gelatin silver prints, Fuentes seeks to recapture the spirit of that complex sociocultural environment by constructing and photographing tableaux combining inanimate objects and disarticulated animal parts. In *Stitches* (figure 1), the image of a decapi-

1 Marlon Fuentes, *Stitches*, from the *Circle of Fear* series, 1981, gelatin silver print, 8" × 10". *Courtesy of the artist.*

tated pig's head with its eyes roughly sutured shut is conjured to symbol-ize the "history of silence imposed by the cultural domination of Spain in three centuries."[27] In a related work, *Tongue* (1981), Fuentes presents a rot-ting cow's tongue overlaid with a crucifix and punctured by shards of glass, sardonically mimicking a European coat of arms—thereby suggesting a new kind of national emblem for his homeland. For Fuentes, the capacity to "speak" as a nation was figuratively ripped from the Philippine's throat; hence, he devised this painful image as a symbol for a people whose culture he believes has "been amputated." He conceives these lushly disquieting black-and-white images as functioning like *anting anting*, which in Tagalog (a native language of the Philippines) refers to ritual objects infused with magical powers. By their cathartic presence, Fuentes believes, these objects can "imbue the viewer with a freedom to speak."[28]

As his involvement with photography deepened, Fuentes became strongly preoccupied with the history and nature of mechanical forms of visual rep-resentation and their central role in the creation of historical memory. In particular, he grew fascinated with the capacity of film to provide seem-ingly coherent, logical, and "truthful" historical narratives, even when obvi-ously stitched together from a pastiche of disparate and often semi-fictive sources. Applying those critical insights, Fuentes wanted to stimulate audi-

ences to think in more-analytic ways about representations of the Other. Concurrent with a developing interest in film, Fuentes increasingly directed aspects of his wide-ranging artistic production to the critique of cultural anthropology—in particular, Western ethnography—a social science that has been aggressively involved with constructing knowledge about non-Western societies and peoples since the nineteenth century. As a vital adjunct to European and American expansionism and trans-Pacific colonialism, ethnographers, frequently in pursuit of fantasies rooted in ancient Western notions of the lives that "barbaric," "primitive," and "tribal" peoples must lead, were often enlisted to justify domestic and foreign policies that served to severely circumscribe and dominate the world of Fuentes's ancestors.[29] Having widely promulgated suspect conclusions about non-Western customs and attitudes that long remained unchallenged inside and outside academe, ethnography not only retains a powerful hold on the Western imagination but also continues to affect the personal and collective ways in which formerly subject peoples, indigenous or not, perceive themselves.

Schemas and the Strategy of the Image • the work of M. E. Fuentes

An early effort by Fuentes to address the objectification of non-Western peoples through anthropological discourses is demonstrated in his text-based piece *Schemas and the Strategy of the Image: The Work of M. E. Fuentes* (1990).[30] Consisting of a simple, spiral-bound presentation folder, it comprises a seemingly official "case study" by a fictitious researcher, Dr. Mia Blumentritt, examining issues central to the artist's life and work as a self-described "ex-native" of the Philippines. This report included the transcript of an imaginary ethnographic interview, invented criticism of the project, and personal medical records that corroborated Fuentes's hearing impairment resulting from the explosion he witnessed as a youth during a demonstration in Manila.

The opening passage of Blumentritt's commentary rather portentously announces, "M. E. Fuentes' work is ultimately about the struggle between illusion and truth. . . . He aims, he says, of nothing less than 'the unification of theater of the internal with the theater of the infernal, that is, solving for the alchemical function $T(t) = T(f)$.'" Skirting between dense, pseudo-scientific prose, poststructuralist theory, art writing, and biography, it slyly leads the reader on a dizzying journey via linguistic maneuvers that simultaneously provoke and deflect attempts at analysis. Evident in each pas-

sage is Fuentes's Dadaesque delight in creating this labyrinthine work that turns ethnographic and psycho-biographical approaches on their heads. In so doing, Fuentes manages to achieve both a high-spirited, knowing parody of the "ethnographic stance" in studies of the Other, and a deeply felt form of self-revelation that goes beyond being simply an "experiment in mockery" to function as a "very good psychological and aesthetic map . . . a device for [an] imaginary platonic dialogue."[31]

By assuming all the roles in these fabricated interactions—actor, director, investigator, interpreter, and teacher—Fuentes aims to disrupt the investigator/subject power relationship implicit in the history of academic research on ethnic or indigenous peoples. In the manner of a trickster, a well-known figure who appears in a host of animal and human guises in cultures around the world, the artist tactically looks to subvert positions like that of the "native informant" in Western anthropology—a prerequisite for social scientists and others who seek singular insight into the unfamiliar and often titillating world of the Other.

Bontoc Eulogy

In his 1995 film *Bontoc Eulogy*, Marlon Fuentes calls upon the conventions of visual anthropology and ethnographic documentaries to tell the fictive personal stories of two characters: the Narrator, a contemporary first-generation Filipino American portrayed by the artist himself, and his putative indigenous Igorot grandfather Markod, a tribal warrior. Through a voice-over narrative, he traces the journey of Markod, depicted as one of the eleven hundred Filipinos in the "Philippine Reservation" who were placed on public display, in "authentic" native villages at the St. Louis World's Fair of 1904 (figure 2). *Bontoc Eulogy* marks out the Narrator's convoluted search for this invented ancestor, who is envisioned as having left his rural village for the fair, never to return home. Fuentes devised this countermythic narrative to speak to the ways in which the confluence of nineteenth-century social science and American expansionism (the Philippines became an American territory as a result of the Spanish American War of 1898) not only created the triumphalist conditions in which the fair's organizers could make his countrymen objects for public display, but also set the terms by which such taxonomic-like spectacles informed American notions of his homeland and subsequently circulated back to the Philippines to be internalized by the descendants of indigenous peoples.

2 Philippine village at the St. Louis World's Fair in 1904. Film still from *Bontoc Eulogy*, dir. Marlon Fuentes, 1995, 16 mm film, 56 min. *Courtesy of the artist.*

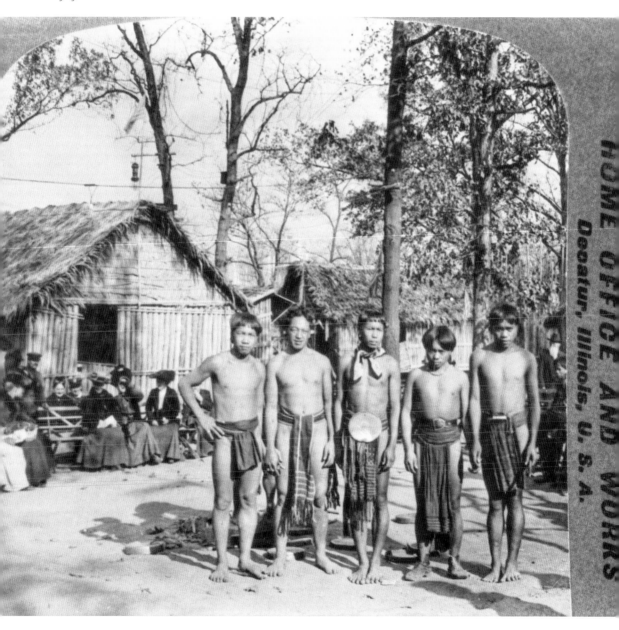

The 1904 ethnographic showcase that Fuentes chose to focus on was just one of many presented in European and American cities. Quite popular with the general public, they were a significant attraction in the succession of spectacular world's fairs whose heyday extended from the 1870s through the 1930s. Visited by millions, in these enormous productions objects and peoples from around the globe, including thousands of other "primitive" peoples from North America and Africa, were gathered together and displayed.[32]

Yet, the real purpose of the 1904 fair was to verify America's emergent status as a global imperial power.[33] By including both Native Americans and Filipinos in the exhibition, a strong sense of historical continuity deeply rooted in providential inevitability was reinforced by merging America's westward expansion across a vast, "unsettled" frontier, and the newest Pacific acquisitions beyond its continental boundaries, into a simple, linear story. In order to celebrate a narrative of superiority anchored in unending Western progress, the St. Louis fair was structured to accent disparity by dualistically contrasting displays of the most up-to-date technologies with the natural state of innocence and rudimentary conditions in which "primitive" peoples supposedly continued to live. According to the artist, "science and economics and progress and growth were [combined in a] unified imperial surface."[34] In this, anthropology, in the service of the Western powers, had a significant role in dividing and controlling native populations by codifying differences among non-Western peoples and cultures. Fuentes looks on the St. Louis World's Fair, therefore, as a variety of cultural drama, an "incredibly sophisticated, choreographed operation" whose imposed representations of "primitive" peoples were orchestrated and legitimized by social anthropologists under the rubric of economic and industrial development.[35]

Filled with a high degree of irony based on the supposition that all historical interpretation is fundamentally revisionist, Fuentes, in *Bontoc Eulogy*, fleshes out the "facts" of the fair from the standpoint of the "natives" who were presented to the Western gaze as domesticated exotica. In this richly imagined film, he combines imagery of his own making with historical footage from a number of sources to give some sense of what might have actually happened among those living in such fabricated environments. Fuentes works from what he terms a "salvage viewpoint"—splicing

into his work filmic and photographic fragments culled from materials as diverse as personal snapshots, U.S. military training films, archival still photos, home movies, and early silent films. As Fuentes emphasizes, since film is easily manipulated, it is possible to combine clips drawn from a variety of sources and tie them together with an authoritative-sounding narration in order to create a sense of whatever reality the filmmaker desires. The clear message in such work, therefore, is that anyone—including the "poor native"—with access to the technology behind contemporary cultural production can construct her or his own version of "official" reality that can be played back to the dominant culture. Where anthropological films produced by Westerners created illusions about Filipinos and Filipino cultures, Fuentes reverses the situation, even drawing on some of the same filmic sources to fashion a pseudo-ethnohistorical film with an implicit antirealist subtext. As he conceives it, the film is "simultaneously a detective story and a highly layered meditation of cultural abduction and social voyeurism, . . . a simulacra [sic] of 'historical' cinema."[36]

Bontoc Eulogy opens with the image of an antique hand-cranked phonograph placed upon a mat in the corner of a bare room. An Asian man enters the space and seats himself before it, winds the crank, and then listens attentively to what sounds like a scratchy, early field recording of indigenous Filipino tribal music (figure 3). As the camera slowly pans in on the rotating record, his action is repeated several times while a solemn narrative commences. Over a subsequent image of paper boats borne away on swirling water currents, the narrator speaks of having left Manila for the United States twenty years before and confesses that as his recollections of the Philippines recede, "it is sometimes difficult to know where reality ends and imagination begins." From this mock-poignant point of entry, the story of his forebear Markod's journey to the World's Fair gradually unfolds. The use of a voice-over is suggestive of a practice common to film noir. According to the artist, who supplies the narration and appears in the guise of the investigator, it is intended to provide an "intimation into the detective story that follows, so that the whole thing becomes a giant flashback—a fabulation— an interpretation of what is encrypted in the records. [It] could have been just a construction in his head, and it's a construction of a construction."[37] Apart from its reference to the well-known RCA Victor trademark of a dog with cocked head listening to "His Master's Voice" on a gramophone, the

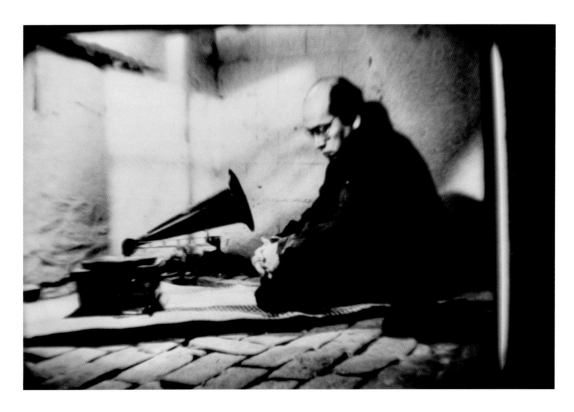

3 Film still from *Bontoc Eulogy*, 1995. *Courtesy of the artist.*

opening scene mirrors a sequence in *Nanook of the North* (1922), credited as one of the first anthropological films. This silent movie, focused on Inuit life in the Canadian Arctic, depicts a native hunter seemingly spellbound by a phonograph playing popular American music.[38] In contrast to the awe-struck expression of this "primitive" intended to entertain Western audiences, Fuentes presents a very different "native," one who is fully capable of using Western technology for his own purposes.

Interspersed throughout *Bontoc Eulogy* are numerous subtle cues and deliberate formal disjunctions meant to indicate that the film is not to be taken as a "real" story. For example, to underscore the ways in which history is reconstituted through visual representation, Fuentes integrates film clips, staged with model warships, of a re-enactment of the Battle of Manila Bay that took place during the Spanish American War. Since the sweep of actual warfare, with all its randomness and unpredictability, was nearly impossible to capture with the technology of the time, such re-creations were staged to compensate for the dearth of actual footage. For Fuentes, the obvious artificiality of the scene underscores the crafted nature of this seemingly historical representation, while simultaneously alluding to parallel methods often employed by ethnographic filmmakers to convey the aura of greater authenticity. At the same time, it also underlines the historical convergence between the first public showing of moving pictures in the waning years of the nineteenth century, the rapid application of this new technology to documentary and ethnographic filmmaking, and a period of significant overseas expansion by the United States into the islands of the Caribbean and Pacific. Indeed, by justifying U.S. cultural superiority over native societies, such "scientific" films helped to enlist public support for America's new overseas imperial ambitions.[39]

In due course, the narrator-investigator's efforts to reconstruct Markod's fate leads him to roam the eerily darkened halls of a U.S. medical and anthropology museum, where he meticulously photographs human skeletal remains and preserved brains, wondering if any of them might belong to his grandfather (figure 4). Unable to locate convincing evidence of Markod's fate, the film ends on an ambiguous note, the narration stressing that the search must continue.

Even as he remains profoundly critical of them, Fuentes fully recognizes and seeks to engage the ironies and tensions that adhere to his position as

a "native" in the West. To this end, he frames *Bontoc Eulogy* in the highly elaborated fictions and representational conventions of ethnography, documentary filmmaking, and American popular culture, while at the same time providing a corrective to such long-accepted narratives that he knows are equally unreliable. Yet, in taking up historic discourses that were produced and controlled by others, the artist also seeks to rectify imbalances of power by returning agency to himself and his contemporaries. Fuentes's aim, therefore, is not solely to counter or speak back to dominant culture, but also to convey a serious message directed mainly to fellow Filipinos about the contemporary problems they face as a continuing legacy of Western domination. Through his imaginative reconstructions of the experiences of Filipinos put on display at the turn-of-the-century world's fairs, those whose perspectives have long been distorted or absent from Western depictions are made to assume a central role. In calling attention to the constructed nature of modern Filipino identities, Fuentes seeks to "inoculate" his compatriots with a counterknowledge that will enable them to pick apart the monolithic narratives that have long shaped their consciousness.[40] These

4 Film still from *Bontoc Eulogy*, 1995. *Courtesy of the artist.*

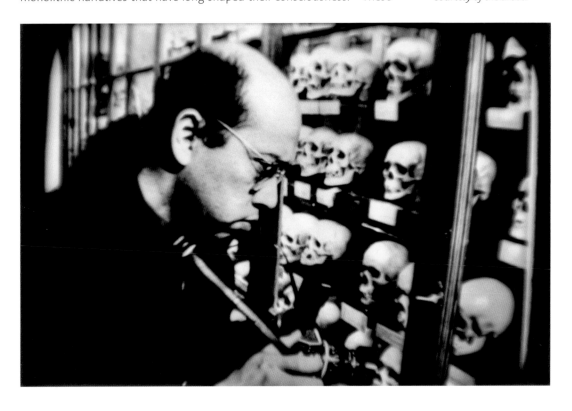

intertwined motives—speaking back and speaking to—infuse his work with a distinctive sense of doubleness, a Janus-like quality involved in communicating in two directions at once, that blends together an undercurrent of dry, poker-faced humor and penetrating commentary with a sincere desire to generate alternative narratives of his own people and their histories.

It is instructive to note that despite Fuentes's critical intent to expose the artifice involved in the Western construction of images of other cultures, numerous viewers (including fellow Filipinos) were unable to apprehend the intellectual motivation behind its subtly mocking premise and instead believed the story in *Bontoc Eulogy* to be factual. At screenings, audience members would occasionally approach Fuentes to express their sorrow over the fate of his grandfather. While this initially presented the artist with an ethical dilemma, he ultimately accepted that "if they saw the indignity of what happened, and they saw the pain of my construction, that's good enough. So they have the emotional truths, however they bypass the construction. It's a story about cultural loss and exploitation and, in the most fundamental way, the cause of human suffering, which is ignorance."[41]

Allan deSouza · orientalism and the Western imagination

The photographer, installation artist, and writer Allan deSouza comes from a family whose lives were shaped in the confluence of two European colonial spheres—those of Britain and Portugal. Born in 1958 in Nairobi to Indian parents of Goan background, deSouza grew up amid the massive social upheavals set in motion by the end of European colonialism in India and Africa.[42] DeSouza was five years old when Kenya gained its independence from Britain in 1963, and the artist's early life spans both the colonial and the postcolonial periods. Only two years earlier, Goa was invaded and reabsorbed into India after more than 450 years of Portuguese control.

Like many Goans who settled in Kenya, deSouza's parents were employed as clerical workers in private industry. South Asians first migrated to East Africa at the end of the nineteenth century, imported by the British as coolie labor to build the railway from Mombassa to Kampala. Afterward, a number chose to stay; however, because they were denied land rights, many became traders, as well as administrators for the railway and local colonial govern-

ments. In the early years following independence, burgeoning nationalism throughout East Africa quickly led to widespread agitation for the deportation of Asians, who were regarded as undesirable foreigners and economic competitors with black Africans. Faced with this increasingly hostile and uncertain environment, deSouza's parents decided to move the family to London in 1965, when deSouza was seven years old; as a result, most of his formative years were spent in England.

The family's departure took place only a few years before the mass deportations of Asians from Uganda, an East African neighbor of Kenya, began in earnest. In 1972, the dictator Idi Amin ordered the wholesale expulsion of all Asians (then numbering about seventy thousand), giving them only ninety days to leave the country. This forced migration of Asians from a land that many regarded as home has its roots in the colonial heritage of contemporary Africa, but it can also be understood as part of a larger post–World War II global phenomenon. Alongside the patriotic fervor surrounding the emergence of newly independent nations, fierce internal struggles for supremacy, civil war, and social chaos often followed the crumbling of the former European empires.

Many of these lands underwent rapid decolonization, which proved to be extraordinarily disruptive, with homegrown institutions and traditions undermined by foreign imposition and colonial administrations doing little or nothing to prepare their subjects for self-rule. With increasing destabilization, long-repressed intercommunity quarrels resurfaced between territories, cultures, and religions arbitrarily and often hastily yoked together under colonialism; ethnic minorities, both foreign and indigenous, were all too frequently made political scapegoats. In East Africa, Asians' commercial success as merchants made them the target of bitter resentment by newly sovereign black Africans seeking full political and economic power. Under such pressures, former imperial subjects were drawn in ever greater numbers to the colonial metropoles—Indonesians migrating to Holland, for instance, and Vietnamese, Cambodians, and Laotians to France. In similar fashion, beginning in the late 1960s through the early 1970s, Asians from East Africa dispersed to countries such as Canada and Australia, traveling within the Anglophone sphere of the former British Empire.

As one Asian American scholar born in the East African nation of Tanzania observes, this forced uprooting and dispersal of postcolonial Asian populations produced a "culture of dispossession" in which community was no

longer conceived in terms of a single homeland but instead as an "arena of floating identifications" in which new nomadic "transidentities" coalesce around wider regional links, like the Indian or Atlantic Ocean.[43] This notion of emergent transidentities formed in the interstices between nations and cultural zones resonates with Allan deSouza's account of his life, which was marked by postcolonial displacement and movement first within the British Empire, and then to the United States. In deSouza's words, having to re-negotiate one's position in relation to shifting diasporic contexts and popu-lations produces an "oscillating view," as one is constantly "re-evaluating [and] remeasuring [one]self always in relation to what's around you, who's around you."[44] In this frenetic process, deSouza came to use his art to probe the ongoing question, "How do I fit? . . . If I'm to live in this place, what does it mean to me?"[45]

Even though Asians in Africa have assimilated aspects of local customs and cultural practices, their citizenship status is contested there, and eth-nicity and race are more determinant of belonging than place of birth. For this reason, once in England, the artist came to reconceive his identity as South Asian or Indian, rather than Kenyan or Goan. Ironically, he found him-self lumped together with black Africans, black Britons, Afro-Caribbeans, and others of South Asian background regarded as "black"—a generic des-ignation for a mélange of ethnicities not considered white by local stan-dards. Such experiences would later draw deSouza to the Black Arts Move-ment (BAM), which was gathering momentum in Britain in the 1960s.

Inspired in part by the black power movement and the Harlem Renais-sance in the United States, and art forms like jazz, as well as by anticolo-nial struggles in Africa and Asia, this cultural movement brought African Caribbeans and South Asians together around a common antiracist and anti-imperialist agenda. Their bonding around experiences of marginality in Britain and their shared history of British colonialism united them; as deSouza comments, BAM regarded black communities as a "colonial labour force" who likewise constituted a "colonized group within Britain itself."[46] His budding cultural activism led him to cofound the artist group Pancha-yat and to cocurate the exhibition "Crossing Black Waters" (1992), which brought together artists of South Asian descent in an effort to reconstruct, reclaim, and revisualize identities that had been deeply affected by colo-nialism.[47]

The *Coconut Chutney* Series

As a former colonial subject with a strong grounding in critical theory, Allan deSouza is keenly aware of the discourses and regimes of representation associated with Western Orientalism that have shaped subject peoples' ideas of themselves and their cultures. He notes that the concept of Indianness itself derives from a colonial construct, given that prior to British occupation the different peoples of the Subcontinent had defined themselves primarily in communal or regional terms. Further, as a member of the younger generation of diasporic artists in Britain who often have no direct experience of the Subcontinent, he finds it ironic that their only source of information about Indian culture and history is filtered through the repertoire of Orientalist images and documents circulating in the West. According to deSouza, this Orientalist Indianness is commonly associated with certain visual traits—bright colors, dense patterning, and mythological references often drawn from popular culture sources, including film posters and calendar graphics—that can be strategically embraced as a site of resistance and political critique. However, rather than having to simply accept "vivid colour" as either a cultural touchstone or a cultural stereotype, for deSouza its use instead is transformed into "an act of cultural defiance . . . a taking back, as well as a parody of the Orientalists from pre-Delacroix to post-Hodgkin, trampling Matisse along the way."[48]

To combat the pervasive authority of such Orientalized images, deSouza maintains that one must directly confront the mechanisms of representation by which Orientalism is produced. Accordingly, artistic practice becomes an "arena to make visible the possibilities of 'disorientalizing' Orientalism, by revealing it and divesting it of its power."[49] In the 1996 series of chromogenic color prints entitled *Coconut Chutney*, deSouza concocts a heady, phantasmagoric pastiche of Orientalist images of things Indian, drawn from sources past and present. Through the medium of computer-assisted collage, deSouza finds an elegant formal means to "disorientalize Orientalism" by exposing the artificial, fragmentary, and constructed nature of such representations, as well as by mimicking the process of appropriation and cultural overlay by which they are superimposed and reprocessed in new guises in the West.

Yet as the title of the series reveals, deSouza is aware of the contradictions inherent in presenting images of India that could be seen as merely

reproducing Orientalist stereotypes. As he explains it, the coconut—something brown on the outside and white on the inside—is a racialized metaphor referring to brown-skinned peoples who identify with whites or who wish to gain acceptance and to assimilate into white society. Further, coconut chutney is a green pickled mixture that most Westerners find exotic, associated with a vision of palm-lined beaches and far-off places. By this reference, he allows, "I'm kind of implicating myself in this celebration of exotica . . . am I brown on the outside and white inside? Am I critiquing it or am I joining in?"[50]

This question is particularly pertinent for diasporic artists like deSouza, considering their ambivalent relationship to India and Indianness. He asks, "As an artist, how do you situate yourself? Am I going to deny being South Asian in order to enter the mainstream? Or do I situate myself in relation to South Asian work to connect to some sort of fabricated idea of roots? Or what other people might expect of me?"[51] Having spent most of their lives in the Indian diaspora, artists like deSouza cannot claim a firsthand, "authentic" knowledge of India. Yet because of their ancestral heritage and appearance, they are implicated in the discourses of Indianness. For those born in the diaspora and shaped by direct experience of Western culture, what critical interventions and strategies of representation are possible that can take their particular standpoints into account? In part, by appropriating existing historical and contemporary images, deSouza's work underscores the received nature of his knowledge, as a pastiche derived primarily from secondary sources—which he locates in the interlocking discourses of Orientalism and colonialism. Further, by seeking out Orientalist images in popular culture and then finding ways to disrupt them, deSouza clearly marks the critical ground he has chosen to mine. His is not a pursuit of authenticity to counterpose against Orientalist stereotypes, but rather an effort to deal directly with the images that exist.

In *Mama India* (1996) (figure 5) deSouza invokes the frantic, carnivalesque spectacle that Westerners have come to associate with India, by collaging the domes of the Taj Mahal Casino in Atlantic City with a gaudy pastiche of dancing girls and movie stars from Hindi film posters. Whirling around these images are elongated, cameolike portraits containing nineteenth-century ethnographic depictions of native "types" by which Indian peoples were once classified. Amid this densely resonant cascade of visual material is a glowing line of orange script that reads, "look mama! a caucasian!" The

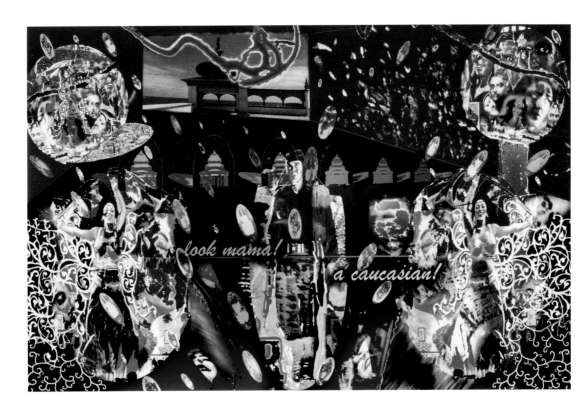

5 Allan deSouza, *Mama India*, from the *Coconut Chutney* series, 1996, computer-assisted chromogenic color print, 24" × 20". *Courtesy of the artist and Talwar Gallery, New York.*

phrase is a deliberate inversion of Frantz Fanon's famous quotation from *Black Skin, White Masks*, "'Mama, see the Negro! I'm frightened!'" referring to an encounter between a black man and white child, in which the black man is demonized solely on the basis of his appearance.[52] This piece of text plays a crucial role by disrupting the giddy swirl of images and drawing the viewer up short. Through its insertion, deSouza signals that the standpoint embedded in this piece is not that of the Orientalist (or the primitivist), but rather of the "native" who is determined to turn around or reverse the objectifying gaze.

About *Taj & Company* (1996) (figure 6) deSouza writes, "Holiday brochures meet the Aladdin Casino meet the Raj."[53] The title of this piece—which collapses references to entertainment, fantasy, escapism, historical theme parks, tourism, and commerce—suggests how Orientalism (signified by icons like the Taj Mahal and Aladdin, the familiar cartoon character that Hollywood appropriated from *The Arabian Nights*) becomes a selling point in a corporate enterprise to market images and products associated with Indianness to Western consumers. Against this exotic architectural backdrop, a row of showgirls wiggle jauntily in the foreground, while above them we glimpse the shadowed outline of Aladdin soaring through the sky on his magic carpet. Yet curiously, the images of the showgirls are disintegrating, as they are so digitized that the color is beginning to break down in the printing process. For deSouza, this is a formal means of emphasizing the fabricated nature of this image, "pushed to its limit of representation . . . [so that] it starts to fall apart, literally and metaphorically."[54]

Echoing the showgirls, a line of Sikh soldiers photographed during the years of the British Raj in India (1858–1947)—whose very distinctive images represent for the artist an "excess . . . [or] overload of Indianness"—stand stiffly at attention.[55] While this motif does point to the Sikh presence in the British colonial military, and while the soldiers also carry the flag of the British East India Company, which was chartered by the British government in 1600, deSouza views their turbans as an immediately recognizable sign of Indianness, rather than as a reference to any specific religious or cultural group.[56] The East India Company's vast commercial enterprise, whose purpose was to establish trade in South Asia for the Crown, came to control much of the territory of contemporary India, Pakistan, and Bangladesh by 1857—paving the way for direct English colonial rule. As deSouza notes, this banner was also the prototype for the first American flag. Such

resemblances are, in fact, no coincidence; the East India Company had a sig-
nificant presence in the developing American colonies, as well as in the Far
East.[57] Through such layerings of images, informed by a strongly associa-
tive historical consciousness anchored within the global sweep of European
colonialism, deSouza makes reference to the intricate web of connections
that define his own position as someone circulating in the lands of the em-
pire that once spanned the globe.

In *Bombay Fling* (1996) deSouza presents, amid colorful visual snippets
plucked from tourist brochures and Air India posters, a nineteenth-century
group portrait of English military officers dressed as Sikhs, with the various
officers' turbaned heads incongruously grafted onto depictions of smaller
native bodies. Having gained mastery over their colonial subjects, India was
recast as a stage upon which Europeans could enact and live out their exotic
conceits. It was, according to the artist, once common practice to engage
in such seemingly paradoxical acts of masquerade; the resulting pictures
would be sent back to England as postcards and ethnographic souvenirs.
He observes that "those were the images coming back into Europe from the
colonies then, the high Orientalist fantasies . . . [that are] partaking of the
fantasy of India."[58]

Indeed, colonial settings commonly became channels for mutual cultural
exchange, fostering the flow of imagery and appropriations in both direc-
tions; for every Orientalism there was a corresponding Occidentalism, as
elements from Western cultures were reworked and incorporated for local
needs. At the same time that pop stars like Madonna swathe themselves
in saris and adorn themselves with *mendhi* (henna body painting) designs,
in a contemporary version of the role-playing British army officers, Indian
culture puts Western popular images to its own uses as well. DeSouza high-
lights this through his use of Hindi film posters and references to splashy
dance revues with their casts of hundreds, reflecting the obvious influence
of 1930s-style Busby Berkeleyesque American musical productions on Bolly-
wood, the center of the Indian commercial film industry based in Mumbai
(formerly known as Bombay, hence *Bollywood*). DeSouza is intrigued by "all
these different levels of masquerade . . . [in which] we don't know who's
imitating whom anymore."[59]

In 1991 deSouza made his first trip to the United States to participate
in "Interrogating Identities," an exhibition held in New York City. Greatly
excited by the energy and optimism of the local art world and the artists

(opposite) **6** Allan deSouza,
Taj & Company, from the
Coconut Chutney series, 1996,
computer-assisted chromo-
genic color print, 24" × 20".
*Courtesy of the artist and
Talwar Gallery, New York.*

he met, he decided to move there in 1992. He subsequently relocated to Los Angeles, which he presently calls home. Since migrating to the United States, deSouza's orientation has shifted, as he has increasingly become engaged in examining constructions of America to better comprehend his relationship to this society. In situating himself, the artist finds important correspondences in contemporary forms of Orientalism on both sides of the Atlantic—not only in the realm of the arts, but also in American mass media and popular and material culture. As he observes, "From the obvious—Disneyland, Vegas, Atlantic City—to the less so—the naming of rock formations at Grand Canyon as Buddha's Butte and Shiva's Temple—to countless sites/sights in between, Orientalism is not only invoked in the American landscape, but dizzyingly and shamelessly celebrated."[60]

At the same time, leaving Britain has also altered deSouza's critical standpoint in addressing colonialism and its various cultural manifestations. While living there, he was acutely aware of the "weight of history" and a burdensome self-consciousness as a former colonial subject, which he likens to having a big hand pointed directly at him wherever he went. Whereas in the United States, the artist acknowledges that "I don't feel implicated in American history. . . . There was always a sense I could function with more anonymity in a way, I wasn't immediately marked, I wasn't overdetermined." This has given him a new sense of freedom and license to step outside the particular objectified role in which British colonialism had placed him. In this respect, the U.S. diaspora offers opportunities for artists like deSouza to look beyond their immediate relationship to European imperialism and to consider more broadly the mechanisms by which these national identities are constructed.

American India Series

In the course of his travels across the country, deSouza produced a series of artworks entitled *American India* (1995–98), which chronicle the "Orientalist sites" he found along the way.[61] Among the pseudotouristic color photographs comprising *American India* is the snapshotlike image of an entrance to New York's Bronx Zoo, featuring a replica of a carved stone Cambodian head from Angkor Wat that conjures the exotic image of a "lost world." To underscore how references to non-Western cultures are commonly distorted and conflated in such surroundings in ways that blur the relationship between reality and illusion, deSouza also photographed a monorail

train traversing the zoo grounds that bears the name Bengali Express. Such make-believe cultural displays are devised to bring to mind the zoo's "immersion sites," in which animals from around the world are exhibited together in enclosures made to resemble their natural habitats. Popular perceptions, moreover, are reinforced by associated entertainments. Summer Safari 2000, for example, featured Journey to India, a program with traditional dance, music, crafts, and storytelling mounted in conjunction with its display of Asian elephants.

In his 1997 series on Disneyland, deSouza directs attention to the Jungle Cruise, in which visitors to Disneyland are ferried on an exotic river journey, replete with mechanized hippopotami and crocodiles arising from the waters, as well as rustic trading posts. Indeed, its designer originally modeled the cruise on the movie *The African Queen* (1951)—although the concept was later expanded to loosely encompass other parts of the world, including regions in Asia as well as Central and South America.[62] The Jungle Cruise attraction is located in Adventureland, the themed area of the park that also includes the Enchanted Tiki Room and the Indiana Jones Adventure, Temple of the Forbidden Eye. This ride—set adjacent to the dock for the Jungle Cruise—is based on the immensely popular Indiana Jones films from the 1980s, which evoke the old-fashioned atmosphere of 1930s cliffhangers. In these overwrought tales, the fearless American archaeologist and expert on the occult travels widely outside the Western world, including journeys to Shanghai, Tibet, and India, in search of rare Asian artifacts.[63]

Particularly noteworthy for deSouza is the way in which the Jungle Cruise and related rides, through tie-ins with popular cinema, cumulatively evoke nostalgic visions of British colonies in India and Africa, by casting visitors who arrive prepared for sensations and thrills in the role of intrepid Western explorers, penetrating their mysteries and carrying away exotic trophies from their cultures. What such themes emphasize for the artist is the "triangulation of Britain, the United States, and India through all these Orientalist sites," and how the "American imagination of itself [is] created itself in relation to somebody else's colonies."[64] This perception was furthered by the vessels deSouza encountered bearing names such as the *Ganges Gal* and the *Zambezi Miss* (figure 7). Indeed, of the many boats currently plying the Jungle Cruise, most are named for rivers flowing through parts of the world that have historically been subject to European or American domination or incursion. Among them are the *Mekong Maiden*, *Irrawaddy Woman*,

Yangtze Lotus, Congo Queen, Nile Princess, Amazon Belle, and the *Orinoco.*
Aside from the Orientalist implication inherent in the feminization of all
but one of these rivers' namesakes, the collapsing of Orientalist and primi-
tivist tropes into a generic, mysterious third world landscape is underscored
by the sign on the dock which greets the weary adventurer-tourists upon
their return: "THIS WAY TO CIVILIZATION" (figure 8).[65]

7 Allan deSouza,
*American India: Ganges
Gal,* 1997, chromogenic color
print, 18" × 24". *Courtesy of
the artist and Talwar
Gallery, New York.*

Pipo · intercultural contact and competition

The work of the Vietnamese-born photographer Pipo Nguyen-duy (who
refers to himself as Pipo) evokes another equally potent facet of Oriental-
ism—the Asian Other as cultural competitor. Paralleling the trope of Asi-
atic inferiority, barbarism, and primitivism, this is a figure of high civiliza-
tion and refinement reflecting centuries of contact and rivalry between
Asian societies and the West. In several series of photographic works, Pipo
projects images of the Asian as an assertive social actor who is conversant

with, and thus able to freely appropriate, the visual narratives and forms of Western art and culture for his own ends.

Pipo was born in 1962 in Hue, Vietnam's imperial capital prior to French colonization in the nineteenth century. He was raised in a prominent, politically well-connected family that lost its fortune during the Vietnam War. The war completely upended the artist's life. As a young child he witnessed the violence and bloodshed of the conflict, and later lived through the turmoil accompanying the massive Communist offensive launched on January 31, 1968, during Tet, the Vietnamese lunar New Year. Communist forces swept into many cities and towns, including Saigon, the former capital, but the most furious fighting occurred in Hue, which witnessed appalling atrocities during its twenty-five day occupation.[66]

Separated from his father, who remained in Vietnam, Pipo came to Monterey, California, in 1975 as a refugee; his mother, who had earlier left with his two sisters and remarried in the United States, sponsored him. Like

8 Allan deSouza, *American India: Civilization,* 1997, chromogenic color print, 3" × 5" (image), 16" × 16" (paper). *Courtesy of the artist and Talwar Gallery, New York.*

many with similar backgrounds, Pipo had originally planned to study in Paris. Until World War II, Paris was generally looked upon as the cultural and intellectual capital of the world, and it remains a magnet for many in Asia. Not only were a number of Japanese artists introduced to Western modernism in Paris in the early twentieth century, but it was also the place where many organizers of Asian anticolonial movements of both the right and left—including the Communist leaders Zhou Enlai, Ho Chi Minh, and Pol Pot—had pursued their education.

Pipo later moved to Minnesota, where he studied economics in college. He then left for New York in 1983 and gravitated to the East Village; it was there that he first came in contact with artists and became involved in the downtown avant-garde arts community. Several years later, he journeyed to India and studied Buddhism (a religion he associated with the culture of his homeland) with Tibetan monks, and, for the first time, felt free from constraining societal expectations about what his identity should be. Returning to New York in the late 1980s, he began working as a model; through this exposure to the fashion industry, he became interested in photography and later pursued formal studies in the subject.

Growing up in postcolonial Vietnam, with its overlay of French culture, induced in Pipo an ever-present awareness of occupying what the artist describes as an "in-between place, where one belongs to both cultures, yet at the same time to neither."[67] Having come from a former European colony, the artist makes clear distinctions between how he is positioned in relation to France as a colonial subject and how he identifies himself in the United States as part of a larger Asian immigrant presence. Exposed to Western influence from a young age, Pipo views the world, and negotiates his position between cultures, primarily through a cache of images acquired from Western art, Catholicism, and popular culture. Yet, due to memories of early traumatic events and the abrupt shift in his circumstances, the artist remains preoccupied with themes of death and loss, as well as matters of intercultural positioning.

Examining how his difference or Otherness is constructed in each respective context has inspired three bodies of photographic work: *Assimulation* (1995–1998), *AnOther Western* (1998), and *AnOther Expedition* (1998). Throughout, Pipo uses himself as an actor in what might be described as self-performative works of still photography that hover somewhere between psychology, theatricality, and myth.[68] Pipo, in the guise of the subject/actor,

has often played multiple and even conflicting roles in this "photographic theater of the self."[69] As someone with a strong visual imagination and a highly developed awareness of the ways in which appearances—including clothing and body language—can serve to define a person to others by signifying membership and position in a culture, the artist often speaks in theatrical metaphors. Pipo comments that for the outsider who seeks to rapidly establish a place for herself or himself in a new society, "the surface counts . . . [in] staging the way that you look so that people think you have been assimilated into the culture already."[70] Working with a repertoire of images and themes that have become iconic in Western art history and visual culture—all personified in the figure of the artist himself—he incorporates and inhabits roles drawn from a range of familiar Western sources, including the Bible, Greco-Roman mythology, European fairytales, Italian and northern Renaissance painting, and nineteenth-century American photographic portraits.

Significantly, as Pipo became more conversant with the works of other artists in the United States, he discovered important precedents among Asian American photographers who similarly employ self-portraiture as a central means of asserting an Asian presence in Western visual culture. Especially influential for him was the work of the late Tseng Kwong Chi, who donned a Mao suit and dark glasses and photographed himself before famous tourist sites in the United States and around the world.[71] Yet unlike Tseng, whose art is firmly situated in the present, Pipo's works are chiefly historically inflected—in the sense that their point of reference (although not necessarily their iconography) is almost entirely anchored in the past.

Apart from the use of far-ranging art-historical references, Pipo's interests primarily coalesce around the nineteenth century, which, as he acknowledges, represents the focal point of his historical imagination. Certainly from the standpoint of a postcolonial Vietnamese American photographer concerned with his place in the West, the nineteenth century can be understood as a major point of historical juncture. Pipo is especially conscious of the role photography has played in the historical depiction of the West's Others. For the artist, the nineteenth century is significant not only for the invention and use of photography in supplying a record of the paths taken by Western explorers and colonizers in foreign lands, including Vietnam, but also for having witnessed the first major wave of Asian migration to the United States, as well as the rise of modern art in France.

In 1992 Pipo produced *A Thousand Deaths*, an artistic turning point insofar as it was his first foray into a performative mode of working. In these disturbing images he restaged scenes inspired by nineteenth-century photographs taken by Western travelers of Chinese criminals being publicly tortured and crucified. It was through such ghastly representations that many European and American audiences of the period got their first glimpse of China.

The *Assimulation* Series

With the dramatic photographic tableaux of the *Assimulation* series (1995–1998), Pipo broadly embodies an internal struggle to come to terms with his conflicted, complexly intertwined relationship to European culture, on the terrain of high art. In these images, a cross-section of classical Western visual conventions and mythic tropes are powerfully reimagined—indeed, reformulated—as a deeply personal yet politically suggestive transcultural meditation on the experiences and fantasies of this Vietnamese-born artist. Depicting himself in multiple guises intended to emphasize an elaborate interplay between and within boundaries of cultural, national, and sexual identity, in this series the artist loosely frames self-imagery within themes, formats, and idioms appropriated from master narratives of western European visual art and literature. Through these highly stylized portraits, he overtly inserts the physical presence of the Asian body into the space of Western art and cultural history. Here, he posits an equivalence between art and lived experience: "*Assimulation* used the visual language of one culture to simulate that of another—an artistic assimilation similar to the act of simulation that takes place during cultural assimilation. The self-conscious artifice serves only to highlight the artificiality inherent in the process of assimilation."[72]

The *Assimulation* series varies in the extent to which different photographs may appropriate or even entirely reinterpret motifs from European art. Often, rather than drawing directly on existing works, the artist extracts images and themes that resonate in his imagination. Among the familiar motifs in Renaissance painting that Pipo "borrows" is that of the Madonna with the infant Jesus suckling at her breast. His *Madonna & Child* (1995) (figure 9) is suggestive of works such as Hans Memling's *Virgin and Child* (ca. mid–fifteenth century). Yet, with his distinctive features, bald head, and Korean traditional dress (known as a *han bok*), Pipo's Madonna has clearly

9 Pipo, *Madonna & Child*, 1995, silver print with wax medium on foam board, 36" × 22". *Courtesy of the artist.*

been transformed. As the artist explains, "I wanted to [use] the great Western painting themes, but create these fabricated . . . artificial cultural beings, that [are] neither Western nor Eastern."[73]

In *Adam & Eve* (1995) (figure 10), Pipo reaches back to recast the West's primary creation narrative, referencing the double portrait from the painted oak panels of the Ghent Altarpiece by Hubert and Jan van Eyck (Ghent, Cathedral of St. Bavon, ca. 1432). Here he not only portrays himself in the poses of both Old Testament figures depicted in this work, but also affixes paper cones symbolizing breasts to his chest in casting himself as Eve. Following Allan deSouza's notion of masquerade as an assertion of power, it should be noted that Pipo makes no attempt to fool the audience about his racialized and gendered identity. Instead, he makes it plain that he has

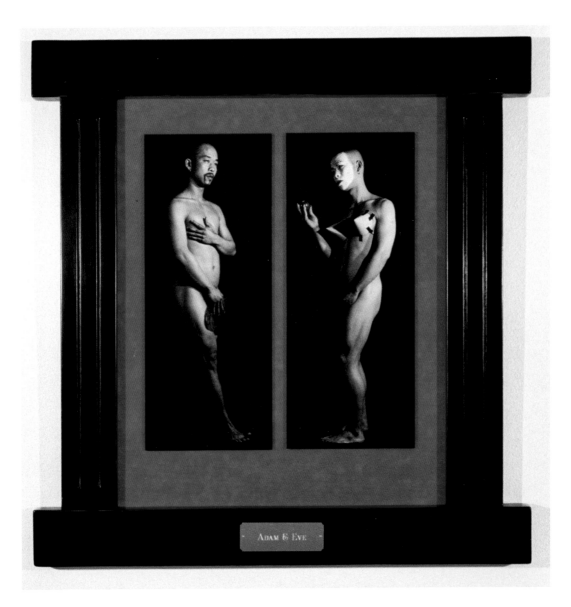

10 Pipo, *Adam & Eve*, 1995,
gelatin silver prints with wax
medium, dimensions variable.
Courtesy of the artist.

the right and the ability to assume whatever role he chooses and to appropriate references and images from European high art, much as Western artists freely appropriated motifs and idioms drawn from non-European visual cultures—including those of Asia, as well as Africa, Oceania, and the Americas. One can readily think, for instance, of the ways that nineteenth-century impressionists and postimpressionists were influenced by Japanese woodblock prints, Matisse by Persian miniatures, Picasso by African tribal art, Franz Kline by Chinese calligraphy, and Jackson Pollock by Navajo sand painting.[74] Additionally, in this piece Pipo adapted not only the motif, but also the mechanisms of display, that confer historical value and authenticity on such objects. As he did for many of the works from this series, here the artist fashioned an elaborate wooden frame complete with a small metal label, such as those used in museums, to present his image, thereby embellishing on his strategy of "cultural forgery."

In the triptych *Susannah & the Elders* (1995) (figure 11), Pipo reinterprets another well-known motif in Western painting. Many artists, including Jacopo Tintoretto and Guido Reni, have produced major works on this theme. However, it is notable that the initial inspiration for this photograph, according to Pipo, was the rendering of *Susanna and the Elders* by Italian painter Artemisia Gentileschi (1593–ca. 1613). Although not directly referencing the actual painting, the artist recognized two important points of identification. As an Asian who often finds himself marginalized in a predominantly white, Western society, and as a person from a non-Western culture subjected to the dominant Western gaze, he responded to both the uneasy position of Gentileschi as a female artist in a field historically dominated by men, and to the theme of a naked woman under secret observation by prying male eyes.

The photographer was also familiar with the well-documented account of Gentileschi's rape in 1612 by an artistic mentor, and with the fact that some scholars have attributed certain subsequent paintings, such as the bloody depiction of the biblical tale of *Judith Beheading Holofernes* (ca. 1618), to the turmoil she felt as a result of that traumatic event. Pipo found, in the idea of Gentileschi's using her art as a means of symbolically avenging herself on those who abused her, and of foregrounding strong female heroes as subjects for high art, an impressive precedent. He reflects, "It had a profound effect on me, this idea [of] how to look at your handicap and use

11 Pipo, *Susannah & the Elders,*
1995, toned silver print with wax
medium on Gatorfoam, 40" × 60".
Courtesy of the artist.

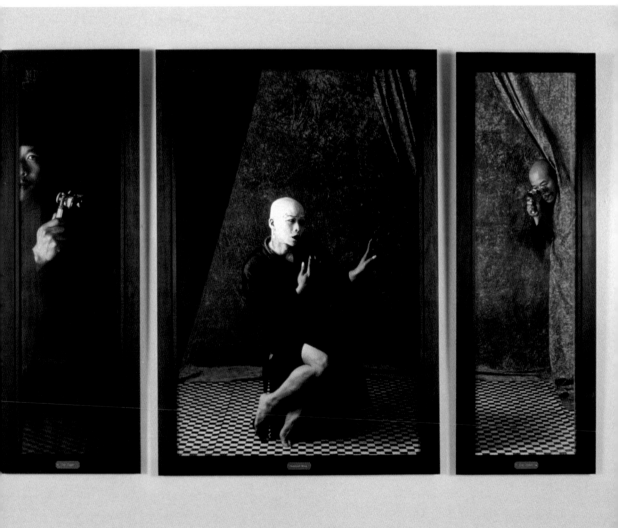

it not as a handicap but [as] a potential weapon. To undermine the lot that's been assigned to you."[75]

In a number of works, Pipo casts himself in stylized poses, costumes, and make-up suggestive of the theatrical conventions of East Asian cultures, such as Kabuki. Characteristically, he plays all the roles in *Susannah & the Elders*; in its central panel, the artist appears on an empty stage in the female persona of Susannah, clad in a simple robe with his hands delicately upraised and with his strongly illuminated bare leg exposed to the viewer. Flanking him on either side are corresponding images of his masculine personae, representing the voyeurism of the Elders who spy upon Susannah in her bath. Partially concealed behind the stage curtains, each holds a pair of antique opera glasses to scrutinize her.

Throughout much of the *Assimulation* series, gender boundaries are continually being crossed, as the artist assumes both male and female roles. He cites historical precedents in traditional Asian theater, which exclusively employed male actors who played all the roles. Hence, for him the act of cross-dressing in an art context does not necessarily carry the same sexualized, gender-bending connotations that it does for many Western viewers.

AnOther Western Series

In the thirty-two self-portraits from *AnOther Western* (1998), Pipo shifts his focus to the American environment, where he has come to identify himself not just as Vietnamese but more broadly as an Asian immigrant — and hence within the historical context of Asian migration to this nation. "*Assimulation* was my own way of weaving myself into the West, that is, the European high culture. Whereas this is my process of assimilating into American culture, the American West."[76] He sought evidence of that Asian presence in historical photographs from the nineteenth century, the period that witnessed the first major influx of Asian (primarily Chinese) immigrants following the California gold rush in 1848, but found a paucity of images.[77] And those he did uncover were severely limited, chiefly portraying Asians as, in his words, coolies, servants, and opium addicts. Yet, as Pipo asserts, Asians were not simply confined to the subordinate roles assigned to them, but in fact occupied a spectrum of positions in society. With *AnOther Western*, Pipo set out to conceive his own images of that historical period by assuming the roles of figures long cemented in the national consciousness — "gunslingers, musicians, and gentlemen." In these self-portraits, similar to tin-

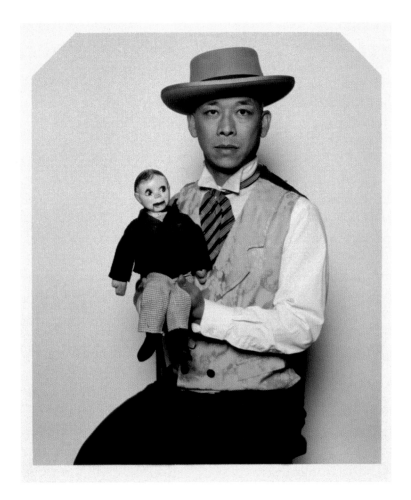

12 Pipo, self-portrait as
ventriloquist, from *AnOther
Western* series, 1998, toned
gelatin silver print, dimensions
variable. *Courtesy of the artist.*

type portraits made during the late 1800s in western regions of the United
States, the artist sought to symbolically "remake history" from a different
perspective by using a nineteenth-century photographic syntax. He writes,
"[In] *AnOther Western* . . . my goal is to question and to challenge the legiti-
macy and authority of the western myth."[78]

Among its more provocative depictions are those where the artist ap-
pears as a nineteenth-century photographer standing beside his camera,
and as a ventriloquist holding aloft a small dummy, while staring fixedly at
the viewer (figure 12). With this pair of images, Pipo explicitly foregrounds
the presence of Asians as contesting social agents, both as documentarians
and narrators of their times. The juxtaposition of the artist's recognizably
Asian image with a dummy bearing Caucasian features also suggests that

it is he, and not the "Westerner," who is now in control of this communication. It could also perhaps be seen as a reversal of, or a visual twist on, the Saidian notion of the West as speaking for the Other. However, rather than making any overt ideological statement, the artist prefers to phrase the question raised by this piece as "Who is speaking for whom?" Thus, each in turn may be the ventriloquist and the ventriloquized.

AnOther Expedition

A 1998 artist grant offered Pipo a unique opportunity to come to terms with the past: this time, to address both the historical relationship between France and Vietnam and his close identification with French culture as a result of this colonial legacy. Traveling to France, he lived in the artist colony at Giverny, the former home of French impressionist painter Claude Monet. Its verdant grounds, including the pond and Japanese-style bridge that Monet had constructed, have been the subject of innumerable paintings by this artist and is well known to the art-going public. Significantly, Monet was an active collector of Japanese prints, and his celebrated series of water lily paintings, the *Nymphéas*, bore the overt influence of Japanese design elements. While Monet always turned these sources to his own formal ends, the growing renown of these paintings would serve to move Japanese art to the center of the French art world.[79]

Because of its significance in the history of European art, Monet's garden at Giverny is, for Pipo, a paramount icon of Western high culture. In conceiving a project that is specific to the sociocultural significance of this place, he decided that, much as European colonial powers had launched expeditions to acquire the finest goods, lands, and resources of Asia, he would turn the tables by mounting his own private "expedition" to "steal what is high culture from France."[80] As a former colonial subject figuratively coming to plunder the best that the West has to offer, the artist's mission would advance on the terrain of art and art history, by capturing images and even samples of the actual soil, air, plant life, and water from Monet's garden. As Pipo explains his strategy for negotiating with the historical import of this place, "The evolution for me is about the gaze, about how aggressive my gaze could be. I'm just going to . . . extend [my] gaze over the West."[81] Pipo deliberately chose to use the same photographic methodologies that nineteenth-century European colonial powers employed to record what they encountered and seized in foreign lands. Toward that end, he selected

a photographic process developed in the 1800s known as cyanotype to cata-logue the plants and seeds gathered from Monet's garden.[82] By appropri-ating the technologies used by the Europeans of that era, the artist estab-lishes certain formal symmetries between his project and theirs.

As he did with the earlier series of works, in *AnOther Expedition* Pipo sought to assert an identifiable (and empowered) Asian presence in what he considers the very epicenter of European high culture. To conjure a role that would place him on a par with an icon of French civilization like Monet, he photographed himself in a Chinese robe both on the bridge in Monet's garden (figure 13) and paddling slowly in a rowboat across the pond (figure 14). As he points out, Vietnam was under the influence of China for over a thousand years, and hence he considers himself heir to the cultural legacy of this millennial civilization.[83] As he describes the scene, "I was stand[ing] alone on the bridge but in this gentlemanly sort of pose, as a *conqueror*, and not necessarily like a tourist or like a servant."[84] By assuming the mantle of Chinese high civilization, he comes to meet Monet / French culture not as a supplicant, but as an equal, and furthermore as a potential rival. Thus the visual narrative embedded in *AnOther Expedition* symbolizes an imag-ined encounter between representatives of high civilizations, in which the Asian figure is firmly positioned as an equal cultural competitor. Beyond displacing and turning back what postcolonial critics have termed the "im-perial gaze," here Pipo also metaphorically alters the balance of power and dominance inherent in an epistemology of supremacy that has placed the West at the apex of the cultural pyramid.

Tomie Arai · countering stereotypes with alternative images

Tomie Arai brings a strong domestic focus to the discussion of Othering, as a member of the postwar generation that witnessed firsthand the post–civil rights, black power, counterculture, and anti–Vietnam War struggles of the 1960s and 1970s. With a standpoint primarily framed in terms of U.S. race politics, immigration, and labor history, she is deeply invested in art as social practice. Born in 1949, Tomie Arai is a third-generation Japanese American printmaker, muralist, and installation and mixed-media artist. Raised in a Japanese American enclave on New York's Upper West Side and married to a Chinese American, she retains an abiding attachment to places

13 Pipo, self-portrait on bridge in Monet's garden, Giverny, France, from *AnOther Expedition* series, 1998, photograph, dimensions variable. *Courtesy of the artist.*

14 Pipo, self-portrait in rowboat in Monet's garden, Giverny, France, from *AnOther Expedition* series, 1998, photograph, dimensions variable. *Courtesy of the artist.*

associated with the Asian presence in this nation. However, because the surrounding neighborhood is ethnically mixed, and her public school class-mates were primarily African American and Latino, she also came to view Asians in this country as part of a wider "third world" urban culture. That awareness, in turn, has moved her to find common cause in the histories and present-day struggles of other minoritized communities, engendering the coalitionist orientation that often informs her work. Consequently, Arai uses art making as a vehicle for collaboration and dialogue with non-Asians as well as Asians, pursuing public art projects in which she can work directly with members of African American, Latino, and Native American groups.

Recognizing the impact on Asian American communities of a past marked by exclusion, discrimination, and often-blatant racism, the artist puts forward alternative images that bear witness to their fortitude and survival. She also critiques the distorting and denigrating stereotypes that have been invoked to justify the mistreatment of Asians at the hands of the dominant society. In framing a response to fragmentation and disruption in Asian American communities, she constructs affirmative images intended to articulate and valorize a pan-Asian sense of wholeness and connection that links Asians of different backgrounds and generations together. Arai observes, "The life I've lived has been an American one. Yet we are victims of everybody else's reality about Asians. . . . We have to re-create a more positive reality, specific to the experience of an Asian being in America."[85]

Early engagement with the nationwide public art and mural move-ment, as well as with grassroots Asian American community arts groups, was integral to Arai's development as an artist. Along with others of her generation, she took part in a groundswell of cultural activism in which Asian American artists sought to produce images and narratives of their own histories and contemporary realities. In the mid-1970s, sponsored by the Cityarts Workshop, she began producing murals in collaboration with local community residents on the Lower East Side, a neighborhood that has historically been a magnet for successive waves of immigrants from all over the world.[86] She recalls, "There was a conscious movement to address and correct stereotypes [and to] create, out of very personal as well as social space, new images that they felt more ownership over. . . . The murals were my introduction to a way of looking at art as a way to build community . . . a sense of identity and place."[87]

Notable among the artist's projects from this period was the *Wall of*

Respect for Women (1974), which she credits as the first large-scale public mural in the United States to be exclusively painted by women.[88] Around the central motif of a sturdy tree with outspread branches and roots deeply anchored in the earth were arrayed portraits of working women of various racial and ethnic backgrounds. Among them were seamstresses, factory and restaurant workers, teachers, mothers with children, and strikers on a picket line. Seeking to "work with people, to share ideas, to learn from them," Arai regarded her dialogues with the community members whose lives she sought to commemorate to be as meaningful as the art that emerged from these interactions.[89]

These encounters extended the artist's concerns to broader consider-ations of the nature of memory and the crucial role of sharing and retelling individuals' life stories in the construction of a collective past. Arai, inspired to find representational means to link individual experiences to larger col-lective histories, began to gather personal memorabilia and oral histories from everyday people, material that subsequently became integral to her public projects. In pursuit of evocative images of the longstanding Asian presence in this nation, Arai began to cull family photo albums and local historical archives. Interlacing these ephemeral mementos of Asian Ameri-can lives with symbols, motifs, and objects associated with Asian cultures, such as scrolls, pendants, and calligraphy, she produced silk-screened prints intended as secular icons that testify to the endurance of successive gen-erations. Given printmaking's historical relation to mass culture and me-chanical reproduction, Arai, like many socially oriented artists, is attuned to the implications of a medium based on the use of the multiple (in contrast to the unique object) as a means of facilitating art as a social practice.[90] Over time, as she was increasingly drawn to working with mixed media and installation, she applied printmaking techniques to a variety of materials and objects.

In considering the context in which Arai functions—and the impetus to blend personal and collaborative expression—it is important to recognize community art as a site for visual expression with its own lineage, concerns, and points of reference. The heuristic of "vernacular aesthetics" is useful in situating works such as Arai's that are conceived as a means of envision-ing and articulating common experiences that bind people together.[91] By placing emphasis on the vernacular, the concept reworks and rephrases prior notions of aesthetics based on Western notions of beauty and tran-

scendent value to allow greater latitude for local meanings, as well as multiple audiences and sites of valorization. It delineates an aesthetics that arises organically from everyday experience, in which the material and visual culture associated with a particular locale are understood as a primary source and catalyst for art making. Phrased another way, it is an *aesthetics of shared social space*, in which cultural production bears an organic relationship to both the place and the social relationships that inspire it.

Three recurrent motives tie Arai's works together: the affirmation of intergenerational connections, the envisioning of sustaining cultural legacies, and the construction of a collective past. To emphasize the enduring power of the family and familial affiliation for Asian immigrant communities, she puts forward images that depict strong, nurturing relationships between mothers and children. These family portraits are presented in centralized visual formats that Arai associates with the dignified formal photographs taken in late-nineteenth-century Chinatown commercial portrait studios. The artist often incorporates decorative motifs derived from traditional Asian fabrics in these silk-screened prints—a way of providing visual traces, a sort of cultural signature, of the heritage of the individuals being portrayed—to indicate that she considers the family to be a primary means of preserving and transmitting an individual's and community's ethnic legacy.

Women's Wheel, one of six mixed-media works in the *Autobiographical Series* (1988), reveals successive images of Arai, her mother, and her grandmother as a wheel is slowly turned. Similarly employing serial repetition, *Sansei—3 Generations* (1989) consists of a tripartite array of identical rectangular plaques. The three sepia portraits that are mounted on the plaques depict, in turn, the artist as a young child, her mother, and her grandmother. Through this device, Arai emphasizes her place within an unbroken female chain linking ancestors in Japan and descendants in America. In the 1991 *Family Meal*, her first multimedia work, Arai uses the motif of an Asian American meal as a metaphor for an intimate communal space where each member can freely bring her or his memories and stories to the "table." It signifies, according to the artist, "those [places] in my life where that kind of exchange of ideas and support occurred."[92] Eight photo-derived, silk-screened portraits of the diners revolve around a central disk that is mounted on the wall above a round wooden table set with rice bowls and chopsticks. In addition to echoing the shape of the dining table, for the art-

ist the circular arrangement of the tableware and eating utensils suggests the numerals on a clock face—alluding to the persistence of memory across cycles of human history.

Countering Stereotypes

At the same time that she emphasizes such affirmative imagery, Arai finds it equally imperative to address the numerous misconceptions that shape the way Asians are perceived in this culture. To establish an animate visual subtext that engages the ways that Asians are framed before the public eye, Arai incorporates imagery of Asians drawn from historical sources, including nineteenth-century anti-Chinese political cartoons and World War II propaganda, as well as from contemporary popular media such as film, television, and magazines. By juxtaposing an array of stereotypes with portraits of real people, she creates an intertextual dialogue, grounded in social realism, that underscores the disparities between those conventionalized representations and the vibrant, complex individuals they supposedly name. In allowing these images to converse among themselves, she also symbolically returns agency and place to those whose presence has been misrepresented and obscured, and whose voices have for so long been silenced.

A number of works from the early 1990s vividly demonstrate Arai's evolving interest in issues of stereotyping and in controverting circumscribed images of Asians perpetuated in mainstream American culture. The first is the mixed-media piece *At the Heart of This Narrative Lies a Human Life* (1991) (figure 15), originally created for a thematic exhibition entitled "Souvenir of SITEseeing: Travel and Tourism in Contemporary Art."[93] The artist saw this project as an opportunity to "look at Chinatown from both perspectives, from the point of view of the tourist coming in and looking at what images existed, but also looking at the community from perhaps the inside out, so it's sort of a window into the community."[94] Working in Chinatown with activist groups over a number of years honed Arai's awareness of how Westerners perceive Asians in this country, since that neighborhood has historically been, in her words, a "locus for tourism, and people were always responding to outsiders coming in and looking at them. . . . [It was] a commercial space where people consumed images of Asians."

At the Heart of This Narrative is centered on the diminutive silk-screen portrait of a young Asian American woman, positioned on a somber back-

(opposite)

15 Tomie Arai, *At the Heart of This Narrative Lies a Human Life*, 1991, silk screen, kallitype, bamboo pole, and mixed media, 54" × 54". Collection of The Bronx Museum of the Arts. Museum purchase with funds from The Rockefeller Foundation and the National Endowment for the Arts, 1999.1.3. *Photo: Oren Slor.*

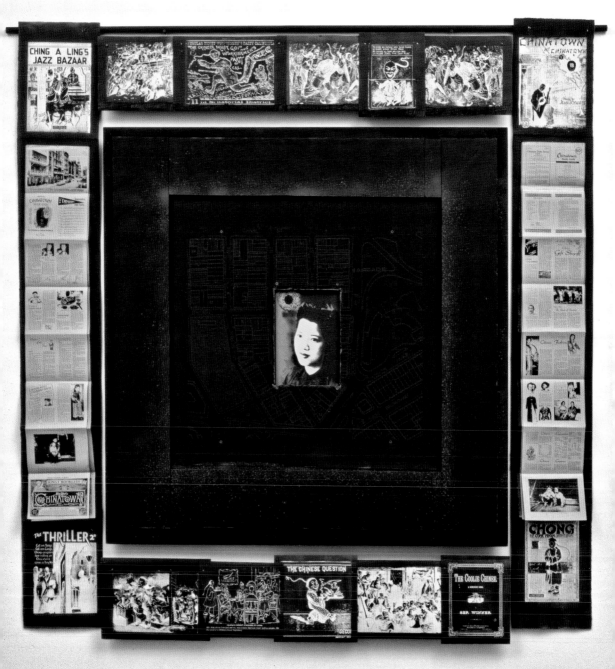

ground imprinted with the traces of a Chinatown street map from the 1950s. Integral to the work is its broad surrounding frame, comprised of a sequence of shallow niches in which are affixed an assemblage of sepia-toned archival images depicting the Chinese in America, appropriated from popular culture and historical sources. Arai, who was then artist-in-residence at MOCA (The Museum of Chinese in America—formerly the New York Chinatown History Project), had access to the museum's holdings of Chinatown tourist guidebooks and restaurant menus going back many decades. Its collections likewise provided stereotypic portrayals of Chinese from a range of vernacular formats: sheet music, nineteenth-century anti-Chinese political cartoons and broadsides, advertising trade cards, and pulp magazines. With inscriptions such as "Ching A Ling's Jazz Bazaar," "The Coolie Chinee," and "The Chinese Must Go!" such ephemera bears testament to the types of representations and attitudes that have long framed Chinese (as well as other Asians) in the American imagination. The artist selected this imagery, produced prior to the 1940s, to point to the ways in which many non–Asian Americans have historically viewed Chinatown and things Chinese. Further, Arai believes that Chinatown remains "actually fixed in that period" in the popular imagination, "fixed in a time and place [that's] not in sync with the way that [Chinese in America] see it now."[95]

Against these misrepresentations, she poses the iconic portrayal of the young woman whose luminous image provides a strong visual counterweight to the crush of Orientalizing, even overtly racist, stereotypes and beliefs that bracket her life. This portrait, in Arai's view, is a potent means of "project[ing] a kind of power, or dignity, or sense of self . . . [that] would balance against the imagery that seems to float around her."[96] Derived from a family photograph, the image depicts the mother of the late Chinatown community activist, teacher, and poet Frances Chung. Arai originally met Chung during a year-long oral history project sponsored by MOCA, in which she interviewed local Asian American women and their daughters and created a suite of prints based on those interviews, entitled *Memory-in-Progress: A Mother/Daughter Project* (1989). In Arai's view, since "oral history [is] a sort of public confession . . . a form of public art . . . the portraits themselves [are] windows into these private lives made public."[97]

In 1992 Arai produced *Framing an American Identity*, a site-specific room-scale installation exhibited at New York's Alternative Museum. Here, she sought to articulate, through a wide array of portraits of living individu-

als, the multiplicity of identities and positionalities of contemporary Japanese Americans—set once again in contradistinction to the stereotypic representations that exist in American culture. As the artist recalls, these mixed-media works were created in response to the intensification of anti-Japanese sentiment in the United States during the previous decade, a time in which an economically powerful Japan was seen by many as a growing threat to American businesses and workers. This climate of tension and widespread resentment had erupted in the brutal, racially motivated 1982 murder of Chinese American Vincent Chin in Detroit, a tragic event that reverberated throughout Asian American communities. As Arai relates, "The idea of these auto workers mistaking a Chinese engineer for a Japanese and killing him . . . made me concentrate on what we as Americans think of as Asian in this country, and how there are so many mistaken notions of what Japanese and Chinese are."[98]

Installed in a deep, rectangular space, *Framing an American Identity* (figure 16) was comprised of two groupings of images silk-screened on wood and glass, displayed in a pattern that alternated depictions of real people and stereotypes. Running around the room's perimeter at eye level were shelves bearing a series of photo-derived life-sized portraits of Japanese Americans imprinted on bare wooden planks, interspersed with an equal number of images on glass slabs suspended by twine from the ceiling, referencing things Japanese, past and present. To symbolize what remains of the past, the shelves also contained a scattering of broken shards of glass stenciled with fragmentary images and newspaper texts that alluded to key historical events shaping Asian Americans' sense of who they are. Among them were references to the Vietnam War, the Japanese American internment, the Ku Klux Klan, and the civil rights movement. To this last the artist believes Asian Americans owe a great debt, since it helped to create the conditions that fostered the repeal of discriminatory laws which long suppressed Asian immigration. Throughout, Arai used impermanent materials such as twine, nails, and raw lumber, making transparent how the numerous elements of the piece were constructed and linked to one another. This handmade approach not only embodied the idea that the artist has full authority over what is being represented, but also functioned as a visual metaphor for her desire to (re)construct the Asian American identities portrayed in the installation.

The first of the portraits that the viewer encountered when entering

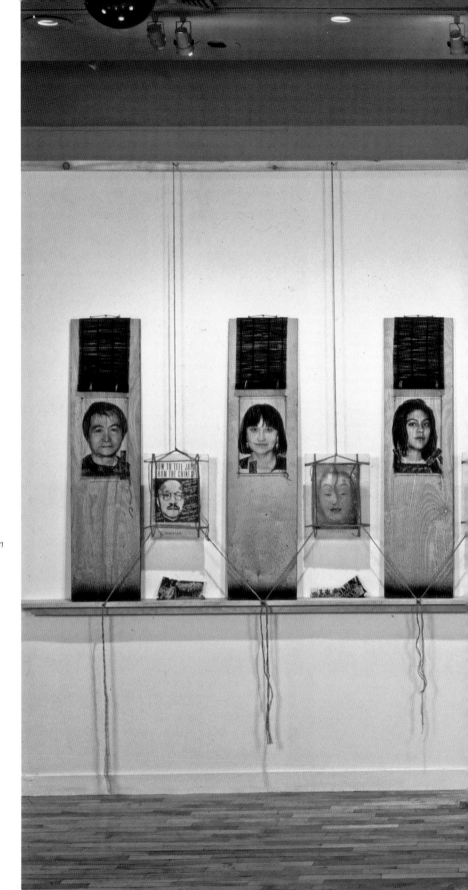

16 Tomie Arai, *Framing an American Identity*, detail, 1992, site-specific installation, Alternative Museum, New York City, silkscreen and laser heat transfers on glass and wood, bamboo shades, twine, glass, and wood, dimensions variable. *Courtesy of the artist. Photo: Wayne Rottman.*

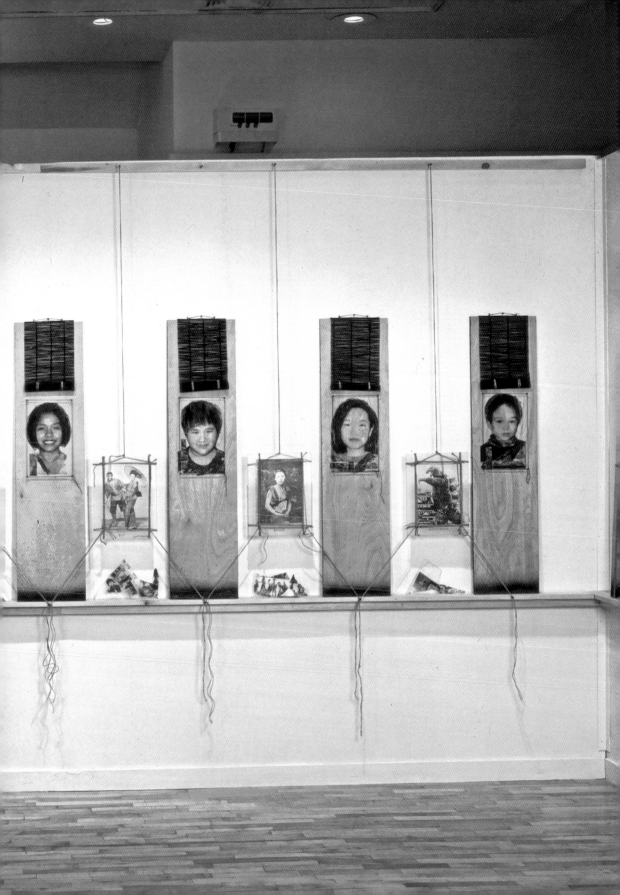

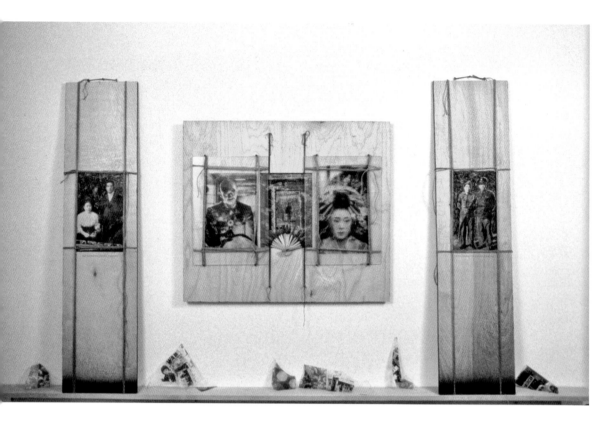

the installation (figure 17) was a small, photo-derived silk-screen of Arai as a little girl, sandwiched between the larger, imposing figure of Tojo, the wartime prime minister of Japan (covetously contemplating a globe of the world), and a heavily painted geisha in traditional makeup—palpably communicating the artist's sense of being confined by such powerful and pervasive stereotypes. As Arai remarks, "I was thinking of the Alice Walker poem at the time, where she talks about 'my small self standing against the world.'"[99] These seemingly unbreachable images were, in turn, flanked by two family photographs: on the right by her father and a friend in American military uniform taken during the Second World War, and on the left by her immigrant grandparents in old-fashioned Western dress. Through these images, Arai juxtaposes the integration of generations of her family into the life of this nation against the negative and exotic ways in which Americans of European heritage commonly continued to view them.

The larger assembly consisted of a set of eighteen portraits of living Japanese Americans. Above each image was a small black bamboo shade,

17 Tomie Arai, "Self Portrait," from *Framing an American Identity*, 1992, Alternative Museum, New York City, silkscreen and laser heat transfers on glass and wood, bamboo shades, twine, glass, and wood, 7" × 8" × 4". *Courtesy of the artist. Photo: Wayne Rottman.*

ceremoniously rolled up to reveal the individual's face to the audience. The subjects were all from New York; among them Arai's son, relatives, and friends—including the well-known political activists Kazu Iijima and Bill Kochiyama—as well as their fourth- and fifth-generation children. Significantly, a number were of mixed backgrounds, reflecting the high rate of outmarriage among Japanese Americans, as well as the larger trend toward interethnic and interracial unions in Asian American communities. Accompanying each portrait was a succinct label encoding the person's ethnic and generational status; below her son's portrait, for instance, was the caption: "fourth generation Japanese Chinese American." While Arai realizes that such designations would hold the most significance for other Japanese Americans, her larger purpose was to emphasize their fundamental Americanness to the broader audience.

Hung between each of the portraits, and roughly held together with twine, were stereotypic images on dense, fractured sheets of tinted glass—what Arai refers to as the "windows" through which Asian Americans are typically viewed. Among these were a Noh mask with a leering devil face, bearing the legend "fiendish"; an image of a geisha with the label "inscrutable"; a still image from the 1956 film *Teahouse of the August Moon*, in which Marlon Brando plays a wily and manipulative Japanese Okinawan character, entitled "sly"; and a nineteenth-century portrait of a Japanese woman in a peasant outfit, labeled "exotic." This last example represented the type of photographic images of Japan produced by Western photographers such as Felice Beato in the 1860s, shortly after the opening of Japan to the West.[100] Beato documented not only famous landscapes and architecture but also social and occupational "types." As Arai observes, these were studio portraits, fabricated images of Japanese woman of that era which were already mediated and removed from their daily environments. Arai explains her intent in counterposing these received images with the contemporary portraits: "I'm trying to humanize the work or the images so that people can connect. [This] is the exact opposite of what stereotypes or mass-media images do. There's a familiarity, but there's no connection."[101]

Apart from her efforts to counteract stereotypes, Arai intended her piece to suggest the possibility for new formations of community among Asian Americans. Recognizing that in New York there is no large, centralized Japanese American enclave, she believes that, instead, community resides primarily in one's imagination. Arai reflects, "I am interested in the ways that

creating these images of community help to reinforce one's sense of it, whereas very often without any visible evidence you really don't believe it exists."[102] Accordingly, this project enabled her to conjure all the people who have been important in her life and to symbolically gather them together into one space, at the same time.

Finally, the mixed-media installation *Portrait of a Young Girl* (1993) (figure 18) is a meditation on the situation of Japanese American women. This intricate structure is composed of multiple frames and screens, parts of which are held suspended in space by a taut web of cords extending from ceiling to floor. To suggest the many presumptions that our society interposes between how we see others and how we, in turn, are seen, the piece is centered on a large, cameolike portrait of a young Asian American woman, brought into high relief by an encircling halo of dark paper — her glowing image partially obscured and mediated through successive layers of materials and imagery. These include a bamboo shade and various female effigies, sandwiched between roughly bound slabs of cracked glass inscribed once again with the words "exotic," "deceitful," "fiendish," and "inscrutable," again referring to stereotypic qualities attributed to Asian women (and to "Orientals" as a group).

By presenting a vibrant female presence juxtaposed against these other images, the artist asserts that unless one learns to look past the scrims imposed by convention, one will never know who contemporary Japanese American women really are. Arai comments that the work suggests how, "despite these barriers, people endure, that they're even strengthened by the experience of having to deal on a daily basis with other people's misconceptions of them or misreadings of them or labeling of them."[103] As one Japanese Canadian critic observes, "In these works, the focus is on the human face, with its dispassionate gaze rising out of darkness or behind a veil, out of the obscurity of otherness urging us toward a recognition of its humanness: toward self-recognition."[104]

Presence, Counter-Understandings, and Alternative Narratives

These stirring words about Arai's artwork could equally be applied to that of Pipo, deSouza, and Fuentes, as the four artists in this chapter share a common impetus: to use art to affirm one's full humanity, in the face of im-

posed and historically bound constraints that would infix and delimit its expression. All are mobilized by the need to assert a strong sense of resilience and personal, as well as collective, sovereignty in their transactions with the majority culture. To examine and imaginatively redress the ways in which they, their peoples, and their cultures have long been represented and generally continue to be seen in the West, these artists evoke a nuanced and profoundly American vision, rooted in complex relations of difference and domination. They play with our experience of history and draw on a variety of devices, guises, and milieus—spectacle, artifice, mimicry, masquerade, tricksterism, theatricality, role-playing and -reversal, self-imagery, stereotyping—to contend with how overdetermined images of Asian and other non-Western peoples and cultures, fed by interlocking discourses of primitivism and Orientalism, are reproduced and reprocessed in various media and situations of engagement with the West.

While their formal approaches to image making may differ, the strate-

18 Tomie Arai,
Portrait of a Young Girl,
1993, mixed media,
12" × 15" × 1".
Courtesy of the artist.
Photo: Millie Burns.

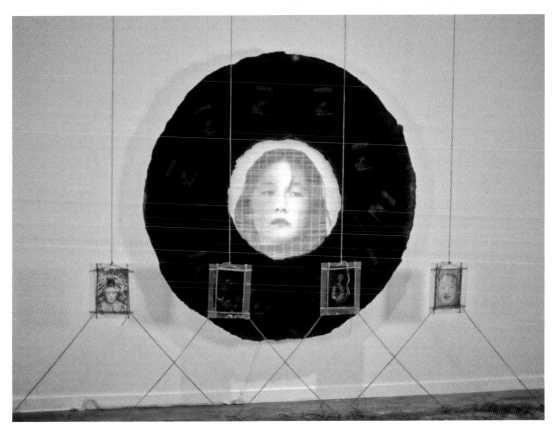

gies, rhetorical tools, and competing narratives that each calls upon to pry open the social handcuffs imposed by Western discourses of difference carry the imprint of language-based and materialist theories of social construction. Beginning in the late 1970s, there was increasing dissatisfaction voiced by Asian American artists over simply providing the type of positive, "authentic" ethnic and racial counterimages that had been associated with identity politics. Mirroring analogous trends in black British art and cultural politics, a palpable shift in artistic practices occurred over the following decade to the adoption of systemic approaches aimed at exposing and undermining the mechanisms of representation by which the dominant culture's images of the Other are constituted and propagated. By the 1990s, many Asian American artists, often fluent with the critiques of Eurocentric claims to epistemic privilege and the objectifying force of the Western gaze vis-à-vis its Others, had become engaged with the complexities of being at once critical of, yet also deeply implicated within, an omnipresent Western culture, its genealogy and legacy of power, its attendant systems of representation, and its lexicon of available images.

Allan deSouza and Pipo readily acknowledge the central influence of feminist and postcolonial theory on their work. DeSouza recalls that exposure to feminism was in many respects his first politicization, as it provided an important tool to articulate matters of race. "The lesson from feminism was that a whole class of people were/are determined and defined by biology. . . . It wasn't such a leap to think of racism and white supremacy in similar ways."[105] Pipo specifically recalls insights gleaned from the observation that the "determining male gaze projects its fantasy onto the female figure, which is styled accordingly" that he later brought to bear in conceiving works like *Susannah & the Elders*.[106] Yet, as an Asian male in the West, he is equally aware of the ambivalent position he occupies, in both being cast as abject, and in possessing relative agency based on his gender. Further, to the extent that Asians have historically been the West's cultural and political contestants, they are perceived as actors (often malevolent) on the world stage driven by their own appetites, and calculations of self-interest based on a will to power. Accordingly, the Asian can figuratively be seen in both roles, as the passive object of the gaze, and as the gazer who, in this case, fixes the West in his sights. As Pipo comments, "The typical cartoon depiction [is] of an Asian bowing to you, but at the same time in the

back [he] is holding a knife . . . there's something darker, something that you don't know what is going on."[107]

As Pipo reminds us, to the extent that ubiquitous images of Asians self-servingly reflect the needs of Western society, the Asian presence can be seen to suffer from a lack of alternative imaging. Perhaps nowhere is that consciousness of the degree to which the identifications and expressive repertories of Asians are historically bound up with the West and its expectations more sharply and provocatively manifested than in the work of postcolonial diasporic artists. Having moved through differing yet often historically linked social and cultural environments, and coming from places where globe-spanning Western imperialisms and cultural impositions are recognized to have made deep material and psychological incursions, these artists are especially attentive to the formative roles played by their respective media in constructing magisterial knowledges of peoples caught up in Western colonial orbits. While deSouza and other artists such as the Philippine-born painter Manuel Ocampo have produced highly critical and ironic bodies of work through the appropriation and recontextualization of Western imagery and motifs, for Fuentes and Pipo this awareness engendered a strong formal preoccupation with manipulating not just received images, but also the vehicles and the technologies of representation themselves. Similar to Fuentes's view of early film, Pipo regards photography as a "colonial tool" whose development is closely linked to overseas expansion, since these technologies were rapidly deployed to document conquests and travels during a period that saw the intensification of European colonialism in Asia.

The pivotal formulation of mimicry, and the concept of masquerade in postcolonial theory, likewise shed light on the work of Pipo, as well as that of deSouza.[108] A principal feature of postcolonial theory is a concern with how agency can be retained by the formerly colonized subject, given that, to a significant extent, the needs and interests of a Western society have shaped her or his outlook and values. One line of reasoning posits that when formerly excluded colonial subjects actively participate in the West's cultural arenas, the very fact of their presence as non-Western Others is inherently productive of fissures in the Western imaginary. Mimicry is not simply the reproduction of a Western model; rather, through slippage and blurring of the original so as to appear similar to, yet not exactly like, the

master, it functions as something very close to mockery, thereby disrupting the authority of colonial discourse.[109] Such an approach, therefore, seeks to displace the power of the authoritative Western gaze by reversing the historic roles of the observer and the observed.[110]

In deSouza's view, there are important distinctions between the two concepts that illuminate the dynamics underlying this type of role-playing: "Mimicry would be more to pass, to drop local styles and customs in order to fit in. Masquerade would be to make the act of mimicry, the act itself, the point of display. You're not trying to pass, you're actually calling attention to the fact that you *can* take on the role."[111] Following that argument, the British officers' masquerade in *Bombay Fling* can be understood as an overt display of power, rather than simple exoticism (whereas a colonial subject's efforts to adopt the appearance, customs, and even values of the colonial master in an effort to pass would be an act of mimicry). The application of masquerade is especially useful in framing a critical aspect of Pipo's project, as the artist overtly draws on the visual language and themes of European high art and culture while simultaneously interrupting their discourses with his unmistakable presence as the Other.

To counter the historic discourses on colonized and marginalized peoples that have served the needs of powerful Western interests, and as self-narrativizing subjects moving to return a fully embodied sense of agency to themselves, Pipo and Fuentes imaginatively inhabit multiple roles as characters in their own self-staged productions, thus literally re-figuring the intermingled social, historical, and cultural positions of the Asian subject through the prism of their own cross-cultural presence. Pipo's *Assimulation* series emphasizes the liberating possibilities of artifice in generating new interstitial spaces for enacting an Asian presence. Beyond the immediate debt he acknowledges to Tseng Kwong Chi, such work can equally be compared to photography-based performative pieces by artists like the Nigerian Yinka Shonibare, who appears in the alternate persona of an aristocratic Victorian dandy in his 1996 *Effnik* series.[112] Among others, the Korean American artist Nikki Lee and Yasumasa Morimura in Japan have also employed forms of masquerade and cross-dressing, and fictional identities that slip the traces of the positions and roles typically assigned to the West's Others.[113]

Pipo's desacralized appropriation and occupation of roles from familiar religious works of Western art history brings to mind Dinh Q. Lê's "photo-

weavings" that were inspired by the handmade grass mats the photographer and installation artist learned to plait as a youth in South Vietnam. A number of these pieces—fashioned from color photographs the artist made of his own body and of Asian and Western art—have been sliced into numerous strips and angular shapes, and then interwoven to form elaborate multilayered crisscrossed patterns. Works of the period like *Self Portrait after Bosch, "The Temptation of St. Anthony"* (1991) mingle depictions of foundational religious figures such as Jesus and the Buddha, as well as Christian saints, with images of the partially nude artist, to signal the presence of an Asian who is equally alert to the religious and mythical precedents of Eastern and Western culture. Despite the artist's use of extensive fragmentation and layering, each source image remains fully recognizable. These "forced together" compositions, as Lê describes them, also provide a formal and personal metaphor for the Asian migrant's state of mind in America—deeply enmeshed in this nation yet "always going back and forth between the two [Asia and America]."[114]

While Pipo's image complicates received notions of people of color in today's world, its primary purpose is to assert a vision of a Western cultural space that the artist, as an Asian male, fully occupies, since he casts, costumes, and plays every role in its visual repertoire. In kindred fashion, by treating his filmic source materials as found objects to be toyed with and recontextualized, Fuentes's highly manipulated scenarios in the pseudo-ethnographic movie *Bontoc Eulogy* allow for the revision of the Western historical record through the performative insertion of Asians as a central presence. Citing the thorough blending of fact and fabrication in the 1983 mockumentary *Zelig* as an influence, in this film Fuentes contributes significantly to a body of contemporary artistic practices addressing anthropology and the politics of primitivism, including critiques of ethnographic film and photography, the collection of the art and artifacts of non-Western cultures, and the ways they traditionally were displayed. Among them have been works by Native American and African American artists tackling Western amnesia for the innumerable injustices committed against their peoples—some using acts of symbolic vandalism and mock-academic repositionings and reconstructions as devices to subvert the context of the traditional museum setting. In *The Artifact Piece* (1986), James Luna has literally put himself on display in museums, galleries, and alternative spaces to contravene and ridicule received notions of the dead Indian. The African American artist

Fred Wilson confronts the very language and values behind the practice of museum display. Invited to create site-specific installations in Western museums, Wilson culls their collections for art and artifacts that are provocatively brought together and remixed in faux exhibitions complete with lighting, sound effects, and wall labels containing counterunderstandings of his own devising. By exhibiting themselves in cages as New World savages before credulous international audiences, the interdisciplinary artists Guillermo Gómez-Peña and Coco Fusco were able to combine a sardonic wit with a pungent social criticism in a series of highly visible, in-your-face didactic spectacles during the early to mid-1990s.[115]

The significance of this turn toward ethnography and museology is that it grants artists license to "relativize and recenter" such scholarly subjects by donning a sort of scholarly camouflage.[116] While such work opens a necessary space to deconstruct academic models that were often based on ethnocentric supposition, hermeticism can also be a problem with this approach, as it could easily become little more than an esoteric diversion for small circles of art-world insiders.[117] Nonetheless this move does afford artists a necessary reflexivity and critical distance that can help them avoid the pitfalls of overidentifying with Otherness and rhetorics of victimization, while still enabling them to engage with these complex issues in the wider realm of cultural politics.

A concern with public spectacle and with the carnivalesque, and in particular with places where dominant culture's preconceived notions of Asians and Asianness are summoned and performed for American audiences, resonates throughout the work in this chapter. While Fuentes invokes the world's fairs and the midways in which the indigenous peoples of his homeland had once been shamelessly displayed, deSouza offers mundane snapshots of zoos and theme parks that provide pseudoexotic adventures on the "darkest" rivers of India, Southeast Asia, China, Africa, and South America. Arai's interests take her to zones of contact that are much closer to home—to the images and souvenirs of American Chinatowns where Asian cultures are commodified, rendered manageable, and consumed by a public ever eager to purchase "Oriental" curios as exotic mementoes of these seemingly alien encounters.

The work of deSouza, Fuentes, and Pipo might be broadly characterized as anti- or postrealist in challenging the truth-value and malleability of various media in the production of historical and cultural memory. By contrast,

having been shaped by the legacy of the Asian American community arts movement, Arai's points of reference are grounded in a form of visual realism that embraces elements of social reportage in putting forward alternate, recuperative depictions of Asians as a counter to the stock Orientalist and primitivist images that are swiftly resurrected in America during unstable times of war and internal crisis. Counting the work of African American feminist artists like Faith Ringgold among her early sources of inspiration, Arai's projects grew out of personal contacts and relationships with people in her immediate environment, as well as with members of other nonwhite communities around the nation with whom she engaged in local public art projects. Though Arai necessarily confronts the ways that racist, exclusionist, and xenophobic images of Asians are conveyed in American popular culture, the primary calling of her artistic practice is to affirm and celebrate the worldly realities and resilience of Asian American life. The centrality of this "vernacular aesthetics" is also evident in the work of a number of her contemporaries, including the graphic artist and cultural activist Jim Dong, who was born and raised in San Francisco's Chinatown. Dong's prints from the 1970s and 1980s, often based on his own photographs of local residents, convey an intimate, detailed vision of Chinese community life anchored in the firsthand observations of an insider.

Yet, no matter how ambiguous, oppositional, distanced and dryly cerebral, or ardently antiessentialist an artist's posture may be in emphasizing the social and discursive mechanisms by which Asian American identities and accounts of life are constituted, there is nonetheless an aura of authenticity that surrounds any project which puts forward extant images of Asians and Asian cultures—because it posits the self-authenticating presence of Asians as social agents and knowing interpreters of their own experience, positioned both within and in contradistinction to delimiting bodies of representation. Seen in this way, to be concerned with matters like Orientalism and primitivism, whether overtly or by inference, is to remain engaged with a politics of identity and identification.

Fundamental to human experience, memory confers the ultimate safe-guard against time's passage, allowing the living to continue in dialogue with the dead. Yet, even as culture and language transmit ancestral stories, feelings, thoughts, and knowledge, memory revises itself endlessly, compli-cating efforts to tell straightforward stories about the past. What is remem-bered and expressed entails an active and convoluted process, configured as much by the larger social environment and the trajectory of the historical events and traumas that have affected one's community, as by shared re-sponses to the circumstances and experiences of the day and the vagaries of individual lives. Social memory is dynamically constituted through un-ceasing negotiation between the two. Collective and personal histories are complexly intertwined, each indispensable to the ongoing development of the other, as individual accounts and understandings are perpetually ac-quired, repeated, transmitted back and forth, and merged with the ever-larger tapestry of narratives and retrospective judgments that cumulatively produce the recognition of a common past. Yet, the formation and public projection of social memory takes on heightened urgency for groups whose immediate histories are inscribed by major disruption and loss, whether due to natural disaster, disease, or famine, or to the impersonal cruelties that can arise from societal enmity and conflict — repression, imprisonment, forced migration, invasion and occupation, torture, violence of unspeakable ferocity, and genocide.

Themes of war, the tension and resilience of remembering, and the impe-tus to recount overwhelming and disorganizing experiences forged under adversity — all are integral to the projects of many Asian American artists, filmmakers, and writers in ways that cut across national, ethnic, and gen-erational lines. Motivated to clarify the trajectories of their own lives, to challenge accepted truths, and to help in fostering communal healing, the three artists at the center of this chapter have sought to engage those who were also indelibly affected by socially inflicted trauma and its continuing

imprint on the lives of their communities: survivors, firsthand witnesses, and members of the succeeding generations. Whether addressing the psychological and social damage resulting from wars and their aftermath, the distortion and erasure of history, or the unequal ways in which social relations are structured in the United States, these artists mobilized the vernacular memories of their communities and those of other groups who have suffered similar hardships as a way to confront traumatic moments that are deeply entangled in personal and collective histories. By challenging common understandings of what constitutes "American" experience, such emotionally charged representations and narratives recast the nation's recent past through a very different lens.

The role of the United States as a global military and economic power is one that resonates deeply within the Asian diaspora. Events surrounding U.S. involvement in Asia have marked the lives and memories of American-born Asians and led to changing alliances and divisions within the various Asian communities. In the twentieth century alone, Americans fought in three major wars—World War II, Korea, and Vietnam—on Asian and Pacific soil. These conflicts in Asia and their aftermath—involving the division or dissolution of nations, persecution, totalitarian politics, widespread systematic government-sanctioned brutality, and the death, disappearance, or psychological collapse of loved ones—have forever changed the lives of many Asian American artists, their families, and the social and political fabric of their communities. Addressing personal anguish and collective trauma, a number of artists use their work to confront the lingering pain, loss, and anger that is thoroughly bound up with memories of hostilities in which the United States was directly involved. Their artworks, therefore, serve both as sites of cultural memory and as grounds for a critique of the legacy of U.S. warfare in Asia among different Asian communities in this country.

The Vietnam War, and its afterlife as an emotionally charged issue in the United States, contributed to the creation of a more unified sense of identity among Asians who lived through that era. The role of the antiwar movement, and the growing sense of Asianness and pan-Asian solidarity it engendered, was crucial in providing the common cause that led many to press for the establishment of an Asian American movement.[1] Among the Japanese American communities, the World War II mass evacuation and imprisonment of civilians of Japanese ancestry in remote and widely scattered

government-run camps has remained a central and thorny issue. Many who lived through this difficult episode emerged shamed, long refusing to speak publicly about their experience. In addition, not only was there initially little sympathy from other domestic Asian groups because of Japan's brutal expansionist policies in Asia and the Pacific, but ironically, in the 1930s and 1940s many Asians who were not of Japanese background actually saw their lives improve when their ancestral homelands became U.S allies.[2] By the late 1940s, however, the emergence of a Communist regime on the Chinese mainland and the division of Korea had altered the national perception of which Asians were considered the "enemy." Although North Korea remains a significant antagonist, attitudes towards the People's Republic of China would shift once more with the normalization of relations following President Nixon's 1972 visit. The U.S. interventions in Afghanistan and Iraq, following the destruction of the World Trade Center by radical Islamists in 2001, ongoing strife in Lebanon, Israel, and the Palestinian territories, and Iranian efforts to acquire nuclear technology provide the national media with a continually reshuffled catalogue of Asian peoples who must be cast as either threatening or benign.

American foreign and economic policies, as well as military involvement abroad, have all played major roles in shaping the demographics of the domestic Asian environment. Whereas earlier waves of Asians reached this nation primarily as laborers, and many continue to be drawn as economic migrants, Asia's emergence as a major theater of struggle between competing superpowers after World War II led to a mass influx of political refugees fleeing the devastation of warfare and the collapse of governments allied with the United States. The Vietnam War forced great numbers of Southeast Asians to leave their ravaged homelands, and it remains the largest and best-known of these catastrophic circumstances. Likewise, the earlier defeat of the Chinese Nationalists, the Korean War, as well as the fall of the Shah of Iran and the struggle of Islamists against the Soviet Union and its domestic allies in Afghanistan, brought many Asians to the United States. The unrelenting sectarian carnage in Iraq following the U.S.-led offensive and continuing occupation has flooded neighboring states with refugees, and in due course many from that fractured western Asian country should also arrive on these shores.

Yet, almost from its inception, the United States has been involved with Asia. In East Asia and the Pacific, that often-discordant legacy includes the

China trade, missionary activity, the whaling industry, Commodore Perry's opening of Japan, the acquisition of the Philippines, Hawai'i, Guam, and Samoa, the Boxer Rebellion, gunboats patrolling the rivers of China, the Spanish-American War, and the ensuing hostilities over the Philippines' bid for independence following the U.S. conquest.[3] Spurred on by the notion of Manifest Destiny, the continental expansion of the United States inexorably led to the acquisition of new territories in the Pacific and the Caribbean. Indeed, it was the annexation of these lands beginning in the late nineteenth century, and the creation of Panama—a nation concocted to provide the site for a transoceanic canal linking America's Atlantic and emerging Pacific interests—that marked the genesis of the United States as an international power. Ironically, the ever-westward movement of the frontier that ultimately carried this nation across the Pacific to the Far East, and whose inevitability remains a defining aspect of American prowess, was simply the realization of a "European people's" destined trajectory.[4]

For Asians born in this country, social memory and perceived affiliations based on shared histories of struggle are commonly connected to labor history (the building of the transcontinental railroad; agricultural labor in Hawai'i, California, and the antebellum South; the Pacific fishing and canning industry), the establishment and growth of local communities (China-Japan-Korea-Manila towns) and small businesses (hand laundries, groceries, restaurants, curio shops), and anti-Asian racism and conflict (exclusionary immigration laws, bachelor societies, nativist massacres, the killing of Vincent Chin, the Los Angeles riots). Newer arrivals, however, may find little with which to identify in this variegated domestic history; if they do locate something of interest, it is often in relation to their own ethnic group. One area that transcends the purely local and can provide grounds for feelings of commonality, even shared identification, between Asians whose families have been in this country for generations and more recent migrants is experiences (frequently traumatic) arising from the intricate web of connections—military, economic, colonial, cultural—of the United States in lands of the Pacific and East and Southeast Asia.

In light of this turbulent history that has directly and indirectly affected the lives of the immigrant and American-born alike, during the 1990s, three art exhibitions of national scope were devoted to the subject of war and its aftermath: "The View from Within: Japanese American Art from the Internment Camps, 1942–1945" (1992), organized by the Japanese American

National Museum in Los Angeles; "Relocations and Revisions: The Japanese-American Internment Reconsidered" (1992), by the Long Beach Museum of Art; and "As Seen by Both Sides: American and Vietnamese Artists Look at the War" (1991), organized and circulated by the Boston-based Indochina Arts Project. Among the films produced during the 1980s and 1990s by Asian Americans on the subject of war and its legacy are *Bittersweet Survival* (Christine Choy and J. T. Takagi, 1982), *Nisei Soldier: Standard Bearer for an Exiled People* (Loni Ding, 1984), *The Color of Honor* (Loni Ding, 1987), *History and Memory* (Rea Tajiri, 1990), and *Homes Apart: The Two Koreas* (J. T. Takagi, 1990). These precedents have, in turn, inspired recent efforts among Asian American scholars to more substantively integrate visual art and visual culture (including popular culture, documentary photography, film, museum exhibition practice, and memorials) into a fuller consideration of the role played by the visual in the positioning of Asians in this nation's historical memory and cultural imagination.[5]

Personal and Collective Memory

The imperative to remember, both individually and collectively, is dependent on the cultural idioms, mechanisms of display, and shaping images employed to generate representations of the past, as well as the multiple means through which memory and history are communicated in the social imaginary. Yet memory, consciously or unconsciously, does not necessarily register what actually took place, but rather what we preconceive (or wish) to have happened or what others inform us has happened. Responding to differing appeals for continuity and change, and selectively bound up with the needs, terms, rites, and personalities of the present, memory is an ever-shifting prism. While there are considerable differences between the nature of vernacular memory and memory that is involved in historical consciousness (especially as the term is applied in academic historiography), everyone contends with the ways in which social memory is legitimized and delegitimized, and by which it is made public and authoritative. Given the complexities and paradoxes associated with memory in developing alternative interpretations of the past, and in public practices (official and unofficial) of remembrance, all questions of who owns, selects, and amends memory are subject to a process of negotiation and contestation,

and are continually mediated by aesthetic, academic, political, commercial, and quotidian demands.

Even as memories come to us through the interior stories we tell about ourselves, since "it is individuals as group members who remember," it is through our contact with other people that memory is renewed.[6] Indeed, memory (particularly autobiographical memory arising from personal experience, as distinguished from historical memory based on documents) is not simply retrieved but is actively and continuously reconstituted each time people come together to remember. The life story of the individual provides a single element in an array of interrelated accounts that are set within the larger chronicles of groups from which individuals draw their sense of common identity.[7] Thus, at a foundational level, memory and identity are strongly connected, as identity entails the recollection of one's origins (historic as well as mythic) and the shaping of narratives in ways that transcend the merely personal.

Crucial to embodied and imaginative conceptions of communal affiliation, the expressive and aesthetic efforts of artists confer tangible shape and form on social memory. As such, contemporary artistic projects specifically intended to activate and incorporate memories of group experiences and shared histories can be seen in light of concepts developed in the sociology of collective memory. Grounded in ideas from collective or social psychology, such understandings emphasize that memory is primarily social and is repeated and elaborated in dialogue with others, and therefore always dependent on a collective context. As memories are formed in specific social contexts, experiential categories supplied by a culture shape beliefs concerning what is important to remember about what has occurred, as well as what may be forgotten.[8] Yet, memory is never simply determined by externally given frames of knowledge and meaning; indeed, a leading researcher concerned with the phenomenon of repressed memory strongly critiques any sociological theory of memory that does not include a conception of "mediating selves" with the autonomy and will to surmount ways of thinking ratified by dominant culture through self-reflexive acts of reasoning and judgment.[9]

Although memory arises through an interdependent conversation between social experience, past and present, and personal consciousness, the fact that the apprehension of memory (and forgetting) must obviously take place in the mind of every individual means that the psychological dimen-

sion cannot be easily disregarded. This remains an ongoing issue in both psychology and sociology, as various practitioners have tried to conceptualize ways to bridge these realms. For instance, in efforts to strike a balance between what is unique to the embodied subjectivity of consciousness, or what is termed the "sociality" of the individual, the concept of intersubjectivity has proved useful.[10] In this, the production of memory, in which individual and social memory interpenetrate and continuously reinfuse each other, has as much to do with the exigencies of present-day relationships as it does with past experience. Remembering, therefore, is necessarily dialogic, as it involves a continual intersubjective striving on the part of each individual to accommodate the tensions between the inner province of emotion and the external world of social relations in which memory and history are embedded.

Social Trauma and Collective Memory

In extraordinary circumstances, such as those of mass trauma, where group members often suppress social memory, individual memory of particular events can also be deeply affected.[11] Most people will, at some point in their lives, be subjected to a personal trauma that is usually more widely experienced: the death of a loved one, for example. Yet the magnitude and duration of the public anguish caused by mass unrest and large-scale conflict, and by the consequences of damaging life conditions originating in social turmoil and institutionalized repression by privileged groups—including pervasive bias, racial and sexual oppression, ghettoization and degrading living conditions, and the loss of civil liberties—is of a vastly different order. Individuals from a culture or a group that has sustained such a social/collective trauma involving a major rupture in the integrity of its social system are often moved to tell the story of what their people encountered, even when their own narratives are distant from the actual events. The contemporary need, therefore, to make the dreadful social consequences of the injuries inflicted by one group upon another a subject of art can be understood both as an answer to specific historical and political conditions and as an effective personal response to a group trauma of which the artist has experience and knowledge.

Although it can be problematic to use a term like *trauma*, with its pathologizing overtones, as an organizing theme for a discussion of Asian

American artwork, it is nonetheless evident that shared traumatic situations and their pernicious effects are indeed formative, even emblematic, in the memory and imagination of some groups.[12] Certainly there are political and historical exigencies, as well as ongoing realities, that keep traumatic social issues alive in people's consciousnesses. For example, the continuing division of Korea remains an unresolved, vexing issue that preoccupies many Koreans both in Asia and in the United States. A social trauma, moreover, need not be directly experienced to affect a person or group. The inability of the children of internees to avoid being drawn into the legacy of the Japanese American internment is a telling case in point.

Beginning in the late 1990s, scholars concerned with the emotional wounds inflicted on Asian Americans as racialized subjects put forward psychoanalytically derived concepts like "racial melancholia" and "abjection" to address the trauma of being unable to entirely assimilate into the state of whiteness on which full "psychic citizenship" in the West is premised.[13] Emerging from the "raced" subject's internalization of dominant culture's persistent rejection, this ongoing "psychical experience of grief," and its ever-present feelings of loss of, desire for, and depression stemming from that which can never be resolved or consummated, bespeaks the person of color's profound inner turmoil over not being accorded full acceptance in U.S society.[14] While some have questioned the political utility of psychosocial formulations in effecting real change, attention to the subjective, intrapsychic dimensions of racism and racialization as lived phenomena offers another useful way to frame the collective impact of social trauma on the consciousness of Asian America.[15]

The term *abjection* came into play to refer to the state and process by which Asians in this nation are deemed loathsome by the privileged social group.[16] Drawing on Freud's formulation of melancholia as a pathological condition resulting from the inability or the unwillingness to dispel a major sorrow associated with loss, other scholars argue that rather than being inherently negative or debilitating, melancholia should be taken as a generative condition, its very open-endedness and resistance to resolution potentially catalytic of fuller and more positive forms of political engagement and change.[17] In this line of reasoning, a sustained investigation of social melancholia will stimulate constructive thinking on ways to reimagine the future as a way both to contend with, and to allow for a movement beyond,

the uncertainty and paralysis intrinsic to the compulsive repetition of histories of loss and victimization in order to actively address what we wish to become.[18]

For practitioners in this area, social melancholia takes many forms — racial, postcolonial, Orientalist, imperial — and is not just an affliction of the racialized Other, as its expression equally enfolds the dominant social order in its broad dynamic. Some speak of a postcolonial melancholia pervading present-day European societies such as Britain and link that nation's refusal to accept and finally mourn the loss of global imperial power with its inability to accept the enormous social changes that have ensued, including the growing presence of nonwhite "alien intruders" from their former overseas possessions.[19] The resulting silence, obfuscation, and active erasure of that troubled history from national memory (reminiscent of U.S. reactions following its loss of the Vietnam War) enable us to better grasp the intercultural dynamic of the postcolonial melancholia voiced in the need of postcolonial Asian artists to return to a subject that often remains deferred and ambivalent: their unresolved relationship to former empires. Others detect an Orientalist melancholia in dealings between Western Sinologists and their object of study, which all too easily become inflected with a longing for a vanished Orient of their own imagining. This nostalgic vision is often complicated or rudely disrupted by the presence of living Asian writers and artists who opt for more Westernized or culturally hybrid forms and motifs.[20] A guest ledger entry of a petulant visitor to "Asia/America" is brought to mind: "I am very disappointed in this exhibit. . . . I came here to see oriental art and instead I see western intellectualism."[21]

Based on extensive experience with survivors of the Jewish Holocaust, mental health professionals engaged with post-trauma therapy generally conclude that in order to come to terms with the overwhelming impact of social trauma, it must be narrativized.[22] As one clinician recounts, there is an "imperative need" among Holocaust survivors to finally "know . . . one's buried truth" so as to move on with their lives.[23] At the same time, merely reclaiming the memory fragments of a damaged life may only provide superficial closure. To extricate oneself from being possessed and defined by a trauma, especially one of such magnitude, with its perpetual state of insecurity, episodes of forgetfulness, and compulsion to endlessly repeat or re-enact a time of vulnerability, a person has to construct a narrative with another. By providing the individual with the social means to re-externalize

their extreme experience—literally shifting the trauma beyond the confines of the self and then retrieving it—traumatic events can be reintegrated.[24] Thus conceived, the assimilation of a trauma becomes fundamentally dialogic, as a teller requires a listener to repossess such a history.

Yet, traumatic experience, by its nature, is also highly resistant to direct narrativization and recall. How, then, is it possible to gain access and give responsible witness to the experience of a trauma, as it simultaneously defies and presses for recognition? Among those who equate social trauma with an unhealed or crying-out wound, the ethical and redemptive potential of trauma lies in its capacity to provide us with a unique "reality or truth."[25] Since such matters are never uncomplicated, some stress the worth of discussing them through means that are "always somehow literary": that is, more personal, metaphorical, symbolic, and indirect.[26] Such forms of communication, whether literary or visual, are a valid and necessary means of accessing the experience of trauma. Observing that history inevitably involves us in each other's traumas, one scholar calls attention to examples from Freud's use of the figure of Tancred, a hero in a sixteenth-century epic about the first crusade, as well as various other literary sources, to illustrate the notion that in "listening to another's wound" a person simultaneously comes to confront two traumas: her/his own and that of the other.[27] Another scholar, invoking William James's argument that memory is revivable rather than retrievable, pursues a related route by foregrounding the capacity of visual and performance art to produce an "affective encounter" with trauma via "sense-memory," an empathic experience that allows both artist and viewer to become spectators of their own immediate feelings.[28]

At the same time, it is important to recognize that the memory of a traumatic event, era, or social milieu, and the capacity (and desire) to remember, are not identical for all members of a group. In writing on the function of civic memorials as repositories for memory, one author takes issue with the notion that such emblematic tributes embody collective memory. Proposing instead the concept of "collected memory," the author argues that social memory should not be taken as something singular but rather as an "aggregate collection" of many variant, even rival, memories. Since individuals cannot literally share one another's memories, it is therefore not collective memory but "collective meaning" that is handed down from generation to generation and given tangible expression through monuments and cultural idioms. Such observations equally emphasize the role of personal

memory, the presence of the author/artist "at the scene of memory," and, by extension, the creative contributions of individuals in actively articulating and transmitting the "forms of memory" into the public sphere.[29]

Cultural Objects, Visual Art, and Social Memory

Focusing on the larger institutional implications of memory as enacted by groups in mass political and religious commemorations and ceremonies, as well as in smaller gatherings in the domestic sphere, sociologists are generally less concerned with the ways in which the arts, per se, contribute to the production and articulation of collective memory. In these lines of thought, works of art tend to become nondescript "physical props" deployed in the background to provide connections between the different "phases of collective life."[30]

In visual culture studies, by contrast, significant attention is being devoted to the distinctive role of cultural objects in the formation of social memory.[31] Distinguishing between the concepts of collective memory and "cultural memory," some refer to the diverse means by which objects and images are manipulated, outside of formal historical discourse, to produce a culture's memory. Here, a work like the AIDS Memorial Quilt is cited as being both a communally produced cultural object whose form is identified with Americana, and a public instrument for unsettling dominant representations of "Americanness" by codifying the common presence of those who are "symbolically excluded": people of color, homosexuals, and consumers of illegal drugs. In this politically tendentious formulation, which enfolds both personal and social memory, such products of cultural memory give concrete visual form to fissures and tensions that exist within this society, thereby making a case for "less monolithic, more inclusive" national images.[32]

Visual objects produced as art, however, are commonly another matter. Such works are often associated with elite culture and the epistemological privilege of the artist, and there continues to be little acknowledgment of the significance of visual art for its own sake, outside of art history and criticism. Where there is interest, it is usually because visual art is seen as useful to the demands of larger academic or ideological frames, like visual studies and the sociology of art. Although visual art can indeed contribute significantly to our understanding of the role played by visualization in cultural production and social relations, something is also inevitably lost by assign-

ing a secondary role to those aspects of art that have to do with emotions and psychological response: individual choice, creativity, and innovation. In addition, visual art and the interventions and strategies of individual artists have not only played a powerful historical role in the social imaginary, but the art object itself, often in ways exceeding that of other artifacts or texts, provides "direct testimony" about the social and physical milieu of people in the past.[33]

While the present Western conception of art is of fairly recent origin, the art object, as a product of a conscious visualizing and signifying practice, is unlike other kinds of objects made by human hands.[34] The arts provide markers—material, sensory, emotional, and intellectual—that help us perceive and anchor ourselves in the world in ways that other domains of human endeavor often cannot. Artists, their work, and the uses to which their art is put are certainly shaped by the cultures and the times in which they were born and function. Yet they, like the rest of us, are discrete individuals, with minds, emotions, and abilities that cannot be adequately accounted for by any single external factor. For artists, moreover, it is individual experience filtered through the imaginative transactions of their work that provides the armature around which memories, impressions, and narratives of shared events and conditions are formed and projected in the civic arena. As one critic argues, the "best foundation for social vision, of which art is a significant part," is located in lived experience, and in the respectful ways individuals convey those understandings to one another.[35]

Although artists generally are more involved with the personal, metaphorical, emblematic, and mythic aspects of experience than with "getting it right" in a strictly historical or documentary sense, what is socially meaningful about art is its capacity to bridge very different spheres of memory: private and public, vernacular and historical. As "a mnemonic device encouraging a type of remembering that is fluid and discontinuous," art has the ability to bring the specificities of individual experience before "wider constituencies of memory," according to a commentator who has written extensively on the issue of memory in contemporary art and photography in relation to the atomic bombing of Hiroshima and Nagasaki.[36]

The Japanese American sculptor Kristine Aono, the Korean American conceptual/ installation artist Yong Soon Min, and the Vietnamese American photographer Hanh Thi Pham are acutely conscious of living in history, yet they are not simply involved with recapturing the past. Strongly committed

to productively engaging the present, these artists—one American-born, the second born in Asia but brought up in the United States, and the third born and raised in Asia—articulate from different vantage points how traumatic historical events shape present-day realities. Each emphasizes sociopolitical relevance and audience accessibility, and seeks to collaborate actively with a community of viewers in producing public documents that foment wider social conversation. By externalizing and drawing attention to their own experience, while also soliciting the vernacular memories and narratives of others around common histories, the artists in this chapter intend their work to be vehicles through which to connect with both their communities and a disparate range of audiences.

Kristine Aono · art and the Japanese American internment

The internment of Japanese Americans during World War II has been a subject for artists who lived through the years of incarceration, as well as for artists of succeeding generations struggling to come to terms with the lingering social and psychic scars of those harrowing times.[37] On December 7, 1941, Japan launched a surprise attack on Pearl Harbor, the naval base of the Pacific fleet in Hawai'i, bringing the United States into World War II. Within two months, President Franklin D. Roosevelt had signed Executive Order 9066, ordering the evacuation and internment of all people of Japanese descent—men, women, and children—on the West Coast.[38] Roosevelt's decision was justified by claims of immediate military necessity and wartime security and enforced without even a hint of due process, as more than 110,000 Japanese Americans of all ages were rounded up and separated from the rest of the population in a matter of weeks.[39] Shorn of all but the most basic of possessions and summarily transferred to temporary relocation centers and local assembly points in public fairgrounds, racetracks, and parks, they were subsequently shipped inland to ten permanent "internment" camps mainly located in isolated desert areas. Scattered across California, Arizona, Arkansas, Colorado, Idaho, Utah, and Wyoming, the majority of internees remained at these sites under close military guard until the war's end in 1945. Suffering the loss of not only their freedom but also their homes, land, businesses, and savings, upon release these now destitute,

socially shell-shocked Japanese Americans were forced to start over and re-build their lives.

For nearly fifty years after the war, the Japanese American internment and its aftermath remained an unresolved issue in this country, unacknowl-edged by the federal government. Even the Japanese American communi-ties themselves, with a few notable exceptions, remained largely silent about this unjust treatment. Finally, in the mid-1970s, the Japanese Ameri-can Citizens League began a redress movement, seeking reparations from the federal government for the deprivation of human rights and severe economic losses suffered by the internees. Bowing to political pressure, Congress eventually agreed to hold public hearings, leading President Rea-gan to sign the Civil Liberties Act of 1988. This legislation offered a national apology and promised reparations of $20,000 per survivor; the monies were finally distributed in the early 1990s.

While the Japanese American internment experience bears a resem-blance to the nineteenth-century displacement of Native American popu-lations from their ancestral lands and the federal establishment of the reservation system—an ordeal that similarly entailed forced mass resettle-ment—this was the first and only removal and incarceration of an entire population of American citizens, based solely on race and ethnic back-ground, in U.S. history. (The right to full citizenship in the United States was not universally conferred upon Native Americans until 1924.) The racialized attitudes of the period are evident in the comments of General John L. De-Witt, commander of the Western Defense Command. According to DeWitt, since the "Japanese race is an enemy race . . . [whose] racial strains are un-diluted," their primary allegiance would be to Japan, despite the outward Americanization of the U.S. born.[40] Indeed, like Native Americans, Asians in America were singled out as a nonwhite population requiring *exceptional* treatment, through a process initiated at the highest levels of government and accepted as appropriate by the vast majority of European Americans.[41] While this experience of large-scale displacement and incarceration predi-cated on racial profiling (as it is now termed) only affected people of Japa-nese ancestry, it has become an emblematic event in Asian American his-tory, a cautionary tale for successive generations.

Aside from the belittling and dehumanizing catchphrases commonly used to characterize Japanese people during the period, the popular argu-

ments marshaled to support the Japanese American internment and the war against Japan are striking.[42] The language and imagery involved—invoking both a worldwide war for domination between the races, and the inherent inferiority, childishness, and barbarism of the Japanese—are drawn from much the same rhetorics of primitivism that were also commonly applied to Native Americans and to other Asian groups.[43] Beyond their echoes of distant Orientalist sources, such phraseology reflects the confluence of ideas that were foundational to the dominant culture's notions of nationhood; as such, they comprise the self-legitimizing system underlying the long history of aggressive governmental intervention in nonwhite communities. It is not surprising, therefore, to discover that amid triumphalist proclamations of the 1880s lauding the upcoming closing of the frontier and the final containment of Native Americans, there were also clamorous supporters of Asian exclusion who urged that policies that had been successfully applied to the Indians could readily solve the "Chinese problem" as well. As early as 1870, Horatio Seymour, the former governor of New York, declared, "We do not let the Indian stand in the way of civilization, so why let the Chinese barbarian?" Seymour later wrote, "We tell them (the Indians) plainly, they must give up their homes and property . . . because they are in the way of our civilization. If we can do this, then we can keep away *another form of barbarism* [i.e., the Asian presence] which has no right to be here."[44]

Speaking to Issues of Japanese American Identity and Heritage

Kristine Aono, a third-generation (*sansei*) Japanese American sculptor, is among those whose families were interned. Born in 1960, more than a decade after the end of World War II, she did not directly participate in that experience. She was raised in Chicago, and her earliest childhood was spent in a predominantly Japanese American neighborhood. However, her family later moved to the suburbs, where the family was surrounded by European Americans. She did not come in contact with other Asian Americans until years later, when she left home to attend college. As matters of ethnic self-definition took on greater importance for her, Aono began to explore her Japanese ancestry and her ambiguous sense of ethnic identity. The more she uncovered about her buried family history, the more ambivalent she became about her own and her generation's acculturation into American society. During this challenging period, Aono grew interested in art and

started to produce work centered on her developing sense of Asian identification. After her graduation in 1983, she was increasingly motivated to address the internment in her art.

Aono deploys a nonfigurative visual vocabulary and references to sites of Japanese American habitation as a way to speak to issues of heritage and identity marked by loss and retrieval. Her work draws on a repertoire of everyday items such as clothing, food, and household objects that function as active constituents of our identities and sense of place in the world. A dress, a pair of shoes, an architectural element—these can variously become a symbolic self-portrait, an embodiment of cultural attitudes and social mores, and a signifier of generation and place. For instance, in the 1983 mixed-media sculpture *Culture Shock*, Aono addresses the hidden divisions within a sense of self-identity in which Japanese and American traditions are supposedly able to coexist. This piece resembles a miniature architectural model, with highly detailed facades, porches, and partial interiors of two stylistically different homes—one a traditional Japanese wood-and-paper dwelling and the other a typical American suburban tract house—joined side by side. However, even as the exterior of this composite building presents a unitary face to the world, its interior walls and floors are jammed up against one another, buckled and crumbling as if deformed by the unstoppable pressure of accumulated geologic forces.

Another early work, *Hashi-Fork* (1985), is a four-foot-tall mixed wood and paper sculpture in which a set of *hashi* (Japanese chopsticks) and a Western-style fork have been melded into a novel eating utensil that at the same time retains the distinctive forms of each component. Sheathed in an elegant folded paper wrapper typical of the kind found in Japanese restaurants, the resulting piece is simultaneously a pair of chopsticks crowned with pointed tines and a slender tapered fork cleaved in half along its entire length. Whereas *Culture Shock* speaks to deep, yet unseen, internal conflict, *Hashi-Fork* embodies physical division in a way that represents that which the artist finds most positive in cultural hybridity. Through this mock-functional object, Aono conveys a personal conception of Japanese American identity in which the different traditions contributing to the artist's sense of self are fused, yet continue to remain distinct.

Aono's regard for the power of quotidian objects and forms, found and invented, as a means of exploring and representing cultural identity has a kinship with contemporary approaches in disciplines as varied as sociology, an-

thropology, history, geography, and architecture that emphasize the salient importance of material culture and place in the formation of consciousness. As has been noted, since the "framework of experience" is made up of the material things that occupy our surroundings, these cannot be dissociated from our sense of self.[45] Objects of daily life, when detached from their original contexts and employed as a medium for art, also have the power to evoke the presence of those who have owned or used them. Even their symbolic representations can serve a significant mnemonic function. For example, what matters most in the Vincent van Gogh painting *Chair and the Pipe*, an image of a simple wood and wicker chair on which a pipe and tobacco pouch gently repose, is not the lowly chair itself but rather the meaning it acquires through the implied presence of the person to whom the items belong.[46]

Moreover, when common objects are recontextualized and presented in museum and gallery spaces, they take on a magnified import, both by association with the stately environments in which they often are displayed and by being accorded the status of hallowed cultural and historical artifacts. Although there are clear differences between the nature of artistic undertakings that incorporate elements of material culture to play upon their aura of popular associations and contemplative possibilities, and exhibitions in anthropological and history museums that employ such objects as didactic aids in promulgating understandings of other peoples, cultures, and times, the dual impulses can be seen as overlapping in and contributing to the power of Aono's projects.

During the 1990s, Aono's work increasingly took on the form of ambitious multimedia installations, in which accumulations of humble objects became the centerpiece for projects meant to engender public participation in the artist's efforts to reconstruct and narrate recent Japanese American history. In her endeavor to approach a little-spoken-of period like the internment, she found it necessary to solicit former internees, including members of her own family, to provide personal information and concrete evidence of their ordeals; as her work evolved, those interchanges became central to her working process. As she explains, "There's a story behind each [object] and a person behind each story. . . . The whole internment experience was about individual people; . . . it wasn't just this mass exodus."[47]

The internment abruptly severed Japanese Americans from the lives they had previously known, it physically displaced them, it deprived them of lib-

erty and the rights of citizenship and property, it set them apart as enemy aliens, and it subjected them to threats of deportation and to the mistrust and hostility of fellow Americans. Both Aono's parents and grandparents were among the interned, and by the artist's account, her grandmother subsequently suffered a nervous breakdown due to that ordeal. As writings about that period reflect, for many from those generations such feelings were often compounded both by confusion, distress, and anger over the fact that the nation of their heritage had attacked their homeland, and by a pervading cultural ethos in which the disgrace of any member of the community is taken to be synonymous with the disgrace of the whole. Moreover, many of the *nisei* (second-generation) were quite patriotic. They had grown up and been educated in the United States and so tended to identify with this nation's professed values and the benevolent authority of its institutions. According to a former internee, who writes of the affective impact this event had on fellow Japanese Americans, the acceptance of such a betrayal by "the government we trusted . . . was so difficult that our natural feelings of rage, fear, and helplessness were turned inward and buried."[48]

Like many *issei* (first-generation) and *nisei* Japanese Americans for whom "Americanization" through assimilation and acceptance were important goals, Aono's grandparents and parents were deeply ambivalent about that experience and rarely mentioned those events. Her family later attempted to submerge themselves in American culture, seeking to distance themselves from the "alien" identity and sense of shame they associated with the confinement. Aono believes that the trauma of internment and her family's resulting assimilationist efforts caused them to limit her contact with Japanese cultural practices and with other Asians. She therefore views the internment as pivotal, an event, the artist says, "that has inevitably shaped the contours of my life and experience."[49] She confides, "If the [internment] hadn't happened, I would have been raised very differently. . . . My parents . . . wanted to be American, and they didn't want anyone to doubt it. . . . They raised their kids as American as they possibly could; . . . the internment really was a very dramatic way of changing [how] the next generation was brought up."[50]

The profound silence of many within Japanese American communities surrounding these events in turn became of concern to the *sansei*, the third generation. They found themselves compelled to recover and to piece together the fragmentary evidence of a period largely marked by its

absence from public discourse, both in U.S accounts of World War II and among Japanese Americans. Aono recalled in a 1989 interview, "My father was twelve when he went into the camps and fifteen when he left, and my mother was nine. . . . They grew up feeling that somehow they had done something wrong. . . . My parents . . . would go, 'Oh yeah, that happened in camp,' . . . and I thought [they] got to go to summer camp. . . . I remember in high school I was in U.S. history and my teacher . . . asked [my sister] and I if our families had been interned . . . and we said yes . . . and suddenly I felt like everybody in the classroom was just looking at us. . . . I didn't really know what had happened. . . . That started getting my curiosity up."[51]

A narrative like Aono's underscores the multigenerational impact of a mass trauma. Certainly, in the context of this nation, the internment needs to be understood as a formative historical marker. For Japanese Americans, the terse expressions "'before the war' and 'after camp'" would serve to define the "essential periodization" of their lives during this discordant period.[52]

In the active pursuit and reconstruction of memories of a time she did not live through, Aono had to fill gaps resulting from the numbing absence of discourse, and ultimately to reinvolve former internees in new collective acts of memorialization. In revisiting historical events that she had not directly experienced but yet had deeply scarred her life, Aono located and brought forward icons invoking a communal past, thereby demonstrating an affinity with the concept of *postmemory*. According to the author who elaborated this model in discussing the children of Holocaust survivors, such generations, "dominated by narratives that preceded their birth," have no choice but to approach the process of memorializing differently from those experiencing the original trauma. Rather than just the recollection of anguish, the power of postmemory accrues through "imaginative investment and creation." Indeed, many contemporary Jewish visual artists and writers who are descendants of survivors employ a distinctive "aesthetic of postmemory," associated with a state of "temporal and spatial exile" and marked by the makers' acute awareness of distancing from their parents' world.[53]

Given her family's pervasive silence surrounding the internment period, Aono found it necessary to reconstruct their buried history from old photographs and memorabilia, as well as through her own research—a process of recovery that became the subject of a series of elaborate installations.

Conceived as an embodiment of the historical passage of generations of Japanese America, and as a personal metaphor for the artist's sense of acculturation and the process of coming to terms with her ethnic identity, the early multimedia work *Issei, Nisei, Sansei . . .* (1990) deploys a rich visual vocabulary of images and culturally resonant objects to evoke a sense of heritage solidly embedded in familial and community history (figure 19).

This site-specific mixed-media installation, in which active audience involvement was fundamental to the artist's conception of the piece, was exhibited at the Washington Project for the Arts, in Washington, DC. Constructed on a human scale, this elaborate work consisted of an elevated "path" covered by an elongated strip of unbreakable glass on which viewers were invited to stroll (figure 20). In doing so, they would pass through three freestanding entrances, each framed by an open doorway fashioned in a different architectural style, whose order was meant to symbolically trace the historical experience and process of acculturation among successive generations of the artist's family in the United States. The first entry was a traditional Japanese wood and paper construction, corresponding to the passage of the immigrant generation. The second, roughly fabricated from tarpaper and raw wood, invoked the drab, hastily thrown together barracks that housed the Japanese American internees and represented the defining experience of the nisei generation. The final portal, made from gleaming white aluminum siding typical of post–World War II suburban homes, signed the presence of the third generation.

Echoing the motif of successive door frames, and clearly visible beneath the glass walkway, the ground below was trisected into corresponding zones signified by distinctive materials: the raked sand and ornamental stepping stones of a time-honored Japanese garden for the first generation, dirt and dust indicative of the camp period (figure 21), and the gray concrete of urban America for the artist and her third-generation peers. Having proceeded in turn through all of the doorways, viewers finally arrived in a red-walled inner sanctum furnished with comfortable cushions, where a collection of objects, artworks, and texts of significance to the artist were displayed (figure 22). The audience was invited to linger in these pleasant quasidomestic surroundings, whose hybrid Asian-Western decorating scheme pointed to the contemporary tastes of the artist's generation. In this hospitable environment, they could contemplate the intimate objects and peruse the written materials, and thereby partake of the per-

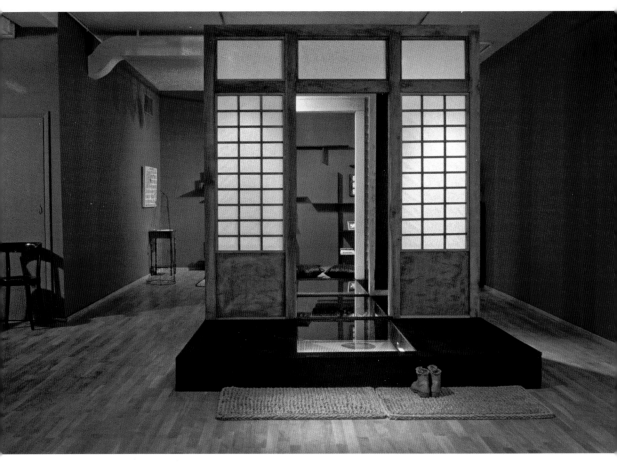

sonal process through which Aono had sought to recover and give tangible form to her family's unspoken history.

Acts of Communal Remembrance • *Relics from Camp*

Beginning in the late 1980s, Aono felt impelled to travel to the sites of each of the ten WRA (War Relocation Authority) internment camps; her parents ultimately accompanied her to the places in Arkansas and Idaho where they and their families had been imprisoned. Responding to the power of objects as material links to the past, she collected artifacts and soil samples at each venue while also photographing the ruins, often with her husband and daughter at her side. In the course of these trips she met with people living nearby, including farmers on whose lands the camps had been built, some of whom were old enough to have seen them in operation. A number

19 Kristine Aono, *Issei, Nisei, Sansei . . .* , frontal view, 1990, Washington Project for the Arts, Washington, mixed-media installation, 28" × 16" × 8.5". *Courtesy of the artist. Photo: Jakrarat "Oi" Veerasarn.*

(opposite) 20 Kristine Aono, *Issei, Nisei, Sansei . . .* , detail, frontal view with artist, 1990. *Courtesy of the artist. Photo: Jakrarat "Oi" Veerasarn.*

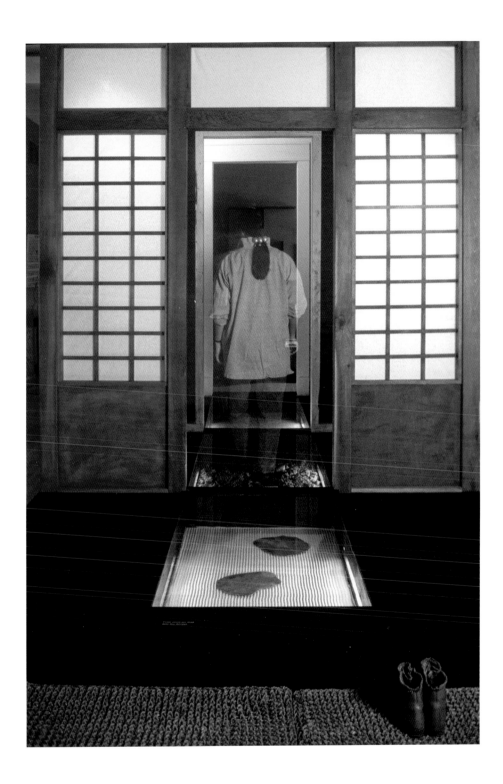

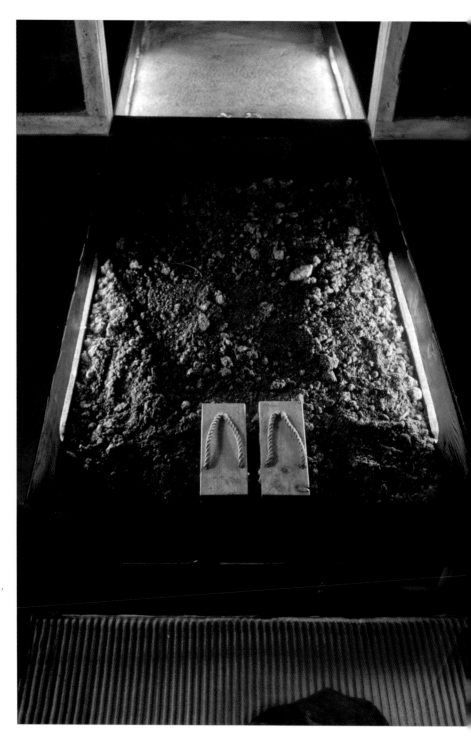

21 Kristine Aono,
Issei, Nisei, Sansei . . . ,
detail of dirt path
with wooden
sandals, 1990.
Courtesy of the
artist. Photo:
Jakrarat "Oi"
Veerasarn.

were eager to share their memories of the period, to give her objects they had discovered, and even to provide quantities of local soil. Aono found the involvement of local people of non-Japanese ancestry in such acts of remembrance especially meaningful, underscoring that for her this story is one that not only addressed Japanese Americans, but one that could also involve and ultimately speak to the entire nation.

Artifacts of this period are exceedingly rare, in part because Japanese on the West Coast, facing immediate detention, were allowed to gather only a bare minimum of possessions. Others took it upon themselves to discard or give away for safekeeping any household goods, foreign-language books, religious shrines, and other memorabilia that might be taken to be Japanese. With the intense war hysteria of the moment, they did this in the wake of rampant rumors that those found holding such items risked having suspicion cast upon their loyalty to this country. In Hawai'i, where Japanese American settlement was also concentrated, the pressure to forego the wearing or use of anything Japanese was so pernicious that to do so

22 Kristine Aono, *Issei, Nisei, Sansei . . .* , detail of inner room with artist, 1990. *Courtesy of the artist. Photo: Jakrarat "Oi" Veerasarn.*

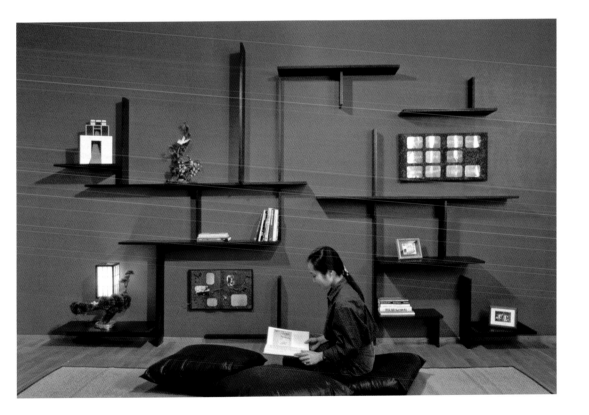

publicly was to be perceived as menacing the welfare of the entire commu-
nity. Japanese material culture, therefore, likewise became "a casualty of
the war."⁵⁴ For those in present-day Japanese American communities, the
resulting scarcity has conferred a great historical and emotional value on
any item, no matter how humble, that has managed to survive from that
era.

Relics from Camp is a large-scale traveling multimedia installation that
debuted at the Japanese American National Museum in Los Angeles in
1996. The piece was inspired by a 1988 visit to the former Topaz internment
camp in Utah. Knowing of Aono's interest in the subject, a friend who lived
nearby later sent the artist a large box of objects he had collected from the
site, including a pair of crumpled eyeglass frames, a baby's shoe, and a glass
syringe. For Aono, these battered fragments from the past were extraordi-
narily meaningful, because they provided "concrete weight to the stories of
the camps . . . and [thus] gave the camps a new reality."⁵⁵

In a darkened exhibition space, objects unearthed at the former camps
were juxtaposed with projected images drawn from the National Archives'
collection of historical photographs of the internment, as well as photo-
graphs of Aono and her family at the present-day sites.⁵⁶ The main com-
ponent was a gallery-spanning platform sectioned into a recessed grid of
fifteen shallow square chambers covered with a layer of dense yet transpar-
ent glass, over which viewers freely wandered (figure 23). Every compart-
ment, labeled with the name of a camp, contained soil collected at each
site, as well as assorted commonplace objects—shoes, dolls, household
items, name tags—battered relics that had once belonged to those con-
fined there. Viewers atop the platform would therefore have the eerie ex-
perience of traversing the very ground that the internees had themselves
walked more than a half century ago. Further, since little or nothing remains
of the structures they had once inhabited, each artifact provided one of the
few material connections that remain to link the present with those times
and places.

Throughout, Aono was concerned with safeguarding the meaning of the
internment by returning agency and recognition to those whose stories had
all too often been forgotten or rendered anonymous by being submerged
within those of official histories. Audience participation was therefore
indispensable to both the realization and the completion of this project.
At each of the exhibition's venues Aono conducted an "artifact collection

day."[57] Before the installation was opened to the general public, she issued a call to local internees to bring in items they might have saved from the period, some of which were then incorporated into the work. She also paid meticulous attention to the way in which these physical remnants of the internment were acquired, handled, and documented, taking this part of the process as seriously as she did the resulting installation. To underscore the extent of her respect for the artifacts, she would only receive and touch them while wearing special gloves, as is common practice when museum personnel handle works of art. Coming from a family that had been among the interned, Aono considered it critical to meet and speak with all the contributors in order to witness the telling of the stories connected to each piece. According to the artist, many of these individuals, who were by then mostly in their seventies and eighties, were publicly sharing their memories of the period for the first time. "Those people were truly the heart and soul

23 Kristine Aono, *Relics from Camp*, 1997, National Museum of Women in the Arts, Washington, mixed-media installation, dimensions variable. *Courtesy of the artist. Photo: Lee Stalsworth.*

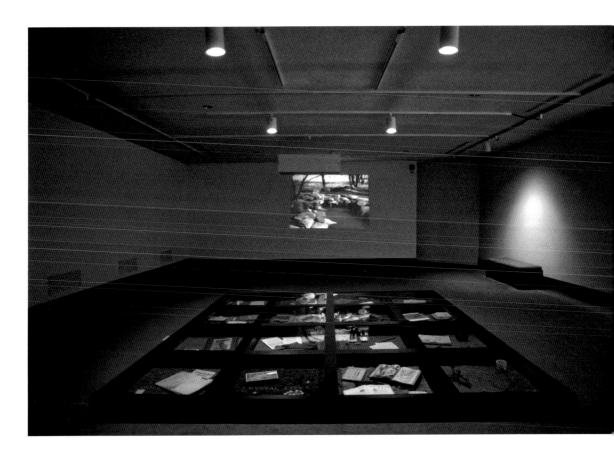

of that exhibit, because their stories were key to what the whole [show] was about."[58]

During the collection days, hundreds of objects were brought in at each venue. Among the items that Aono found especially memorable was a tablecloth-sized hunk of fabric inscribed with the names and birth dates of the infants who had been born in one of the camps over the years of the internment. Contributed by the daughter of a midwife, the use of this homespun registry is not unlike the transplanted European tradition of making the household Bible the repository for key events in a family's life. Such a vernacular social document is also a solid reminder that despite the shock of incarceration and the internees' isolation from the rest of the nation, the rhythms of domestic life continued unabated, as indeed there were many who were born, wed, and died in the camps.

An exceptionally poignant artifact was a handmade pair of *zori*, Japanese-style slippers whose braided herringbone fabric had been scavenged from the suit worn by the contributor's father on his journey to camp (figure 24). Though he had left wearing his best clothing, he soon found that he had little need for formal attire, given that he would be mainly engaged in manual labor. In addition, as Aono learned, both because they wanted to maintain the Japanese custom of removing one's shoes when entering the house and because the rough-hewn floors of their barracks made walking barefoot impossible, the internees had to fashion sturdy indoor slippers from whatever scraps of clothing were available. Apart from the level of material privation that an object such as this embodies, it also speaks strongly of the ingenuity and resilience of the internees, who continually found means to maintain as much of the structures of normal life as were possible in the face of great disruption.[59]

By drawing on the gravitas of the museum setting and deploying some of the modalities of the history museum (which typically combine objects, images, and text) in a work of art, Aono contributes directly to the construction of social memory in a way that is qualitatively different from contemporary official public rites that are devised, according to contemporary scholarship, to emphasize the immutable and enduring nature of nations as "all-embracing pseudo-communities."[60] With its intertwined spirit of communal participation and social criticism, *Relics from Camp* can be viewed as an example of the new type of memorial espoused in an article in *Time* magazine.[61] Rather than providing a supposedly enduring testament

to common national ideals and glorifying sacrifices and triumphs by the military and great men, as monuments have mostly done in the past, the article's author envisions the new monument as a vehicle through which to question dominant values and understandings, even as it memorializes historical events. The article, published at the beginning of the twenty-first century, cites the Vietnam Veterans Memorial, the U.S. Holocaust Memorial Museum, and the Oklahoma City National Memorial as examples. By inviting public participation and the active interrogation of history, such memorials are construed to be inherently more democratic because they "consecrate ordinary people" and provide for the individual to form a more "personal understanding."[62]

Unlike a permanent monument, however, a project like *Relics from Camp* is a work of art whose very design is predicated on being relatively ephemeral. Once the exhibition ends, the only thing that remains of the installa-

24 Kristine Aono,
Relics from Camp, 1996,
Japanese American National
Museum, Los Angeles,
installation with cloth
sandals, dimensions variable.
Courtesy of the artist.
Photo: Norman Sugimoto.

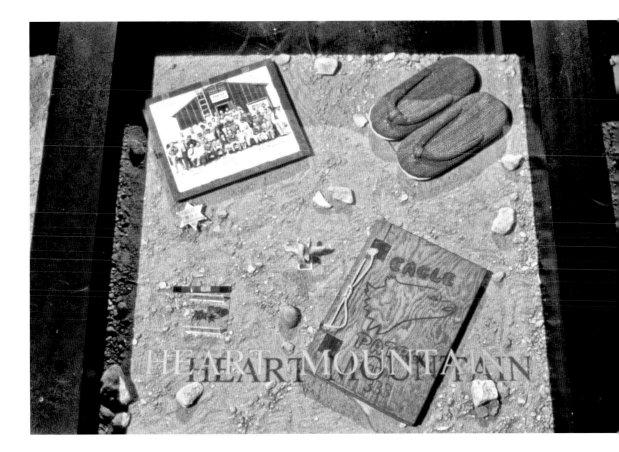

tion is a body of secondary documentation. Yet by sharing their recollections with the artist, and having also witnessed the stories of others who came to speak of their experiences, those involved—former internees and their families, as well as members of the wider audience—became part of a new community of memory that could be as substantial as a monument made of stone and mortar. Indeed, in citing Web-based projects like the interactive "Widows of War Living Memorial," the author of the *Time* magazine article on the "new memorial" also suggests that the contemporary public memorial no longer even requires an overt physical presence, nor does it need to be mediated through official channels. It can, instead, be created, maintained, and preserved through the conscious volition of individuals who actively seek to remember in the company of like-minded others.

The mobilization of popular memory brings into play the sort of memorializing impulses that often come to the forefront in times of heightened social tension and catastrophe. Although it occurred long after their internment, in a sense the moving response of aging Japanese Americans asked to contribute artifacts to projects such as Aono's can be compared to the spontaneous outpouring of raw emotion that followed the events of 9/11. Of their own volition, average New Yorkers came together in the aftermath of that terrorist act to erect memorials around the city that publicly expressed their sorrow. For months following the tragic event, passersby created makeshift vernacular shrines. They lit memorial candles and densely festooned the surrounding walls and sidewalks with colorful ribbons, toys, flowers, and private trinkets; with photographs of the dead and missing; with handwritten notes that served as testimonies to what they had witnessed; and with moving images of a still-intact World Trade Center.

Yong Soon Min · the Korean War

Asian nations—Korea, Vietnam, and Afghanistan—became major Cold War battlegrounds for the two post–World War II superpowers in a contest for political and economic influence that played out around the world. Alongside growing Soviet might in the Far East, the near-simultaneous emergence of militant Communist regimes in China and North Korea so soon after the defeat of Japan raised the possibility of a new and even greater threat to the interests of the United States in the Pacific. Until the collapse

and breakup of the Soviet Union in 1991, both the United States and the USSR would commit troops and treasuries to these arenas, often working through surrogates but also suffering substantial casualties and dissention at home in the process.

Having spent her early life in a nation divided into allies of the competing superpowers and laid to waste by protracted warfare, the Korean-born artist, educator, curator, and political activist Yong Soon Min considers herself a child of the Cold War and identifies deeply with people from other nations who also suffered as pawns in that long-running international conflict. Min's work reflects a highly politicized sense that ties personal history to worldwide power struggles. Consequently, Western foreign policy, colonialism, and racism are basic concerns in her work. Deploying a charged iconography addressing the East-West conflicts and inequitable relations that characterized interactions during the Cold War, Min seeks to identify her experience with broader international issues of cultural disruption, oppression, and resistance.

Korea, as has been stressed, is "a culture forged in the crucible of wars."[63] As a bridge between Japan and the Asian mainland, the Korean peninsula occupies a strategic position in northeast Asia. Situated between far larger and more powerful neighbors—China, the Mongol Empire, Japan, Manchuria, and Russia—Korea was continually invaded, occupied, fought over, and pervaded by foreign cultural influences. For long periods of its history Korea was most directly affected by the Chinese, through whom Confucianism and Buddhism were introduced. During the slow ebbing of imperial Chinese power in the nineteenth century, a sharp competition between Russia and Japan ensued to control Korea and the neighboring Manchurian lands of northeastern China, leading to the Russo-Japanese War of 1905. After their victory over Russia, the Japanese claimed Korean as a protectorate; Japan officially annexed Korea in 1910, ruling and colonizing that country until the end of World War II.

With Japan's defeat in 1945, Korea was split along the 38th parallel into occupation zones administered by the United States and the Soviet Union. Within three years a U.S.-backed Republic of Korea and a Communist Democratic People's Republic of Korea had been established in the south and in the north, respectively. In 1950 North Korea invaded and nearly overwhelmed the south. United Nations forces under American command then entered the fight, leading to a prolonged and devastating war that seesawed up

and down the Korean peninsula—inflicting extensive casualties on com-batants and civilians alike and prompting a massive Communist Chinese counterattack. An armistice was finally declared in 1953. Since the cessation of hostilities found each side occupying positions roughly along the bound-ary that had been established at the beginning of the conflict, the ceasefire line was formalized into the demilitarized zone that continues to this day to separate the two Koreas. Without a final peace treaty, a substantial force of American combat troops remains stationed in South Korea—a continuing source of contention with the north, for oppositional political groups in the south, and among some Koreans in the United States.

The 1948 division of Korea into two nations with antagonistic ideological and political agendas had arbitrarily separated families, leaving relatives cut off from one another, and touched off a mass flight of Korean refugees from north to south. The near-total devastation of the ensuing war and the resulting economic privation would lead many South Koreans to go abroad; many of them settled in the United States. Those who came immediately after the conflict were principally war orphans and the wives or relatives of American soldiers formerly stationed in Korea, along with members of the South Korean military and diplomatic corps and their families. With the Immigration Act of 1965, however, the Korean presence here changed sig-nificantly. Lured by opportunities for economic and social mobility for them-selves and their children, and by the relative political stability of this coun-try, as well as by *migukpyong* ("American fever")—a vision of the United States as an earthly paradise—a growing number of South Koreans, includ-ing middle-class professionals and intellectuals, began arriving.[64]

Yong Soon Min was born in Bugok, a small rural village in South Korea, several months before the truce that brought the Korean War to a halt in 1953. Her father, an officer in the South Korean armed forces, left for the United States before she was born to teach at a language school run by the American army. While her mother worked at an American military base in the southern capital of Seoul, the artist's grandparents raised her in the countryside. At the age of seven, she and her family joined her father in the United States. Min grew up in California and then moved to New York City in 1981, where she first became involved with the Asian American cultural activism that would have a formative influence on her work and concerns. The artist, who now lives in Los Angeles, is a member of the "1.5 genera-

tion"—a term by which Korean Americans describe those born in Asia but raised in America.

Longing for an idealized Korean homeland, "a place of belonging, wholeness, and rootedness," Min views herself as "half home as an American and half home as Korean."[65] After spending so many years in the United States, when Min paid a return visit to Korea as an adult she found herself initially feeling like a tourist in the land of her birth. The continuing partition of her homeland, therefore, is for Min a vivid metaphor for an abiding sense of personal displacement and internal division.

In early graphic works like *American Friend* (1986) and *Back of the Bus* (1985), Min anchors her family history in world events by incorporating old snapshots, taken during the Korean War, of her parents with American soldiers. In the lithograph *Talking Herstory* (1990), Min's self-image is depicted recounting the story of her early life, her "words" billowing overhead as a swirling stream of images derived from childhood photographs of her family in Korea (figure 25). Overlaid against a background of archival images, rendered in ghostly halftones, of the World War II Allied leaders meeting at the Yalta and Potsdam conferences that divided Europe and Korea into spheres of influence and control, she speaks of a family and a national history entangled with the all-powerful forces that so radically changed their circumstances. By personalizing these earthshaking world events, Min stresses the very real effect that history has had on individuals like herself, people who, while acutely affected by those times, have all too often had little control over the ways in which they were later depicted. For the artist, such "alternate histories [have] as much significance . . . as the dominant history that one reads . . . in textbook[s]."[66]

Beginning in the mid-1980s Min's art increasingly took the form of installations. *Whirl War*, created for New York's Jamaica Arts Center in 1987, represented her first effort to fashion a large-scale, room-filling environment. Integrating matching texts in Korean and English with elements of drawing, painting, and sculpture, *Whirl War* aggressively spilled over the walls and floor of its entire exhibition space. By combining references to Korean cultural practices, the Korean War, and third world politics, this complex, freewheeling mixed-media piece was a summation of themes that had long engaged the artist. On one wall, to suggest the depth of the divisions produced by the Cold War, Min cleaved the surface into distinct black

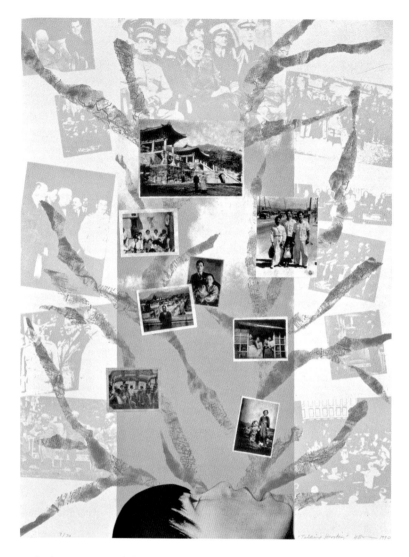

25 Yong Soon Min, *Talking Herstory*, 1990, lithograph with collé, 30" × 22". *Courtesy of the artist.*

and white zones, and then vertically bisected them with the letters "DMZ" (Demilitarized Zone) emblazoned in jagged strokes of dark red paint. Affixed on scroll-like hangings, the opposite wall contained a scattering of texts, objects, and images associated with the artist's heritage, the Korean migration, and the legacy of that war. Among them was a pack of Lucky Strike cigarettes, a brand that, owing to U.S. military involvement in several Asian countries, has for many in the region become a readily recognizable icon of that presence. On two adjacent walls were dual pseudomythological images of Min, one reminiscent of the ancient Greek god Atlas, bearing the

weight of the world squarely on her shoulders, and the other hurtling head-
long to the gallery floor as if, according to the artist, diving directly into the
swirl of life. Such contrasting self-images were intended to embody Min's
awareness of the rigors and rewards that a commitment to political activ-
ism in the arts calls for: it is for her as much a weighty responsibility as it is
a joyous vehicle for self- and social liberation. "I have always tried to put the
image of myself out there . . . to personalize it . . . [thereby] suggesting the
connection between the personal and the political."[67]

As inheritors of a history wherein subjugation, suffering, hardship, and
oppression, imposed by outside forces as well as domestic rulers, are domi-
nant motifs, Koreans speak of the concept of *han*. Variously translated as
"unresolved longing" and as a "grudge that lasts forever, an eternal un-
requitedness," it is a term used by many of Korean background to character-
ize a major aspect of their worldview.[68] Since the source of han lies chiefly
in radical disruptions of Korean society extending over centuries, Koreans
retain a finely honed awareness—indeed, a deep vernacular historical con-
sciousness—of the political and cultural forces that have indelibly shaped
their society. It is, moreover, a frequent practice in Korea, and, by extension,
in Korean America, to use the dates on which formative events occurred as
a form of temporal shorthand—an allusion, based on shared knowledge,
to traumatic historical mileposts that continue to resonate in the collective
imagination of Koreans.[69] One such defining moment for Korean Americans
is *sa-i-gu* (or *sa-i-ku*),[70] translated as 4/29, the day that the 1992 Los Angeles
riots began, the four-day disturbance in which numerous Korean American
businesses were looted and burned to the ground. This violent event, which
also witnessed television images of armed Korean businessmen defending
their livelihoods, so unsettled Korean Americans that one commentator
was moved to describe its effect on her community as the "han of Korean
people . . . com[ing] to rest in the psyches of Korean Americans."[71]

The Korean use of salient dates is a central element in *Defining Moments*,
Min's 1992 photographic suite of six black-and-white silver gelatin prints,
originally inspired by the jolting events of sa-i-gu. Herein Min's body and
face metamorphose into a corporal template, an animate screen on which
is inscribed an outpouring of dates, phrases, and images that hold deep
meaning for the artist, as well as for many other Koreans and Korean Ameri-
cans. The recent history of Koreans and their longing for a very different
future is evoked and played out directly on the artist's body, through this
vivid visual metaphor. Likening her body to the Korean nation physically

separated by the DMZ, Min depicts herself as a divided territory, cut off from the land of her birth by years of war and turmoil.

The first of the six prints, a high-contrast photonegative, provides a key to other works in the series (figure 26). In this starkly delineated nude image, a string of dates scrawled across the artist's limbs and torso pairs important events in recent Korean and Korean American history with turning points in Min's life, along with terms that compare her own body to the Korean body politic—"heartland," "occupied territory." The year 1953, for example, marks both Min's birth and the end of the Korean War, while 4/19/60 is the day riots broke out leading to the military overthrow of the South Korean government, after which she left for the United States. Ironically, 4/29/92 not only denotes the beginning of the Los Angeles riots but also happens to be the artist's birthday. Corresponding to these dates, in each of the following four photographs of the ensemble the artist's face and upper body are densely overlaid with scenes from the Korean War or of one of the later mass demonstrations and riots involving Koreans in Asia and the United States, all gleaned from documentary sources (figure 27). Conversely, the fifth and final photograph, with its luminous image of Mt. Paektu, speaks not to the embattled past, but to a hoped-for better future that will dispel the accumulated traumas of her people's history (figure 28). Revered in Korean mythology as the traditional birthplace of the Korean people, this dormant volcanic peak, situated in what is now North Korea, also functions as a common symbol of the wish for national reunification that resonates across political and ideological differences among Koreans.

As the locus and repository of contemporary contestation, in *Defining Moments* Min's body is literally transformed into the site on which Korean memory and heritage are mediated. According to one commentator, musing on the refashioning of the Asian body by migrant artists in this country, "What could be closer to me than my own body . . . yet what could be more permeable to the currents of the world?"[72] Since this writer believes that "truth" fundamentally emerges via "the sensorium of a gendered body," she maintains that historical memory and the insidious legacies of colonialism and patriarchy primarily come to women artists of Asian heritage "through the textures of a gendered awareness."

Although gender is not explicitly addressed in *Defining Moments*, it nevertheless is organic to the piece, as it is the foundation on which Min's art stands. By clearly establishing an image of herself as the knowing subject—

(opposite)

26 Yong Soon Min, photograph of artist's body with inscriptions, from *Defining Moments* series, 1992, gelatin silver print, 20" × 16". *Courtesy of the artist.*

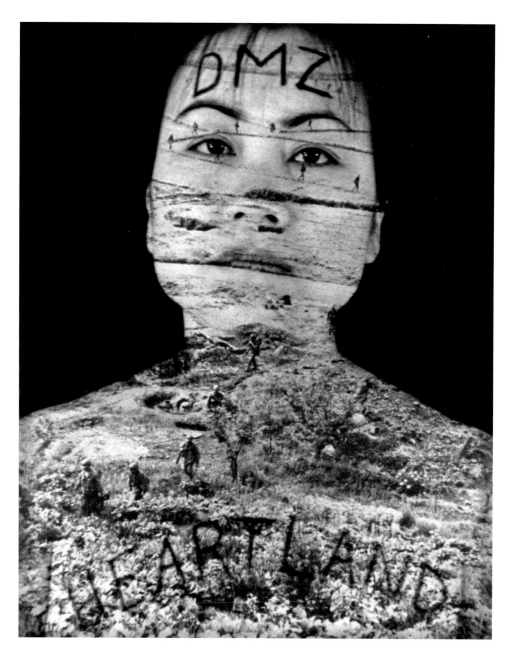

27 Yong Soon Min, photograph with images of the Korean War, from *Defining Moments* series, 1992. *Courtesy of the artist.*

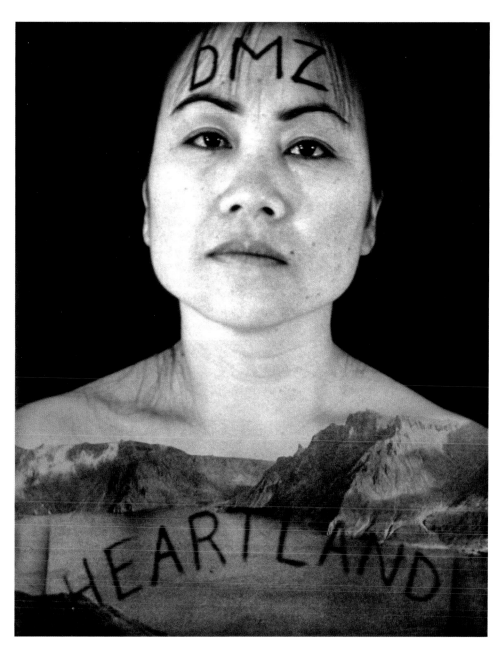

28 Yong Soon Min, photograph with Mt. Paektu, from *Defining Moments* series, 1992. *Courtesy of the artist.*

the Asian woman who as actor, witness, and commentator vigorously confronts contemporary events—she wants to "engage in [what], at least in Confucian terms, has always been considered the male domain. Issues like world affairs."[73] Min's oppositional stance to Confucian values highlights an issue of central concern to many contemporary Asian and Asian American women. In referring to the pervasive influence of Confucianism, Min alludes to an ethos that enshrines patriarchal authority and continues to be expressed in the hierarchical social structures of East Asian cultures that place women in a markedly inferior position. In this ancient Chinese doctrine, which idealized antiquity and, above all, earthly harmony and respect for age and authority, social relationships and rules of conduct were established for all members of society, and a woman's "place" was rigidly defined by familial roles, whether as daughter, wife, or mother. Notwithstanding major social changes in both Asia and the United States, for Asian women certain Confucian mores have often endured, among them the expectation that a "good" Asian daughter should respect and obey figures of authority, including parents, elders, and, above all, males. Though many younger Asian and Asian American women certainly find these traditional expectations oppressive, pressures continue to be brought to bear on women who assert themselves or put their ideas forward in the public arena.

For Korean women in particular, representations of a strong, explicitly politicized female presence also provide an important counterweight to the male-centered character of Korean nationalism, a contemporary ideology imported from Japan by way of the West, in which, not unlike Confucianism, the role of women is perceived as subordinate to that of their husbands and sons. Modern South Korea is described as an "androcentric nation" guided by patriarchal neo-Confucian mores and solidified through the dictatorial efforts of a series of U.S.-countenanced military regimes, in which women remain relegated to the position of "voiceless auxiliaries."[74] Underscoring how present-day Korean nationalism has at times run counter to the interests of women, some cite the long silence of the South Korean government surrounding the mass exploitation of Korean women as "sex slaves" for the Japanese army during World War II. Needing Japanese support to help rebuild their nation after the extensive destruction of the Korean War, the ensuing male-dominated South Korean regimes consistently opted for a conception of the national strategic interest that left little or no room for the needs and demands of women.

Interweaving Histories • *DMZ XING*

In the traveling multimedia installation *DMZ XING* (1994), Min connected her personal history with the postwar experiences of Southeast Asian refugees—Vietnamese, Cambodians, Laotians, Hmong, and Amerasians.[75] These people's lives were forever changed by the collective trauma of mass uprootedness and forced dispersal, and their very presence in the United States, like her own, is the result of armed struggle during the Cold War. In response to the military debacle that ended the Vietnam War, the United States passed the Refugee Resettlement Act of 1975, which initially allowed five hundred thousand people from the former Republic of South Vietnam to enter the country. Southeast Asian immigration grew further with the passage of additional legislation in 1980 and 1987 that included people from other nations in Southeast Asia and the offspring of U.S. soldiers.[76] According to the federal census, by 1990, more than a million Southeast Asian refugees had settled here.

The title of Min's piece, with its reference both to commonplace American street crossing signs and to the abbreviation for the Demilitarized Zone (a Cold War geopolitical imposition that had once bisected Vietnam as it still does Korea), is for the artist a loose visual and verbal double entendre.[77] As such, it is meant to conjure the intersections between the histories and experiences of very different Asian groups, as well as the removal, the "X-ing out," of the Cold War–imposed barriers that have long split nations and peoples in Asia and in the United States. The Hartford, Connecticut, nonprofit art exhibition space Real Art Ways commissioned the piece, extending a broad mandate to produce a work that addressed regional history, community life, and culture. Already "intrigued by the genre of oral history and testimonials and . . . hopeful that the firsthand account would provide information and knowledge not readily available from other sources," Min decided to meet and interview local Southeast Asian refugees who had been resettled in that state.[78] Taking an approach similar to Aono's *Relics from Camp*, Min solicited public participation in the process of memorialization—devising a piece that grew directly from oral testimonies granted by people displaced by the U.S. war in Indochina.

Real Art Ways provided the artist with contacts with local Asian American social service organizations, including the Connecticut Federation of Refugee Assistance Associations, which serves both Asian refugees and

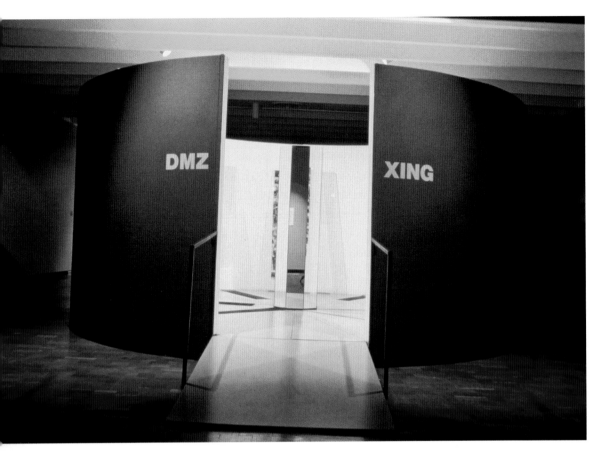

more recent European arrivals. With their help, Min met with local South-east Asian and Amerasian families at their homes, as well as with members of a Vietnamese Buddhist temple, accompanied by translators and a photographer hired to document the visits. In ensuing discussions, she encouraged her interviewees to recount the situations in their homelands during the period, the effects the war had had on their lives, the ways in which they had come to the United States, and their circumstances since arriving. Conducted over several months during 1993, the interviews yielded a rich body of textual and visual material that provided the conceptual core around which Min developed the installation. As the artist indicates, the piece was meant to be "very synthetic, an attempt to bring together [the] new oral history material I had gathered . . . and also to create a context for these interviews. . . . Digging back into the history of the Vietnam War just brought into focus the incredible level of parallels and connections to the

29 Yong Soon Min, *DMZ XING*, exterior view, 1994, Asian American Cultural Center, University of Connecticut, Storrs, mixed-media installation, dimensions variable. *Courtesy of the artist.*

Korean War, and so those two histories . . . served as anchors for me in this project [and] a frame for incorporating these interviews."[79]

For *DMZ XING* Min used an eight-foot-tall, gallery-sized circular enclosure fabricated to contain texts, images, and historical references reflective of the life trajectories of Asian Cold War refugee and migrant families—her own and those she had interviewed locally (figure 29). Centered around a sturdy, freestanding octagonal pillar sheathed in mirrors, sixteen attenuated vertical glass panels framing ensembles of photographs of the refugee families were widely spaced around the pristine interior wall of the edifice (figure 30). Arrayed sequentially and each focused on a different theme or account, the panels were densely overlaid with text lightly etched into their lustrous surfaces (figures 31 and 32).

This complex, self-contained installation was, in essence, an extended intertextual group narrative in the form of a running visual chronicle. It incorporated, among other things, excerpts from the life stories of local Asian

30 Yong Soon Min, *DMZ XING*, interior view. *Courtesy of the artist.*

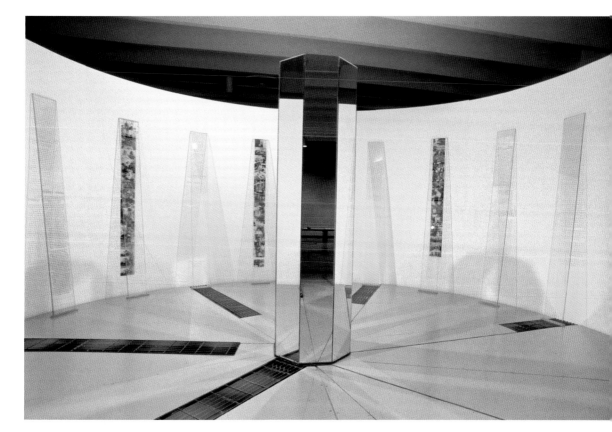

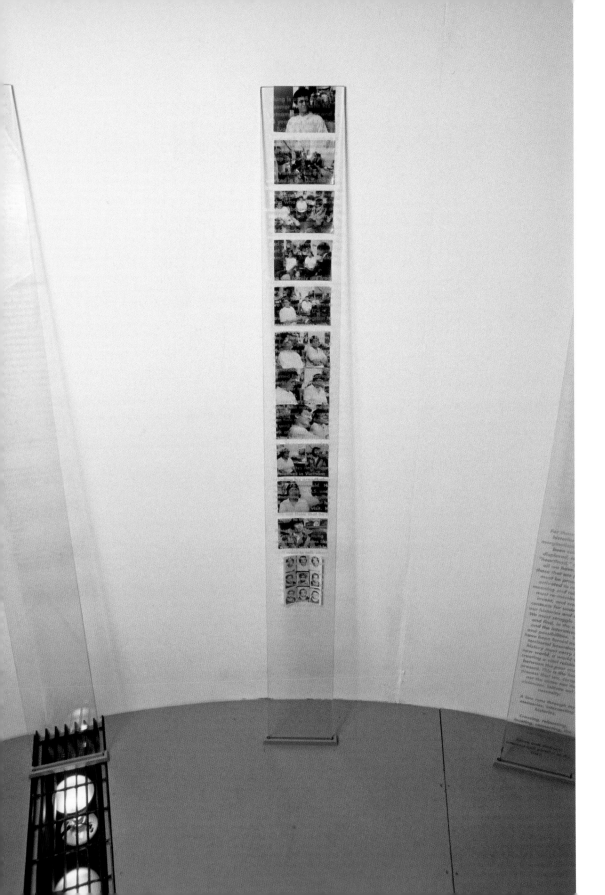

(opposite)

31 Yong Soon Min, *DMZ XING*, detail of glass panels with text and photographs. *Courtesy of the artist.*

32 Yong Soon Min, *DMZ XING*, detail of glass panels with text and photographs. *Courtesy of the artist.*

refugees, historical material on the division of Korea and Vietnam, statistics on war casualties and recent Southeast Asian migration, a recollection of the 1989 visit Min had made to the Korean DMZ, and personal ruminations on the Cold War, including an account of sharply clashing views within her own family over its causes and consequences.

It also was the artist's intent to jolt audiences by making the process of engaging with the installation physically uncomfortable. To this end, Min sought to induce a visceral sense, through the viewer's encounter with the piece, that "there's a reality to what the refugees went through and what [she] went through as an immigrant."[80] After entering via a sloping ramp gently leading inward through a floor-to-ceiling gap in the surrounding wall, viewers immediately found themselves subjected to the blindingly intense illumination that flooded the interior of the rotunda-like structure.

As spectators moved clockwise around the curved space, at timed intervals searing bursts of crimson light shot up through metal grates recessed beneath the floor.[81] The spectator was therefore made to undergo a level of bodily and mental distress intended to suggest the states of those compelled to come to terms with lives entangled within traumatic and tumultuous histories—a disconcerting experience that one local reviewer likened to an interrogation room. In discussing her use of the flashing red lights, Min asserted that she "wanted . . . [it] to be alarming. . . . [The] DMZ is a very disturbing concept; . . . in Korea it is a very highly charged zone."[82]

Although Min designed *DMZ XING* to induce significant unease, she also meant the installation to be poetic and suggestive, a metaphorical space transcending simple didactic and journalistic readings. Thus, she made extensive use of the transparency and the reflective properties of glass and mirrors to suggest the elusive, fragmentary, and evanescent character of personal and historical memory. The mirrors also allowed visitors to see their images refracted within them, thereby suggesting how their own lives are implicated in these histories. Depending on the angle of reflection and the viewer's constantly changing position while navigating the environment, different combinations of narratives and images would emerge, altering and shifting repeatedly as the space was traversed. By ensuring that the written material could not be effortlessly grasped—indeed, as visitors sometimes complained, it was extremely difficult to decipher, given the shallowness of the incised inscriptions and the multiple reflections and shadows cast on the panels and surrounding wall—spectators were made acutely aware that they were also engaging in acts of reconstruction and interpretation when encountering the texts.[83] Min related to a local reporter at the time, "I did want the narrative with the glass to function in a way that alludes to how difficult it is to interpret history, so-called official history and things that are recollected."[84] By having viewers strain to take in the information on the panels, Min hoped they would begin to question more closely what was being seen and said, much as the artist had also been enjoined to rethink her own perceptions of the period while working on the piece.

While many of the accounts that Min chose to include in the installation speak of the hardships of refugees, suffering is by no means all that the artist conveys. This multilayered piece equally reflects individual transformation and rebirth—the perseverance, hardiness, and determination of

those who managed to re-create their lives in a different country and culture, despite the often deep traumas they were forced to endure. To be sure, the artist's own attitudes and convictions were also affected by her work on this project and the vivid testimonies of those who had suffered enormously in these harrowing times. In light of graphic evidence regarding deplorable things done in the name of Communism, Min was challenged to re-examine some of her own longstanding ideological sympathies in more nuanced and self-critical ways. One of the accounts that prompted such reconsideration is the emblematic story of the Srun family of Cambodia, who were persecuted during the regime of the Khmer Rouge and eventually fled the country.

With their 1975 victory, the xenophobic Khmer Rouge immediately began to restructure Cambodia (or Kampuchea, as it was temporarily renamed) into a Maoist-inspired vision of a preurban, pre-Western agrarian utopia. Initiating an extraordinarily brutal reign of terror, they emptied the cities virtually overnight, destroying the country's infrastructure to transform the economy radically into one based on agriculture. Anyone showing signs of higher education, wealth, or "Western sophistication" was subject to death; those suspected of being ethnic Vietnamese or ethnic Chinese also fell under dire suspicion. Under this horrific regime, up to 4 million of the country's 7.5 million people are estimated to have been murdered or died of overwork and starvation in the countryside, their massed skeletons later found piled high in open graves. During the short but extraordinarily harsh period of Khmer Rouge rule, numerous Cambodians were impelled to escape this genocidal rampage by making a dangerous overland trek into neighboring Thailand, where they joined Laotians in a string of refugee camps arrayed along the border. While the camps offered relative safety, many from this devastated generation would remain there for years before being allowed to come to the United States.

The ultra-nationalistic Khmer Rouge would also launch assaults on newly unified Vietnam in the name of atavistic fifteenth-century territorial claims; the Vietnamese army invasion in 1978 forced the Khmer Rouge into a long-running and ultimately unsuccessful guerrilla war which continued until the late 1990s. The Srun family, as Min's text relates, were middle-class people of part-Chinese descent and were thus targeted for persecution. After losing numerous friends and relatives and being stripped of their home and possessions, they were able to flee to Thailand in 1979, follow-

ing the Vietnamese invasion. Languishing for three years in a Thai refugee camp, they departed for the United States under the sponsorship of a Lutheran agency and were resettled in Hartford.

The process of creating *DMZ XING* also yielded unexpected insights for Min into the traumas and divisions caused by war and ideological conflict within immigrant families, including her own. As she recalls in one of the texts, hearing the narratives of survivors of the Indochinese wars inspired her to revisit her own memories of the 1960s, a pivotal time in her intellectual and political development. While her parents were staunch anti-Communists who supported the U.S. involvement in Asia, during her first decade in the United States, Min was educated in public schools where many of the teachers opposed the war then raging in Vietnam. Like many of the children of refugees she interviewed who were born or raised in the United States, Min had great difficulty understanding the attitudes of her parent's generation about those times. Through her dialogues with these Southeast Asian refugees, many of whom were also anti-Communist, however, Min gained a heightened empathy for her father's position, though she did not necessarily adopt it as her own. Having herself never witnessed the Korean War, the artist reflects, "It certainly helped to try to step out of my own privileged perspective and try to imagine a different kind of relationship to that war."[85]

In *Heartland*, one of the last panels prior to exiting the piece, Min offers a deeply felt affirmation of the importance of memory to everyone who has suffered through social trauma and loss. Overlaid on an intense portrait of the artist gazing directly at the viewer, the text inscribed on the panel reads, "For those of us whose histories have been marginalized, or who have been colonized or displaced, or have lost a 'heartland,' memories are all we have. . . . They must be preserved and activated to renew their meaning and relevance. We must re-remember and reinvent, and create new contexts for understanding our histories and ourselves. . . . This is the healing process that we . . . initiate out of necessity. . . . A line runs through my memories, intersecting histories. Crossing, relocating, locating, connecting . . . Korea and Vietnam intersect and parallel at the DMZ."[86] In ways similar to how the past is actually recollected, here personal and social memory are not portrayed as constant, fixed truths to be simply retrieved, but remain mutable, open to active reconstruction by each individual within the social context of the art gallery. However, unlike many contemporary public ceremonies,

rituals, and monuments that are presumed to be rooted in common beliefs and understandings of what is expected from participants, and are thereby intended to cement social solidarity and cohesion, an installation like *DMZ XING*, with its uneasy mixture of ambiguity and confrontation, makes little accommodation for conventional emotional or intellectual closure and renewal.

To produce a work of art that functions as a public memorial, albeit a very temporary one, and to do so in a context that is primarily arts oriented, is to bridge what commonly are distinct realms with quite differing needs, conventions, and expectations. Whereas, for example, the central purpose of most exhibitions in history and anthropological museums is to make what is depicted more accessible to the general public, a work like *DMZ XING* avoids any clear-cut resolution and asks more of the viewer. Given the artist's personalized approach, coupled with a discontinuous, fragmentary visual-discursive strategy toward historical narrative and inter-Asian relations, a far more dedicated level of engagement is required. As is noted in the catalogue essay for *DMZ XING*, which characterizes the piece as "a small monument to memory and communication, familial devotion and social rebirth," since the contemporary art-gallery space is, by its very nature, a "self-conscious arena of comparison, analysis, and contemplation," spectators in such a uniquely focused frame are challenged to summon up their own means of coming to terms with what is proffered—particularly, I would add, when engaging with such an intricate transhistorical work.[87]

Hanh Thi Pham · the Vietnam War and refugee memory

An estimated four million Vietnamese combatants and civilians on both sides were killed or wounded in Vietnam, to say nothing of the neighboring Cambodian and Laotian casualties.[88] Nearly fifty-eight thousand U.S. servicemen and women would also die as a result of the conflict.[89] Born in 1954, the photographer Hanh Thi Pham became an involuntary witness to the decades of unremitting warfare between her fellow Vietnamese and to the corrosive impact of the American intervention. While her family had ties throughout her homeland, owing to the division of their nation after the French withdrawal, she was raised in Saigon (now Ho Chi Minh City), the capital of the Republic of South Vietnam—a nation created and erased

by the cruel imperatives of the Cold War. Although most of Pham's relatives had once been farmers, and her grandparents had worked as domestic servants for the French and then the Americans, during this period both of her parents were able to improve their circumstances, one securing a position with the government and the other with the American embassy. Believing they were in grave danger when Communist forces emerged victorious in 1975, they boarded an overcrowded cargo plane with their children and, like thousands of others, joined the desperate exodus to the West.

The direct involvement of the United States in Vietnam is comparatively recent, beginning in 1946, when its wartime ally, France, sought to reclaim the territories in Southeast Asia that it had colonized in the nineteenth century. When France was defeated by Nazi Germany in 1940, colonial authorities in French Indochina acquiesced to Japanese imperial influence and military occupation of its three component states (Vietnam, Laos, and Cambodia) for the duration of World War II. In the 1950s, small numbers of U.S. advisers were sent to support French troops in their struggle against the Vietnamese Communists, who had proclaimed independence immediately after the Japanese surrendered to the Allies in 1945. The Communist victory in 1953 finally expelled the French after a century of colonial rule. Vietnam was subsequently divided into northern and southern areas pending a popular plebiscite to determine whether the country would be reunified. When a Communist government was installed in the north, many northerners, especially those whose families had converted to Catholicism during the colonial period, relocated to the south.

The division of Vietnam was intended to be temporary. However, when the government established in the south with Western support refused to allow the 1955 plebiscite, the North Vietnamese encouraged rebellion among their numerous supporters in the south, many of them veterans of the anti-Japanese resistance and the independence struggle against the French. As the conflict escalated, the United States began providing advisers and then combat troops to bolster the faltering South Vietnamese military; the North Vietnamese responded by sending ever-increasing numbers of their own forces into the south. By 1968, over half a million United States military personnel, and an extensive civilian support and intelligence infrastructure, were in Vietnam. With ever-growing losses, intense domestic opposition, and an inability to win the war despite an overwhelming

technological advantage, the United States began to remove its troops in 1969; all combat activity in Vietnam ceased by 1973. Two years after the U.S. military had left, Communist forces began a major offensive, and the South Vietnamese army, no longer able to call on the power of outside arms, was rapidly defeated. By the end of 1975, the three nations of the former French Indochina were all ruled by Communist regimes.

In the wake of the Communist victories, individuals who had been supported by the United States—military officers, civil servants, professionals, business people—were condemned as enemies. Those who could do so fled South Vietnam to escape long imprisonment in re-education camps or death; 140,000 departed for the United States in 1975 alone.[90] This first wave of refugees was generally better off and more capable of dealing successfully with modern urban society than later arrivals, and they would have less difficulty than did their less privileged, less skilled, and less politically well-connected compatriots who followed.[91] They would, moreover, be joined by numerous members of the indigenous peoples such as the Hmong, as well as an outpouring of ethnic groups violently displaced by a resurgence of local nationalisms—Vietnamese from Cambodia, Chinese from Vietnam—who had been in those lands for many generations.

Owing to failed economic policies, severe food shortages, political persecution, and the warfare with Cambodia that sparked a brief war with the People's Republic of China, the next five years witnessed a grim mass exodus from Vietnam. Bounded by the long coastline of the South China Sea, epic sea journeys became routine. Numerous boat people, willingly risking death by exposure, starvation, drowning, rape, and attacks by pirates, took a chance on the open ocean to escape their dire situation.

For involuntary migrants, this "forced migration to an unknown destination" can painfully rend one life from the other.[92] Episodes of acute danger provoked a hurried flight with little or no time for preparation and the sudden loss of all that is familiar; such traumatic experiences, governed by external forces, and entailing strife and the severing of family ties and friendships, have been especially common among America's Southeast Asian community, over 90 percent of whom arrived after 1975.[93] Most are grateful to have found refuge in the United States.[94] However, it should be no surprise that people who lived through European colonialism, Japanese occupation, the subsequent decades of increasingly vicious warfare, and

the forced settlement as strangers in an alien land would remain preoccupied with recollections of lives left unfinished and the overwhelming events that wrenched them from their homelands.

The most publicly visible U.S. conflict until the short-lived 1991 Gulf War, Vietnam has been frequently characterized as the first true media war. For years, televised images of aerial bombardment, large-scale helicopter-borne assaults, burning hamlets, and U.S. soldiers fighting and dying in the dense jungles and cities of this far-off country were a daily staple of the evening news. Within a decade after the withdrawal of U.S. troops, the war had been memorialized and mythologized in countless novels, stories, and memoirs, many by war veterans, and in journalistic and scholarly publications on U.S. history and foreign policy in Asia. It has also been the subject of the influential public television series "Vietnam: A Televised History," as well as of major Hollywood films like *Apocalypse Now* (1979), *Platoon* (1986), and *Full Metal Jacket* (1987).

Still, as the Indochina Arts Project sought to point out, amid this vast outpouring of material, comparatively little recognition was given to the impact of the war on Asians, apart from limited depictions of them in the mass media as either hapless victims of U.S. military power or (recycling the ways in which the Japanese were commonly portrayed during World War II) as inhuman, treacherous, and inscrutable killers—now cast in North Vietnamese, Vietcong, Khmer Rouge, and Pathet Lao uniforms. As a result, works of art that bring forward the perspectives of Asian people and the effects of the war on their lives add a much-needed dimension to a public discourse that until recent times has been mainly framed by the U.S. standpoint. Unfortunately, the handful of art exhibitions that had previously been mounted on the subject, such as "War and Memory" (1987) and "A Different War: Vietnam in Art" (1989), presented only Americans' view of the war, and not the perspectives of Asian peoples.[95]

This absence of representation inspired "As Seen by Both Sides." This landmark 1991 show, organized by the Indochina Arts Project, sought to bring Vietnamese artists' representations of the war into public dialogue with their American counterparts. Yet, even here it is notable that among the twenty Vietnamese artists chosen to participate, only one was a Southeast Asian refugee.[96] Recognition of this wider presence finally began to be reflected in 1995, when the Smithsonian Institution mounted "An Ocean Apart: Contemporary Vietnamese Art from the United States and Viet-

nam."[97] This body of artistic production makes it plain that though the war had ended over a quarter century ago, its legacy remained very much alive within the collective memory of those who survived those cataclysmic events.

As many who have chronicled the era note, for opponents as well as supporters of the conflict, Vietnam became virtually synonymous with a deep sense of national failure, cynicism, and doubt about the common values of U.S. society. The absence of sufficiently coherent and acceptable justifications for America's actions and defeat in Vietnam (the first war the United States was generally presumed to have lost) left such a profound institutional silence that a "moral fog . . . in American minds" was perceived to have settled over those events.[98] Unlike veterans of prior conflicts, soldiers returning from Vietnam often found that not only were there no parades and ceremonies to greet them, but also very little in the way of a collective national rite that would provide a positive transition to civilian life. It was only with the 1982 dedication of the Vietnam Veterans Memorial in Washington, D.C., that many were finally able to give collective vent to their feelings and to mourn publicly for the first time since the end of the conflict.[99]

Among Vietnamese, the failure of America's involvement in Vietnam and the decades-long exodus following the collapse of South Vietnam continues to resonate deeply. Not only is there now a large postwar Vietnamese diaspora scattered around the world, including more than eight hundred thousand in the United States alone, but given the extent to which enmities long held sway, it wasn't until 1995 that full diplomatic relations between the United States and a Communist-ruled unified Vietnam could be established.

Haunted by that violent era, Hanh Thi Pham, like numerous fellow Vietnamese, Cambodians, and Laotians, has found herself compelled to grapple with a host of contentious matters arising from the sudden traumatic loss of the cultural context for her life and work. Not only did the artist have to face unresolved feelings of connection to the place and society of her birth and the pressures of adjusting to the complexities of America's multicultural society, but she also had to confront the heavy baggage of this history—a reconstituted Vietnamese American community that continued to mirror many of the deep postcolonial political schisms and traditional social expectations of Vietnamese society.

Settling in Orange County, California, the largest Vietnamese refugee

community in the United States (where over half of all Vietnamese now live), within five years after her arrival in 1975 Pham found work in commercial photography and later enrolled in college to learn more about the subject.[100] Pham studied photography not only to support herself, but also as a means to come to terms with the memories of that violent era. Soon she began to create highly manipulated color photographs in which she strove to confront the life she has been forced to leave behind in Asia, as well as the unresolved legacy of decades of fierce internecine struggle whose aftermath still plagues the Vietnamese communities in America. Pham's work from this period speaks forcefully and passionately to social and psychological trauma, from the stance of a civilian who as a young girl in an embattled Saigon was caught up in the chaos, terror, and disorientation of the war. The artist recounts, "Every night during the bombing years . . . around midnight the sirens would go out, and my parents would drag the kids down into the trench. . . . You cannot have a good sleep, you're always afraid; . . . you live a different life. . . . I was very puzzled by the whole thing. Why? And then the bombing went on, and you can feel the rumblings in the ground because they throw the B-52 bombs, . . . so you['re] very scared."[101]

Pham has also sought, through her art, to engage with difficult issues of power and domination. From the early 1980s on, Pham's work has followed an arc that first emphasized the traumatic impact of the Vietnam War, on both a personal and community level, and then moved on to far more self-focused ruminations on her sexuality and intimate relationships, mediated through race, cultural differences, and unequal power relations. Her images challenge the dominant mores and social institutions of both modern American and traditional Vietnamese culture by simultaneously reimagining and asserting her own presence as a refugee, a Vietnamese, an Asian woman in American culture, and an open lesbian. Defiantly asserting that in the United States, "I will self-govern myself," the artist determined that she would no longer allow herself to be suborned by others' demands.[102] To challenge the forces that aspired to render her invisible, Pham solidly implanted her own image at the center of her overtly confrontational photography-based work. Stung in particular by reactions from the members of her community who insisted that a "Vietnamese woman is not supposed to say things in public," the artist was soon made to realize that others in the United States—both Southeast Asian refugees who

objected to her artistic re-enactments of war-related hostilities and non–Asian Americans who expected Asians, particularly women, to take a subservient position—were often incensed by her efforts.[103]

Enacting Trauma

For Pham, art provides an indispensable platform from which to extend herself into the world, to stimulate ongoing conversation about the social issues that most concern her. "My purpose is to get the picture out there so I can talk about it, and the talking is more important than even what is represented in the image."[104] Pham grounds her art with a fierce subjectivity that works to provide a personal context in which to address the distress she experienced over separation from her homeland. The incorporation of charged self-referential imagery in semiautobiographical photographic suites like the two *Post-Obit* series (1983) and the related *Along the Street of Knives* (1985) enables the artist to face the psychic and collective trauma resulting from the Vietnam War. In the *Post-Obit* series, conjoined groups of color photographs are presented on two horizontal panels, one positioned above the other. Reminiscent of filmstrips or unfurled scrolls, both image sets are washed in a contrasting range of hues—the upper portion primarily in warm earth tones and white, the bottom section dominated by somber blues and blacks. Portrayed in a variety of photographic techniques, including multiple and double exposures, a friezelike progression of self-images of the artist in different guises and contexts advances across each panel.

The lower panel portrays the artist alone in her night-darkened bedroom as mysterious shades emerge, unbidden, from her imagination. Citing a recurrent dream she had at the time in which she saw herself "as a ghost, going home," Pham explains that this imagery evokes her sense of profound isolation and displacement as a Vietnamese forced to live among Americans. Ironically, the images of Pham enacting the dream have a more immediate and literal appearance than those of her observing the dream, as if to imply that the memories of Vietnam remain more substantial than the artist's corporal presence in the United States. In this dark, oneiric vision, a heavy-hearted Pham finds that her ties with the past remain unalterably severed. In a particularly poetic passage, echoing the Judeo-Christian-Islamic story of the expulsion of Adam and Eve from the Garden of Eden, Pham depicts herself as an unsettled naked spectre desperately attempting to return to

a Vietnam that no longer exists (figure 33). Though her spirit struggles to open the door that would finally allow her to re-enter her childhood home, she is utterly rebuffed by invisible forces that would cast her eternally back into a realm of unrelenting darkness and chaos.

Alongside this scene, the artist summons her own spectral presence in traditional Vietnamese dress, attempting to kneel before her family's household Buddhist altar, even as the shrine housing photographs of her ancestors and offerings of fresh food falls apart before her eyes. As Pham puts it, in this disturbing apparition the "picture of her [my spirit's] grandfather disappears, the fruit and candles fell off, and everything becomes so nightmarish."[105] In a similar vein, in writing on the postwar experience of the Vietnamese in California, a Vietnamese American writer cites his mother's use of the phrase "*ma troi*" (wandering ghosts) to indicate how completely lost many felt after being forced to leave South Vietnam.[106]

Says Pham, people in America "don't want to talk about the Vietnam War, but I want to do something to wake them up." Within two years of completing the *Post-Obit* series she produced *Along the Street of Knives*, a suite of color photographs based on still-vivid memories of a childhood lived during decades of conflict, military as well as cultural.[107] In this 1985 group of performative, loosely autobiographical *tableaux vivant*, Pham employs her own image and that of the white California sculptor Richard Turner, who had lived in Vietnam as a teenager, as stand-ins for their respective societies.[108] Pham staged and enacted these pieces as a way to foreground, from dual vantage points, the uneasy cohabitation that was distorting life on both sides. Prey to mutual voyeurism, incomprehension, and "secret hatred for each other," these were the sort of attitudes and misunderstandings that (in her view) all too often typified relations between Vietnamese and Americans during that period.[109]

Although Pham's collaboration with Turner in *Street of Knives* was not overtly conceived in theatrical terms, her work has always been strongly grounded in a form of self-performance. Indeed, personally enacting the scenes she devises for her photographic imagery, and also involving friends, lovers, and family members, is central to the artist's working process. "I will act those things out and I will go to extremes," she explains. "The woman [must] talk out . . . to become real."[110] Pham's use of privately staged enactments, whose participants come to function as living witnesses to the traumatic experiences of the Vietnamese, can be understood as the artist's

means of putting a human face on a national catastrophe—even as she seeks to externalize and discharge outrage toward those she holds responsible for the turmoil and pain visited on her people.

Based on the use of the theater arts in working with victims of war and extreme political violence in places like Kosovo, it is argued that dealing effectively with the emotional undercurrents of social trauma requires an "active outlet . . . in the world that is creative, rather than destructive," thereby allowing for previously unarticulated shared experience to be acknowledged, symbolized, and transformed.[111] Here, "theatrical enactment" and performance provide such a channel, by taking such harsh experiences out of the realm of internalized pain and pathology and relocating it to a "communal space" where it would be better approached "as shared material, appropriate for a public forum."[112]

33 Hanh Thi Pham, *Post-Obit / Series 1 #4*, from *Post-Obit / Series 1*, 1983, series of six color photographs, type-R print, each 20" × 24". *Courtesy of the artist.*

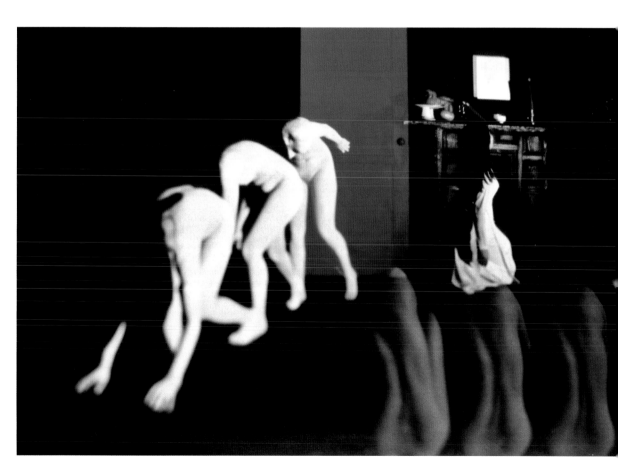

In this context, art can provide a safe space where public dialogue about traumatic experiences can occur. Consumed by unspoken resentment, in the relatively protected environment of the photographic studio, Pham has been able to vent an intense post-traumatic outrage that would otherwise have no acceptable social outlet or might have been disastrously turned inward against herself.[113] As the artist unequivocally discloses, "I always want to make something bad to the white people, and that is sometimes very dangerous because it weave[s] right into my personal life. . . . I have to do that because of all the Vietnamese history. . . . All the pain you experience, all the oppression and the demeaning stuff you have to put up with. . . . You have to somehow express it and the best thing is to do it through art, . . . because the person who understand[s] about oppression and history has to react."[114] Despite the extent of the trauma, the blatant disregard of the United States military for the welfare of ordinary Vietnamese people, and the artist's continuing antagonism, Pham nevertheless believes that mutual accommodation based on respectful dialogue should not be foreclosed. Thus, even with its emphasis on an imagery of conflict and vengefulness between nations and peoples, the hope for a more humane and egalitarian result, especially for future generations, remains a prominent refrain throughout *Street of Knives*. As such, the artist intended this imagery to be a catalyst for fostering dialogue with the viewing public, especially other Vietnamese.

Ultimately, the suite of images comprising *Street of Knives* is neither designed to convey a linear narrative, nor to suggest that there is or even should be a final resolution to the complicated, contradictory feelings the artist associates with the Vietnam War and the ensuing relationships between Vietnamese and Americans. To this end, each time the work is exhibited, the artist has reconfigured the piece, varying the order and number of photographs in the installation to allow different readings to come forward. Mirroring the inner turmoil Pham experiences in struggling to come to terms with a situation that defies easy closure, this work evokes the inherent complexity of the situation on all sides, as well as the melancholic sense of incompleteness often found among those who remain unable to put the war and its aftermath behind them. While some viewers might find it disturbing that Pham provides no clear solutions to the matters she raises, as one reviewer approvingly notes, what impresses most about this work is its

assumption of a political posture devoid of propaganda.[115] Indeed, it is this very quality of relentlessly searching for the meanings behind the events she has witnessed, without falling back on conventional rhetorics of anti-Americanism, that imbues Pham's work with a fierce and uncompromised honesty.

In a photograph (*Untitled*) from *Along the Street of Knives*, Pham gives sharp evidence of her persistent struggle to keep memories of the war alive, despite her perception of the willful amnesia then pervading her adopted nation. In this scenario, she and Richard Turner appear together in dual guises (figure 34). In the central tableau, Pham presents herself reading an account of the war in a popular Vietnamese magazine, its cover sporting the staunch faces of victorious North Vietnamese soldiers. A solemn figure, she is clad in a white *ao dai*, a simple tunic worn over loose-fitting trousers, which is for the Vietnamese a costume linked to their national culture. While the color is indicative of the wearer's age and status (young Vietnamese girls are often clad in white to symbolize their purity), it is also closely associated with death in the Buddhist tradition. Wearing the white ao dai, Pham thus becomes a figure of innocence—suggestive of the people of South Vietnam who chose to believe in the promises of lasting support and protection offered by the United States—while also signaling that she continues to mourn for the nation and the multitudes lost during the war. Sitting humbly at Pham's feet, Turner is clad in a male version of the Vietnamese costume. To commemorate the tragedy of a dead nation, he holds up a cluster of incense sticks used in Buddhist ceremonies to honor departed ancestors.

In the second motif, the two artists face each other from opposite sides of the image. Drawing on memories of the Hollywood films Pham had seen in her homeland, here the artist has Turner attired like a nineteenth-century cowboy, an emblematic figure she associates with the westward expansion of the United States, the trajectory that would eventually send Americans to the shores of her homeland. As Turner sets a photograph from the war ablaze with a cigarette lighter, Pham, watching vigilantly, is poised to douse the fire, a bucket of water raised high above her head. Presenting herself as the agent of remembrance, the artist intervenes, ensuring that the cowboy—i.e., the United States—who has been "trying to forget about the war in Vietnam . . . [by] burning the picture" is abruptly "trans-

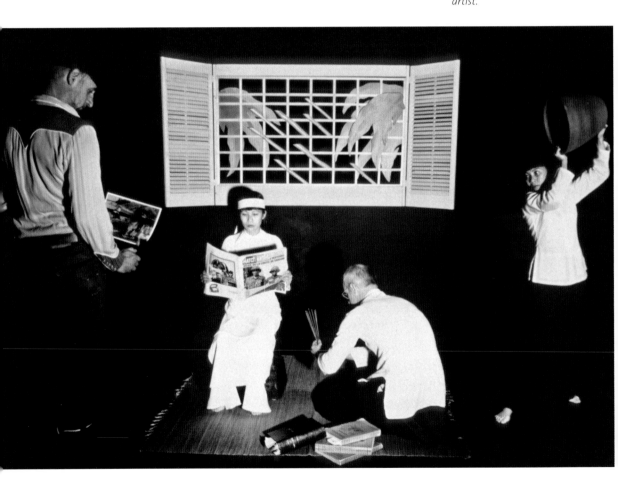

formed into this guy who . . . pay[s] homage to the death of Vietnam."[116] Pham believes that without visible interventions by displaced Vietnamese like herself, this nation's bitter experience of the war, as well as the sufferings of the Vietnamese people, would be made to disappear. For the artist, therefore, Americans and Vietnamese will never be able to establish a less conflicted and more respectful relationship with each other if memories of this nation's past actions in Southeast Asia are not publicly kept alive and expressly acknowledged.

Though Pham raises the possibility that sincere mutual recognition could occur, she nevertheless retains strongly conflicted feelings about the nature of the relationship between Vietnamese and Americans, given the cultural differences and a Western arrogance born of unequal power relations that all too often continue to separate them. In a pair of photographs from *Street of Knives*, *Evening Stroll / Night Patrol* and *Reconnaissance / Cái nhà nãy nhà cũa ta (This House Is My Own House)*, the artist summons a vision of cross-cultural misunderstanding and contrary expectations through symbolic portrayals of relations between Vietnamese and Americans in her homeland. In the first image, an American couple surreptitiously peer into the window of a Vietnamese home like a pair of touristic peeping toms, seeking a glimpse of something they could consider authentically exotic. In the second, the roles have been reversed. To convey that "there was a definite gap between these two worlds; these people didn't know much about each other," in *Evening Stroll* Pham depicts a young Asian girl presenting the couple with a Mickey Mouse doll, something prototypically American that she believes they would be pleased to see in an alien place.[117] In *Reconnaissance*, by contrast, a young child grasping a toy rifle spies on Americans in their home and reacts with a blend of fascination and bitterness at what she discovers within: a mixed-race (black/white) couple living in a luxurious villa adorned with the skin of a Vietnamese tiger. Having viewed most Americans she met in Vietnam as self-absorbed and blandly indifferent to the fate of her people—akin to big-game hunters and tourists coming to her homeland for sport and entertainment—Pham found herself, as an adult in America, finally able to give clear voice to her youthful resentment over their presence.

Pham's darkest visions are given expression in *Forever Avenging*, *Interrogation & Avenge I*, and *Interrogation & Avenge II*, other photographs from this suite in which acts of mayhem are made disturbingly visible. In *For-

ever Avenging, (figure 35) she mimics the infamous image of a South Vietnamese general executing a suspected Vietcong infiltrator with a bullet to the head during the 1968 Tet Offensive—a powerful journalistic depiction of casual brutality that instantly became iconic of the war for many around the world.[118] Presenting herself as both executioner and grim witness to this politically inspired murder, Pham, again in a white ao dai, "shoots" Turner, who is costumed in a plaid shirt like the one worn by the Vietnamese man killed at point-blank range. Under the artist's intense gaze, the dying Turner twists and drops away, as if in successive frames of an imaginary film recapturing the raw shock of this event. For Pham, the effect of this gruesome scenario was cathartic: "It makes me feel like I have shed something to the outside, so the burden on me is less. . . . I have to do something to . . . tell [Americans] right in the face, not playing the submissive part, the nice smiling Asian anymore. In the photographs I can become very terrible."[119]

As the complex and multilayered reflection on the meaning of the war revealed in *Street of Knives* attests, a discharge of revenge fantasies is by no means the endpoint for Pham. Indeed, by working with a white male artist who lived in Vietnam and who had more than a passing familiarity with traditional Asian practices and symbols, Pham was able to move beyond her own wrath toward the United States, making the recognition and incorporation of a sense of the other's trauma a significant element in the series. For instance, in *Interrogation & Avenge I* and *Interrogation & Avenge II*, a pair of starkly dramatic photographs reminiscent of Goya's depictions of atrocities perpetrated during the Napoleonic occupation of Spain in his series of prints entitled *Disasters of War* (1810–ca. 1820), Pham and Turner, as representatives of their respective peoples, engage in committing deadly acts of aggression against each other. With arms bound tightly behind her back, in *Interrogation & Avenge II* the artist is being drowned by the American in a metal washtub; in *Interrogation & Avenge I* the positions are reversed, as Pham, having captured the struggling foreigner, forces his head deep underwater. Amid the distressing image of the drowning in *Interrogation & Avenge II* (figure 36), both artists are also depicted suspended upside down like slaughtered animals in an abattoir. Pham narrates this scene ostensibly drawn from the visual language of horror films: "The Vietnamese girl was hung from the ceiling, . . . and so is the American guy. And then the GI guy has the blood drain[ed] out of him, and the VC girl . . . is having the blood

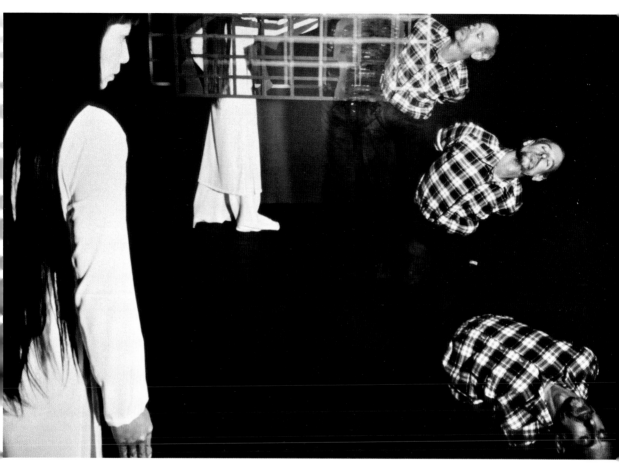

35 Hanh Thi Pham, *Forever
Avenging*, from *Along the Street
of Knives*, 1985, 20" × 24". *Courtesy
of the artist*.

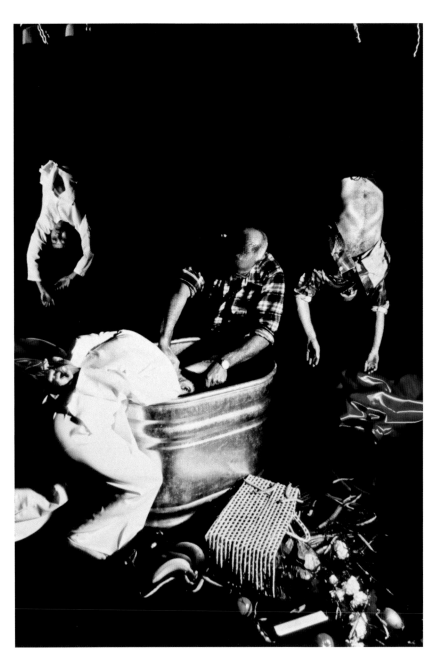

36 Hanh Thi Pham,
Interrogation &
Avenge II, from *Along*
the Street of Knives, 1985,
24" × 20". *Courtesy of*
the artist.

drained, . . . so it's a mutual kind of response between two people involved in a war situation; . . . both people were hurt."[120] Recalling the metaphor of the crying wound, in which the victim of trauma becomes aware of her own pain through perceiving the wound of the other, these comments suggest that despite the implication of the U.S. audience in the acts of depravity being portrayed, through the process of mutually re-enacting the blood-thirsty ferocity and wanton slaughter of war Pham acknowledges that the perpetuation of a cycle of violence would only serve to destroy everyone involved.

In the last photograph in the series, entitled *Détente / Dieu Dinh* (figure 37), the artist speaks of those who took advantage of the conflict, and to the devastating effect that this struggle had on the ways in which her compatriots came to look upon themselves. Here Pham again dons a white ao dai while Turner, as the personification of the United States, is outfitted as Uncle Sam, replete with a striped top hat, star-spangled vest, and nineteenth-century tailcoat. Such "curious representations of the nation" drawn from nineteenth-century political cartoons are meant to embody popular perceptions of a nation's character "as seen by the members of the nation itself."[121] Yet this vision of Uncle Sam, with his penis openly exposed as he brazenly propositions Pham's figure to have sex, a thick wad of cash proffered in his outstretched hand, is hardly a vernacular symbol of U.S. national ideals and patriotism. Separated from Turner by a bed overspread with a crimson sheet, a Western-influenced reference to licentiousness, Pham disdainfully holds herself upright while coldly staring straight ahead. Yet, even while she imperiously disregards Uncle Sam's lewd advance, her naked right breast is fully bared to his leering gaze. As the artist explains, "He's showing his cock. . . . He step[s] into a Vietnamese house . . . to buy sex, . . . and the Vietnamese woman . . . is very conscious that maybe she is a collaborator, but . . . it was Uncle Sam with money who . . . create[d] a situation where she was portrayed as a prostitute."[122] Through this highly sexualized metaphor, Pham alludes to the humiliating and exploitative situation in which the South Vietnamese, who saw themselves as devoted Vietnamese nationalists, felt they had little choice but to collude, by accepting U.S. military and financial support to survive.

As counterpoint, Pham deploys an additional motif. In the foreground, a grinning, self-satisfied man in a loud tropical shirt, symbolic of American touristic attitudes toward Vietnam, blissfully flies a kite, oblivious to

everyone around him, while crouched at his feet two female children, one Vietnamese (again the artist) and the other Caucasian, intently play hop-scotch. Pham relates, "You see a Vietnamese child playing with an American child, and they both seem to have fun. . . . Children can make friends on that level. . . . Whereas the upper level is about the game that is played by adults, . . . where you see the power and the sexes. . . . Down here it's more equal . . . This one is détente, meaning a time where they try to have equal voices."[123]

Whereas Aono's and Min's endeavors are inherently reconstructive and empathetic, engaged in piecing together evidence of war and the wartime eras in which neither directly participated, Hanh Thi Pham is a living witness to the traumatic events cited in her art. Moreover, Pham's efforts to present and discuss her work in the local Vietnamese refugee community, despite the political differences and social tensions that generally divided the artist from her compatriots, becomes all the more significant when viewed against the backdrop of the immediate post-Vietnam period. As a vocal critic of the established, politically conservative, and primarily older male leadership within her community, the artist seemingly could not escape marginalization. Since Pham publicly raised issues they did not want to revisit or expose to outsiders, her urgent need to use her art to force Vietnamese (and Americans) to confront the war and its consequences was actively resisted, and she did not really reach the very groups with whom she hoped to engage. As she recalls, "The community members were outraged, and they chased me out of the place. . . . [They] told me . . . 'Why do I have to separate the people, why do I make [it] as if Vietnamese hate Americans? Because that's not good for the community.' But, I said . . . 'These are the things that are most honest to me.' . . . The truth hurt[s] a lot, and it [could] hurt [their] business, and that's a no-no in the United States."[124]

This candid account, by emphasizing both the potential and the limits of art making as a tool for contact, emotional release, and self- and community integration in confronting social trauma, is poignant and disturbing in equal measure. Ironically, given Pham's community-oriented aspirations, she has primarily found acceptance and appreciative audiences in the American art world and academy, as demonstrated by the many scholarly publications and exhibition catalogues featuring her work. While this type of attention is certainly significant and meaningful, it does raise hard questions about the possibility of effectively bridging the demands of private

37 Hanh Thi Pham, *Détente/Dieu Dinh*, from *Along the Street of Knives*, 1985, 20" × 24". *Courtesy of the artist.*

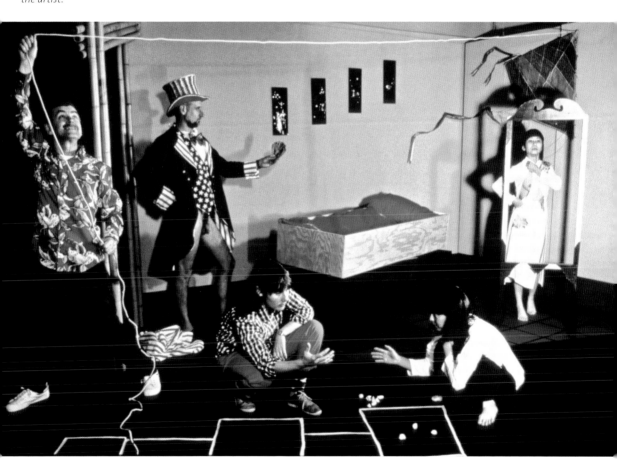

artistic expression and the needs of the Asian immigrant communities in this country, especially when the artist raises complicated and potentially explosive issues without an accepted institutional infrastructure to provide support and validation. Unlike, for instance, Aono's *Relics from Camp*, hosted by the Japanese American National Museum—long a leader in bringing matters surrounding the internment to national visibility—there is as yet no ethnic-specific museum with established links to the Vietnamese communities that could provide a viable, nonpartisan, and informed context for the art Pham has produced. Without such venues, the "communicative circle" connecting an artist like Pham, her striking body of highly charged work, and the audiences in the ethnic communities that she intends to reach cannot be satisfactorily accomplished and maintained.

Memory, Dialogue, and an Aesthetics of Connection

Paralleling scholarly efforts to recuperate difficult emotional states like grief, melancholia, and abjection as sites of productive engagement, the work of Aono, Min, and Pham emphasizes how the deep social and personal scars of the Japanese American internment, the continued division of Korea, and the legacy of decades of brutal warfare in Southeast Asia remain extant. These psychical "wounds that will not heal" in turn precipitate an unending need to engage with these subjects, to reclaim the narratives of their communities by excavating and exposing painful memories, even long after the fact. In examining how such sensibilities are externalized through visual art, one interpretation stresses the significance of spatiality and a "performative transference" that is enabled by placing art in a gallery or public space, thereby allowing private loss to enter into the social sphere and, through an affective displacement of this loss onto the viewer, to be recognized as part of a larger, collective experience.[125] Indeed, by marking and bringing forward these alternative and often repressed histories inflected with a sense of perpetual disquietude, the three artists in this chapter go beyond simple attempts to resolve unrelenting anger, alienation, and despondency.

For all the hazards involved in trying to initiate public discourse around such difficult and often emotionally charged issues, Aono, Min, and Pham persevere. Marked as much by their compassion, insight, and sense of com-

munity and mission, as by an interrogatory tension born of pervasive feel-
ings of loss, their work bears testament to the magnitude of the repercus-
sions felt in the Asian diasporic communities as a result of long-standing
U.S. involvement in their countries or cultures of origin. Seeking to activate
and to keep social memory alive by fashioning compelling means of link-
ing injuries inflicted by the past to the present and the future, they involve
themselves in a collaborative reiteration of the extreme events and circum-
stances that have come to define their peoples' experience. These artists,
therefore, share in the need to double back, both literally and metaphori-
cally, by returning repeatedly to the sites and times of social rupture and
collective trauma. Although there are marked differences in the historical
situations of their groups, each artist, like a dogged investigator pursuing
a troublesome mystery, uses her work to engage in acts of personal and
collective recovery of the aspects of their past that remain unresolved and
resistant to closure. While they are not necessarily scholars, artists such as
these who set about to excavate the difficult past of their peoples and com-
munities, who make the interrogation and reconstruction of traumatic cir-
cumstances in Asia and in this nation integral to their art-making process,
and who ground the events of which they speak in larger frames of collec-
tive self-understanding, are likewise engaged in a process that contributes
significantly to the production of historical memory.

Further, as sites of recollection and (sometimes mournful) contempla-
tion—whether mounted in public venues or privately staged settings—
Min, Aono, and Pham's efforts are fundamentally dialogic in their incor-
poration of living actors for the purpose of reconstructing histories, giving
responsible witness, dealing with loss, anger, and overt rage, and narra-
tivizing social trauma. In the formulation of a "dialogical aesthetic" in art,
one author observes that our ethical engagement with one another does
not emerge from "some abstract sense of duty"; rather, it is foundationally
embedded in, and must be worked out through, "corporeal" relationships
with real people.[126] The insistence on the integral importance of performing
bodies in the activation of social memory and the re-formation of relations
between societies and peoples is intensely manifested in Pham's *Along the
Street of Knives*. Here the artist appears as the central actor and symbolic
instrument of change, using her photographic tableaux as a vehicle to act
out unresolved (and likely unresolvable) feelings of loss as a refugee severed
from the Vietnam of her childhood. At the same time, those staged encoun-

ters are meant to hold out the possibility for peaceful and respectful rela-
tionships between Vietnamese and Americans. In certain respects, Pham's
collaboration with the European American artist Richard Turner is reminis-
cent of the historically and racially charged 1977 performance by Suzanne
Lacy and Kathleen Chang in *The Life and Times of Donaldina Cameron*. To
confront the local politics of ethnic and racial exclusion underlying the cre-
ation of the San Francisco Bay immigration station on Angel Island, this
pair assumed the respective historic personae of Cameron, a nineteenth-
century missionary in San Francisco, and an imaginary Chinese immigrant.
Clad in period attire, they sailed across the bay in an antique vessel to per-
form this self-invented relationship before a waiting audience onshore.[127]

Whereas Pham's *Street of Knives* is structured as a privately staged and
documented performance, and the responses of ordinary people are not
woven into the resulting work, Yong Soon Min and Aono employ interactive
public formats to engage the viewer in a more thoroughly embodied, kin-
esthetic interaction with the art, thereby lending a greater temporal im-
mediacy to the histories and experiences re-presented and embedded in
their installations. Even as Aono fashioned open-ended, hospitable vehicles
for participation and sharing in those histories, Min's *DMZ XING* remains
ambivalent: above all directed to the recovery of Southeast Asian refugees'
experiences, yet also turned sharply outward by confronting viewers with
uncomfortable and disorienting sensations intended to force a visceral en-
gagement with the piece, one that might perhaps lead a broader and more
mainstream American audience to recognize the tension, alienation, and
confusion common to Asian survivors of war and forced displacement who
arrive on these shores.

Min's self-questioning attitude and her frequent use of overlays and
splicings of multiple voices, textual sources, poetry, and imagery in purpo-
sively discontinuous ways also speaks to how the consciousness of Asians
who came to the United States as a result of the Cold War is tempered and
continually re-formed in a dynamic interplay between several sites of iden-
tification. With a mindset that can never be wholly anchored in a single na-
tional and cultural context, they perpetually move back and forth between
allegiances and nostalgia for their countries of origin, their presence and
place in the diaspora, and a sense of having been suborned by the larger
political and economic developments that brought Asians of very different
backgrounds together in this country. While such a restless psychic con-

dition is broadly characteristic of the migrant situation, especially in the contemporary world, it is particularly acute among groups such as Koreans, Vietnamese, Cambodians, and Laotians, whose relationship to their countries of origin often remains unresolved. Viewed from a different angle, the deliberate imbrication in Min's art of multiple images and texts—personal, historical, polemical—is reminiscent of the work of other creative diasporic Korean women of her generation. The films of Korean women filmmakers who were born in Asia but raised in the West have been described by one commentator as pervaded by "plural or multiple forms of consciousness."[128] As such, Min's work invites comparison with the late Theresa Hak Kyung Cha, a Korean-born filmmaker and writer whose influence the artist freely acknowledges.[129] Cha was a fellow student and friend when Min attended the University of California at Berkeley during the 1970s, and her work, which also referenced the trauma of the Korean War and its aftermath, similarly underscores the resistance of historical events to easy recall and narrativization. As is noted in an influential essay on Korean immigrant women artists, writers, and filmmakers who use their work to address issues of self in relation to memory, history, gender, and national identity, the intent is not to provide overall coherence or linear development, but rather to quite self-consciously destabilize narratives based on "authoritative declarations and evocative traces" by introducing "doubt, misrecognition, and deliberate construction."[130]

In the 1990s, installation was the medium that many Asian American artists dealing with self- and community definition used to address histories of social rupture, ethnic and racial subjugation, and the embedded bias and silence surrounding those events and experiences that had been ignored or suppressed. Such works can also serve to foreground the tenuousness of the legal, political, and social boundaries that divide citizens from noncitizens in the United States.[131] Among them is *made in usa: Angel Island Shhh*, a multimedia installation by the second-generation Chinese American artist Florence Oy Wong begun in 1997 and mounted in 2000 at the still-intact site of the former federal complex on Angel Island (now a historic landmark). Drawing on the recollections of Chinese detainees and others who had successfully passed through Angel Island (and in some instances New York's Ellis Island or Hawai'i), the piece deals with secrets long held by elderly Asian immigrants who entered the United States under assumed identities in order to circumvent restrictive immigration laws.[132] In the installation the

voices of the immigrants themselves, recorded by the artist, are heard re-counting their various experiences, accompanied by information on their immigration histories and texts describing the genesis and use of Angel Island. The piece also featured twenty-five rice sacks—each painted with the motif of the American flag—overlaid with hand-painted texts pairing the names of the immigrants with salient facts about their secret past and matched with offerings of rice tinted red, white, and blue. This, says Wong, was intended to present a poignant tribute to "these hero[es] and heroines in my life."[133]

Yet there are also artists from this period who were uninterested in re-articulating these truncated histories in any straightforward documentary or archival sense. In discussing the theme of melancholia in his conceptu-ally based installation *April 25, 1975 (resonance)*, the Vietnamese-born art-ist Khanh Vo describes how—rather than seeking to concretely call forth and re-figure what was lost by arresting the passage of time—he sought to manifest a "compulsion to preserve loss" through the manipulation of "space, suggestion, and allusion."[134] For instance, as a way to evoke what Vo terms a "refugee space"—the "in-between-existence . . . where the mind of the refugee finds itself"—in this 1995 installation, the artist arrayed a collection of items (including articles of clothing, a bicycle, and a conical straw hat) across the gallery floor and enveloped them with overlapping strips of packing tape.[135] As denoted in the artist's title, this scattering of "lost objects" suggests the final days of his homeland, when abandoned uniforms and equipment littered South Vietnam's major highways follow-ing the disintegration of its military. Although each item was submerged under a unitary surface, their discrete shapes nevertheless remained dis-cernible, and they were, in the perception of an engaged observer, concur-rently preserved and encrypted within a complex "psychic topography."[136] For the artist, such imagery conjures past traumatic events in his homeland, the locations in which they occurred, and the melancholic state of a refugee who forever "sits between hope, disappointment and loss."[137] Nevertheless, the overall visual effect of the mnemonic site that Vo's piece constitutes is inherently ambiguous and enigmatic, its meaning—by teasing the viewer's imagination—intended to be ever open to further contemplation and inter-pretation by the artist and viewers alike.

These uses of installation as a primary ground for Asian American medi-tations on trauma, loss, and historical memory also enters into a larger con-

versation in the arts that was very much in evidence in the internationalized art world of the 1980s and 1990s. Not surprisingly, given the sheer statistical magnitude of death, destruction, and dislocation caused by the First and Second World Wars, a major theme was the historical and social resonance of the Shoah, the Jewish Holocaust, in the Western imagination. For instance, in certain mixed-media assemblages from the 1990s by the French artist Christian Boltanski, the spectral presence of its millions of victims is invoked through the use of anonymous snapshots and archival photographs, as well as collections of humble artifacts such as cast-off clothing, fading newspaper clippings, old biscuit tins, light bulbs strung on bare electrical wire— all material objects associated with the minutiae of daily life. Notably, these images and common items, with their ostensibly hallowed associations, are not meant to be taken as evidentiary of the Holocaust (or even of buried memories of the Holocaust), in the sense of extending the personal into larger history through a "living archive" like the oral testimonies and the authentic artifacts provided to Aono by former Japanese American internees for *Relics from Camp*. Indeed, many of Boltanski's selections do not even represent Holocaust victims. Rather, in line with Boltanski's preoccupation with memory, mortality, and the mechanisms of mourning, and despite prolonged post-Holocaust debates about moral equivalence and relativization, they provide for a more general meditation on the unimaginable numbers of people, soldiers and civilians alike, killed on the battlefields and in the concentration camps of Europe during the twentieth century. Even so, the artist's use of source material intended originally for other purposes, and the often somber, shrinelike interior environments where they are exhibited, function as highly evocative indexes of that gruesome history of mass death, enabling Boltanski to trace—through clues of an undeniable human presence—the vanished multitudes to which they gesture. Instead of diminishing the power or importance of such devastating memories, this complexly situated stance, at once a respectful acknowledgement and a subtle parody of commemorations of bereavement, ultimately "speaks of life" by recognizing, as a curator of his work notes, that "life is never black or white, but filled with ironies and inconsistencies."[138]

The idea of the *trace* recognizes the impossibility of representing acts of almost ungraspable enormity and horror, and is therefore often called upon in dealing with absence. For example, resonating with events in Cambodia, Rwanda, Darfur, Sri Lanka, Kashmir, and scores of other tragic conflicts, the

Colombian sculptor Doris Salcedo's installations from the 1990s refer to the disappeared victims of the still ongoing civil war in her homeland, as well as to the dense, memory-devouring atmosphere of fear and uncertainty that has long dominated life in a number of South and Central American nations, forcing many into hiding or exile. In *Unland* (1998), she offers a cluster of roughly bisected and rearticulated wooden kitchen tables etched with undulating scratches on which patches of fabric and strands of human hair ominously adhere. As did Aono in *Issei, Nisei, Sansei...*, Salcedo deploys architectonic references such as freestanding doorframes and household furniture, although here they to refer to the profound violence and social and political divisions that are pulling Colombia apart. Other works from the 1990s speak to a lingering sense of loss engendered by one of the most momentous, unexpected, and still-reverberating events of the period—the collapse and breakup of the Soviet Union in 1991. Partly drawing on familial memories, in his installation *The Toilet* (1992), the Russian artist Ilya Kabakov invited audiences to enter a restroom seemingly being used as a living space that was crammed chockablock with old furniture, kitchen goods, and other domestic detritus. Not unlike the slippers woven from odd strips of clothing in Aono's *Relics from Camp*, the everyday articles in Kabakov's piece refer to the stoic resilience and enforced creativity of former Soviet citizens who long endured shoddy goods and continual shortages in a declining economy by finding viable means to transform all available material resources into things usable.[139]

Asking open-ended questions and envisioning new relationships to a troubled history is just as vital to the processes of reckoning with the past as it is to resisting erasure or oblivion. While the artists in this chapter tend to view the histories and circumstances of their communities through the lens of their own preoccupations, and their methods are generally more intuitive and associative than empirical, their approaches to art making nevertheless resonate with the concept of a "connective aesthetics" by creating sites that enable both symbolic and physical interchange with others.[140] In bringing forward formerly alienated or repressed experiences associated with humanity's destructive impulses, they certainly do not intend to suggest or provide workable solutions for the barbarities of world affairs, or even for the sorrows and disruption of social trauma. Rather, their aim is to acknowledge and integrate them as part of a body of shared

knowledge that will in some way contribute meaningfully to the collective memory and self-conception of their communities and nations.

Despite differences of background, orientation, and tone, a common element conjoins all of these installations: the use of assemblage to incorporate quotidian objects as markers of human presence, thereby allowing the pastiched and fragmentary nature of memory, both public and private, to be made manifest. Through the personalization of historical events and the denial of easy closure, these artists create important alternate narratives and spaces that parallel the official sites in which social memory is typically constructed (whether scholarly publications, national monuments and ceremonies, or the mass media). While often meant as a solemn homage to the past, their work is ultimately oriented toward the future, in speaking to the artists' continual hope for personal and collective renewal in the face of enormous challenges.

Migration, Mixing, and Place

4

Geography is so intimately tied to collective conceptions of history, place, and belonging, and to definitions of (and dichotomies drawn between) self and other, that it could easily be regarded as an "epistemic category" on par with race and gender.[1] Indeed, the most fundamental story of humanity— a "traveling species" from its inception—is its extraordinary mobility. As people have spread out to virtually every place on earth, their numbers have expanded prodigiously over millennia by adapting to its many climates and by learning to successfully alter and manipulate its resources, its environments, and its other forms of life.[2] The global patterns of human movement and settlement, the contests for influence and territory, and the cultural, technological, and commercial currents that continue to reshape the social and the natural world are therefore inherently ancient phenomena. Yet, the scale and rapidity of the world's transformation following the collapse and decolonization of centuries-old Western empires, a process further accelerated with the cessation of the Cold War, is unprecedented.

Along with significant realignments of political power, the postcolonial / post–Cold War era is witness to both the expansion of the non-Western presence throughout the West and the emergence of major new non-Western centers of capital formation and cultural influence. We live in a global economy that is becoming ever more interdependent, characterized by massive population shifts driven by economic expediency and the exigencies of modern transportation, communication, and information networks, as well as by power politics, warfare, and social upheaval. Swept into this ever-expanding vortex, individuals, families, and even entire communities are traversing continents and oceans to resettle or to pass through faraway lands. With at least one hundred million immigrants circulating the planet, migration has been proclaimed as the "world historical event of late modernity."[3]

Inasmuch as globe-spanning mobility and interchange foreground the complicated circumstances of many in today's world, linear narratives are

increasingly incapable of containing their experience, in which cultures of origin and (often multiple) points of embarkation, disembarkation, and habitation remain part of a wide-ranging circuit they continue to travel, both physically and psychically. Alongside a host of global actors—immigrants, refugees, expatriates, exiles, tourists, laborers, and entrepreneurs— many Asian artists can also be found wandering these transnational corridors. As growing numbers of Asian artists become witnesses to, and participants in, contemporary migration and experiences of transcultural passage, intertwining thematics of place, movement, arrival, and dwelling emerge as significant motifs in their work. Not only do Asian artists invoke the lived experience of many by speaking to contemporary issues of globalization, migration, and dispersion, but by raising complicated issues of hybridization that transcend claims of homogeneous identity, their work also stresses that cultural and physical plasticity are primary engines of change, as societies are continually modified through the introduction and commingling of new peoples, ideas, and ways of doing things.[4]

Although dispersion and multiple placements and displacements have come to typify contemporary life as Asians circulate between Asia, far-flung Asian diasporas, and the West, the impact of migration on art in the United States is hardly a novel phenomenon. The American art world was forever transformed by an earlier wave of artists and intellectuals who fled their European homelands beginning in the 1930s, in the period leading up to World War II.[5] With the subsequent upheavals of the postwar era, and the emergence of the United States as a preeminent economic, political, and cultural power, there has been a continual influx of artists and scholars from non-Western societies the world over, including many from former Western colonial spheres.

Art produced under migratory conditions illuminates an intricate interplay between the global and the local, in which the trajectories it frames are often considerably more complicated than those suggested by standard accounts of migration, settlement, and assimilation that envision a one-way passage between a country of origin and a final point of settlement. Immigrant artists are capable of providing closely observed insights about this society and its mores, born of the heightened alertness to their situation that periods of flux induce and require. In a similar vein, attention to the details of how individual artists negotiate their passages between cultures and nation-states through works of art can permit more-nuanced under-

standings of travel and movement, and the multifaceted perspectives and sensibilities they produce among artists. Whereas travel is typically characterized by a particular itinerary and the expected return to one's home, the inherent uncertainties of migration are well invoked by the claim that they clamor instead "for a dwelling in language, in histories, in identities that are constantly subject to mutation."[6]

Upon crossing a threshold, migrants soon find themselves immersed in a new environment with its unique exigencies. Reflecting on the work of immigrant artists encountered in the 1994 exhibition "Asia/America," a fellow Asian-born observer writes of the "shock of arrival" as an experience that can reverberate long after an individual first becomes directly involved in a new society. For her, such a shock not only "crystallizes the jagged boundaries" of these artists' "disjunctive worlds," but more significantly, "a phenomenology of Asian American art might be traced" via our contact with such work.[7] Experiences of arrival can be especially stark for refugee artists, who remain preoccupied with recollections of lives left unfinished and the overwhelming events that wrenched them from their homelands. In grappling with the often inchoate and ambivalent feelings involved in adjusting to a new life, a number of immigrant Asian artists use their work not only to examine their present circumstances but to also understand their personal concerns in the context of broader cultural, historical, and political issues that induced them to leave their homelands.

Migration may also provoke a compelling need to remember and retrieve past places and events. Drawing on Old Testament imagery, a well-known British novelist and essayist of Indian birth observes that migrants are often impelled "to look back, even at the risk of being mutated into pillars of salt."[8] Recognizing that memory is often partial and selective, giving rise to "imaginary homelands," he nonetheless maintains that it is exactly the fragmentary quality of these "shards of memory" that makes them so intensely evocative. Based on his personal experience, such recollections, no matter how mundane, took on "greater status, greater resonance" by virtue of the fact that they are "remains."[9]

In an era characterized by hypermobility and the permeability of national boundaries, and a world awash in the images, words, and music of many cultures, "where is home?" has become increasingly difficult to answer. With no single location around which to center oneself, and with newer communities of migrants often retaining much of the cultural and social trap-

pings with which they arrived, home can become a portable and expansive notion. In this, the idea of diaspora—with its connotations of movement, dispersal, displacement, and multiply located, intersecting identities—appears to offer an alternative to fixed or nation-bound notions of identity. Diasporic identity in itself becomes a subject, as artists try to create a place and a sense of continuity for themselves by finding connections between their homelands and outlying communities. Yet, extant concepts of diasporic identity also have their limitations if we try to use them as overarching frameworks to understand the contemporary situations and standpoints of Asians in the United States. Noting that discussions of diaspora are "strong on displacement, detachment, . . . [and] disarticulation," but are on uncertain footing in accounting for how the local is rearticulated in "spaces of dispersal," one scholar argues for an "uncoupling" and reconsideration of each of the terms by which diaspora is typically framed.[10] Another scholar, concerned that current models of diaspora tend to essentialize and fetishize the origins of diasporic groups by being overly dependent on a "definitive relation to place," calls instead for the concept of the *diasporic imaginary*. The idea of diaspora, as he conceives it, would have more to do with a process of identification in the present based on "formations of temporality, affect, and corporality," than it would with a diasporic group's overt relationship with their geographic origins.[11]

Since the 1980s amid the continual realignment of global and local relationships, rhetorics of globalization, mobile subjects and nomadism, and trans- and postnationalism, as well as post-black and post-Asian art, have gained currency. Questions have been raised over whether it is more meaningful to view the world as a unitary place or as any number of discrete places. Moreover, inasmuch as migration is equally defined as a series of landings, as it is by movement or travel, we are also reminded that the objective is not to supplant "the cultural figure 'native' with the intercultural figure 'traveler,'" but rather to attend to "concrete mediations of the two."[12]

The language of globalization and a kind of an unanchored, peripatetic cosmopolitanism is increasingly being tempered by an awareness of the continuing importance of localism, place, and embodied histories in shaping contemporary consciousness. Although some may claim multiple points of affiliation in their globe-circling travels, few in the modern world are so persistently nomadic that they can unequivocally maintain to be from no-

where in particular. However transitory or uncertain one's presence in a culture, region, or nation-state might be, the fact remains that an individual's experience is always located somewhere. Artists, obviously, also come from somewhere and must alight someplace—or in a succession of places. In so doing, they contend with how they see themselves, and how others see them in a variety of political and cultural landscapes, each with its own distinctive configuration of peoples, circumstances, and histories.

To the extent that a number of Asian American visual artists have chosen to address the cultural and emotional resonance of local geographies as a primary subject, it is important to recognize place (and movement between places) as a focal point in the imagining of contemporary identities. Nonetheless, place is too often conceived as merely a backdrop against which events occur, rather than as being centrally important, in fact indispensable, to human awareness. Underscoring connections between place and memory, one course of reasoning notes the inherent resonance of "place memory" and points to how place's "stabilizing persistence . . . as the container of experiences" is instrumental in shaping individuals' perceptions and understanding of the self in the world.[13]

From the moment a person enters the sphere of a new nation, she or he inherits, for better or worse, the cumulative historical experiences, politically determined status, and assemblage of beliefs and representations that surround what is perceived to be her or his group. So long as physical features (alongside language and culture) remain a primary marker of difference, individuals of Asian heritages will be set apart from the majority population and identified by its racialized and culturalist discourses. As foreign-born artists engage with U.S. society for longer periods of time, they come to perceive the presiding culture's deep ambivalence about the new migrant presence despite the immigrant ideal to which the United States has long aspired. In the process, they also may encounter, and to differing degrees engage with, aspects of Asian American identity politics and U.S. multiculturalism. These interactions can engender a larger positional claim to citizenship in, and sense of belonging to, the nation. In the face of systematic attempts at every level to exclude Asians from the American body politic and to view them as forever foreign, and in recognition of the struggles and sacrifices of prior generations to establish themselves here, there has been a strong desire among Asian Americans—especially among the American-born generations—to stake a claim to the only land they have

known. As a contemporary Chinese American novelist stirringly writes, "We are old enough to haunt this land."[14] Part of that claim to place involves efforts to trace and to assert the historical and contemporary presence of Asians in the United States, including representations of the urban neighborhoods in which Asians have settled, such as the Chinatowns, Koreatowns, Japantowns, Manilatowns, and Little Saigons of this nation.

This chapter is devoted to the work of four Asian American migrant artists: Ming Fay, Zarina Hashmi, Allan deSouza, and Y. David Chung. Each addresses aspects of the migrant condition, whether in reinterpreting globalization, history, contemporary events, and the U.S. environment through subjective and culturalist filters; in framing the trajectory of a peripatetic life; in scrutinizing sites of crossing through which travelers first encounter new lands; or in speaking of developing affinities and synergies, as well as of conflicts and collisions, that connect Asian immigrants to other immigrant and minority communities throughout urban America.

Ming Fay · circulation and cross-cultural pollination

Having lived in Shanghai and Hong Kong prior to his arrival in the United States—two restless, polyglot Chinese port cities where Western cultures have long had a definitive influence—the New York–based Chinese-born sculptor and installation artist Ming Fay offers an all-embracing vision in which contact, hybridization, and intermixing are the primary engines of change in human and natural history. In Fay's highly anthropogenic conception, humanity is an integral constituent of life on this planet, and human action is an inherent form of natural activity. He regards the human and natural worlds as thoroughly interconnected—a continuum of sentient beings enmeshed in a reciprocal "coevolutionary" relationship in which human beings manipulate the planet, fellow humans, and other creatures as the object and scrim for their own desires and purposes, while being themselves remade in the process.[15] Indeed, Fay equally views himself as a product of the same generative, hybridizing forces that continually remake the fabric of the world at all levels. Such an integrative notion of humankind's place as simply "one aspect" in nature's "broad spectrum" of animate being can also be seen as consonant with Taoist traditions of thought.[16]

Through his use of a botanical metaphor that has evolved into a larger

personal metaphor, the artist argues against all notions of purity in nature and human societies. Inspired by the shapes of flora, Fay likens his art to the efforts of botanists and naturalists who intervene in the world by gathering specimens and altering nature's forms to produce previously unknown varieties. Best known for highly representational, outsized sculptural renderings of fruit, vegetables, plants, roots, and seedpods—deeply resonant motifs in Chinese culture—Fay's more recent works have increasingly departed from that realism in creating imaginary crossbreeds that he inserts in both indoor and outdoor environmental installations. By devising such visibly hybrid forms, the artist alludes concurrently to the role of human intervention in transforming life on the planet, and his own relationship to those ongoing processes.

Not unlike many modern Chinese who grew up in cities with large Western enclaves, Fay's early life was strongly shaped by cosmopolitan sensibilities. Pointing to such sites, Fay suggests how, on a grand scale, whole societies and cultures are complexly recast through processes set in motion by outside human intervention. The fact that he is hybrid Chinese because of the historic actions of the British in Shanghai and Hong Kong, has made him quite aware that "it's all invention." "You think I'm Chinese?" he asks. "Yes, I'm Chinese, but I've been in New York longer than I have been in China. So this is who I am, and that's what you can describe my work [as being]."[17] The artist's comments illuminate one of the many ways in which contemporary Asian immigrants conceive of themselves both in relation to the ancient histories of their homelands and to the historical processes that have drawn Asians to journey around the world. In recent times, some critics have employed the term "transexperience," conceptualized by the late Chinese artist Chen Zhen, to speak of how contemporary diasporic experience and cultural identifications are adaptive, fluid, and continually being reconfigured in different contexts.[18]

The artist was born in 1943 in Shanghai, one of the first treaty ports forced upon the imperial Chinese government by European nations beginning in the mid–nineteenth century. Formerly known as "the Paris of the East" and situated in a region where one of China's major rivers meets the sea, the city and its surrounding area were built on commerce, both domestic and foreign. Described as a "polycentric, decentered" metropolis in which English was widely spoken, and under the control of "many different hands," by the 1920s Shanghai was the world's sixth largest city.[19] The site of China's first

newspapers and films, and a haven for its political radicals, Shanghai contained over sixty thousand foreign residents during the 1930s, including numerous European refugees.[20] The artist, having been born under Japanese occupation during World War II, retains vivid recollections of the enormous appeal of export items from the United States that were available during the brief period of prosperity that followed Japan's defeat in 1945. "There was a craze for anything American, from chewing gum to hot dogs, cowboys to submarines, Mickey Mouse to Superman, and blue jeans to tuxedos. . . . I remember watching Walt Disney cartoons and cowboy movies and drinking Coca Cola [as] something very special."[21]

Amid the anti-Western and anticommercial policies that prevailed with the establishment of the People's Republic of China in 1949, Fay's family soon joined an outpouring of Chinese who emigrated to Hong Kong. Like Shanghai, this port city and former Crown colony of the British Empire had thrived as a crossroads of international trade. Living in Hong Kong between the ages of nine and eighteen, he came to regard it as an "extension of old Shanghai," not only because of the wealthy business elites who relocated there, but also due to both cities' kindred histories of extensive foreign, primarily Anglophone, influence. Describing the giant neon signs advertising Sony, Toshiba, and other brand names that dominated the skyline of Hong Kong's harbor, Fay speaks of the charged atmosphere of such global economic zones: "Hong Kong's called the Pearl of the Orient . . . because it's one of the most commercial, big-time places. It's a cosmos of that stuff. [That's] the culture where I grew up."[22]

Fay's interest in visual art and culture was stimulated by being raised in an artistic family; both his parents had studied with Zhang Chongren, a European-trained sculptor who returned to China to teach Western techniques. According to the artist, his mother owned the first wax museum in Hong Kong, and his father was employed in the local film and television industry as an art director. Throughout his youth, he observed his parents working on product designs, as well as exhibitions of wax figures and puppetry projects, allowing him to see firsthand how such colloquial objects are crafted. Fascinated by American popular culture, and especially Western film, Fay secured an art school scholarship in 1961 to study in the United States. As a self-described "big-city boy," the artist ultimately gravitated to New York City, another world-class cosmopolitan center and port city with a large Chinese population. In the early 1970s Fay set up a studio on Canal

Street in Soho, a neighborhood adjacent to Chinatown. Throughout he emphasizes the importance place has had in fundamentally shaping his art: "I believe the [current] work actually comes out of being in New York. . . . Being Chinese led me to know and meet a lot of Chinese artists and . . . artists from other countries who choose to be in this great metropolis. . . . New York interests me because it is unique and I know of no other place that has this kind of energy."[23]

Catalyzed by chance encounters in New York with fellow urban Chinese from Hong Kong, mainland China, and Taiwan, in 1982 the artist became a founding member of Epoxy Art Group. The establishment of Epoxy, whose name alludes to the potent "glue" bonding Asian and Western cultural influences, led to a decade-long collaborative effort to mount a series of multimedia installations and performances that dealt with cross-cultural phenomena from an explicitly Chinese standpoint. Hong Kong, Shanghai, and Taiwan share histories as international contact zones where Western and other influences have had a definitive impact through trade and an imposed foreign presence, and the Chinese artists from these places who joined Epoxy were in many respects already attuned to and fluent in the visual vocabularies of cultural hybridization. Such artists knowingly negotiate the cultural geography of complex intercultural discursive spaces that are at once Chinese and also syncretic and continually evolving in response to changing conditions.

Thirty Six Tactics

For members of Epoxy, their desire to assert a common presence inspired them to delve more deeply into their own cultural resources, both by finding means of attaching themselves to this new place and by emphasizing active connections between their homeland and the diaspora. They recognized that present-day political maneuvers in their adopted country had antecedents in Chinese history, and that the principles governing such actions were already well codified in proverbs from ancient Chinese texts. For example, in the multimedia work *Thirty Six Tactics* (1988), photocopied archival and media images based on current events are paired with pithy proverbs inscribed in both English and Chinese, underscoring how commentaries derived from the accumulated wisdom of China's past handily anticipate and shed light on present-day political affairs. Through the English translations of these proverbs, insights linked to a sense of deep history

emerging from a millennial civilization are put forward as meaningful epistemic resources for Chinese and non-Chinese alike to use in negotiating and making sense of the times in which we live. Seemingly paralleling the intent of the ancient text, Epoxy's *Thirty Six Tactics* can itself be viewed as a strategic maneuver on the terrain of visual culture, a positional deployment by Chinese diasporic artists to assert their sense of cultural coequality and authority in the West.

Yet, Fay's own studio work as a sculptor is quite different in character from the pieces he produced with Epoxy. Long engaged in exploring the material and metaphysical connections between man and nature, the artist's earliest sculptural experiments—executed after moving to New York in the 1970s—were inspired by the shapes of fruit and vegetables in local Chinatown green markets (figure 38). Beyond their being a source of bodily sustenance, the artist chose these familiar foods for the auspicious cultural associations they hold for the Chinese. "I used the most common folk symbols from the Chinese culture as my reference materials, such as oranges for good luck, . . . peaches for longevity, pears for prosperity."[24] Although considerably scaled up, these naturalistic freestanding objects closely mimicked the colors and surface textures of the artist's fruit and vegetable models. Fay continually added to this larger-than-life repertoire, drawing on the forms of medicinal herbs, horns, and bones (figure 39), gradually conjoining many of these motifs in highly elaborate environmental mixed-media installations he later characterized as "mythical folk gardens." The method employed in producing these works involves direct modeling over wire armatures, a technique inspired by the making of kites and paper lanterns common among Chinese artisans, taught to him by his mother.

Money Tree & Monkey Pots

Among Fay's recent projects is *Money Tree & Monkey Pots: An Installation of Montalvo Specimens* (2004), a fanciful environmental piece incorporating living trees that was first installed on the Montalvo estate in Saratoga, California. Comprised of related indoor and outdoor sculptural works created in response to a site housing an extensive private collection of exotic plants and trees, this project introduces a new "species" into the surrounding setting, suggested by an actual plant form: the monkey pot, a tree indigenous to the tropical jungles of the Amazon. The name refers to the tree's large, gourd-shaped fruits that attract passing monkeys; it is said the monkeys'

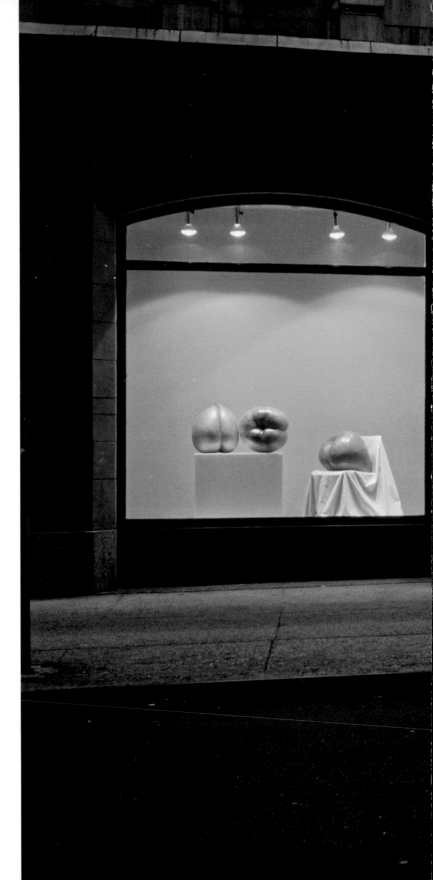

38 Ming Fay, installation
at Broadway Windows,
New York, ca. 1980s, mixed
media, dimensions variable.
Courtesy of the artist.

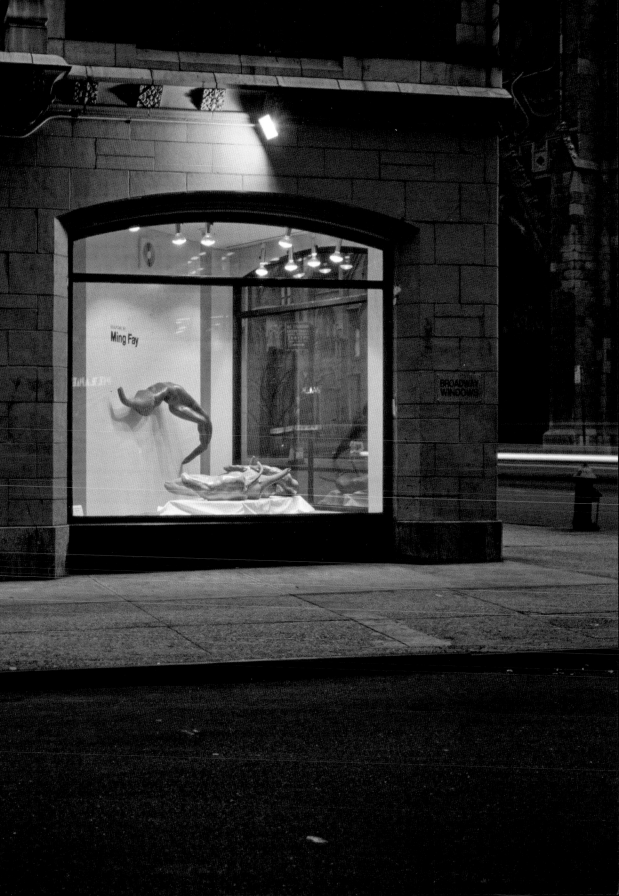

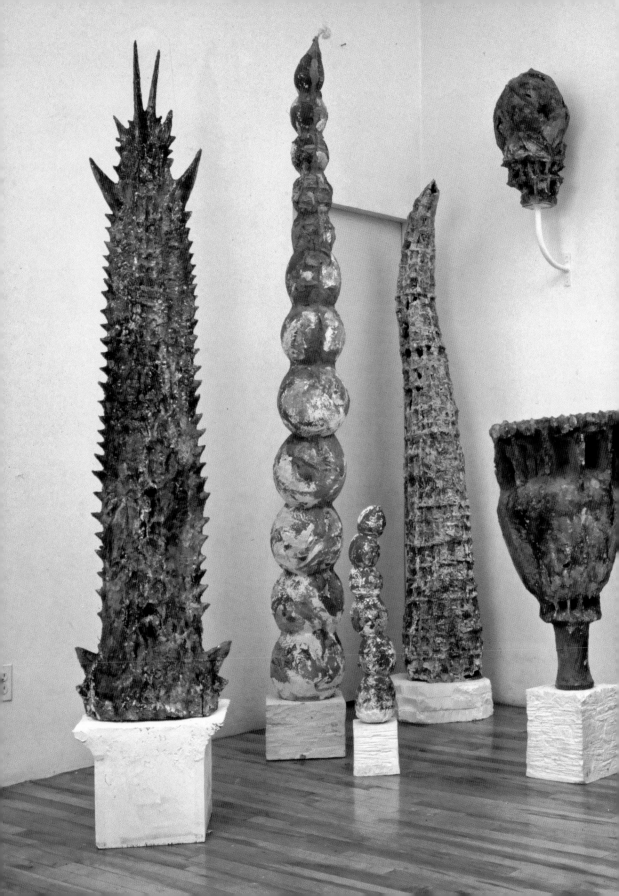

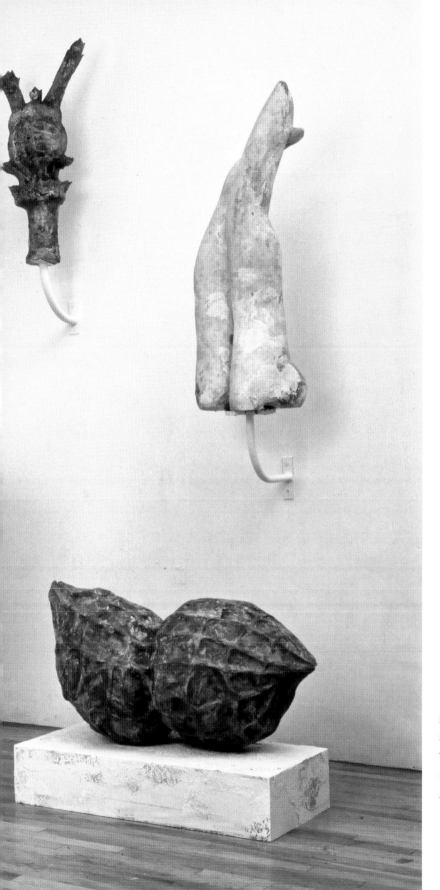

39 Ming Fay, installation at Broadway studio, New York, ca. 1993, mixed media, dimensions variable. *Courtesy of the artist.*

heads often become lodged in their recesses in the act of gorging on their delectable seeds. The interior portion of the installation, alluding to the quiet serenity of a small garden, brings together assorted elements from Fay's established repertoire of simulated fruit, flowers, seeds, and pods (figure 40). However, in a notable departure from earlier bodies of work in which these forms are meticulously rendered, the artist's translations of the bulbous monkey pots in the outdoor component of this estate-wide installation have a roughly assembled, haptic quality, and are coated in shimmering, otherworldly colors, imparting an aura that is simultaneously seductive and unsettling (figure 41). While obviously still based on the morphology of flora, their skeins of dense paint, chunks of pigmented foam, and partially exposed wire frameworks overlaid with gauze overtly call attention to the process of their creation, stressing the artist's role as an agent of human intervention in the natural world (figure 42).

Fay first came across the monkey pot in the Singapore Botanic Gardens, located in a city founded by the British in the early nineteenth century at the tip of the Malay Peninsula. Like other major hubs of commercial activity such as Hong Kong and New York, Singapore (which today has a majority Chinese population) began as one of a series of trading posts established around the world by competing western European nations that were de-

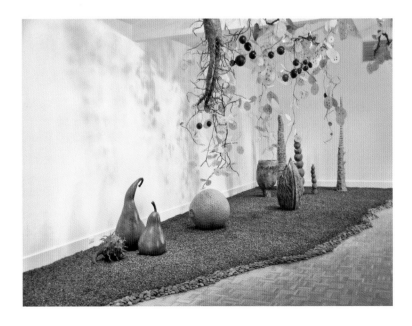

40 Ming Fay, *Money Tree & Monkey Pots: An Installation of Montalvo Specimens*, indoor gallery installation, 2004, Montalvo, Saratoga, California, mixed media. *Courtesy of the artist*.

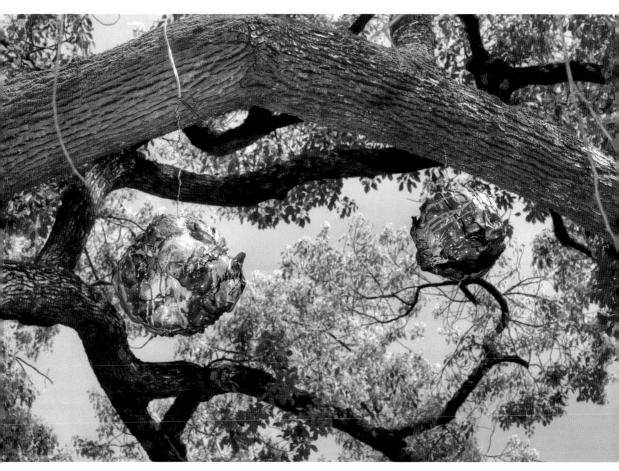

41 Ming Fay, *Money Tree &*
Monkey Pots: An Installation
of Montalvo Specimens,
outdoor installation, detail,
2004, Montalvo, Saratoga,
California, mixed media,
each pot 8"–20" diameter.
Courtesy of the artist.

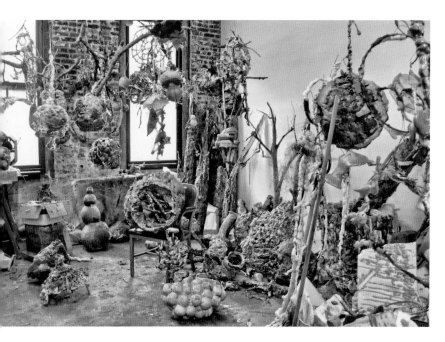

42 Ming Fay, studio view of works-in-progress including Monkey Pots, 2004, wire, gauze, foam, dye, paint, size variable. *Courtesy of the artist.*

signed to pump wealth into the mother countries. This encounter in Singapore led Fay to ponder the extent to which "the British Empire changed the world. They sent botanists all over, transplanting seeds everywhere."[25] The presence of the monkey pot so far from its geographical origins thus became emblematic for the artist of the transfer of botanical items throughout the empire in the scientific pursuit of commercial applications. Foreshadowing the material and cultural globalization of our time, the rise of this earlier botanical globalism via the international circulation of plants also reflects the way that these worldwide networks of biodiversity have historically served as a critical resource for the amassing of vast fortunes by Western interests in the post-Columbian age, based on the discovery, cultivation, and transplantation of African, Asian, and American crops for distant markets, including coffee, rubber, cotton, cacao, sugar, potatoes, and spices.[26]

Following this reasoning, the artist began to envision himself as akin to a "Field Scientist / Artist," who in his own way seeks to acquire and transfer unknown species to other ecosystems and to graft them with indigenous plants to produce novel varieties.[27] Having spent time under British rule, he metaphorically inserts himself into the process by which eighteenth- and nineteenth-century botanists, such as the famous British naturalist and

explorer Sir Joseph Banks, traveled the world gathering rare specimens for study and crossbreeding in government-sponsored research schemes. This period of growing mobility coincided with the founding of major botanical gardens, arboreta, zoological parks, herbaria, and museums of natural history, whose combined holdings provided a vast informational system intended to advance the Western scientific project of classifying life on every part of the planet. Such an imaginative conception of the manmade world as it intersects with the natural one not only brings forward different layers of meaning, but also (to follow Fay's use of a scientific metaphor) makes us all "fellow investigators" gathering evidence and following clues that allow for multifaceted insights about the historical moment we share.

Zarina · migration, home, and memory

The art of the Indian-born sculptor and printmaker Zarina Hashmi (or simply Zarina, as she prefers to be known) embodies a constantly evolving meditation on a life embedded in movement and defined by the closely interrelated themes of home, place, travel, and time. Yet because her passage through the world began amid acts of anti-Muslim violence, Zarina is also acutely conscious of mistreatment and discrimination directed against her fellow coreligionists. The artist's early experiences have engendered a keen appreciation of human vulnerability and resilience in the face of social disruption on a vast scale—especially the need people have to rebuild their lives and to establish a new place for themselves, however provisional those homes prove to be. "If you don't make your home wherever you are, you are totally lost, you will sink," she comments. "All humanity is migrating. . . . There are people who have lived their lifetime in refugee camps . . . [and in] shanty towns. . . . They are so lucky to have that little space where they can sit under the sky."[28]

Born in 1937, during the waning years of the British Raj, Zarina's pursuit of her art has taken her to Asia, Europe, the Middle East, North Africa, and Latin America. The United States has been her primary residence since 1976, and she became a citizen in 1993. While the artist feels strong sympathy for displaced peoples the world over—remarking that "we are [all] in a way exiles wherever we [are]"—she is careful to distinguish between the circumstances of those forced to flee their homelands under threat of anni-

hilation and those she terms "intellectual exiles" or expatriates, including artists like herself, who voluntarily elect to take up residence outside their homelands because of the freedom and opportunity that situation offers.[29] Although she has not lived in India in over forty years, Zarina remains ambivalent about the nature of her position and standing. As she asserted recently, "I have not yet accepted my status as a migrant [and am] still thinking of going back one day."[30]

Raised in a traditional Islamic household, she identifies herself as an Indian Muslim and considers this heritage deeply meaningful as a cultural lens through which she filters her profoundly personal and autobiographical art. She nevertheless conceives of herself as a secular artist, her aesthetic influences and practice shaped mainly by cosmopolitanism and mediated by the cultural hybridity of the Indian environment in which she was raised. Throughout, there is a vital tension and interplay between the two central narratives governing Zarina's art, as movement and place alternately receive heightened degrees of emphasis in different bodies of work. Over the past few years, these dual dimensions of her experience have increasingly been integrated in rich and complicated syntheses.

Zarina grew up in the university town of Aligarh, a major center for Muslim education located near Delhi, where her father was a professor of Indian history who specialized in the Mughal Empire (1524–1707), a period when much of India was ruled by Islamic dynasties. At the age of ten, she was witness to a momentous event: the 1947 partition of India into predominately Hindu and Muslim areas. With the simultaneous emergence of India and Pakistan as independent nations, chaos engulfed the Subcontinent. Amid the intercommunal carnage and huge population exchange that followed the hurried British withdrawal, an estimated fifteen million people were uprooted and forced to abandon their homes, as neighbor turned against neighbor.[31] Described as the "greatest migration in history," streams of refugees flooded roads and fields in ragged processions, and packed all available trains, those unable to find a space recklessly clinging to the sides and roofs of onrushing railroad cars.[32] Along the way, many would be slain by rampaging mobs or die from disease and starvation as crops went unharvested. All told, possibly a million lives—Muslim, Hindu, and Sikh—had been lost, and the living were commonly reduced to impoverished refugees.

The extreme turmoil also divided Zarina's family; many were inhabi-

tants of a region of the Punjab that was absorbed into Pakistan. Zarina, her mother, and her sisters were compelled to flee their home. "We were scared. We thought we would be killed," she recalls. "I did see the villages around Aligarh burning. Then we were all taken to Delhi for safety in a covered truck . . . There was a very strong smell. Until this day I remember it, a smell of rotting flesh. There were people dead in the streets and there was nobody to pick them up."[33]

Those inflamed times remain a recurring memory for the artist, and profoundly affect her view of the world. "I saw my family, friends, and masses of people move aimlessly, searching for safely and home. I understood from a very young age that home is not necessarily a permanent place: It is an idea we carry with us wherever we go."[34] Despite the extent of death and destruction, Zarina, along with her immediate family, was among the millions of Muslims who chose to remain in India, which currently is home to the third-largest Muslim population in the world. Yet, a decade after independence, her parents and siblings relocated to Pakistan. Part of a generation in which many fervently believed in the ideals of Indian secularism, the artist views the wrenching conflicts that followed partition with deep dismay. With the growing prominence of Hindu forces espousing a highly xenophobic Indian nationalism, however, Zarina came to feel that the Islamic heritage in her homeland was increasingly under siege: "Muslims were . . . not a loved minority. Your life was threatened, your culture was threatened, your identity was threatened. So we had to really take a stand, my generation, . . . especially since they started demolishing the monuments or banning the language which we spoke. . . . Eight hundred years of history are wiped out as if [they] never happened."[35]

In 1958, at the age of twenty-one, Zarina married and resettled in Bangkok, Thailand. It was there that she initially encountered the Japanese woodcut prints that would kindle her interest in printmaking. She moved again in 1963, going to France to study art, then returned to India in 1968 to pursue her profession as a printmaker. After briefly taking up residence in West Germany, Zarina traveled to Japan before making her way to Los Angeles and ultimately to New York. Explaining her choice to remain here, Zarina remarked, "You don't feel like a migrant when there is a sizeable minority you can become part of. If you must live outside India, America is the easiest country to live in."[36] Since coming to this nation, she has taught

printmaking and exhibited actively in India, as well as in galleries and museums worldwide, and made frequent trips to Pakistan to visit her parents until her father's death in 1994.

As Zarina recalls, her first exposure to art was through her father, who encouraged his daughters to cultivate their intellectual interests and later sent her to college, where she studied mathematics while privately pursuing her artwork. While Zarina comes from a Muslim home that contained few paintings or other art objects, during her childhood her father would take her to visit Mughal buildings and monuments in Agra and Delhi. Captivated with his accounts of the former Muslim empire in India and by her exposure to such magnificent sites, Zarina's visual imagination was strongly affected by Islamic design and architecture. Since Muslim art is predominantly nonfigurative, based on religious precepts that regard figuration as idolatry, its artistic and design traditions emphasize the use of geometric forms, patterning, space, symmetry, and calligraphy to represent attributes of the divine.

As an artist who was "always attracted to order and space," Zarina has been increasingly drawn to Sufism in recent years.[37] In Sufism, a major mystical movement in Islam with an esoteric, highly spiritual orientation, religious experience is based on a perception of the world as divinely ordered. Art and architecture, in turn, should be reflective of that order, and through this symbolism, an intuitive awareness of the divine may be attained. Indeed, as one scholar notes, since symbols are so central to expressions of Sufism, the "entire journey in God" itself becomes "a journey in symbols"—an outlook that endows the movement's followers with an abiding sense of "the higher reality within things."[38]

Nonetheless, Zarina's first serious engagement with visual art began through her exposure to the work of European and American modernists. This occurred in 1963, after she was accepted for training with a renowned Paris-based printmaker and teacher. Zarina perceives a formal congruence between Islamic artistic traditions and aspects of Western geometric abstraction and minimalism, both idioms oriented toward visual simplification. What such approaches share is a kind of compression, in which relatively straightforward designs and materials are seen to contain and communicate a wealth of meaning. Adapting such spare means to her own ends, she draws on this hybrid visual language to speak about her percep-

tions of worldly realities and map the trajectory of her far-ranging journeys and multiple points of dwelling over more than four decades.

House on Wheels / Moving House / I Went on a Journey

The motif of an abode that is also a vehicle, composed of a wheeled square with a triangular "roof," surfaced as a recurrent image in Zarina's work beginning in the early 1990s. Emblematic in their simplicity, these freestanding and plaquelike cast metal sculptures meld two archetypal forms—the house and the wheel—in a primary symbol of motion. Often small enough to be grasped in a nomadic hand, they speak directly to the artist's conclusion that "I have become my own home and I move. . . . That's all I have now."[39]

In *I Went on a Journey*, *Moving House*, and *House on Wheels* (all 1991), Zarina employs this icon to signify that while the act of having left India remained a permanent psychic condition, she could also come to feel at home wherever she might be. The motif of a house on wheels introduced the concept of dwelling in movement—in which the journey, rather than simply being an interstitial space between points of settlement, actually becomes the substance of one's existence. Zarina has produced variations on this image since 1991, which a Pakistani commentator characterizes as the "leitmotif of her nomadic life."[40] In *Moving House* (figure 43), the artist horizontally aligned identical images of the house on wheels in a series of friezelike rows to suggest both the succession of places she has inhabited and the serial displacements that have marked her passage.

In part, the house on wheels functions as a poignant self-sign, evoking memories the artist recounts of her first desperate passage in being whisked, as a child, to safety in a covered truck during the birth of modern India. Yet, as an index of Zarina's roving presence in the world, this symbol has proven to be quite malleable, serving as a container of broader social as well as personal associations. Depending on the context, it has variously functioned as a sign of family, shelter, home, and culture; as a repository of the accumulated experiences of a lifetime; and as a marker of human presence and habitation. "Over the years as I navigated my life between cultures and continents . . . the idea of a moving house germinated in my mind. Houses-on-wheels, impressions from travels became an ongoing narrative of my creative experience. I have sculpted houses on wheels, drawn tracks

left by moving vehicles, made prints of road lines which become compan-
ions on lonely roads, and tried to depict the stillness of flying above the
clouds over a restless world."[41]

The notion of home remains immensely important to Zarina at the same
time that she is acutely aware of its impermanence and mutability. She
speaks, therefore, of a need to create homes for herself that are as much
psychic dwellings as actual physical locations in the world. Even as her
travels have taken her to lands spanning the globe, Zarina's gaze has often
turned back to the childhood home in India that she was compelled to leave
so long ago. Although the artist does not speak of her formative experi-
ence in terms of trauma, it might be said that this separation engendered a
yearning to revisit this site of rupture and to try to recover and reconstitute,
through acts of memory, what had been lost. With a repertoire of simple,
abstract shapes that serve as mnemonic devices to trigger connections to
her past, Zarina imaginatively returns to the site from which her journeys
began, her father's house at Aligarh.

43 Zarina, *Moving House*,
1991, cast aluminum, five
units, each 8" × 2½" × ½".
Courtesy of the artist.

The House at Aligarh and The House with Four Walls

The House at Aligarh (1990) and *The House with Four Walls* (1991), related portfolios on the theme of home, each consists of seven etchings that reference memories and tales from Zarina's childhood in India. Every print in *The House at Aligarh* is dedicated to different members of her family, and paired with a brief caption that alludes to the daily activities that took place in that long-distant structure. The artist's childhood home was built around a courtyard on which the lives of the women of her family were centered. Similar to a planar projection, the central form in *At Night I Go to the House at Aligarh* (an etching in *The House at Aligarh* portfolio) is based on a highly simplified schematic of Zarina's former family compound as viewed from above: a traditional South Asian building with its inner courtyard open to the sky, and internally bounded on all sides by arched bays. "My work is not illustrative," Zarina comments, "but I used familiar images that evoked a certain emotion."[42] For instance, the print entitled *Rani Asks Me to Sing a Song* conjures the shape of the little drum, the *dhola*, that she and her sisters played to accompany their singing, as a shadowy effigy reminiscent of an archaeological rubbing. Such visual aides-mémoires revive the intimate sights, sounds, and smells of a past hallowed by personal associations, and often charged with spiritual significance.

Far Away Was a House with Four Walls (figure 44), the first print in *The House with Four Walls* portfolio, was inspired by a trip Zarina took in the late 1980s to see her family in Pakistan. On that visit, against the backdrop of growing conflict in the Islamic world between secular and religious forces, the artist had decidedly mixed emotions about the resurgence of traditionalism. She was particularly disturbed by the fact that it was being promulgated as an official instrument of government policy. Since 1977, Pakistani authorities had vigorously advanced Islamization programs, including the establishment of courts based on Shariah (or Sharia), traditional Islamic law, to insure that all national institutions closely conformed to Islamic principles and values. One of the popular catch phrases Zarina heard during that time was the saying, "chador and *char-diwari*," a word play in Urdu signaling the proper appearance and place in society prescribed for Muslim women. In this reference, the chador is a traditional garment fully covering Muslim women who appear in public, while char-diwari, according to the artist, is translated as "four walls." The phrase is thus an allusion to ortho-

44 Zarina, *Far Away Was a House with Four Walls*, first in a series of seven etchings from *The House with Four Walls*, 1991, etching and chine collé on paper, 9" × 8" (plate), 17" × 29" (sheet). *Courtesy of the artist.*

dox Islamic teachings that instruct women to stay covered and within the walls of their home.

The artist herself had grown up in a household where the women's quarters were kept apart from the rest of the dwelling, because her mother observed purdah. Variously translated as "veil," "curtain," and "screen," *purdah* is the term for the Islamic practice of secluding women from the sight of men in the outside world and, to a certain extent, in the domestic realm as well. The artist, who does not view herself as being "of the world that does not look at other things," is nevertheless an observant Muslim.[43] Acknowledging that such traditions and practices can certainly seem confining in the modern world, she also recognizes that in her own life they have been a source of comfort and protection and therefore remain a personal focus for nostalgia and longing. As she recalls, the house was a "woman's territory . . .

that was my mother's world."[44] In *Far Away Was a House with Four Walls*, the rendering of a white square edged on all sides by schematic rows of incised dark lines—emblematic (as in the earlier print portfolio) of the courtyard and walls of Zarina's childhood home—serves as a personal touchstone to a rich and complicated relationship to Muslim traditions, as well as an evocation of a particular place and time that, for the artist, now only exists in memory.

Mapping the Dislocations / Atlas of My World

No longer conceiving of her life as comprising separate or discrete events, by the time Zarina reached her late sixties she was far more interested in envisioning the span of her years as a totality and taking their measure. In 2001 she produced two sets of woodcut prints, *Mapping the Dislocations* and *Atlas of My World*. By invoking maps of air routes and national boundaries, these prints confer an overall shape and coherence to her globe-circling journeys. In *Mapping the Dislocations* (figure 45), the artist adopts the format of the maps provided by airlines to trace their international air routes as a means of charting her own travels in a long and eventful life. As it is for many people today, the airplane is her primary means of transportation; as she reflects, in flying over such great distances without actually experiencing the terrain being traversed, the only way these passages can be grasped is through the abstraction of maps. Using dots to mark each place she has visited, the artist then drew lines to connect them into one continuous circuit that represents, in her words, "[her] own navigation" of the world.[45] Such symbols can be understood as part of an emergent visual language that inscribes the condition of those around the planet for whom motion and dwelling have become ongoing, interchangeable activities.

In the six woodcut prints that comprise *Atlas of My World* (figure 46), maps ranging from representations of individual nations to whole continents, each with their winding boundaries prominently underscored in thick black lines, chart the terrains she has traversed. To signal her symbolic possession of those sites, Zarina identifies each nation with a text in Urdu, her mother tongue and a major language of South Asia that is written in Arabic script. By claiming these far-flung territories for her personal "atlas," the artist emphasizes the multiplicity of contexts in which she locates herself.

45 Zarina, *Mapping the Dislocations*, 2001, woodcut printed in black on Nepalese paper, 11½" × 41¼" (block), 20" × 47½" (sheet). *Courtesy of the artist.*

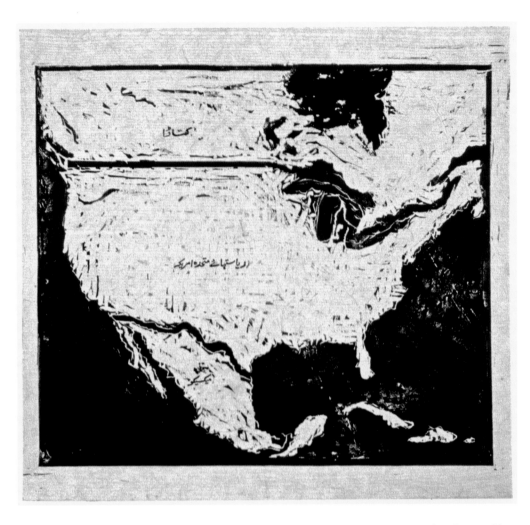

46 Zarina, *Atlas of My World I*,
2001, from portfolio of six
woodcuts with Urdu text,
block size variable, 25½" × 19½"
(sheet). *Courtesy of the artist.*

Displaced Homes / Displaced People

Despite the retrospective turn of her recent work, world political events continually spur Zarina to revisit themes of displacement, the loss of home, and the profound disruption suffered by millions of people brought about by ethnic and religious conflicts raging across the globe. Cut up and reassembled from thick stacks of her old prints, the motif of a house re-appears in *Displaced Homes / Displaced People* (1999) (figure 47). Snaking back and forth, and designed to be viewed from above, in this floor piece a massed procession of these iconic forms are strung together at intervals, like an undulating string of beads. This project was conceived during the final act of the bloodiest conflict on European soil since the Second World War—the malign 1998 attempt of Yugoslavian authorities to retain Serbian dominance in Kosovo by forcibly expelling all ethnic Muslims from their then-southernmost province. Having lived through events in India that she likens to the 1990s ethnic cleansing of Bosnian Muslims, Zarina recalls, "At that time the Kosovo war was going on, and on TV you had lines and lines of all those refugees. . . . In my lifetime we have seen these images, people always walking; they follow each other carrying bundles, whatever they can, as they're leaving home. . . . So I cut [my prints] up . . . made bunches of them. . . . I just tied them [together] and let them walk."[46]

Zarina regards forced migrations, particularly those involving fellow Muslims, as a seminal aspect of the modern age. The black knotted cord tying the house-bundles together in *Displaced Homes / Displaced People* is a palpable means of emphasizing their multiple points of connection: they are conjoined by shared refugee status, movement, and specific events and places. The artist compares her use of string and knots to Indian folk traditions in which knotting is commonly used and understood as a means of marking time and of recalling important events in the lives of individuals, families, and communities. "Birthdays were kept like that; there's a special thread and every year the grandmother will tie a knot for a year and then they will be counted. . . . All this work is done by women at home."[47] Like her other symbols, knotting—as a focus for memory that is both visual and tactile—becomes a minimal means of suggesting a wealth of associations: personal, cultural, historic, and geographic.

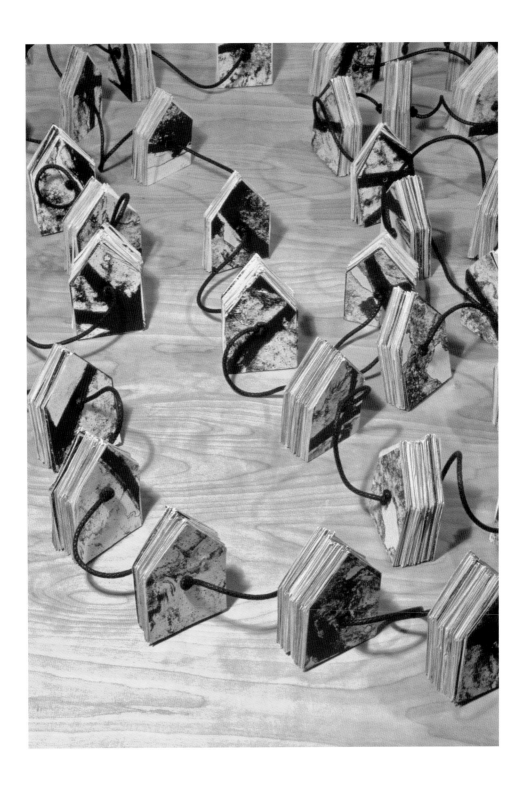

Cities, Countries, and Borders

In 2003, motivated by a newspaper photograph of Grozny, the devastated capital of the breakaway Russian republic of Chechnya, and shaken by growing Islamophobia in the West, Zarina produced *Countries* and *those cities blotted into the wilderness*, two sets of woodcuts under the overall theme of *Cities, Countries, and Borders*. Rather than taking refuge in silence, through these disquieting works the artist evidences her deep unease over attacks against Muslim communities during the course of her lifetime, as well as in the distant past. Made two years after the 2001 destruction of the World Trade Center by Islamic extremists, each series consists of literal and symbolic maps, with their names in Urdu text inscribed on each plate, of places visited by major acts of anti-Muslim violence.

Consisting of five prints labeled *Chechnya, Bosnia, Iraq, Afghanistan*, and *Holy Land, Countries* alludes to the contemporary plight of her coreligionists in Asian and European nations (and territories aspiring to nationhood) ravaged by conflicts whose ultimate resolution still remains largely unknown. With its title derived from a nineteenth-century Urdu poem by the Indian poet Ghalib, *those cities blotted into the wilderness* consists of nine plates whose titles bear the names of places that have witnessed havoc and bloodshed. *Baghdad* (figure 48) refers to the 1258 Mongol destruction of that city, *Jenin* to the Israeli military operation that leveled part of the West Bank town, and *Ahmedabad* to the three days of anti-Muslim rioting that shook this Indian city; these final two events took place in 2002. *Beirut* touches upon the devastation of the Lebanese civil war (1975–1990), *Sarajevo* (figure 49) recalls the brutal siege of 1992–1995, *Srebrenica* references the 1995 massacre of thousands of unarmed civilians during the war in Bosnia, *Grozny* marks the city's gutting during Chechnya's first attempt to secede from Russia (1994–1996), and *Kabul* (figure 50) references the creeping, decades-long devastation following the 1979 Communist coup in Afghanistan that spans Soviet intervention, fierce fighting among victorious resistance groups, and the violent 2001 U.S. overthrow of the theocratic government which was shielding the Islamists behind the destruction of the World Trade Center.

In the prints entitled *New York* (figure 51) (the city in which Zarina currently lives) from *those cities blotted into the wilderness* and *Holy Land* from *Countries*, the artist replaces maps with abstract, monochromatic imagery,

(opposite) 47 Zarina, *Displaced Homes / Displaced People*, 1999, stacked and cut prints and cord, sixty-eight units, each 4" × 2½" × 2". *Courtesy of the artist.*

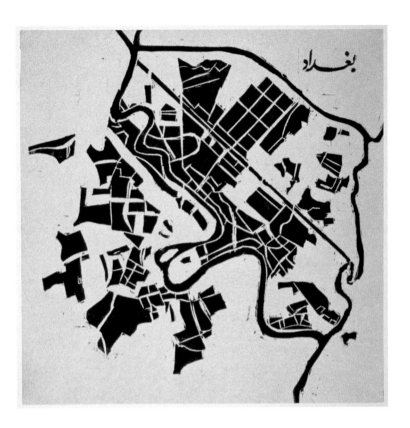

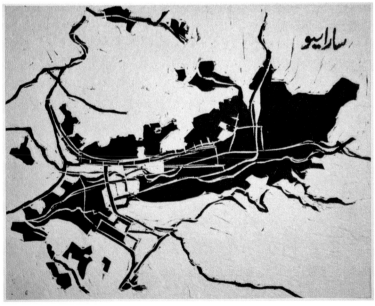

48 Zarina, *Baghdad*, from *these cities blotted into the wilderness*, 2003, portfolio of nine woodcuts with Urdu text, 7.25" × 7". *Courtesy of the artist.*

49 Zarina, *Sarajevo*, from *these cities blotted into the wilderness*, 2003, portfolio of nine woodcuts with Urdu text, 7½" × 6". *Courtesy of the artist.*

50 Zarina, *Kabul*, from *these cities blotted into the wilderness*, 2003, portfolio of nine woodcuts with Urdu text, 5½" × 7.25". *Courtesy of the artist.*

51 Zarina, *New York*, from *these cities blotted into the wilderness*, 2003, portfolio of nine woodcuts with Urdu text, 7.25" × 5½". *Courtesy of the artist.*

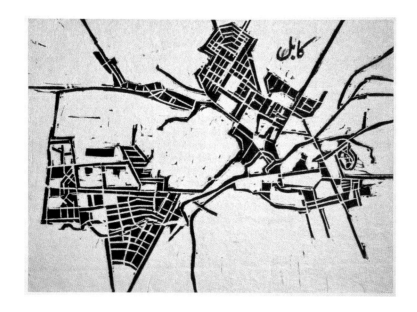

thereby concluding each group on a more textured, introspective note. Both are vertical, centralized compositions; the focal point of *New York* consists of a parallel pair of opalescent stripes running bottom to top on a raven-black ground, while in *Holy Land*, with its broad ebony band edged on both sides by a pale field, the configuration is reversed. Not unlike architect Maya Lin's Vietnam Veterans Memorial, these restrained motifs invite contemplation of world-encompassing contemporary events that ineluctably bind together our fates as human beings.

Allan deSouza · points of transit and contention

Migration, movement, and experiences common to postcolonial peoples have powerfully shaped the consciousness of Allan deSouza. The artist is from a generation of formerly subject peoples who were the first in their immigrant families to come of age while living within the colonial mother-lands. His vision of migration is freighted with ambivalence, as it is informed by an acute awareness of his liminal status as a former colonial subject who was born in Kenya but resided in the West for most of his life. Indeed, deSouza considers the idea of diaspora, which he describes as a "politics of dislocations . . . engendered by relocation and settlement," to be a possible alternative to the formulation of nation-centered identities and simplistic conceptions of multiculturalism.[48] In this, his identifications and interests are more immediately connected to the postcolonial diaspora itself—a broadly conceived notion of diaspora, which includes not only South Asians but also others from the third world who continue to make their way to the West.

DeSouza is acutely aware of the primal importance so many in the world attach to having a sovereign territory of their own. Having lived in the Indian diaspora and moved thorough multiple diasporic settings, the artist finds that his identity has been continuously redefined in relation to different nation-states and cultural groupings, an experience that closely informs his sensibilities. As he remarks, "I'm still making work . . . about identity and how it's formed by the nation or in relation to the nation. . . . In England, in Kenya, [I'm] always creating myself in relation to these nationalisms."[49] Accordingly, he is drawn to locales that have historically been the objects of bitter, sometimes violent contestation between competing postcolonial

nationalisms. The artist is ever alert to the symmetry between his experiences and the different paths and fates of other colonized peoples in the Anglophone sphere—both in terms of their struggles against British rule in India, Africa, and Ireland, and in their grappling with the lingering effects of colonialism. Similar sentiments are certainly shared by others who have endured external imposition and oppression. As a Spanish-born Basque scholar notes in her feminist ethnography of the violence in Northern Ireland, the struggle for Irish independence in the early twentieth century so captivated nationalists from Asian and Africa that they often "made a point" of seeing Ireland firsthand.[50]

In three bodies of color photographs from the late 1990s—*Threshold* (1996–1998) and two related series entitled *Auto* and *Dwelling* (1998–1999)—deSouza takes up dual themes inspired by his own migration and subsequent travels within the former British imperial realm. His strategies in these works, with their allusions to modern sites of international transit and to places scarred by sectarian violence in Northern Ireland, were shaped by the artist's conscious effort to address the intricate and often elusive questions of identification facing those whose lives are shaped by transnational movement and by ongoing political realignments in the postcolonial world.

The *Threshold* Series

In the twenty-four photographs of the *Threshold* series, deSouza set out to examine the airports and train and bus stations through which contemporary migrants typically pass. These "in-transit spaces," he writes, "suggest the ambivalence of travel: anticipation and loss; excitement and frustration; the desire for new futures, the escape from a past."[51] At the same time, deSouza observes how such institutionalized spaces begin to mold third world migrants' behavior and perceptions of themselves from the moment they arrive. An inveterate traveler, he culls images from his frequent flights overseas, which comprise the bulk of the *Threshold* series. Each of the airline terminals the artist documents represents a familiar point of crossing and recrossing in his regular trips to London, Belfast, and Lisbon (his parents came to reside in Portugal), and to different cities throughout the United States, including New York, and Los Angeles and San Francisco (the California cities where he is currently based).

For present-day migrants, there is perhaps no more recognizable signi-

fier of diasporic passage than the image of an airplane, at a time when relatively inexpensive air travel has made populations ever more mobile. The airport as a site and a metaphor for lives immersed in displacement, transnational passage, and cultural intermingling figures prominently in the writings of Pico Iyer, a British-born travel writer, essayist, and novelist of Indian ancestry. Recalling his youthful journeys, he remarks, "The airport was the spiritual center of the double life: you get on as one person and get off as another."[52] A number of photographs of the *Threshold* series focus on the airport as an emblem of contemporary migrancy to the West. This space of transition can mark both the beginning and the end of a diasporic journey, at least for those with the means to afford such travel. Indeed, for some migrants the airport terminal has literally become the point from which their dwelling in the West begins—as demonstrated by the outlandish saga of the Iranian exile (on which the 2004 film *The Terminal* is loosely based) who by necessity and choice lived as a stateless person in Paris's Charles de Gaulle airport from 1988 to 2006.

Leaving the land of his birth as a young child, deSouza passed through the vast airline terminal in Frankfurt, Germany, that serves as a transnational hub through which millions of migrants from the subcontinent and Africa must transfer aircraft before proceeding to their final destinations. Revisiting his boyhood memories of that airport, deSouza describes it as "everything you imagine the West is going to be. . . . Everything seems so wealthy, everything is so clean."[53] In his view, that first sighting is "central, iconic . . . [a] sort of defining moment for this generation of migrants."[54]

A number of the snapshotlike photographs from the *Threshold* series depict London's Heathrow Airport, a setting that holds special meaning for the artist as the entryway through which he and his family first stepped foot on English soil. Its imagery is meant to evoke both the allure and the terror such spaces can hold for present-day migrants. To call attention to the architecture itself, deSouza prints the photographs in saturated tones and deliberately eliminates all references to the crowds that normally throng the terminals. As he says, "I wanted them to be really beautiful, [to have] this kind of sinister attraction."[55] In the modern airport, as the artist points out, the traveler must pass through a series of "forbidding, frightening spaces."[56] Although these might appear to be rather unremarkable images of sites familiar to many travelers, for those who have made the

life-altering crossing from Africa, India, or other points outside the West, entering such cool and sterile, yet restless, portals into an unknown future can be especially unsettling. "It's attractive because you're arriving at this new place, but it's also anxiety bound, because you're not quite sure what's going to happen."[57] Reflective of the migrant's difficult adjustments and uncertain emotional state, these images of a cavernous, glittering airport, with its barren waiting areas and always-moving walkways, escalators, and baggage-claim carousels, exude an air of ominous expectancy.

In one evocative image, *Heathrow, 3* (figure 52), we see a shadowy, deserted airport lounge in which a vast stretch of empty plastic chairs bolted together into uniform rows awaits the traveler. DeSouza comments that such fixed public seating structures negatively affect the way migrants behave and relate to one another, by not permitting families to cluster around or to alter their environment to better suit their needs. In two associated works, an imposing bank of escalators in *Heathrow, 2* (figure 53) and an expanse of moving sidewalk in *Heathrow, 4* emphasize the impersonal, highly utilitarian nature of these settings, as they are primarily designed to expedite the rapid movement of large masses of people from point to point, like inanimate objects on a conveyor belt.

First zones of contact with the West are, according to deSouza, also zones of control, as they mobilize powerful technologies and information systems to manage, track, and regulate the traveler's movements. These spaces commonly subject the migrant to continuous surveillance via security cameras mounted in the terminals, inducing a heightened self-consciousness. Beginning from this initial encounter, the artist views the migrant as someone subjected to a highly developed body of expectations and imaginings about the non-Western Other. In this light, entering the West is not simply a matter of passage, but also an act that brings the migrant directly under the Western gaze. For deSouza, therefore, the modern airport, like the touristic encounter, is charged with very particularized associations as a primary site where power relations between the West and its Others are continually played out. "You're always watching yourself, . . . always aware of being looked at, so you start monitoring your own behavior . . . because you've become a representative of the whole race whatever you do." According to deSouza, such scrutiny engenders in the migrant a "double consciousness . . . [as] you take on the eyes of who's watching you."[58] The artist's concerns

52 Allan deSouza, *Heathrow, 3,*
from the *Threshold* series,
1998, chromogenic color print,
16" × 16". *Courtesy of the artist
and Talwar Gallery, New York.*

53 Allan deSouza, *Heathrow, 2*,
from the *Threshold* series,
1998, chromogenic color print,
16" × 16". *Courtesy of the artist
and Talwar Gallery, New York.*

recall both Foucauldian comments on the profound power that the ordering of physical space has in the shaping and control of human behavior and the key concept of "doubleness" or split consciousness in the black psyche—referring to the conflicted state that arises by attempting to look at oneself through the eyes of the dominant culture.[59]

In *O'Hare, 2* de Souza alludes to the fetishization of third world peoples and cultures by the West in travel advertising placed throughout airline terminals. Reflecting his interest in postcolonial theory, which applies the Freudian psychosexual notion of the fetish as an object of displaced desire and projection to the native or native culture, deSouza views himself as an object of the externalization of the (narcissistic) Western self and its needs onto the Other. Therefore, what might appear to be rather unremarkable advertising images familiar to many travelers constitute, for the artist, highly suggestive visual signs replete with personal as well as collective meaning. As a contemporary cultural critic writes, the more blatant instances of such fetishization transform "all specificity and difference into a magical essence."[60]

Terrible Beauty • the Terrains Series

DeSouza's circulation within nations of the former British Empire moved him to create works that express feelings of affinity with other peoples and lands that fell under colonial rule, and which later became sites of protracted postindependence struggles. These ties are doubly freighted for the artist, as Kenyan independence from Britain was catalyzed by the 1952–1960 Mau Mau rebellion, and India witnessed Asia's first major anticolonial uprising, the Great Mutiny of 1857, which began when Indian soldiers serving in the British East India Company's armies turned on their British officers. For those who share such highly contested histories, the local landscape is forever marked by inescapable tensions—as it is both the site of the bloodshed and strife that have permeated its soil, and the locus of nostalgia, identification, and longing. Since 1995 deSouza has made annual trips to Ireland. Growing up in England, deSouza found bonds with the Irish—based on being from groups once enfolded in the globe-spanning British Empire, as well as on having a common religious heritage, since his family (like most Goans) were Catholics because of the Portuguese colonial influence.[61]

Engaged in photographing the Irish landscape for over a decade, deSouza is "fascinated by how the land itself becomes the source of mythology and

longing."[62] Not only does he seek evidence of collective efforts to construct a sense of Irishness in the national heritage houses and other public memorial sites that he photographs, but also in traces of violent conflict he discovers embedded in its terrain. The images in the related series of color photographs from the late 1990s entitled *Dwelling* and *Auto* depict the aftereffects of the campaign by the IRA to reunify Ireland that has left its imprint on the countryside, towns, and residents along both sides of the border. Shot mainly in areas in Ireland that abut Northern Ireland, de-Souza scrutinizes the landscape as a "complex manifestation of nationalisms in relation to the 'Troubles,' rural depopulation, . . . as well as the emigrant's nostalgia and yearning for 'home' and the 'land.'"[63] The "Troubles" is the local term for the violence that has gripped Northern Ireland since the 1960s, in response to anti-Catholic discrimination. With a predominately Protestant population, the six northeastern counties of Ireland remained British after Ireland gained full independence in 1937, a state of affairs that has never been recognized by the Republic of Ireland.

The *Dwelling* series depicts abandoned buildings identified only by the name of the town or region in which they were located. Among them is *Omagh, Co. Tyrone, August 1998* (figure 54), which offers the seemingly prosaic image of a tidy row of houses on a small-town street; only on closer inspection does the viewer notice that almost all their windows are boarded shut. DeSouza took this photograph in Omagh on August 17, 1998, two days after the explosion of a five-hundred-pound bomb in that town, which caused twenty-nine deaths and hundreds of injuries. This appalling act of terrorism, described by local observers as the worst single incident in Northern Ireland in recent times, was committed by a paramilitary splinter group calling themselves the "Real IRA." It announced their opposition to growing local acceptance of the peace initiative between Sinn Fein, the political wing of the mainstream IRA, and Britain.

For the artist, images of shattered or derelict cars set in otherwise idyllic Irish landscapes bear witness to a "transient and intervening violence."[64] While he believes that the wrecks depicted in the *Auto* series were the result of IRA bombings, deSouza withholds graphic representations of bomb blasts and carnage. Nor does he generally exhibit his associated photographs of the armed guard towers and barricades that line the nearby border between Northern Ireland and the Republic of Ireland that would make these connections all too plain. Instead, in works like *Carrowkeel, Co. Sligo,*

54 Allan deSouza, *Omagh, Co. Tyrone, August 1998*, chromogenic color print, 16" × 20". *Courtesy of the artist and Talwar Gallery, New York.*

the mutilated, upturned remains of an automobile can be seen at a distance, resting on the gentle slope of a green hillside. In *Ballymote, Co. Sligo* (figure 55), one of the most striking images in this group, a solitary tree bears a bizarre metallic object embedded high in its trunk—a torn-away fragment of an automobile, hurled into it with immense force.

While these photographs are certainly intended to stand as a silent testament to dreadful unseen and unnamed events, they are deliberately uninflected. By their very ordinariness, they arrest the spectator's gaze with glimpses of something that has gone awry in the otherwise mundane, tranquil settings they witness and record. Such understated imagery suggests that while incidents of violence may occur with shocking, devastating swiftness, our lives are chiefly spent in the lingering shadows of their aftermath or in the intervals between them, as we seek to reconstruct those events from the traces they leave behind. By becoming, as he says, more "visually questioning," deSouza hopes to provoke audiences to recognize how historical memory buries some images while elevating others, and to ferret out meaning by delving below the surface of the seemingly commonplace.

Vacationing in a quiet Donegal village, deSouza writes, "Evidence of violence and change [nonetheless] intrude everywhere, at times discreet, at times traumatic. . . . [C]elebrating my son's birthday as the news comes over the radio that a car-bomb has just gone off in a crowded shopping street. . . . I've looked, then, to the ordinary and to what others might have passed by as unworthy, since it is the ordinary and unworthy in all their surreal presence that seem . . . to somehow embody and preserve the contradictory traces of what, with deference to W. B. Yeats, has changed, changed utterly; when a terrible beauty is born."[65]

Y. David Chung · sites of contact and mixing

Having traveled the world since he was a child, the Korean American artist Y. David Chung is fascinated by sites of cultural contact, diffusion, and cross-fertilization. For Chung, the Asian immigrant experience exists within a larger multicultural vision—that of a nation continually re-formed by waves of newcomers from around the globe who, by circumstance and necessity, have come to live side by side in this nation's cities. By conjuring

55 Allan deSouza, *Ballymote, Co. Sligo*, 1998, chromogenic color print, 12" × 18". *Courtesy of the artist and Talwar Gallery, New York.*

the intercultural complexity of an American metropolis, his work from the mid-1980s through the early 1990s invokes the atmosphere of a fast-paced, constantly changing milieu, with its complicated and volatile mixtures of races, cultures, and languages. The urban environment of Washington, D.C., became an inexhaustible source of material for Chung. Roaming the streets and the Metro (the Washington subway system), Chung produced quick sketches of the people he encountered, images that were later distilled and synthesized into numerous drawings and prints. "Interpreting what you saw really gives a very personal stamp to the work," he reflects. "You can just create a whole new imagery from these memories."[66]

Through a variety of media, including large-scale charcoal drawings, prints, film, video, music, and performance, Chung offers an expansive vision of urban American communities as continuously being reconstituted by ongoing migration and replete with possibilities for interchange and mutual transformation. "We're now thinking globally. . . . People from around the world are coming to this country and living here, [so] this culture is as much a part of yours as anything else. . . . To share with it is the most important thing."[67] His swirling invocations of city life have a strongly stochastic quality, with their dense aggregations of line, imagery, objects, and sounds intruding on and jostling one another. Out of this highly compressed jumble of elements, Chung suggests the potential for multiple contacts, collisions, fusions, and even new formations that can arise organically in places where groups come together. Often, he observes, this cross-fertilization "happens unwittingly . . . without any conscious, deliberate action" on the part of those involved.[68]

In the artist's conception, the result of such interactions has not simply been diversity, but rather the active formation of "new mixed cultures."[69] By pointing to inner-city neighborhoods in transition where different groups encounter one another, Chung underscores a new urban ethos that is emerging throughout the nation. Whereas concepts like "contact zones" are often framed in oppositional and critical terms, Y. David Chung's vision of urban contact and mixing tends to be more open ended and ecumenical. It brings to mind a particularly stirring characterization of cultural mixing: "To mix means both to mate and to battle. . . . It incorporates . . . interethnic violence . . . as well as the possibility of a 'rainbow future,' when everyone is of 'mixed race' and the barriers of race-as-class are destroyed."[70]

The artist's years as an observer and participant in diverse societies

have provided unique insights into the experiences of other immigrants in America. In turn, his presence in the United States allows for comparisons with other societies where parallel processes of cultural mixing and syncretism are at work. For Chung, a firm grounding in localism led him to discover affinities that not only link him to other Korean diasporas, but also to groups in this nation and around the world whose lives are being profoundly transformed by new cultural contacts and fusions. Indeed, by the late 1990s, Chung began to extend his collaborative, interdisciplinary approach to working with overseas artists and performers in both Western and non-Western nations.

Born in Bonn, Germany, in 1959, Chung is the son of a former South Korean naval officer and diplomat who spent his formative years shuttling between postings in Europe, Africa, and the United States, with periodic visits to Korea. After attending an American boarding school during the early 1970s, Chung rejoined the family that had moved to Washington, D.C., where his father, who had since retired from the foreign service, opened a string of groceries, sandwich shops, and other businesses in which the artist and other family members worked. Since childhood, Chung demonstrated an interest in art; initially entering college as a premed student, he soon transferred to visual art. After moving to New York City in the early 1980s to work in graphics and animation, he eventually returned to Washington to assist with the family businesses. There he resumed studying art and was greatly encouraged by his first one-person show at a commercial gallery, which took place in 1987, the year he received his American citizenship.

Even though the artist spent much of his life outside South Korea, because his father was an official representative of his homeland and his family frequently lived in places where few Asians were present, he grew up with a strong awareness of his Korean identity and of the power of difference. He recounts, "Personally, I was always conscious of the race issue when I was living in foreign countries. Like in Africa, in some places they had never seen any Asians before they saw my family."[71] However, it was not until attending college in the United States that Chung first felt compelled to confront the imperatives of race and what it meant to shift between cultures—by crafting a life-sized plaster statue of a man tearing off a Western mask to reveal a Korean face.

Insights born of personal experience led Chung to address the lives and

struggles faced by Korean merchants like his father in America's inner cities. He evokes a complex vision in which the most recent waves of immigrant Asians have come to share in a beguiling and explosive urban landscape that, while certainly resonant with conflict, danger, and contradiction, is also filled with hope for the kind of regeneration that new possibilities can bring. Even as the artist alludes to the complications that at times arise in any interplay between groups and cultures, he steadfastly denies any political intent behind his work, nor does he offer a political or sociological analysis of present-day conditions. Rather, his work is subjective, immediate, and experiential—the outcome of proximity, affiliation, and interchange between peoples viewed as unpredictable and contingent. Despite the often difficult and conflict-ridden social conditions Chung depicts, his chief interest lies in telling stories about the places and times he has witnessed. He emphasizes, "It's not like a cause. . . . My approach is very different, it's much more autobiographical. . . . It's more of a search [for] my own past and my own questions about identity as a person in society."[72]

The Store, Seoul House (Korean Outpost), and Angulas—Street of Gold

The Korean-owned small store, and the multiethnic inner-city neighborhoods in which they often are situated, are subjects that have figured predominantly in David Chung's early work. In *The Store* (1987), *Seoul House (Korean Outpost)* (1988), and *Angulas—Street of Gold* (1990), Chung provides insights into facets of immigrant life that have become endemic to the urban American landscape. Unlike the Chinatowns or other ethnic enclaves where Asians tend to predominate, Chung's locales are chiefly mixed urban settings in which Asians are generally in the minority or constitute one minority among many. These are the grounds where rapidly expanding Asian immigrant populations commonly come in contact with other minority groups and with the dominant culture.

To the extent that Asian immigrants have historically made niches for themselves as small businessmen the world over—often as a result of barriers that prevented them from pursuing other occupations—the image of the family-operated neighborhood store, like the restaurant and laundry, can be seen as a primary trope of settlement: a landfall in a new nation and a nexus of collective memory. Explaining why he made the store a subject of his art, Chung states that during this period Koreans "have made a considerable impact on changing the face of the American urban landscape. . . .

Not all Koreans . . . go into the store business; however, it is in this business that they are best known."[73]

In a charcoal drawing from this period entitled *The Store* (figure 56), a scowling Korean merchant and his glum assistant stand behind the counter in uneasy mutual silence, evoking stark moments of solitude. As Chung notes, running such businesses can be acutely isolating, "especially if you have to work these incredibly long hours, or you're behind this bullet-proof glass. You're not communicating with your neighbors or your customers. You are kind of locked in there."[74] Its edgy atmosphere, rife with the possibility for random violence, is underscored by the elongated foreground shadow of an unseen onlooker standing in the doorway—suggesting the tensions of life in a strange, imperfectly understood place. Faced with an atmosphere of growing racial tension and resentment against primarily Korean merchants in inner-city neighborhoods, Chung sought a means, through art and music, to convey the present-day situation of Korean immigrants in this country. Noting the ubiquitous presence of Korean-run markets and businesses on virtually every street corner in major urban areas, Chung comments, "I lived in a depressed area in Washington, and it appeared that every store was run by a Korean person. It really struck me as being very peculiar. . . . They don't speak English, they don't know anything about American customs, much less about black American culture. . . . How do these people get along?"[75]

In 1988 Chung debuted the "electronic rap opera" *Seoul House (Korean Outpost)*, an elaborate multimedia production that consisted of seven non-linear tableaux focusing on the travails of three generations of a Korean immigrant family struggling to run a grocery store in the inner city: a father preoccupied with business, a grandmother yearning for her lost life in Korea, and a teenage son longing to break free. Explaining his reference to the store as a "Korean outpost," he relates, "It's like a war-zone. . . . these people are going to an outpost where they fortify themselves. . . . They are behind bullet-proof glass."[76] Through converging, slice-of-life narratives, the store serves as the site of contact with and tension between the demands and attractions of the outside world.

The tale unfolds through a highly stylized drama based on elements of traditional Korean mask theater, reminiscent of Japanese Noh theater, in which each actor wears a mask that symbolizes a certain character type, rather than appearing as an individual.[77] Apart from local popular enter-

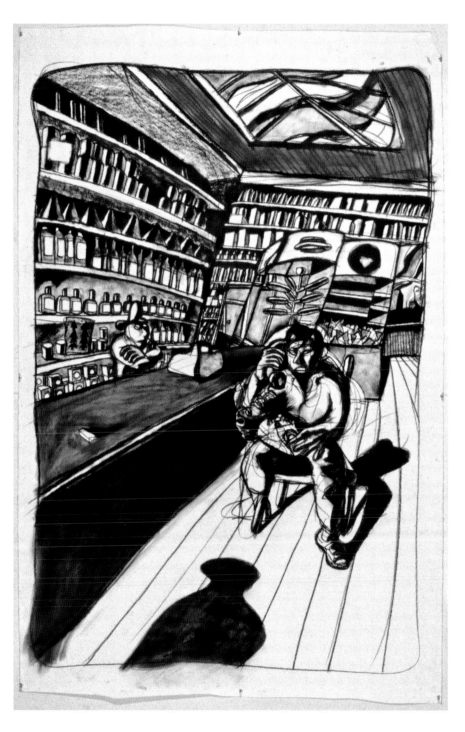

56 Y. David Chung,
Store, 1987, charcoal
on paper, 80" × 50".
Private collection.
Courtesy of the
artist.

tainer Black Elvis, who acts as a commentator, each pantomimes her/his tale to a recorded vocal track scripted by the artist. In choosing this antique theatrical form, Chung indicates that his heritage remains a primary lens through which he envisions these contemporary events, even as those idioms must be interwoven with the technologies that shape the visual imagination of his generation. He reflects, "I think we should try to reinterpret traditions from our ancient past with modern technology, so one does not completely wipe out the other."[78]

First mounted at Washington Project for the Arts, *Seoul House* combined performance, music (blues, rap, and classical), dance, visual art, video, and martial arts to deal with issues that sprang from the artist's own experience. A collaboration with the composer Charles Tobermann, the ethnomusicologist William (Pooh) Johnston, and the singer-songwriter Black Elvis, the production embraced musicians, performers, and filmmakers from African American, Latino, and Euro-American as well as Asian communities in the D.C. area. All the live action took place in the stockroom, indicated by the stacked boxes of merchandise that enveloped the performance space. A floor-to-ceiling, wraparound charcoal mural that Chung drew to depict the store interior and the frenetic urban panorama outside (figure 57) served as a backdrop. Installed overhead was a glowing television "surveillance monitor," similar to those found in many grocery stores, continually displaying videotaped images of an actual store interior, as well as footage of the son's youthful character jauntily walking in the surrounding neighborhood—a depiction of the freedom that awaits him beyond the stifling confines of the family store. The principal characters included a Korean merchant, the merchant's Korean American son "James," who is torn between his obligations to help the family in their businesses and his desire to escape to the outside world, an African American deliveryman, and a pushy Caucasian salesman (figures 58 and 59). For Chung, the deliveryman represented the voice of the community, watching the inexorable takeover of their old neighborhood by the new immigrant groups.

As Chung remarks, in *Seoul House* the family situation is centered on the figure of the son, "because it's on his future that this sacrifice is based. . . . He's symbolic of the young Korean friends that I had . . . he's . . . all those things . . . [in] one character."[79] James's dilemma is reflected in the following excerpts from "Tableau Four—James' Aria": "When I'm not at school /

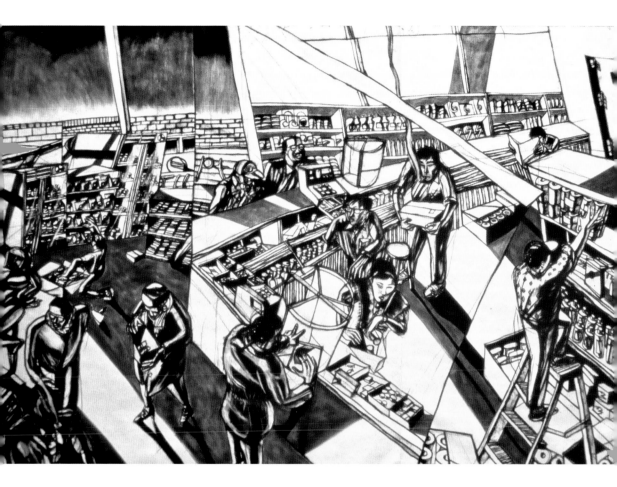

57 Y. David Chung, *Seoul House (Korean Outpost)*, detail of installation view, 1988, Washington Project for the Arts, Washington, charcoal mural, 10" × 70". *Courtesy of the artist.*

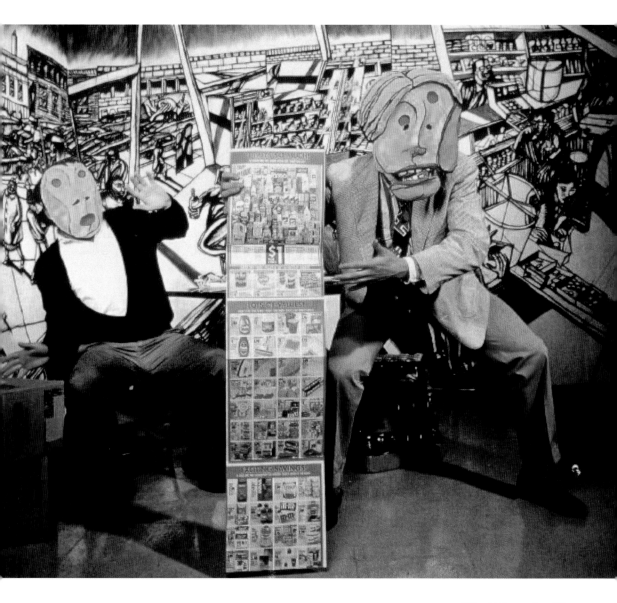

58 Y. David Chung, *Seoul House*,
scene from live performance
with Mr. Kim and Salesman, 1988,
Washington Project for the Arts.
Courtesy of the artist.

59 Y. David Chung, *Seoul House*, scene from live performance with Black Elvis portraying the Delivery Man, 1988, Washington Project for the Arts. *Courtesy of the artist.*

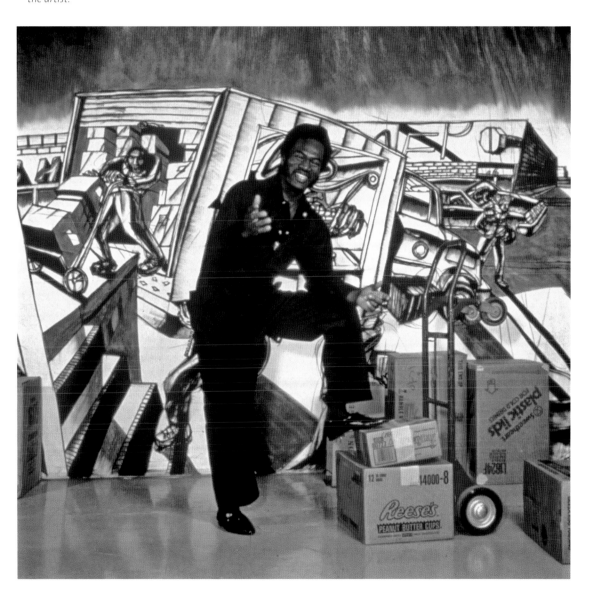

I'm here . . . playing the fool / This is really beat . . . / I'd rather be on the street / But what can I do? . . . I don't know where to start / Without breaking Granny's heart / Got to fit in . . . to win / To get out of this scene / So, I don't feel in between a spook . . . and a gook." At one point the son rebels against the claustrophobic atmosphere of the store and cries out, "I need some air!"[80] By setting the son's narrative to the cadence of rap music, a popular form associated with inner-city youth, Chung gave a contemporary voice to the younger generations in the Korean immigrant community who have been raised in the United States.

Meanwhile, for the character of the father (Mr. Kim), the pressure to succeed is intense, as reflected in "Mr. Choi's Song," in which a prosperous Korean businessman visiting the store shouts in outrage when he sees bare shelves: "Mr. Kim . . . / What are you doing? / Your store is poorly stocked. . . . / do you want to get out of this hole? / . . . Well . . . you've got to work hard! . . . In just five more years . . . / You could get outta here . . . outta here . . . OUTTA HERE!!"[81]

In a 1990 article entitled "Beyond The Melting Pot," *Time* magazine foretold that "in the 21st century . . . racial and ethnic groups in the U.S. will outnumber whites for the first time . . . within the lifetime of those born now, the 'average' U.S. resident . . . will trace his or her descent to Africa, Asia, the Hispanic world, the Pacific Islands, Arabia—almost anywhere but white Europe."[82] Indeed, as of 2005, in four states (California, Hawaii, New Mexico, and Texas) ethnic minorities comprise more than 50 percent of their populations.[83] Seemingly echoing that prediction, in the same year Chung—in collaboration with the photographer Claudio Vazquez and the actor-poet Quique Aviles, along with Dibble, Johnston, and Tobermann—devised *Angulas—Street of Gold*, a layered, multisensory walk-in environment to depict life in Mount Pleasant, a rapidly growing ethnically mixed enclave of Washington, D.C., where the artist then lived.

First exhibited at the Jamaica Arts Center in New York, this traveling installation incorporated an expansive vision of the Korean American experience in a contemporary urban landscape made up of migrants from around the world—a multiethnic civic space shared by overlapping diasporas that embodies the inexorable process transforming America into a society of peoples and cultures whose origins are non-European. The multilayered character of the inner city—what the artist describes as a "stunning tableau of strange yet beautiful alphabets and faces; Arabic, Urdu, Vietnamese,

El Salvadoran, Cambodian, and South Carolinian"—is evoked by a flurry of images and sounds that convey the vibrant quality of a cityscape in continual motion and transformation.[84] With his choice of the title *Angulas* (a Spanish delicacy of baby eels that somewhat resembles linguine), Chung references an exotic dish, overflowing with tangled ethnic ingredients, that serves as an apt metaphor for the considerable impact of immigrants on the contemporary American city as agents of cultural exchange.

Angulas—Street of Gold is, for Chung, a "visual analysis" of the immigrant experience that, through a process of collaborative free association, interweaves drawings, photographs, video, and original music. Its centerpiece is a thirty-two-foot-long mural, presented as a series of eight conjoined vignettes. Employing a frenetic interplay of multiple vantage points, the images arrayed across these panels are composites—accumulations of fragmentary "notations" that are almost cinematic in their capacity to embody a succession of ephemeral situations. One segment, for example, exposes the interior of a car parked on a street bustling with human activity and dominated by an unbroken wall of seemingly animate buildings (figure 60). Cloistered within, a lone passenger waits in a private limbo that is simultaneously reassuring and disconcerting. Through giddy juxtapositions of extremes—inside/outside, alone/engulfed, silence/stridence—the layered sensory environment, so intrinsic to the experience of inner-city life, is evoked.

Accompanying *Angulas* is a twenty-two-minute videotape directed by Chung with music, images, and sounds culled from the Mount Pleasant neighborhood. The video is composed of impressionistic scenes from the life of a fictitious El Salvadoran restaurant worker, played by Aviles. The footage was shot with a Hi8 camera held sideways, using a vertical format that gave the images a strikingly abstract, disorienting quality. The tapes were played on two video monitors inset in freestanding, three-dimensional figures fashioned by Chung from paper and wood—one a fantastical charcoal rendering of Cap'n Crunch (a cartoon character used to advertise children's breakfast cereal) (figure 61) and the other a large, Amazon-like woman with a television monitor mounted in her stomach. According to Chung, the images in *Angulas* were meant to echo the sensory overload and disequilibrium experienced by the main character, who is being "bombarded by messages from the new American culture as well as his own traditional values. He's trying to make sense of it all."[85]

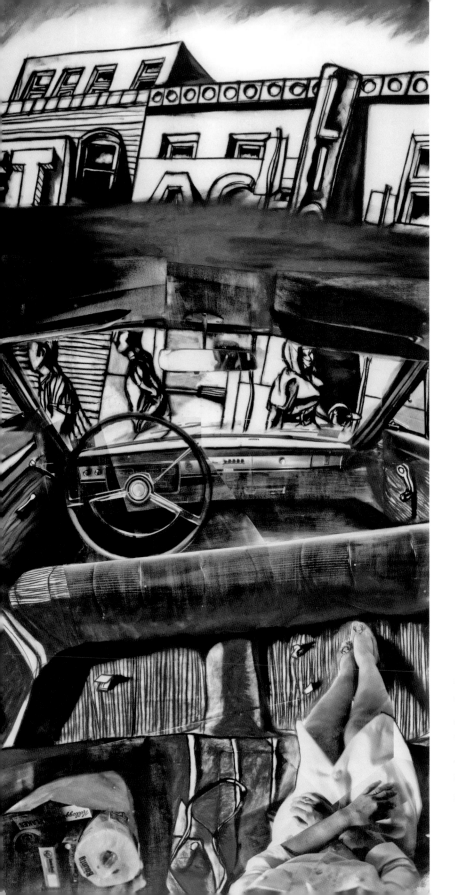

60 Y. David Chung with Claudio Vazquez, *Angulas—Street of Gold*, detail of mural, 1990, multimedia installation, Jamaica Arts Center, New York, 8" × 32" (mural). *Courtesy of the artist.*

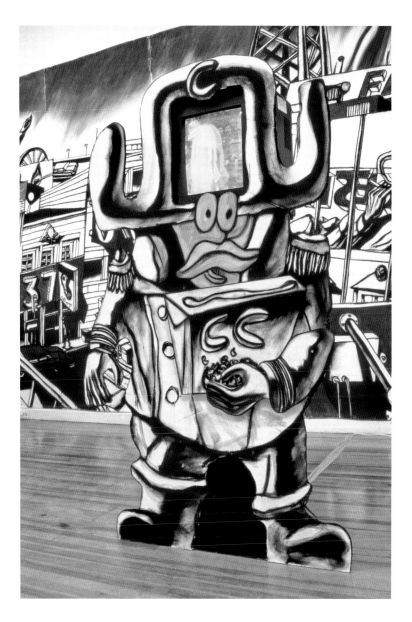

61 Y. David Chung, *Angulas: Captain*,
from *Angulas—Street of Gold*, 1990,
second version at Maryland Art Place,
Baltimore, charcoal on paper, wood,
and video projection, 48" × 33" × 24".
Courtesy of the artist.

Turtle Boat Head and *The Wishing Tree*

Beginning in 1992, the artist increasingly sought to engage with subjects that are more wide reaching. He initially focused on forming connections with a deeper Korean history and cultural legacy, albeit from a very personal vantage point. In *Turtle Boat Head* (1992), Chung created a gallery-sized multimedia environment for the Whitney Museum of American Art at Philip Morris in New York City. Incorporating folktales and epics familiar to other Koreans, yet largely unknown to American audiences, the installation was meant to take the viewer on a "walk through the mind" of a young Korean immigrant whose thoughts constantly dart among childhood memories of Korea, events from his homeland's history, and his current life in the United States. Reinforcing this idea of stepping into an immigrant's psychic space was a pair of large cutout drawings of a young Korean male's face, flanking either side of the glass doorway leading into the gallery. Chung's term "head" comes from the American vernacular expression for "thinking too much about something."[86]

On the surrounding gallery walls were three panels of a large black-and-white charcoal mural, each section dedicated to a different theme. The largest segment dealt with modern Korean history, stretching from the Japanese invasion and occupation of Korea from 1905 to 1945 through the Korean War and the subsequent division of that country. The second juxtaposed images of contemporary Korean immigrant experience in the United States with scenes from modern-day Korea. The historical images Chung evokes are primarily those reflecting the experience of his parents' generation. The artist contrasts them with his own immediate memory and those of other Korean youth in America who grew up in the 1960s and 1970s—which also marked the beginning of the major period of Korean postwar immigration. In a passage of the mural entitled "The Dream of Al Sharpton," Chung addresses the struggles of fellow Koreans to create a place for themselves in American society—by references to incidents of anti-Korean agitation, violence, and boycotts against local merchants that occurred in New York, Washington, and Los Angeles in the early 1990s, as well as to the 1992 Los Angeles riots in which numerous Korean businesses were ransacked—some reduced to smoldering ruins.

Like *Seoul House*, *Turtle Boat Head* seeks to impart a visceral sense of the experiences and collective histories of Korean people in the diaspora. Al-

though the installation only allows viewers to encounter the lifeworlds of Korean immigrant merchants in a highly mediated, symbolic fashion, the simple act of traversing the space can nonetheless impart an intensified feeling of reality and immediacy. The physical and temporal anchor of the installation is a scaled-down replica of a small Korean corner grocery that viewers could enter (figures 62 and 63), containing a video installation created by the artist, along with collaborators Dibble and Johnston. Here the store, called the "Hi Sence" market, is a boxlike, eight-foot-tall plywood structure whose exterior and interior walls were papered with Chung's drawings and made to resemble a typical Korean grocery with goods claustrophobically stacked on encircling floor-to-ceiling shelves.

Audience members entering the "Hi Sence" vestibule came face to face with a thick Plexiglas partition, similar to those found in many inner-city convenience and liquor stores, on which video images were projected. As the video begins, the life-sized figure of the Korean store owner serves an unseen customer, while sounds of the transaction can be heard over the audio system. As if viewed through the proprietor's eyes, various scenes from his past surface and then recede as he goes about his routine. Shelves stocked with the merchant's inventory fade into old wartime footage of Seoul, where soldiers march down rubble-strewn streets of the South Korean capital as refugees flee the city (figure 64). That interlude is interrupted by the customer's voice, and the image shifts back to the present. Images of American planes flying over Seoul reappear, raining propaganda leaflets that morph into a shower of candies falling on the store. Fantasies of hitting a golf ball transmute into scenes of the Second World War, and images of Seoul blend into South Central Los Angeles in flames, with images of armed Korean merchants defending their stores during the riots.

Amid all this, the storeowner dreams of middle-class American life and his pristine suburban home. In the living room he has installed an *ondol*, a traditional Korean heated floor covered by varnished paper. Although the piece contains harsh images of a history of strife and suffering that marks relations between the United States and Korea, what Chung finds most compelling are the "elements of traditional Korean life brought over and integrated into the new Western world . . . some of the roots of this new syncretic culture."[87]

By the late 1990s, Chung actively sought to collaborate on projects with artists and performers in other parts of the world. During this period he

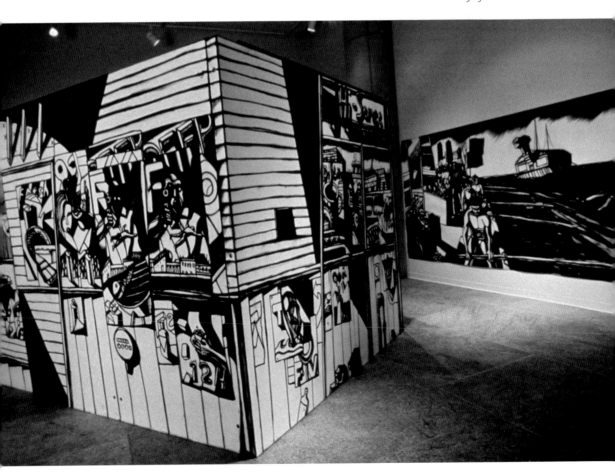

62 Y. David Chung, *Turtle Boat Head*, detail of installation with store, 1992, Whitney Museum of American Art at Philip Morris, New York, charcoal on paper, wood, and video projection, 8" × 9.5" × 12.5". *Courtesy of the artist.*

63 Y. David Chung, *Turtle Boat
Head*, view of store interior, 1992,
Whitney Museum of American Art
at Philip Morris, New York.
Courtesy of the artist.

64 Y. David Chung, *Turtle Boat
Head*, video still image, 1992,
Whitney Museum of American
Art at Philip Morris, New York.
Courtesy of the artist.

65 Y. David Chung and Pooh Johnston with the Kazakh music ensemble Echoes of the Centuries for the live music and video performance *New Light*, directed by Y. David Chung, 2001. *Courtesy of the artist.*

would make several trips to Kazakhstan, a Central Asian nation that had gained its independence with the dissolution of the Soviet Union in 1991 (figure 65). The artist was especially struck by the ways that identity is being constituted in Kazakhstan, whose distinctive mixture of peoples is reflective of a history of Russian colonization and forced population movements that took place under both the Czarist and Soviet regimes.[88] While ethnic Kazakhs are still the predominant group, there are significant numbers of Slavic Russians and Ukrainians, as well as Uzbeks, Turks, and Germans. Further, to Chung's surprise, he discovered a settlement of ethnic Koreans who have been absorbed into Russian culture. Captivated by this encounter, Chung puzzled over the dynamics of a society in which Asians of various backgrounds and intermixtures constitute a large percentage of the population. Yet even in this faraway setting, he found that his observations of multiculturalism in America remained meaningful, if not necessarily readily transferable to Kazakhstan. "It's very interesting [how] the whole Asian dynamic over there works. . . . They're the people in power. . . . But . . . they're still dominated by Russian culture. . . . This whole idea of identity and race,

...it's at a very different level than you would deal with it here in the United States."[89]

Collaborating with local artists and musicians, Chung, along with Dibble and Johnston, cowrote, staged, and created the set design for a one-act opera entitled *The Wishing Tree*, which was performed in 1999 at the State Art Museum in the capital of Almaty.[90] Like *Seoul House*, this work speaks to the dilemmas facing the younger generations in choosing which paths to follow amid rapidly shifting circumstances. Sung in Russian and Kazakh, the native language of the region, which had been outlawed under Soviet rule, and combining folkloric music with contemporary Western musical forms, this mini-opera tells the story of a young shepherd's daughter caught between tradition and the attractions of urban life and spreading Westernization, addressing issues of identity that have become centrally important to that country in the years since independence.

A New Nearness

As has been remarked, a major feature of the current round of globalization is the "terrible nearness of distant places"—a new worldwide sense of proximity reflecting the extent to which diverse peoples and their cultural practices have come to intersect and overlap.[91] By tracing their passages over far-ranging landscapes and time, and framing them through culturalist, historicist, and performative readings of experience, Asian migrant artists make manifest critical relationships between geography, diaspora, history, and emergent subject formations. Catalyzed by surging non-Western immigration, globalized cultural discourse, and cross-cultural exchange, Asian American art can usefully be seen as a bellwether of these ongoing transformations. Even as Ming Fay, Zarina, Allan deSouza, and Y. David Chung point to the rich networks of meaning that surround conceptions of place, home, settlement, dispersal, displacement, loss, and hybridity, their work in this chapter only begins to suggest the subjects, positions, and discourses— including those of internal migration, regionalism, localized identifications and affiliations, and mixed ethnicities—that can be brought to light in a broader examination of visual art arising from contemporary and historic Asian migratory experiences in this nation.

For some migrants the impact of forced displacement and a difficult

passage to America has sharply demarcated one life from the other. In the painting *Soul Boat No. 2* (1990), the Vietnamese painter and sculptor Long Nguyen evokes the grave circumstances of the night that he escaped in an overloaded rusted freighter from the coastal city of Nha Trang, following the collapse of South Vietnam. Through the haunting image of a craft with a human head at its prow carefully wending its way through perilous waters, the artist suggests how the four thousand refugees who embarked on this journey to the open ocean were seemingly transformed into a single animate being united by a common purpose.

Especially amid difficult circumstances, migration evokes desires for a place in which to feel "at home." Consisting of beliefs, memories, and experiences that are often shared with one's family and extended community, conceptions of home are necessary epistemic templates from which to draw sustenance and a sense of continuity. Yet, as Zarina's house-on-wheels motif emphasizes, home and place do not have to proceed from a fixed or essentialized schema, nor are they wholly rooted in territory and place of origin. Much as Zarina is able to metaphorically bring her cultural "house" with her on her travels, home and place can be viewed as contingent and relational concepts whose character is continually being revised and reimagined as the migrant moves through various spaces and engages with different societies. The notion of home as a portable site, and the dynamic conceptual linkages that form between points of origin and the societies through which migrants pass and settle, are given striking form by Do-Ho Suh in a pair of tentlike silk sculptures that are figuratively designed to be readily collapsed and hand-carried in a single suitcase. Based on full-scale paper sewing patterns tracing their contours, and faithful to the smallest architectural details, *Seoul Home / L.A. Home* (1999) is a replica of the artist's one-room family house in Korea, while its companion piece, *348 West 22nd St., Apt. A, New York, NY 10011* (2000), takes the shape of his New York studio apartment.

Since the 1960s, powerful currents in Asian American art and cultural politics have evoked belonging and place in efforts to manifest and thereby symbolically lay claim to this nation as home. According to recent scholarship concerned with the significance of claims to space, the articulation of shared memories associated with specific places vitally contributes to a sense of common membership in American society. Building on the idea of "cultural citizenship," here, the impetus to elevate one's sense of connection

as a stakeholder within a place is spoken of as having more to do with "a sense of cultural belonging" than legal membership in a nation.[92]

Among those who have sought to visualize the longstanding Asian American presence is the Hong Kong–born installation artist and painter Ken Chu, whose film and popular culture–influenced, mixed-media work *Chop Suey* (1988) depicts a Chinese cowboy seated before his campfire on the American frontier. The work of Florence Oy Wong testifies to the importance of localism in situating oneself in the United States. Raised in the Chinatown of Oakland, California, Wong's largely autobiographical subject matter is deeply embedded in the experiences and histories of Chinese diasporic communities. In early graphite drawings such as *Wiping the Table* (1984) from the *Oakland Chinatown* series, the Chinese American artist depicts herself as a teenager working as a waitress in the family restaurant that her parents, both immigrants from southern China, operated from the 1940s to the 1960s. A number of years after her marriage to a fellow Chinese American raised in Augusta, Georgia, Wong inaugurated the *Baby Jack Rice Story* (1993–1996), a mixed-media series that culminated in an installation that honored her husband's close childhood relationships with African American families. Visiting the old neighborhood where his parents' grocery store had functioned as a local gathering place in the segregated Jim Crow South of the 1940s, she gathered photographs and oral histories commemorating that era. To spotlight the historical connections between different peoples of color, Wong used photo-derived, silk-screened images of these Chinese and African American households, accompanied by hand-sewn texts, to adorn commercial burlap sacks once used to store rice. For the artist, rice functions as a matter-of-fact token of the Chinese presence, as well as the means through which she evokes a further commonality between African Americans and Chinese Americans—recognizing that each group has long been involved with the planting and cultivation of rice in the United States.

The Shanghai-born installation artist May Sun, by comparison, uses her relationship to America as a historical anchor, by locating local connections between Chinese diasporic communities in California, where she lives, and China. In *Fugitive Landing* (1991/1994), a multimedia, room-sized installation centered on a wooden "dock" built over a shadowy pool of water, the artist alludes to the globe-circling travels of the Chinese revolutionary leader Sun Yat-sen (no relation), who became the first president of the Re-

public of China. The piece evokes Sun's clandestine arrival by ship in San Francisco in 1896, doggedly seeking financial support among the overseas Chinese communities for his ultimately successful effort to overthrow the last imperial dynasty.

Noting the extent to which the city "permits and generalizes the experience of proximity," one essayist posits the birth of a global urban culture and the extension of that contemporary "urban model to almost all other cultural phenomena."[93] Spurred by their immediate surroundings, urban artists adopt local, street-level perspectives to speak of ongoing changes in American society brought about by migration, globalization, and cross-cultural mixing. Making urban sites of multicultural contact, transaction, and patterns of settlement the subject of art calls attention to communities and civic identities that are too commonly viewed by the majority culture as marginal—and whose experiences (and interactions with one another) are often little known beyond limited stereotypes offered by the mass media and entertainment industry. Enfolding the lives of many, cityscapes, in the words of a close observer, serve as principal "storehouses for . . . social memories."[94] Among the works highlighted by this individual are public projects by the African American artist Houston Conwill and the Native American artist Edgar Heap-of-Birds that directly involve the use of urban landscapes as vehicles for the re-creation of public history and the activation of vernacular memory. In the sensorily loaded multimedia piece *Angulas—Street of Gold* (1990), Y. David Chung evokes the bustling crowds in the hybrid ethnic enclaves in Washington, D.C., and New York, where immigrants from Asia and Latin America often live side by side with each other and with African Americans in these volatile and swiftly evolving environments. The Taiwanese-born photographer Jeff Chien-Hsing Liao, in the panoramic photomurals of *Habitat 7* (2004), follows the extended route of the elevated no. 7 subway line (informally known as the "Immigrant Express") as it snakes through Queens, a section of New York City with two major airports that has become home to sizeable mixed immigrant communities from East and South Asia, Latin America, the Caribbean, and Africa. Parallel to Liao's project, Pedro Lasch, a Mexican-born photographer, collaborates with fellow Latinos in Queens to produce images of these communities that link local concerns to broader political and cultural relationships between the United States and Latin America.

For the Russian-born art team Komar and Melamid, the multiethnic,

working-class town of Bayonne, New Jersey, inspired a suite of photographic collages simply entitled *Bayonne* (1990). Noting that one of their first works upon moving to America involved an image of "the Kremlin as viewed from Manhattan," the artists sought to address America's historic capacity to accommodate "varied cultures from around the world."[95] Conjuring the contemporary geo-temporal experience of migrants for whom travel and new technologies are rendering distant homelands and cultures ever nearer, in one image from the series, the Great Sphinx of Giza rises like an ancient Egyptian colossus from behind a row of nineteenth-century storefronts on which a sign reading "Bayonne Sewing Machine Co." is prominently displayed.

Migration catalyzes the formation of new relationships to place, often negotiated in the details of everyday life and personal encounters, but also in the ways that one is categorized in different societies. In *Souvenirs of the Self* (1991), a series of postcards by Korean-born Canadian Jin-me Yoon, the photographer and video artist poses touristlike before vistas in Banff National Park in Alberta. Like the Grand Canyon in the United States, for Canadians images of this familiar wilderness site are strongly allied to a sense of nationhood. Aware that her appearance would likely lead Canadian viewers to see her as a foreign visitor, Yoon toys with how racialized conceptions of belonging are constructed through long-held associations concerning ties between certain bodies and places. Through loosely diaristic, interrelated bodies of work she refers to as "books," the Korean-born multimedia artist Jin Lee gathers together words and images that are used to reshape and sometimes misshape how she is cast in this country. In a "page" from *Book of Names* (1992), a piece comprising texts on aluminum plates, Lee presents the list of terms by which she is commonly designated—"Asian," "American Woman," "Korean American Woman Artist," and so forth—to indicate that such fixed ways of classifying her impart a very provisional form of knowledge.

Life in the United States also provides migrants with fresh vantage points from which to view their cultures of origin. In the *The New Wave* series, the Japanese-born painter Masami Teraoka has used his position in Hawai'i to gauge the changing social attitudes of his compatriots by observing the degree of openness and curiosity about foreigners that Japanese tourists display in their chance encounters with Westerners. These often comic interactions, painted in the antique *ukiyo-e* style of Japanese woodblock prints,

are typified by the beach scene *What Are You Looking At?* (1992), which depicts an uneasy encounter in the roiling surf between a gaping samurai and a Caucasian woman in a revealing swimsuit.

Since themes of journeying and the figure of the artist as traveler loom large in the art of migration, a well-developed visual lexicon has grown up in tandem with discourses of migrancy and globalization, in which the means, paraphernalia, and sites of travel—airplanes, airports, ships, maps, flags, passports, citizenship papers, travel brochures, tourist souvenirs, luggage, and so on—are often enlisted to signify passage, place, and transition, as well as the personal and social impact of movement. Allan deSouza scrutinizes the architecture of intimidation practiced in the airport terminals and lounges that constitute zones of international mass movement and contact through which migrants must cross, whereas Zarina has conferred primacy on the journey itself, through schematic maps that trace the world-spanning webs of air routes that join together the many nations and cities she has traversed. In the mixed-media piece *American Dream* (1988–92), the Korean artist Sung Ho Choi takes a more straightforward approach by incorporating the suitcase he possessed upon landing in the United States, with all its destination and immigration tags left intact.

Choi also makes compelling use of flags. Like many of his fellow Koreans who grew up in the war-devastated period of the 1950s, Choi came to the United States in search of new opportunities. His faded, rice-encrusted version of this nation's flag in the painting *America = Rice Country* (1992) confers tangible form on a dream of the United States as a land of unbounded freedom and abundance, that, unfortunately, did not live up to the artist's hopes. Yukinori Yanagi likewise draws on flags as visual devices to mark national identity. Analogous to Ming Fay's use of flora as a metaphor for the cross-cultural transformations brought about by global circulation, transplantation, and mixing, in *World Ant Farm* (1990), a wall sculpture containing 170 flags from around the world encased in transparent plastic boxes, this Japanese artist alludes to the inexorable erosion of political and cultural boundaries due to travel and migration. Here the continual passage of a colony of live ants arbitrarily redistributes the grains of multicolored sand out of which all these modern emblems of nationhood are formed.

For some, the performative presence of the traveler takes center stage. One thinks of the late Hong Kong–born, New York–based photographer Tseng Kwong Chi, who is well known for his self-staged scenarios from

the 1990s in which he appeared in a Mao suit and dark sunglasses, and solemnly posed before famous American monuments and popular tourist destinations like Disneyland as part of an ongoing project enacted in sites around the world. Through an image of the modern Chinese presence in the West that is simultaneously distant and personal, the artist transforms long-held perceptions of the American landscape.

Given the rapidly changing interethnic composition of America, a number of migrant artists do not simply frame social relations as they exist. Rather, influenced by artistic models like "constructed situations" (temporary life-based settings aimed at rousing the spectator out of a passive role), "social sculpture" (whereby "every living person becomes a creator, a sculptor, or architect of the social organism"), and "relational aesthetics" (centered on the collective elaboration of meaning via interaction, participation, and sociability, and emphasizing the commonplace sites and contexts in which they occur), they have devised socially collaborative ways to make use of art and art venues as crucibles to foster interaction and dialogue with heterogeneous publics in immediate, participatory ways.[96] Closely allied to traditional forms of theater (with a script, dramatic structure, and cast of characters), Y. David Chung's 1988 *Seoul House* provides an earlier example of such interactive efforts to destabilize conventional boundaries between art and other activities by embracing the quotidian in contemporary life. In more recent years, a number of Asian artists have ventured further by creating amorphous situations where they can physically engage with other migrants and members of the "host" society alike in "moments of constructed conviviality."[97] Beginning in the mid-1990s, Rirkrit Tiravanija, an artist of Thai heritage born in Argentina, prepared real-life environments, including makeshift kitchens, in which to initiate informal open-ended interchanges with visitors. Involving the cooking and sharing of meals, such simple acts offer unique opportunities for conversation and personal contact between the artist and strangers. By transforming galleries and museum spaces into coexperimental venues for casual socialization around everyday gestures and tactility, the artist poses salient questions about the role of art in contemporary society. Tiravanija remarks, "It is not what you see that is important but what takes place between people."[98]

A contemporaneous project was *Cultural Melting Bath: Projects for the 20th Century* (1997), by the Chinese-born conceptual and installation artist Cai Guo-Qiang. Centered on a rock garden fashioned from limestone boul-

ders shipped from the artist's home region in China, and positioned according to the ancient Chinese geomantic principles of *fengshui*, it contained a hot tub laced with traditional medicinal herbs and an urn that dispensed tea brewed from health-giving mushrooms. During the course of the installation, invited groups of viewers would publicly bathe while partaking of the Chinese tea's reputed healing properties. In 2003 the Taiwan-born artist Lee Mingwei invited New Yorkers of all backgrounds to give him a personal tour of their favorite parts the city; the resulting installation, *The Tourist*, was based on memorabilia that the performance and conceptual artist acquired during these trips.[99]

Cross-cultural conjunctions and mixing are rich in dynamic possibilities, as it is through face-to-face contact with others that difference is commonly negotiated, preconceptions about the unfamiliar are tested, and new forms of affiliation are imagined. Transcultural identification with peoples who shared a common colonial sphere has shaped the interests and itineraries of some Asian migrants. Similar to deSouza's affinity for Ireland as a former English imperial domain, having come from a land that had once been part of the French overseas empire, the Vietnam-born American writer and filmmaker Trinh T. Minh-ha spent time in a number of nations in former French West Africa. Her sojourn in these lands, where she found much that was reminiscent of the land of her birth, led to her to make two films, *Reassemblage* (1982) and *Naked Spaces—Living Is Round* (1985).

Closer to home, visions of the copresence of diverse groups in the United States—contested, transgressive, or ecumenical—bear a relationship to the idea of U.S.-Mexican border culture. One Chicana writer, poet, and social activist conceives of the zone flanking the boundary shared by both nations in metaphorical terms, as the incarnation of the psychological, sexual, and spiritual precincts that people must continuously navigate. Although this commentator portrays the region as riddled with inequalities and suffused with a history of colonialism, "as a member of a colonized people in our own territory" she nevertheless regards it as a generative place, where close interaction between groups and ideologies inevitability gives rise to cultural and biological fusions and hybrid identifications. For her, therefore, the emergence of such a new "alien consciousness presently in the making . . . a new *mestiza* consciousness . . . of the Borderlands" is to be received as a positive development.[100]

Richard A. Lou, a Chicano conceptual and performance artist of Chinese

and Mexican heritage, provides another way in which to view the socio-political implications of this historically fluid and porous territory extending from the Caribbean to the shore of the Pacific Ocean. Drawing on the trope of the door as both means of access and barrier to contact between peoples and cultures, in *Border/Door* (1988) the artist wryly erected a working, free-standing door on a Mexico-U.S. border site intermediate between Tijuana and San Diego to provide a new unofficial point of entry. By unlocking the door with one of 134 keys affixed to the Mexican side of its frame, Lou's piece mingles the literal, the political, and the allegorical by offering passing migrants an open invitation to "cross the border with dignity."[101]

Yet, as deSouza's chilly images of European international airport terminals stress, control over movement and surveillance typically go hand in hand. Although the enlarged reproduction of Hung Liu's Immigration and Natu-ralization Service identification card (green card) in the painting *Resident Alien* (1988) is generally taken as an icon of Asian immigration to America, it also summons troubled memories of the artist's past in the People's Re-public of China. Coming of age during the Cultural Revolution, and having been brought up in a society where internal "re-entry papers" are necessary to live in and travel between every city and region, Liu is acutely aware of the power of governments to control individual lives and to regulate their movements. Hence, the artist found it ironic that upon entering and later applying for citizenship in the United States, she would once again be sub-jected to bureaucratic surveillance and tracking—her identity reduced to a document by an indifferent system. A comparable impulse informs *Alien Staff* (1992–1993), a component of *Xenology: Immigrant Instruments, 1992–*, a series centered on acts of interaction between migrants and strangers by the Polish-born conceptual artist Krzysztof Wodiczko. Raised, like Liu, under the omniscient gaze of a Communist regime, Wodiczko is highly attuned to authoritarian techniques of observation and intervention, an awareness that extends to the inequitable treatment migrants often re-ceive as "strangers" in host societies. While *Alien Staff* mimics the elongated figure of an antique ceremonial crook or stave, it is equipped with audio and video technology, and sports a clear plastic shaft packed with actual passports, work permits, and identity photos. Providing migrants with up-to-date means of narrating their own stories, which too often are occluded or ignored, various incarnations of *Alien Staff* were toted around the streets of American and European cities by "operator-immigrants" from different

parts of the world, while video images of its bearers spoke of their diffi-
cult lives and prerecorded responses anticipated the questions of passing
strangers.[102]

More recently, Yong Soon Min produced four video installations in South
Korea under the collective title *XEN* (2004), to investigate the growing
presence of migrant labor, primarily from poorer Asian nations, that is be-
coming a significant issue in the land of the artist's birth. Having left Korea
as a child, Min positively notes the signs of a new diversity that migration is
bringing to Korea. Employing extensive videotaped interviews, she came to
sense a kinship between the present character of her Korean identity and
the "outsider and marginalized position of these migrants."[103] To examine
the discomfort and unresolved emotional state of migrants in a nation that
views them as inherently alien, in the component of the installation en-
titled "Strangers to Ourselves," Min references recent psychoanalytic writ-
ing on the position of the foreigner that draws upon Freud's concept of the
uncanny.[104]

Transcultural Negotiation

Despite millennia of exchange and cross-influence between cultures, and
the profound global impact of the West on other peoples and civilizations,
difference is hardly disappearing or being overtaken. If anything, it con-
tinues to proliferate, as ever more intricate cultural crossovers, mixtures,
and hybrids emerge from today's encounters and negotiations. In an arena
marked largely by diversity and nearness, no single scholar can possess a
magisterial knowledge of all the cultures, languages, belief systems, sen-
sibilities, and polyphonic discourses that give rise to present-day art. Since
questions of interpretation are often further complicated when meaning
must be negotiated across realms of cultural difference—made more pro-
nounced by the heightened presence of foreign-born artists from non-
Western societies—the challenge is to develop lines of inquiry capable of
capturing what is happening at many levels in textured and open-ended
ways. Such approaches—whether informed by art history, ethnic studies,
area studies, or cultural studies—must be able to account for the specifici-
ties of individual artistic standpoints, while simultaneously discerning the
intellectual and political preoccupations, the boundary-hopping contexts,

the larger historical and cultural conditions, and the shared ideas and multiple thematic strands that currently inspire, link, and frame their efforts. As the art world, like American society in general, becomes increasingly transcultural, engaging with difference means to be guided by a spirit of active inquiry in which one is ever alert to superimposing and reproducing existing assumptions, expectations, and hierarchies of value on the expressive production of another people or culture—whether beyond or within the boundaries of the United States. As one prominent art critic asserts, indispensable to a "close reading of work that is embedded in experience not easily accessible" to the U.S. born, yet largely absent from present-day U.S. art criticism and writing is "the discriminating knowledge of the details of other people's histories, assumptions, desires, and disappointments."[105]

While a reflexive focus on one's relation to rapidly shifting contexts and cultures as a subject for art making is a significant hallmark of contemporary cultural discourse, simply positing art as intentionally ambiguous and elusive, or migrant identities as dynamic and constantly in flux, does not mean that an artist's conceptions and identifications are not also appreciably impacted by points of origin. Indeed, artistic involvement with what I identify as "culturalist conceptualism" represents a perspective that is not only intimately connected to transcultural experience—given the many points of encounter and dynamic interplay between modern societies—but is also inspired by artists' need to manifest their perceptions of a distinctly non-Western way of conceiving the world from a position of being in the West.[106] As Ming Fay reflects, our "common heritage has been really transformed into a conceptual tradition rather than a [specific] practice tradition."[107] Culturalist conceptualism, therefore, stresses how the intellectual and associative thought processes behind art are culturally enmeshed, and thus often influenced by an artist's background and experience. Evocative of the spirit of newer models like "rooted cosmopolitanism," such conjectures demonstrate that framing the contemporary world through culturally specific filters need not be an excuse for nostalgia, or a fixed referent for romantic or atavistic notions of authenticity, but instead can serve as a compelling epistemic resource for dealing with an ever-changing present—in the midst of plural power centers and ongoing cross-cultural movement.[108]

Ming Fay, for instance, is fluent in the visual languages and methodologies of modernism and postmodernism, and, like many Asian migrant art-

ists, he grew up in a cosmopolitan Asian environment already suffused by Western cultures and influences. Yet by his own account, the artist nonetheless remains strongly aware of, and seeks to assert, his standpoint perspective as a Chinese living in the West by activating connections to his Asian cultural heritage through art. The installation of Cai Guo-Qiang likewise incorporates traditional Chinese systems of knowledge as a means to connect with Western audiences, and Tiravanija's interactive projects gesture as much to his Buddhist beliefs as to Western performance art and conceptualism. Since Buddhism, as Tiravanija denotes, is about "letting go of physicality and this object world," his art attends to the more mundane and ephemeral activities of everyday life.[109]

Examples of culturalist conceptualism are also to be found among artists born in the United States, such as Kaili Chun, a sculptor and conceptual artist of mixed native Hawaiian and Chinese ancestry. While her 2006 installation *Nāu ka wae (the choice belongs to you)* makes use of Western artistic and intellectual concepts, its formal and epistemological foundations are firmly embedded in a place-based sensibility shaped by the artist's Hawaiian heritage.[110] Raised in a Pacific-island setting long swayed by forces of globalization through the combined interventions of Oceanic, Asian, and Western peoples alike, the artist constructed a densely referential space out of local materials like volcanic rock, water, and salt as a way to embody the close spiritual relationship native Hawaiians have to their ancestral territory, while also intermingling symbolic references to indigenous figures in Hawaiian history, and to cultural hybridity via Christianity, syncretism, and external imposition.

The works in this chapter illuminate the cross-cultural connections and slippages that emerge as artists of non-Western ancestry and the West dynamically produce, permute, and retransmit images of one another in an elaborate, frequently ambiguous, and paradoxical process of mutual transformation. Yet, to render the diverse worldviews and intentions of such artists, as well as the contextual meanings of their work, legible to wider audiences in a globalized field—and hence available and socially useful as part of a larger body of collective knowledge about the times we share—requires a measure of humility and willingness to be potentially uncomfortable and open to entering into conversation with art's makers, as well as a capacity to engage in strategic acts of translation and ongoing dialogue at many

levels. Even as artists seek to redraw the maps of contemporary cultural experience, staking claims to knowledge with a particular cultural-historical provenance can provide them with a firm mooring point from which to extend outward into the modern world, while also alluding to cross connections and assertions of commonalities deeply located in human experience and desire.

Toward an Ongoing Dialogue

A glance at the turbulent developments over just the last twenty years suggests that pronouncements aimed at delegitimizing concepts like identity and identification as anachronisms are at best premature. For a host of reasons—ethnic, economic, religious—cultures and boundaries are in a heightened state of rearrangement and flux. At the same time that changing relations among nation-states are evidenced in the ongoing expansion of a supranational entity like the European Union and the formation of vast regional trade alliances capable of spanning oceans and continents, other nations are being fractured or split apart by ethnonationalisms, as new axes of identification are seemingly born every year. Despite the accelerated pace of global restructuring and the oft-proclaimed demise of the grip of nationalism, the affective power of social identification and affiliation is hardly dead or dying. Indeed, with the end of the Cold War, many groups in the former satellite and successor states of the Soviet Union actively sought to reidentify with their pre-Communist source cultures, despite generations of pervasive indoctrination. Although there clearly are histories, cultural and religious bonds, language communities, class interests, and ideological allegiances that overlap local and national particularisms, the need to assert, valorize, reclaim, or invent forms of identification and contexts of association continues to resonate among disparate peoples whose desires are powerfully shaped by contemporary events.

Not only do cultures still matter—sometimes in new and unexpected ways—but also the idea of culture has hardly been neutralized, superseded, or rendered obsolete. Humanity, as we are reminded, continues to form groups and generate the "symbols and systems with which to communicate," since it is through interaction around shared meanings that communities are shaped, a process that ultimately remains "an expression of culture."[1] Despite dispersal and social fragmentation, a prevailing ethos of placelessness, and the profound impact of globalization and things

Western in the contemporary world, works like those gathered in this book demonstrate that social and cultural heritages, histories, and ways of doing things retain a strong hold on the artistic imagination. The need to seek and to articulate a sense of affinity and interconnectedness with others remains of significant concern, and art provides a vehicle for social inquiry and a visible platform to envision such relationships. Ultimately, each group that enters the social and political space of the United States recasts and contests its public culture on various levels, from the smallest details of daily encounters between peoples and lifeways to the larger political and intellectual realms. The range of issues and conceptual and formal visual vocabularies that engage the artists in this book reflect the complicated combinations, intertwining histories, and difficult questions of identification that are continuously generated afresh as groups circulate and come in contact and conflict with one another in the ever more mixed and dynamic terrain of the United States.

Moreover, active projections of presence by minoritized and historically marginalized groups have ethical and political implications for American society as a whole that should not be dismissed. As one senior historian contends, the efforts of peoples of color, women, and gays have been largely responsible for safeguarding and advancing the "core values and ideals" of U.S. democracy.[2] Similarly, the concerns articulated by artists of non-Western heritage and marginalized groups are integral to enlarging America's most fundamental visions of itself, its ethos, and its character as a continuously evolving and heterogeneous society.

Once artists enter into the public realm through exhibition and publication, their expressions—symbolic, material, conceptual, and virtual—offer points of encounter with various audiences, around which fresh identifications and imaginative connections might be fomented.[3] As a communicative act, a work of art projects the maker's ideas, beliefs, and experiences into the sphere of the social imaginary, where these visual images and their meanings (however interpreted) circulate as part of the shared body of information through which we construct our personal and collective understandings of the present historical moment and our places within it. As has been observed, contemporary artists advance a worldview "that grows from the inside-out," one with the potential to further an "entire civilization's ability to see."[4] Without overstating its impact on public consciousness and vernacular culture (as compared to film and mass media, for

example), visual art nonetheless provides a valuable space in which to articulate our relations to one another, including our intellectual and political commitments. One deeply felt account of the Chicano arts movement and Latino cultural production describes culture as a powerful ground for resistance and survival, in which art and community institutions become the archives, embodied knowledge systems, and image banks in the creation of an "emancipatory culture."[5]

Alongside visions of culture as a liberatory force, discourses of position, affiliation, and place in the visual arts can also be thought of as claims to cultural citizenship, an idea that has had a significant impact on cultural politics and activism among U.S. communities of color since it first arose in the 1980s. Notably, whereas citizenship has traditionally been determined by nation-states and juridical status, with heightening globalization, transnational migration, and the formation of supranational bodies, the growing field of citizenship studies emphasizes that the grounds on which such assertions are being made have expanded significantly. By showing greater concern for "norms, practices, meanings, and identities" than for legal precepts, citizenship is now being defined more broadly as the "social process" involved in "claiming, expanding or losing rights."[6] Efforts to recognize emergent forms of differentiated citizenship, therefore, now encompass cultural, sexual, and diasporic claims among their many variants. From the perspective of Latino/a studies, for instance, the concept of citizenship needs to be expanded to include the recognition of cultural difference as a matter of domestic national policy for groups historically subject to discrimination based on ethnic and racialized difference in the United States.[7]

Taking a more wide-ranging stance, one commentator who was born and raised abroad maintains that cultural and political citizenship ought to be conceived more generally as "responsibilities to our [many] collective selves: nations, communities, groups, majorities and minorities," and notes the need to transform American culture into ongoing conversations among "diverse inter-national interests."[8] Reflecting on the connections between culture, citizenship, and human rights, this critique maintains that culture should provide support in advancing notions of "ethicality, tolerance, [and] communality."[9] Whereas current discourses on human rights are primarily oriented toward achieving enforceable solutions for more immediate problems, here the possibility is raised for alternative formulations in which

emancipatory aspirations are posited as "non-tangible but concrete goals" outside an essentialist perspective. Such proposals shift the discursive ground toward a more expansive conception of the parts that the imagination and the arts have to play in the formation of social relations and culture around the world.

Reconceiving Identification and "Community"

Asian American—like *Latino* (or *Hispanic*) and *Native American*—is an all-embracing metacultural term that refers to a wide collection of groups. While these groups often share experiences of racialization, ethnicization, displacement, and migration (external and internal) in the U.S context, as well as some cultural patterns and heritages, they also may have considerable differences, including long histories of conflict with one another, to say nothing of extensive internal diversity.[10] At the same time, conceptions of panethnicity are not solely constituted in reaction to outside pressures; they are also "creative," arising organically through "internally generated dynamics."[11] Given the complex, heterogeneous nature of the Asian presence in this nation, efforts are being made to expand and broaden Asian American conceptions of citizenship and community by moving beyond rhetorics rooted in narrow domestic multiculturalist agendas or tied to the specific historic and political claims of particular groups. Along similar lines, characterizing community in ecumenical terms as "collective formations of individuals" that are connected "through common bonds of interest and solidarity," one scholar of the Puerto Rican diaspora asserts that there are no overriding reasons to view community as confined to conceptions of geography or nationality.[12]

In the theoretical framing of denationalization, Asian Americans and diasporic communities are envisioned as part of the global circulation of Asian peoples and seen in dynamic interaction with other groups they have encountered in their journeys and points of contact and settlement.[13] Instead of focusing on difference configured along specific ethnic or racialized lines, models of hybridity offered by Latino cultural critics likewise seek to conjure broader theoretical contexts. For instance, to place U.S. Latino theater and performance in its appropriately wider hemispheric frame, there is a need to point to historical and social processes of transculturation whereby

the different groups who were brought into contact in the Americas via Western colonialism—indigenous peoples, Africans, Asians, and Europeans alike—converged and merged with one another in the New World.[14] Such a view emphasizes that conceptions of collectivity are not solely fixed by culture, nationality, or geography, but rather are more loosely articulated, criss-crossed by strains of similarity and difference, and formed through interrelational processes, including (as they note) intersubjective expressive transactions between artists and their audiences. As such, they resonate with present-day models of coidentification among diverse peoples and cultures projected across the modern world, like urban-based "cultures of conviviality," and the germinal idea of "epistemic cooperation" as a social goal enabling multiple conversations across realms of difference.[15]

New Questions and Directions

Despite present attitudes toward questions of collectivity and difference that range from uneasy ambivalence to strong antagonism, a number of influential scholars note that the time has arrived to reconsider our under-standings of these contested subjects. One, for example, writes of a re-newed turn to "collective attachment" and the surfacing of an "optimism of attachment" through discussions of the "sociability of persons . . . in con-texts of enunciation and experience"; a second forecasts the emergence of a new "theorizing of collective subjectivities" that is free of the language of discredited conventions and received ideas.[16] Musing on the putative ob-solescence of the politics of difference in the wake of 9/11, a third draws on the concept of "partial collectivity" to envision a fresh form of minoritarian identification based not on autonomy but on partial selfhood and interests "in relation to the other's presence" and emerging through "a process of affiliation."[17]

As some critics seek to identify new grounds for re-engaging with con-ceptions of social and cultural cohesion, others are re-examining the under-lying premises of eliminativistic arguments that challenge the very bases upon which claims of collective identity are conceived. Recent theorists have incisively critiqued the equation of group identity with homogeneity, as if the two were unalterably synonymous, instead envisioning fresh and useful ways to think about group identifications and variant conceptions

and configurations of community that both embrace internal differences and ongoing change. For instance, one approach builds on Ludwig Wittengenstein's theory of familial resemblance to illustrate the misconceptions that commonly occur when identity and difference are treated as if they were inherently polar opposites. Its author maintains that "identity is bound up with difference and . . . all identity categories are intrinsically heterogeneous and necessarily unstable."[18] Contrary to assumptions that collective assertions of identity must impose internal homogeneity as a prerequisite to membership, this Spanish-born scholar posits instead that any conceptions of commonality should be based on diversity, since it is cultural mixing and contradiction that, in his view, characterize "Hispanic identity" (his preferred term). Challenging the idea of coherent collective subjects or monolithic social entities, he draws on the family as a metaphor in arguing that there is no reason to assume that all individuals in a group share the same characteristics and beliefs. As with families, group membership does not preclude considerable internal diversity. Beyond their origins as historical formations whose cultural and political implications are continually open to interpretation, this observation acknowledges that within every group there is a broad range of positions, views, and social and class interests—often coexisting uneasily—that reflect significant links as well as internal differences. Such critical writings, by foregrounding the fragmentation and internal differences found in all groups, can be usefully extended to more capacious and flexible conceptualizations of Asian collectivities and affiliations-in-formation in the United States.

Visual Art and "Communities of Cultural Imagination"

Fully recognizing that claims of community are highly contested, I do not seek to assert in any immediate and literal way that embodied communities in the arts must inevitably exist, or that the artists under discussion offer incontrovertible evidence of communal affiliations (even where thematic and iconographic threads connect their work), although individuals certainly may know each other, know of each other, or be influenced by one another's work and ideas. Nor am I proposing that their work should necessarily serve instrumentalist ends in providing specific models or grounds for larger collective formations to inevitably come together, or that the im-

mediate concerns, production, and reading of art should mechanically incite political action and social upheaval. At the same time, there are artists who do envision their work as provocative and interventionist, extending into and integrally involving their own and other ethnic communities (and members of a general audience) in various collaborations and actions with political, social, and intellectual consequences.

For Susette Min, a younger Asian American art and cultural critic and scholar who is uncomfortable with applying an identitarian lens, the continued value of promoting art as "Asian American"—and thereby invoking collectivity—lies in finding alternate means of reframing and re-envisioning the experiences and the historical and cultural contributions by these groups to U.S. society as something that remains obscured or is actively denied. Although this commentator is fully open to innovative ways of conceiving and questioning the implications of social connectivity, she nevertheless puzzles over whether it is possible to "build a community of singularities," citing a recognized critique of existing interpretations of community in which "affiliations, attachments, and bonds are unmarked, absent any shared value . . . or experience."[19] Further, as she maintains, even with the acknowledged limitations of "bounded" notions of Asian American art associated with multiculturalist identity politics from the 1980s and 1990s, it is not currently feasible to do away with identity-based conceptions as strategies and venues for collective representation. For her, race therefore continues to have a significant impact; despite a wider recognition of diversity, Asian American artists still contend with a general lack of mainstream institutional, critical, and academic interest.[20]

With Asian America itself becoming progressively more diverse, new concepts are indeed needed that pay close attention to changing lines of affiliation, channels of communication, and spaces of transmission around which people come together. By mirroring and critiquing social relations, speaking to power, and offering a tangible locus for shared attachments and sociability across variant histories, interests, orientations, and discursive terrains, visual art simultaneously constitutes and attests to the undeniable presence of Asians in the Western social imaginary. Seen in dialogic and processual terms, its presence as a social object can provide an entrance to communicative spaces that offer fresh and often unpredictable opportunities for making linkages with other peoples, events, and subjectivities. Indeed, by allowing for the visions and voices of artist and spectator alike to claim a

space in civic discourse, artistic production can also be seen as being bound up with the participatory production of emergent citizens.

Ultimately, the drive to make meaning of our existence and share our accumulated understandings is a social project that is fundamentally imaginative and dialogic in character, with art providing an important nexus for such interchange to take place. Beyond enabling us to think about culture's role in enacting and visualizing our various attachments in the world, works of art, by helping us to recognize and articulate experiences held in common, contribute toward constituting what I term "communities of cultural imagination."[21] In this schema, the realm of the imagination can be conceived as an ever-fluctuating communicative field in which conversations between individual and collective imaginations continually flow back and forth in reciprocal and mutually enriching ways, and where human consciousness has an active role in the social imaginary as an agent of innovation. Multiply located, embodied and virtual, situated and mobile, public and private, unstable and open to continual regeneration and amendment through dialogic processes, the concept of communities of cultural imagination recognizes the character of this historical moment as a time of enormous social and cultural permeability and creative variety.

Moving away from the opposing traps of either having to wholeheartedly embrace or self-erase (even self-police) one's sense of identity and identification, the idea of communities of cultural imagination acknowledges both internal and external heterogeneity by signaling the need for flexible means of conceiving identities, identifications, conjunctions, and positions that include, but do not solely depend on, traditional forms of affiliation that are being increasingly destabilized. By allowing for the capacity to outrun the terms of our present understanding, communities of cultural imagination can be understood as an open-ended metaphor that is intended to emphasize aesthetic, intellectual, and political exploration with others, as well as worldly ways of thinking about human collectivities and our perceived affiliations to them. Unlike the overly sanitized idealism common to earlier pluralist and coalitionist visions, this concept recognizes the many disagreements, as well as the salient questions and critiques that challenge us at various levels to reconsider the very bases on which we claim identities (however utopian or transient some arguments might be), while allowing imaginative space for people to still envision empathy, common cause, and engaged real-world responses around shared grounds.

Rather than laying out some comprehensive formula or scheme, or suggesting any naturalized, territorially or temporally bounded notion of community constituted through social contracts, sociopolitical bodies, or mythic unities, this nondeterministic concept posits that the arts provide a generously eclectic conceptual scaffold upon which producers and spectators alike can continually revise their accounts of personal and collective experiences through investing in acts of imaginative identification. By simultaneously acknowledging the permutations of consciousness and internal complexity of subjectivities, their interrelatedness, multiple moorings, and layers of association, as well as the messiness and contingencies of life as lived, the concept of communities of cultural imagination accepts that all self- and social conceptions are partial, positional, and open to contestation and contradiction, as individuals and groups continually test, reformulate, and reconstitute their various standpoints and attachments to one another. Deeply anchored in visual art's complex entanglement with the world, and receptive to overlapping conceptions from other creative media, such a relational formulation encompasses both discursive nodes of identification and the civic implications around which traditional notions of community and communal bonds have historically been shaped—and it extends to their various positionings, intersections, and coexistent affiliations. These may include, but are not necessarily bounded by, common nationality, culture, beliefs, lifestyle, or geographical location, and enfold historical formations of race, ethnicity, gender, and class; relations of power; situated and subjected knowledges; alliances and friendships; ethical imperatives and consequences; practical politics; and creative initiatives based on present-day interests, needs, and responsibilities.

In this, the concept of communities of cultural imagination resonates with how contemporary art itself is both stylistically diverse and continually shape-shifting by enabling new meanings and readings through the extension of its boundaries and idioms, through the coming-to-voice, circulation, and intervention of new practitioners from diverse life worlds, and through the manipulation and recombination of its forms and themes toward new ends and expressive purposes. Seen in this light, the chapters in this text could themselves be provisionally conceived of as a type of community of cultural imagination, as they set in motion an interdependent dialogue among the works of art themselves; the narrative, critical, and intellectual circuits in which they function; and the content, particularities, and ambi-

guities of the artists' (and their audiences') mutual life experiences. This animate, multivocal dynamic points simultaneously to the imaginative and transformational potential of human agency, to the fluidity and miscegenation of contemporary cultures, to vital connections shared by many Asian Americans, and to the delimited, problematic nature of contemporary conceptions of Americanness.

In positing art as an epistemic ground upon which artists and audiences come together (whether literally or figuratively) to exchange thoughts and perspectives around projects of meaning making, the concept of communities of cultural imagination also bears a relation to the notion of interpretive communities. Whereas this latter term is commonly associated with literary theory, it has more vernacular applications as well; for instance, some cultural critics have used it to broadly indicate communities formed through active, dialogical engagement with the world.[22] Certainly, in an engaged research approach like mine that seeks to collaborate with its subjects rather than commandeer them, there is a generative relationship that develops between artist and critic that can often extend over many years. A leading feminist art critic underscores the reciprocal connections between critic and artists in constituting a type of interpretive community in living and creative flux. As she maintains, a community that seeks to collectively enfold artists and their audiences, in contrast with more limited notions of community, also includes the "commentative structure" thorough which both "may view the process and product of art making."[23] Given that this book in itself is an artifact of interactive exchange, in the long run the texts and readings that result from discussions such as these will hopefully produce a kindling effect in transforming how many artists, curators, educators, and arts writers are disposed to think about, talk about, write about, and present art.

The potential for forming cointerpretive communities around issues of the cultural imagination is suggested by Ella Shohat's reflections on the work of the Japanese American artist Lynne Yamamoto in *Fresh Talk / Daring Gazes*. Shohat's essay points to cross-cultural global connections between migrant women arising from shared experiences of menial labor. Shohat, an Israeli-born scholar who describes herself as an "Arab Jew," comments, "I ask myself, why am I willing to participate in this project? And what do a Japanese-Hawai'ian-American and an Iraqi-Israeli-American have to do with each other, apart from sharing residency in the United States?"[24] Seek-

ing common ground on which imaginative linkages might be formed across cultures and geographies, Shohat found an evocative point of encounter in the 1992 installation, *Ten in One Hour*. Here Yamamoto alludes to the hard life of her immigrant Japanese grandmother, who worked as a laundress on a sugar plantation in Hawai'i. Through the motif of lumps of soap embedded with patches of hair, Shohat perceived resonances with her own grandmother's life as a household servant for Israelis of European heritage, following the expulsion of the majority of Iraq's ethnic Jewish population after the creation of Israel. She remarks, "We, the granddaughters of diasporic domestic workers, have traveled a long road."[25]

While it is sometimes argued that any attempt to gather together diverse artists and works under the sign of an ethnicized or racialized group will automatically impose false coherence and closure and should therefore be refuted on aporetic grounds, such framings do not intrinsically contradict the critical recognition of significant internal difference and contestation. Simply to speak in terms of "Asian America," therefore, is not to advocate for a corporate project to (re)constitute some harmonious vision of collectivity that selectively enlists artworks as mute instruments in its articulation. To the contrary, the works considered in this book make it evident that the term *Asian America* could as easily characterize a cultural continuum in which no single vantage point or sensibility prevails. While there certainly is no core of meaning or belief, no dominant guiding principle, no singular vision of an all-encompassing Asian American–ness or Asian American aesthetic that unifies the efforts of artists of Asian backgrounds in the United States, the foregoing discussion underscores that there are nonetheless useful, nonsystematic ways of pointing to historic forms of coidentification within and across social and cultural groupings that are characterized by various strategies of representation and intervention, clusters of themes, and subjecthoods-in-formation.

Since no single cultural experience or collective narrative unites Asian Americans, there are many possible responses to the problematic of Asian identification and affiliation in various contexts and discourses. Indeed, acceptance of heterogeneity and difference is integral to the very sense of commonality within the collection of peoples who constitute Asian America, given the often attenuated bonds among Asians of different cultural and national heritages. Returning to the image of the United States as being like a vast contact zone, a nation that embraces multiple intersecting

diasporas and hybridities, as well as indigenous peoples, many artists of Asian heritage are distinguished by their interrelational orientation as they actively seek to situate themselves vis-à-vis other cultures, narratives of history, and art-making traditions, while also affirming identifications with aspects of their own ethnic heritages. Thus, in both a complex intercultural and a pragmatic sense (indeed, in full acknowledgment of the creative tensions inherent in the plural complexities of Asian America), accounting for and effectively responding to difference demands an abundant and ever-evolving repertoire of positions, affiliations, and representational strategies. These extend from assertions of traditional lines of identification like self-hood, belonging, and otherness, to intensely personal concerns, to highly oppositional artistic practices and tactics that critically analyze U.S. and Western culture and institutions, or entail unpredictability, elusiveness, de-familiarization, and the artist's refusal to be named as anything other than an artist.

While widespread and valuable changes have taken place across the Asian American generations in attitudes toward individual and collective identification—and much evil is certainly committed in the name of nationalism, cultural distinctiveness and pride, chauvinism, and various pernicious theories of race—I maintain nevertheless that the headlong rush to deny or negate conceptions of community, and the affective, political, and cultural investments a sense of social identification entails, calls for a period of constructive pause and reconsideration. As one Filipina American installation artist cogently observes, "These are different times . . . we're trying to break stereotypes, break what people have assumed for so long about a culture, about an individual, about the world, about thinking. So this is a time for discussion, this is a time for not assuming things."[26]

NOTES

Introduction · Art, Asian America, and the Social Imaginary

1 Tchen, "The New York Asian/Pacific American & Asian Documentation Project."

2 In fact, much of the new writing in this emergent field is being done in conjunction with exhibition projects. Among them are national and regional survey exhibitions mounted during the 1990s, such as "Asian Traditions / Modern Expressions: Asian American Artists and Abstraction 1945–1970" (Jane Voorhees Zimmerli Art Museum, Rutgers University, New Jersey, 1997); "They Painted from Their Hearts: Pioneer Asian American Artists" (Wing Luke Asian Museum, Seattle, 1994); and "With New Eyes: Toward an Asian American Art History in the West" (San Francisco State University Art Department Gallery, 1995). Concurrently, there have been exhibitions focused on specific periods in American history, such as "The View from Within: Japanese American Art from the Internment Camps, 1942–1945" (UCLA Wright Art Gallery, Los Angeles, 1992; co-organized by the Japanese American Museum, UCLA Wright Art Gallery, and the UCLA Asian American Studies Center); and "Relocations and Revisions: The Japanese-American Internment Reconsidered" (Long Beach Museum of Art, Long Beach, California, 1992)—as well as thematic, ethnic-specific, and sociopolitical shows, which include: "Asia/America: Identities in Contemporary Asian American Art" (The Asia Society Galleries, New York, 1994); "Across the Pacific: Contemporary Korean and Korean American Art" (The Queens Museum of Art, New York, 1993); "Picturing Asia America: Communities, Culture, Difference" (Houston Center for Photography, Houston, 1994); "Who's Afraid of Freedom: Korean American Artists in California" (Newport Harbor Art Museum, Newport Beach, California, 1996); "Memories of Overdevelopment: Philippine Diaspora in Contemporary Art" (University of California, Irvine Art Gallery, 1996); "Uncommon Traits: Re/Locating Asia" (CEPA Gallery, Buffalo, 1997–98); "Out of India: Contemporary Art of the South Asian Diaspora" (Queens Museum of Art, New York, 1997); "Site of Asia / Site of Body: Contemporary Asian Women Artists" (Taipei Gallery, New York, 1998); and

"At Home & Abroad: 20 Contemporary Filipino Artists" (Asian Art Museum of San Francisco, 1998).

3 See Elaine Kim, "Interstitial Subjects," 1–50.

4 For example, in "Engaging 'Tradition' in the Twentieth Century Arts of India and Pakistan," from the catalogue *Conversations with Traditions: Nilima Sheikh and Shazia Sikander* (2001), Indian-born art historian Vishakha N. Desai juxtaposes the work of Sikander, a Pakistani-born artist living in the United States, with her counterpart in India in order to initiate a conversation about the use of tradition in the art of the Subcontinent. The curator and artist Yong Soon Min takes a pandiasporic approach in the Gwangju Biennial catalogue, *THERE: Sites of Korean Diaspora* (2002), in which she compares works by Korean artists in the United States, Kazahkstan, China, Brazil, and Japan.

5 In *From Vietnam to Hollywood: Dinh Q. Lê* (2003), Roth's published e-mail exchanges with this Vietnamese-born photographer, who regularly travels between Ho Chi Minh City and Los Angeles, form an intricate web of co-interpretive texts about his ideas, experiences, and work.

6 Among the outgrowths of this project is the forthcoming anthology and biographical directory edited by Gordon Chang, Mark Dean Johnson, and Paul Karlstrom, *Asian American Art: A History, 1850–1970* (Stanford University Press, 2008).

7 Elaine Kim, *Fresh Talk / Daring Gazes*, 40–42.

8 Clearly, the themes highlighted in this book are by no means exhaustive but rather indicate significant directions the artists pursued in their work. Although not directly addressed, other noteworthy topics such as local and regional distinctiveness, mixed ethnic and racial heritages, internal migration, religion and spirituality, economic and class hierarchies, and sexuality and gender are touched upon in these chapters.

9 In 1965, President Lyndon B. Johnson signed into law a new immigration act that not only repealed restrictive quotas set by the National Origins Act of 1924 but also established new immigration policy, reopening immigration to all Asian countries and allowing twenty thousand immigrants per country to enter the United States each year. This change in America's inequitable immigration laws (which had long favored northern and western Europeans) opened the door wide for Asian migration.

10 The term *Asian America* first gained currency in the 1970s, and it continues to be widely applied in Asian American scholarship. This expression is contested in some quarters, and any project that groups artists together based on common heritages and shared social themes in their work is inevitably impli-

cated in ongoing debates over imposing collective definitions. Nevertheless, the use of the term acknowledges that despite their differences, the artists under discussion share a common status with past generations of Asian Americans, in being positioned as minoritized and racialized subjects in a society historically riven by racial and ethnic strife. In this, David Palumbo-Liu's formulation is especially cogent in positing the Asian presence in this nation as a catalyst of social transformation. As he conceptualizes it, Asian America refers to "certain historical reformulations of modern America, both as it has modified itself with regard to Asia and as Asians in America have variously affected its refiguration." Palumbo-Liu, *Asian/American*, 1.

11 Pratt, *Imperial Eyes*, 6–7. While Pratt primarily examines "contact zones" as spaces of colonial encounters dominated by coercion, inequality, and conflict, I find the concept useful as a way of characterizing any site that is shaped by the interactions of groups from different cultural heritages.

12 Although most members of the Asian American arts community are either descendants of the first wave of Asian immigration—those whose ancestors came to the United States in the nineteenth and early twentieth centuries—or members of the second wave that arrived after 1965 (reflecting both the elimination of the exclusionary law and the new refugee statutes enacted in the wake of the Vietnam War), some are members of the second generation whose parents arrived during the interim. A small trickle of Asians were allowed in during the intervening years for various reasons, particularly in the first two decades of the Cold War, when somewhat greater numbers of immigrants were accepted from allied Asian nations like South Korea and the Republic of China on Taiwan, as well as those fleeing Communist regimes.

13 Although he is chiefly concerned with how social understandings are transacted in the informal realm of everyday life, the philosopher Charles Taylor acknowledges, "It very often happens that what start off as theories held by a few people come to infiltrate the social imaginary, first of elites, perhaps, and then of the whole society." Taylor, *Modern Social Imaginaries*, 24.

14 For an extended discussion of this concept, see Becker, "The Artist as Public Intellectual," 389.

15 Bourdieu, *The Rules of Art*, 351; Bourdieu, *The Field of Cultural Production*.

16 Raymond Williams uses the concept of "structures of feeling" to examine the epistemic role of drama and literature in the formation of social consciousness by limning an interstitial position between formal systems of belief and vernacular forms of "practical consciousness." Williams, *Marxism and Literature*.

17 This exchange between the artist Y. David Chung and myself took place prior to the public reception for the exhibition "Asia/America: Identities in Contemporary Asian American Art" at the Asia Society Galleries in New York City. The show was on view from February 16 to June 26, 1994.

18 My use of the term *epistemic* in this context is influenced by Kandice Chuh's conception that Asian American literatures function "as epistemological projects engaged in a politics of knowledge." Chuh, *Imagine Otherwise*, x.

19 See Frisch, *A Shared Authority*. A fundamental connection with oral history lies in its focus on the subjective as a valid source of knowledge about the world, using interviews to explore how living individuals look upon their experience in constructing a sense of their lives and historical moment that tightly interweaves the public and private realms. In addition, I share with oral historians a broadly democratic outlook about who should be involved in the production of social knowledge. There are certainly well-established precedents for the use of oral history with visual artists, both in documentary and archival projects, and to aid in writing the cultural history of a place or period (for instance, Richard Cándida-Smith's pioneering work, *Utopia and Dissent: Art, Poetry, and Politics in California*, which employs archival oral history material). Nevertheless, I have yet to find relevant models in the field for using oral techniques to specifically hermeneutic ends, in interpreting works of visual art in dialogue with the artist/producer.

20 Rather than being a unified theory, philosophical tradition, or a particular methodology, hermeneutics encompasses a range of attitudes and interpretive approaches. Taken up and adapted by fields like philosophy and sociology beginning in the nineteenth century, hermeneutics would increasingly be applied to investigations of how meaning and interpretation shift over historical time, how they are constructed through human action and shaped by social structure and language, and how, in turn, human experience and activity are objectified in the world. Especially with postmodern usage, the term *text* has also come to refer to any inscribed mode of expression (including objects made to be "read" visually).

21 Wollheim, *The Mind and its Depths*, 134.

22 On observant participation, see Tedlock, "From Participant Observation to Observation of Participation." In anthropological and sociological fieldwork, *observant participation* acknowledges the distinctive position of critical observers who share full or partial membership in the group or community that they are observing, whereas *participant observation* refers to the outsider status of observers whose background differs significantly from that of their informants. On expressive logics, see Joli Jensen, *Is Art Good for*

Us? Jensen draws on John Dewey's theorization of aesthetic experience in developing this expressive model of culture.

23 See, for example, Heywood and Sandywell, *Interpreting Visual Culture.*

24 Hirsch, *Validity in Interpretation*, 68. Hirsch vigorously critiques theories of "semantic autonomy" and argues instead for the importance of authorial meaning in providing "valid" interpretations of text. Given the traditional concentration of hermeneutical investigation on textual analyses in which the participation of the living author or authors is hardly an issue, as well as the growing acceptance over the twentieth century of the notion that textual meaning is ultimately beyond the author's control, it appears that no conventions have developed within hermeneutics that would allow for the prospect that the living author, if available, could (or should) be meaningfully consulted in the interpretation of her/his work.

25 In his seminal formulation of dialogism, Mikhail Bakhtin posits textual meaning as being polyphonic (i.e., produced by multiple speakers), including the author's voice, which is always seen to be present in the text. However, even this model of dialogism does not evince a need for the living author's input in textual interpretation. Bakhtin, *The Dialogic Imagination.* See also Bakhtin, *Problems of Dostoevsky's Poetics.*

26 Hans-Georg Gadamer contends that even as each interpretive action constitutes the horizon of an immediate present, "beyond which it is impossible to see," that horizon is continually being revised by new information in successive interpretive encounters, resulting in an unending "fusion of horizons." Gadamer, *Truth and Method*, 306.

27 Interpretive approaches centering on authorial meaning remain contested on many fronts. Following reception-centered theorists like Jacques Derrida and Roland Barthes (whose views in the late 1960s on the "death of the author" became a benchmark), critical theory has done much to disentangle text from authorial intention, allowing meaning to be understood as multiple and forever indeterminate, to be successively reconceived by each reader in conversation with other texts. Challenges to the traditional scholarly focus on artist/producers have also been posed by social art historians who link the emphasis on the figure of the artist to an individualistic bourgeois ideology associated with the rise of capitalism in the West (e.g., Hadjinicolaou, *Art History and Class Struggle*). Coupled with Michel Foucault's formulation of power/knowledge, in which the discursive production of knowledge is seen as inseparable from the exercise of power, such moves have served to decenter the perceived hegemonic epistemic authority of the author/producer. Still other critics dismiss a focus on art-

ists and their narratives about their work and lives as simple journalism or atheoretical biography, rather than critical analysis. Whatever one's vantage point, it is notable that recent years have seen a tempering of such positions in favor of more synthetic analytical approaches. Janet Wolff, for example, while recognizing that traditional ideas of the author/artist as the fixed source of meaning have largely been rejected, still asserts that the artistic subject must be theorized in order to account for (among other things) the very real impact of human agency. Wolff, *The Social Production of Art*. Even Edward Said, who acknowledged a great debt to Michel Foucault, nevertheless found it meaningful to retain the concept of the "determining imprint of individual writers upon . . . a discursive formation like Orientalism." Said, *Orientalism*, 23.

28 These population figures and ethnic breakdowns were based on the 2000 U.S. Census. See table 1, Asian Population by Detailed Group: 2000, in United States Census Bureau. *We the People*.

29 Sassen, *The Global City*, 3.

30 Other expressive media, such as film, video art, performance art, or computer art, Web-based media, and text-based art, are mostly beyond the scope of this book.

CHAPTER ONE A Play of Positionalities

1 Hall, "Cultural Identity and Diaspora," 225.

2 Ibid., 222.

3 See Mohanty, "Under Western Eyes," 51–80.

4 Lowe, *Immigrant Acts*, 2.

5 Ibid., 3.

6 Indeed, the desire to actively connect and dialogue with others of Asian background apparently continues unabated, as evidenced by the efforts of successive generations of artists to form panethnic Asian American artists' groups—some the products of converging streams of U.S.- and foreign-born artists, arts writers, and curators. Among them are Asian American Arts Initiative in Philadelphia and Asian American Women Artists Association (AAWAA) in San Francisco, as well as more loosely cohesive social and collaborative forums like Godzilla: Asian American Art Network and Godzookie in New York; Godzilla West (also in San Francisco); and the Barnstormers, a transnational group currently based both in New York and Tokyo. These organizations appear alongside a host of ethnic-specific art-

ists' groups across the United States. Publications by Asian American cultural organizations—including *Dialogue* (Asian American Arts Alliance), *Artspiral* (Asian American Arts Centre), and the Godzilla newsletter—have provided important vehicles to generate new writing about Asian American art and culture.

7 Castells, *The Power of Identity*, 6.

8 Marlon Fuentes, interview with the author, March 24, 1990.

9 Castells, *The Power of Identity*, 7. Castells also mentions biology and productive and reproductive institutions. Yet many other factors readily came to mind, including language and regional dialects, generational experience, institutional and occupational affiliations, shared enemies, traumas, spiritual revelations, and sexual orientation, which can and often do contribute to a sense of identity.

10 Ybarra-Frausto, "Transcultural New Jersey," 21.

11 McEvilley, *Art and Otherness*, 131.

12 Ong, *Flexible Citizenship*, 25.

13 In employing terms like *Asian America* and *Asian American–ness*, it is not my intent to put forward some overarching construction of collectivity that posits the presence of unified Asian subjects. Indeed, given the complex cultural and ideological tensions bound up with contemporary identifications (and their denial), to portray Asian America as a static or unitary site predicated on a common narrative would be an evident falsification. Consequently, I neither seek to offer a comprehensive formulation of what comprises Asian American art, or to suggest that matters of identification and positioning should necessarily be understood as the defining issue for artists of Asian descent.

14 This is not to say that the effects of critical theory and cultural studies are uniform, whether within the academy, in ethnic communities, or among individual artists. Not only has the development of these discourses been uneven, depending on which sector one examines, but there are many who are not engaged by the types of issues that preoccupy many academics and intellectuals. It is therefore important not to make overarching claims about the influence of any single point of view or theoretical posture in the decidedly heterogeneous arena of Asian American art and cultural production.

15 See Bolton, *Culture Wars*.

16 Croce, "Discussing the Undiscussable," 18. Writing about a work entitled *Still/Here* by Bill T. Jones, a black, openly gay, and HIV-positive choreographer, the dance critic Croce argued that this piece, which incorporated video

and audiotaped depictions of terminally ill people, was outside the bounds of criticism. She says of Jones: "I think of him as literally undiscussable—the most extreme case among the distressingly many now representing themselves to the public not as artists but as victims and martyrs." Her remarks extended to the criticism of multiculturalism and agencies that fund the creation of such works. For some especially cogent responses to Croce, see Joyce Carol Oates, "Confronting Head-on the Face of the Afflicted," and Homi K. Bhabha, "Dance This Diss Around," both in the anthology *The Crisis of Criticism*.

17 Clifford, *Routes*, 2.

18 Lefebvre, *The Production of Space*, 36–40.

19 See Pêcheaux, *Language, Semantics, and Ideology*.

20 Muñoz, "Feeling Brown," 70.

21 Mirzoeff, *Diaspora and Visual Culture*, 6.

22 Ibid.

23 Wei, *The Asian American Movement*, 10.

24 Among these early Asian American cultural organizations were Kearny Street Workshop, Japantown Arts and Media, and Great Leap Inc. in San Francisco; and Basement Workshop, Asian CineVision, Asian American Arts Centre, and Pan Asian Repertory Theater in New York City.

25 The Asian American Art Centre, under the directorship of Robert Lee, is another venue that provided exposure for emerging Asian American and Asian artists in New York.

26 Wei, *The Asian American Movement*, 1.

27 Jim Dong, interview with the author, May 25, 2003.

28 Chiang, "A Place in Art/History," 52–53.

29 Adams and Goldbard, "Community, Culture and Globalization," 8.

30 Ibid., 9.

31 Wei, *The Asian American Movement*, 64.

32 This position was taken by the musician Fred Wei-han Ho. See Ho, "Revolutionary Asian American Art," 7.

33 Newfield and Gordon, "Multiculturalism's Unfinished Business," 76.

34 Eller, "Anti-Anti-Multiculturalism," 251.

35 Shohat and Stam, *Unthinking Eurocentrism*, 346. They cite Fuss, *Essentially Speaking*, 20–21.

36 Ibid. Although the distinction remains cogent, a number of thinkers, including its author, have come to reject the use of "strategic essentialism," because it provides some with a license to continue espousing essentialist

agendas under another name. "I have disassociated myself from it [strategic essentialism]," comments Spivak, "first, because it has been taken as an excuse for just essentialism which is an excuse for just identitarianism." Spivak, "Resistance That Cannot Be Recognized as Such," 7.

37 LaCapra, "Experience and Identity," 228.

38 Ang, *On Not Speaking Chinese*, 139.

39 In their Web page for their poster "Traditional Values and Quality Return to the Whitey Museum," the Guerrilla Girls state, "The 1993 Whitney Biennial was the first ever to have a minority of white male artists. It was also the most reviled and criticized biennial in recent history. In 1995 the museum returned to previous miniscule percentages of artists of color."

40 Kimball, "Of Chocolate, Lard, and Politics," 54.

41 Kimmelman, "At the Whitney, Sound, Fury and Little Else"; Heartney, *Critical Condition*, 175–76.

42 hooks, *Art on My Mind*, 105.

43 Suni Chen, "Us Others in the Global Village," 54. This Minneapolis-based artist saw the exhibition at the Walker Art Center.

44 Ibid., 55.

45 Yang, "Why Asia?" 105.

46 Ibid.

47 Hall, "New Ethnicities," 442.

48 The roots of postmodernism are in the formal linguistic theories of structuralism, associated with the Swiss linguist Ferdinand de Saussure. This focus on language and the structures by which ideas are expressed also represents a dominant current in twentieth-century philosophy, addressed by key figures such as Bertrand Russell, Ludwig Wittgenstein, and Martin Heidegger, among others.

49 Gates, *Race, Writing and Difference*, 5.

50 Ibid.

51 Spivak, "Can the Subaltern Speak?" 24.

52 Trinh, *Woman, Native, Other*, 88.

53 Trinh, *Framer Framed*, 186.

54 At the same time, it must be noted that not all artists' resistance to categorization necessarily follows the same theoretical or ideological lines. Some simply want to be recognized as individuals, rather than as "Asian American" artists, much as figures like the painter Georgia O'Keeffe steadfastly rejected being categorized as a "woman artist."

55 Abraham, "Nobody Knows My Name(ing)," 2.

56 Yang, "Why Asia?" 97.

57 Pfeiffer, "Paul Pfeiffer and John Baldessari in Conversation," 33. Born in Hawai'i, Pfeiffer is a Filipino American of mixed heritage who spent part of his childhood in the Philippines.

58 Golden, *Freestyle*, 14. Golden writes that "post-black" is characterized by artists "who were adamant about not being labeled as 'black' artists, though their work was steeped, in fact deeply interested, in redefining complex notions of blackness."

59 Alcoff and Mohanty, "Reconsidering Identity Politics," 7.

60 Millner, "Post Post-Identity," 551.

61 Abel, "Mania, Depression, and the Future of Theory," 338.

62 Ibid.

63 Moya, "Introduction: Reclaiming Identity," 10.

64 It is notable that some cultural institutions have recognized the importance of initiating interchange between Asian and Asian American artists. For instance, The Queens Museum of Art's 1993 exhibition "Across the Pacific: Contemporary Korean and Korean American Art" expressly brought together overseas Korean artists and Korean Americans.

65 Alexander, "Is There an Asian American Aesthetics?" 627.

66 I use terms like Asia, Asian, Eastern, Western, and their derivatives (Asian American, non-Western, etc.) with the full understanding that they originate in European categorizations of geography and race and that there are serious critiques that militate against their retention; that is, such categories imply a false homogeneity, they are foundational in maintaining imaginary boundaries that have been employed as premises for exclusion, and their reinscription entails complicity with Western epistemic imperialism. While I note the problems inherent in the use of these linguistic constructions and provide quotation marks where appropriate, I find it unnecessary to do so as an ironical distancing tactic—both because I judge the real-world political resonance of such a rhetorical device to be limited, and because my use of these terms should be comprehensible in the context of the ongoing discussion. I also suggest that a deliberate disregard for these conventions, and the differences and hierarchies to which they point, as if they do not really exist, not only serves to deny historical and social facts but, more importantly, does not offer a productive alternative strategy with which to engage the complex conflicts and relations of power in today's world.

67 Wilson and Dissanayake, "Introduction," 3.

68 This influential shift toward a diasporic and transnational orientation in Asian American studies is demonstrated in Lisa Lowe's *Immigrant Acts: On Asian American Cultural Politics* (1996), Rachel Lee's *The Americas of Asian American Literature: Gendered Fiction of Nation and Transnation* (1999), and Kandace Chuh and Karen Shimakawa's edited volume *Orientations: Mapping Studies in the Asian Diaspora* (2001).

69 Sau-ling C. Wong, "Denationalization Reconsidered," 2

70 See Gary Okihiro's discussion of the global circulation of Asian labor in "Is Yellow Black or White?"

71 Hu-DeHart, "From Area Studies to Ethnic Studies," 5–16.

72 Gilroy, *The Black Atlantic*, 4.

73 Ibid., 14.

74 Alexander, "Is There an Asian American Aesthetics?" 628.

75 Heartney, "The Visual Arts."

76 Sau-ling C. Wong, "Denationalization Reconsidered," 5.

77 Among those featured in "Magiciens de la Terre" were the Chinese artists Gu Dexin, Huang Yong Ping, and Yong Jiechang. The exhibition catalogue accompanying "Inside Out: New Chinese Art" describes the show as possibly the "first time Chinese avant-garde artists are shown in a major international exhibition since the end of the CR [Cultural Revolution]." Gao, *Inside Out*, 200.

78 Chiu, "Asian Contemporary Art," 3.

79 The diasporic section of the 2002 Gwangju Biennial was curated by the artist Yong Soon Min. Min, "Certain Latitudes," 10–58.

80 Mirzoeff, "Introduction," 2.

81 Ibid., 6.

82 Mirzoeff cites Shohat and Stam, "Narrativizing Visual Culture," 46.

83 DeSouza, "The Flight of/from the Authentic Primitive," 123.

84 Poshyananda, "Roaring Tigers, Desperate Dragons in Transition," 23.

85 Bhabha, "Shazia Sikander Interviewed by Homi Bhabha," 20. This is an edited text from a public dialogue between Homi Bhabha and Shahzia Sikander on March 8, 1998.

86 Yu, *Thinking Orientals*, 199.

87 Sau-ling C. Wong, "Denationalization Reconsidered," 20.

88 See Appiah, *The Ethics of Identity*, chap. 6.

89 Gilroy, *After Empire*, xi.

90 Poshyananda, "Yellow Face, White Gaze," 31.

91 Higa, "Origin Myths," 21.

92 "Uncommon Traits: Re/Locating Asia" was a three-part exhibition orga-
nized for CEPA Gallery in Buffalo, New York, running consecutively from
September 13, 1997, through March 28, 1998. It was cocurated by Marilyn
Jung, Monica Chau, and Margo Machida.

93 Smith, Weekend Arts.

94 See Le, "How Come Charlie Don't Surf?" 7–12.

95 Samantha Chanse, telephone conversation with the author, January 10,
2006. "Pirated: A Post Asian Perspective" was on view at Kearny Street
Workshop May 5–29, 2005.

96 Said, *Orientalism*. On subjectification, see Bhabha, "The Other Question,"
67.

97 De Lauretis, "Statement Due," 368.

98 "Post Post-Identity" was evoked as the title of a 2005 review by Michael
Millner in *American Quarterly*, in which the author directs his critique at
two books challenging aspects of postidentitarian discourse: *The Shape of
the Signifier: 1967 to the End of History* (2004) and *So Black and Blue: Ralph
Ellison and the Occasion of Criticism* (2003). The first book, by Walter Benn
Michaels, claims that despite the efforts of postidentitarian practition-
ers to conceive of identities in fresh ways, their formulations still proceed
from essentializing assumptions. The second, by Kenneth W. Warren, dis-
approves of the displacement of political activity aimed at effecting larger
social change by a more indirect politics primarily centered on cultural rep-
resentations of black identity.

99 Among many recent examples, one can think of the notorious 1999 case of
Los Alamos physicist Wen Ho Lee, who was unjustly accused, incarcerated,
and condemned in the American press of being a Chinese spy.

100 Min, *Shifting Perceptions*, 19.

CHAPTER TWO Othering

1 Clifford, *The Predicament of Culture*, 7.

2 By this I refer to historic federal and state policies and actions primarily
directed toward nonwhite groups, among which are exclusionary immigra-
tion laws, racial segregation and legalized discrimination, reservations and
internment, seizure of lands and property, forced assimilation, and unequal
education.

3 Said, *Orientalism*, 5.

4 Said, "Orientalism, an Afterword," 51.

5 Ibid., 3. It should be noted that Said's emphasis on the direct connection between Orientalism and European colonialism has been taken to task for being highly selective and polemical. As a Palestinian activist living in the United States, his main interest lies in explicating the historic roots of the discourse driving contemporary Western relations with the Arab and Islamic world, and as such, he is criticized for overstating the role of the British and the French, the two nations most deeply involved in the Middle East and north Africa since the late eighteenth century, while disregarding the considerable Orientalist scholarship and literature of European nations that lacked colonies in the region. Nevertheless, *Orientalism*, as the founding document of post-colonial studies, has led numerous scholars since the late 1970s to closely scrutinize the historic biases that accompanied and validated Western colonialism.

6 Said, "Orientalism Reconsidered," 94.

7 Okihiro, *Margins and Mainstreams*, 20.

8 Hughes, *Heaven and Hell in Western Art*, 215.

9 Ibid.

10 Such characterizations recently resurfaced in the 2007 film *300*, a fictionalized retelling of the ancient Battle of Thermopylae, in which a small contingent of Spartans sacrificed themselves to delay a Persian invasion of Greece. The popular film, based on a graphic novel, portrays the Persian king as androgynous, and equally devoted to brutal violence and perverse sensuality. As the leader of a vast, undifferentiated horde drawn from Asia and Africa, this exoticized figure stands in stark contrast to the overly masculine Spartans, with their heroic martial ethos, highly muscular physiques, and individualized personalities.

11 While there are many uncertainties and conflicting theories about the ancient origins of the names for Asia and Europe that have entered English via Latin from Greek—including that they are either Greek, Hittite, or Sanskrit in origin—another argument traces one or both of these terms to ancient Semitic languages. Here they are identified with the Akkadian words for sunrise and sunset (*asu* and *erebu*) and sometimes with *ereb*, the Phoenician word for evening. These derivations are found in Klein, *A Comprehensive Etymological Dictionary of the Hebrew Language*, 43; and Room, *Placenames of the World*, 37, 121.

12 Torgovnick, *Gone Primitive*, 19.

13 Ibid., 8.

14 Ibid., 124.

15 There is a long history of Western fear of and competition with Asian cul-

tures, reflecting an undercurrent of dread about the prospect of being over-whelmed by non-Western rivals that is based on a succession of formidable aggressors—Persians, Huns, Magyars, Mongols, Saracens, Turks, Tartars—with which Europeans found themselves in conflict over thousands of years.

16 When the British author Sax Rohmer inaugurated his lengthy series of novels, comparable Asian villains previously had appeared in Western popular fiction and drama. It was the widespread popularity, however, of Sax Rohmer's stories that would provide the primary templates of the dia-bolical Asian genius with a megalomaniacal plot to rule the world, as well as the dragon lady (via Fu Manchu's equally nefarious daughter), tropes that were subsequently adapted in numerous horror and adventure films, radio programs, novels, and comic books.

17 Dower, "Yellow, Red, and Black Men," 158.

18 Ibid.

19 Okihiro, *Margins and Mainstreams*, 146–47.

20 Tchen, "Believing Is Seeing," 15.

21 Such a notion, taken to the extreme, was foundational to the murderous "völkisch" doctrine of a German regime that conceived of nationality and culture in overtly racial terms. While some in Europe, the United States, and Asia (most recently in Singapore) have conflated aspects of culture and race, Nazism's radical form of ethnic nationalism was predicated on a belief in an inherent relationship between the two. When thrown together with ideas from social Darwinism and eugenics, this belief in racial purity and a racial hierarchy that designated German ethnic groups, along with other European peoples, as genetically inferior to "Aryan" Germans, produced an especially toxic nationalist ideology.

22 Borshay, "The Dilemma of Television Portrayals of Asians," 11.

23 Wilson, "Stereotypes, or a Picture Is Worth a Thousand Lies," 20–21.

24 Marlon Fuentes, telephone interview with the author, July 8, 1991.

25 Marlon Fuentes, telephone interview with the author, May 22, 1996.

26 Marlon Fuentes, telephone interview with the author, January 1, 1993.

27 Marlon Fuentes, interview with the author, May 27, 1991.

28 Ibid. While there is extensive indigenous linguistic diversity in the Philip-pines, and English remains widely spoken, Tagalog is being promoted as the national language. Consequently, it is now used extensively in the media and is taught in elementary and secondary school.

29 Here I am pointing to certain uses to which ethnography has historically

been applied. It must equally be acknowledged that there have been active efforts from within the field to critique its ethnocentric biases and limitations, and to reconceptualize its practices, reflecting today's intellectual climate. Among the many publications that address key issues in this arena is Marcus and Fischer, *Anthropology as Cultural Critique*.

30 This work was first presented in the 1991 exhibition "Eight Paths to a Journey: Cultural Identity and the Immigration Experience," the Elipse Arts Center, Arlington, Virginia.

31 Marlon Fuentes, interview with the author, March 24, 1990.

32 Corbey, "Ethnographic Showcases, 1870–1930," 338.

33 See Rydell, *All the World's a Fair*.

34 Marlon Fuentes, telephone interview with the author, May 22, 1996.

35 Ibid.

36 Marlon Fuentes, "Bontoc Eulogy," unpublished artist's statement.

37 Marlon Fuentes, interview with the author, May 22, 1996.

38 In fact, the Inuit people had long been in contact with Western technologies via the Hudson Bay Company that had been trading in the area since the mid-1600s. As subsequent critics of *Nanook of the North* have pointed out, many aspects of Inuit life were selectively distorted to support the filmmaker's vision of an unspoiled noble people living in harmony with nature.

39 Feng, *Identities in Motion*, 24. See chap. 1, "The Camera as Microscope," for an analysis of the filmic devices employed in *Bontoc Eulogy*.

40 Marlon Fuentes, interview with the author, May 22, 1996.

41 Ibid.

42 Allan deSouza's mother was born in Kenya but went to school in Goa.

43 Joseph, *Nomadic Identities*, 87.

44 Allan deSouza, interview with the author, June 21, 2001.

45 Ibid.

46 DeSouza, "An Imperial Legacy," 6.

47 Panchayat, whose name refers to a council of village elders, was founded in 1988 in London by five artists of South Asian background: Allan deSouza, Bhajan Hunjan, Shaheen Merali, Symrath Patti, and Shanti Thomas.

48 DeSouza, "An Imperial Legacy," 7.

49 Allan deSouza, interview with the author, June 21, 2001.

50 Ibid.

51 Ibid.

52 Fanon, *Black Skin, White Masks*, 112.

53 DeSouza, "The *Coconut Chutney* Series," 14.

54 Allan deSouza, interview with the author, June 21, 2001.

55 Allan deSouza, e-mail correspondence with the author, June 12, 2000.

56 Sikhism, founded in the Punjab region of India in the fifteenth century, is an eclectic faith that combines elements of Hinduism and Islam. Due to severe persecution by Muslims during the Mughal period, Sikhs developed a strong martial tradition. While Sikhs handed the British their worst defeat in India at the battle of Chillianwala in 1849, a significant number later came to the British's support during the Great Mutiny of 1857. Sikh units also fought for the British Empire in Europe, Africa, and Asia during both World War I and World War II. Despite Sikh agitation for an independent homeland and the assassination of Prime Minister Indira Gandhi in 1984 by her Sikh bodyguards, Sikh's contribution to today's Indian military remains significantly higher than their presence in the general Indian population. Paradoxically (given deSouza's use of the Sikh headdress as a distinctive sign of Indianness), Balbir Singh Sodhi, a Sikh American gas station owner in Arizona, was taken for a supporter of Al-Qaeda a few days after 9/11 for wearing the turban and was shot dead. Ostensibly, many Americans would tend to conflate Sikh and traditional Arab attire. *Waterborne*, a 2005 film by Ben Rekhi, a Sikh American director, incorporates this misidentification in a plot to poison the Los Angeles water supply by homegrown Caucasian terrorists.

57 The flag of the East India Company from 1707 to approximately 1800, consisting of a Union Jack in the canton and thirteen stripes, was (according to the East India Company) the inspiration for the first U.S. flag, known as the Grand Union flag of 1775, or the Continental flag. Sir Thomas Smyth, formerly the governor of the East India Company during its first ten years, was also the governor of the Virginia Company, the first British colonial enterprise in North America. See the East India Company, "The East India Company in North America."

58 Allan deSouza, interview with the author, June 21, 2001.

59 Allan deSouza, interview with the author, October 30, 1999.

60 DeSouza, "The *Coconut Chutney* Series," 14.

61 Allan deSouza, unpublished artist's statement about the *Coconut Chutney* series.

62 Marling, "Imagineering the Disney Theme Parks," 105.

63 Of the three extant films in this series, *Indiana Jones and the Temple of*

Doom (1984) perhaps most overtly displays elements of Orientalism. Jones crashes his plane somewhere in India and winds up battling idolatrous and murderous Thuggees, who worship the Hindu goddess Kali, over the mystical "Shankara stone" believed to confer great power on its owner. In these adventures, his sidekick is a small Asian boy named Short Round.

64 Allan deSouza, interview with the author, June 21, 2001.

65 Although many ships are named after women, it is not much of a stretch to conjecture that a quasi-Orientalist impulse may stand behind this American amusement park's evident feminization of these vessels, and by association, the geographies they traverse, given that these rivers wind through three continents that experienced extensive Western penetration and colonization. While gender was not central to Said's argument, *Orientalism* was published at a time when feminist and woman's studies were beginning to have a significant impact on the American academy. Moreover, Said did note examples of gendered and sexualized language and female types in Orientalist texts that link the Orient and Orientals to effeminacy and passivity, and the Occident and Occidentals to activity and male prowess. Influenced by *Orientalism*, subsequent scholars would increasingly incorporate a gender-inflected analysis into critical discourses on Western colonialism and constructions of the Other. I use the term *incursion* in this context to acknowledge the fact that even though the Yangtze River basin was never colonized, European powers and the United States did cruise China's rivers and coastal waters as a consequence of that nation's defeat by Britain in the Opium Wars (1839–1842; 1858–1860). Indeed, from 1854 to 1941, vessels from the U.S. Asiatic Squadron patrolled the Yangtze as far as thirteen hundred miles inland, and put armed landing parties ashore to defend American interests. *The Sand Pebbles*, a 1966 film that drew parallels with the then-growing U.S. military presence in Vietnam, portrays one of these American gunboats on that river in 1926.

66 Karnow, *Vietnam, a History*, 538.

67 Pipo, interview with the author, August 29, 1997. French Roman Catholic missionaries began arriving in the 1600s but were subject to persecution from Vietnam's rulers. In 1858 French forces began an assault on southern Vietnam, seized Saigon in 1861, and by 1883 also had control of the north. In 1883 they forced its ruler to sign a treaty giving them control over the entire country, which they held until the Japanese took control of French Indochina during World War II. After the Japanese surrender in 1945, the French were ultimately unsuccessful in their attempt to reimpose colonial domination.

68 Despite the fact that Pipo's pieces allude to the theatrical and can be said to be influenced by body art and performance genres, they cannot strictly be classified as performance art in that they are not staged for a live audience. Rather, these are works of still photography, for which the artist stages particular tableaux. As with Cindy Sherman's mock self-portraits, there is a kinship to film stills created by motion picture studios for publicity purposes, as well as to certain types of fashion advertising, in which entire scenes are created for the camera.

69 Celeste Connor, "Pipo Nguyen-duy at Bucheon Gallery." 22–23.

70 Pipo, interview with the author, August 29, 1997.

71 For further discussion of Tseng Kwong Chi's work, see Machida, "Out of Asia," 96. Also among the Asian American artists Pipo cites as influences are Patrick Nagatani, a former teacher, and fellow Vietnamese artists Dinh Q. Lê and Hanh Thi Pham, for their visible acts of self-assertion as an integral aspect of their work.

72 Pipo, artist's statement, *Dialogue*, 26.

73 Pipo, interview with the author, July 19, 2001.

74 While there is a substantial literature on the impact of Japanese woodblock prints on European modernists, a good succinct account can be found in Sullivan, *The Meeting of Eastern and Western Art*, 209–40.

75 Pipo, interview with the author, July 19, 2001.

76 Pipo, interview with the author, June 23, 2000.

77 Asians from China and the Philippines first arrived in the Americas via Spain's sixteenth-century Pacific galleon trade between Acapulco, Mexico, and Manila. Some migrated to other areas, including Louisiana, a territory incorporated into the United States in the early nineteenth century.

78 Pipo, artist's statement, *Dialogue*, 26.

79 Sullivan, *The Meeting of Eastern and Western Art*, 224.

80 Pipo, interview with the author, June 23, 2000.

81 Ibid.

82 The cyanotype process is generally credited to Sir John Herschel, who invented it in 1842. The basic procedure involves sensitizing a piece of paper to light through the use of an iron salt solution. It is then printed by being placed directly in contact with the negative and exposed to sunlight until an image appears.

83 Vietnam was held by China from 111 BC to AD 939 and then was a vassal state for subsequent periods.

84 Pipo, interview with the author, June 23, 2000.

85 Tomie Arai, interview with the author, November 30, 1989.

86 Cityarts Workshop was a nonprofit arts organization, founded in 1968, that sought to bring art to the communities and to encourage participation by local residents in its creation.

87 Tomie Arai, interview with the author, July 27, 2001.

88 For an account of the beginnings of the mural movement in the 1960s, see Cockcroft, Weber, and Cockcroft, *Toward a People's Art*, chap. 1. There are also references to other New York City mural projects involving Asian Americans, including *Chi Lai—Arriba—Rise Up!* and *History of Chinese Immigration to the United States*, both directed by the artist and activist Alan Okada.

89 Tomie Arai, interview with the author, November 30, 1989.

90 See Benjamin, "The Work of Art in the Age of Mechanical Reproduction."

91 For instance, see Chavoya, "Customized Hybrids," 142.

92 Tomie Arai, interview with the author, April 2, 1997.

93 See Lee, Higa, and Casely, *Souvenir of SITEseeing*.

94 Tomie Arai, interview with the author, July 27, 2001.

95 Ibid.

96 Ibid.

97 Ibid.

98 Ibid.

99 Ibid.

100 For an account of Felice Beato's work, as well as that of other Western photographers in Japan, see Banta and Taylor, *A Timely Encounter*.

101 Tomie Arai, interview with the author, July 27, 2001.

102 Ibid.

103 Ibid.

104 Sakamoto, "The Process of Memory," 11.

105 Allan deSouza, e-mail correspondence with the author, July 17, 2001.

106 Mulvey, "Visual Pleasure and Narrative Cinema," 366.

107 Pipo, interview with the author, August 29, 1997.

108 See Bhabha, "Of Mimicry and Man." Bhabha's foundational concept of mimicry differs from deSouza's own art-related formulation, in that he places greater emphasis on its subversive potential.

109 Bhabha, *The Location of Culture*, 86.

110 Ibid., 89.

111 Allan deSouza, interview with the author, June 21, 2001.

112 See Hall and Sealy, *Difference*, 64.

113 A related approach focuses on the colonial and gendered implications of appearance, via vestimentary codes informed by the ethnography and politics of dress. For example, in her mixed-media painting *The Filipina: A Racial Identity Crisis—Maria Isabel and Liwayway* (1990), the Filipina American artist Pacita Abad addresses the tensions inherent in modern Filipina identity. Divided sharply in half, the canvas depicts a fair-skinned mestiza woman in European-style clothing on one side, and a dark-skinned woman in a brightly colored indigenous outfit on the other. Each represents a different mentality and political position: the former admiring and emulating Western culture, the latter taking pride in maintaining and reviving local traditions despite the erasures effected under centuries of Spanish and American colonial rule.

114 Aletti, "Playing God."

115 *Two Undiscovered Amerindians Visit Madrid* was first performed in 1992; variations on this piece were subsequently staged in several international and U.S. venues. For a critical account of the project, see Fusco, "The Other History of Intercultural Performance."

116 Foster, "The Artist as Ethnographer," 183. Among the well-known U.S. conceptual and installation artists he cites are Fred Wilson, Renée Green, Jimmie Durham, and James Luna.

117 Ibid., 196.

CHAPTER THREE Trauma, Social Memory, and Art

1 Wei, *The Asian American Movement*, 2.

2 Sucheng Chan, *Asian Americans*, 121. It should be noted that this pattern was uneven, as other East Asians still contended with being mistaken for Japanese; nor did many white Americans find it necessary to make such distinctions.

3 Also referred to as the Philippine-American War, that legacy of conflict recently inspired an ambitious edited volume that incorporates visual essays and writings by artists and filmmakers, among others, in a cross-disciplinary, transnational consideration of its impact on the Philippines, its culture, and people, both in their homeland and in the U.S. diaspora. See Velasco Shaw and Francia, *Vestiges of War*.

4 Okihiro, *Margins and Mainstreams*, 28.

5 For example, Elena Tajima Creef's *Imaging Japanese America: The Visual*

Construction of Citizenship, Nation, and the Body applies the insights of visual culture studies to a wide-ranging examination of representations of the Japanese American internment, including the hallmark "visual autobiography" by the artist Miné Okubo, *Citizen 13660*.

6 Halbwachs, in Coser, *On Collective Memory / Maurice Halbwachs*, 22. Halbwachs extends Emile Durkheim's concept of collective representations—the ways in which people classify themselves in society—into a hypothesis on how collective memory is constituted by different groups and social classes in what are termed the "principal locations of memory." By laying the groundwork for understanding the interwoven nature of identity in group membership, his ideas have been consequential to a growing body of work focused on the social sharing of experience, the nature of autobiographical and reconstructive memory, and social trauma.

7 Connerton, *How Societies Remember*, 21.

8 Prager, *Presenting the Past*, 4.

9 Ibid., 90. Prager is interested in the emergence of "repressed memory" (also termed "recovered memory syndrome")—chiefly among adult women who have begun remembering previously forgotten incidents of childhood sexual abuse—as a growing phenomenon in late twentieth century American life. In his view, such discourses take on a life of their own, becoming potent mythologies that in some cases have encouraged people to search for incidents of traumatic abuse as a means of explaining their present difficulties.

10 Ibid., 54–57. The term *intersubjectivity* is also used in theories of society such as action theory, phenomenological sociology, and symbolic interactionism that start with the individual as a social actor.

11 The psychiatric definition of trauma is based on experiencing life-threatening situations or bearing witness to or hearing about the threat of harm to others and involves feelings of "intense fear, helplessness and horror." See American Psychiatric Association, *Diagnostic and Statistical Manual of Mental Disorders*, 424.

12 Although the work in this chapter certainly deals with collective and personal pain arising from histories of war, societal rupture, and forced displacement, none of the artists central to this discussion did originally envision or identify trauma as the dominant idea framing their work. I review some to the literature on trauma and associated theorizations of loss, abjection, and melancholia (some of which did not exist at the time these interviews were conducted) to offer an important and productive means of illuminating certain psychosocial dynamics that help to give this art its

expressive force and moral urgency. The same holds true for conceptions of remembering and memorialization surrounding the Jewish Holocaust.

13 Eng and Kazanjian, "Introduction," 16.

14 Cheng, *The Melancholy of Race*, xi, x.

15 As Anthony Lee notes, despite efforts to move beyond prior rhetorics of race and race politics via these sophisticated theoretical models, by holding out possibilities for promising alternative futures (albeit ones that must forever remain undefined lest they be associated with discredited notions of progress), "racial melancholia, like identity politics, still asks that we *do* something about social inequalities." "The Meanings of Melancholy," 99. Apart from their value in stimulating internal academic debate, Lee calls into question what real-world forms such "new" activism might take, and also asks how in the final analysis it differs from some of the idealistic goals of community and identity politics.

16 Shimakawa, *National Abjection*, 2. Via Julia Kristeva's use of Lacanian psychoanalytic theory, the literary and performance studies scholar Karen Shimakawa understands "Asian American" as a "category both produced through and in relation to abjection within and by dominant U.S. culture." Abjection as a critical tool provides latitude to conceive Asian American–ness not simply in terms of racialization, but rather as a mutable and variegate set of relationships to the dominant culture which are both imposed and—as the author demonstrates in her study of Asian American theatrical productions and theater companies—constitute primary sites of symbolic intervention.

17 Freud, "Mourning and Melancholia."

18 Eng and Kazanjian, *Loss*, 4. In their formulation of a "politics and ethics of mourning," they link Freudian melancholia to Walter Benjamin's concept of historical materialism, an approach to writing history intended to be productive of positive social change in the present. In this, they consider melancholia in a broader context, as a response to catastrophic events that tear people, cultures, and nations asunder—war, genocide, terrorism, religious conflict, the AIDS pandemic—as well as to the consequences of traumatic social conditions such as racism and colonialism.

19 Gilroy, *After Empire*, 98.

20 Chow, *Writing Diaspora*, 4.

21 Anonymous visitor's commentary, guest ledger for "Asia/America."

22 Through such an argument I do not seek to conflate the wide range of experiences, individual and collective, formed in perilous circumstances

under the umbrella term of social trauma, as if all such events are of equal magnitude and ferocity, and thereby taken to be interchangeable aspects of some monstrous whole. Overgeneralization can elide real disparities between an extraordinarily dire situation that practically defies human reckoning and overwhelms the ability to bear witness, such as the Jewish Holocaust—to which a great deal of contemporary writing and testimony on social trauma is keyed—and experiences that, while certainly terrible, do not involve a program aimed at the deliberate and systematic elimination of a whole people or culture. Allowing for such difference is not meant to imply a hierarchy of suffering, but rather to emphasize the need to make careful distinctions when considering specific histories and individual positions in relation to different forms of social trauma.

23 Laub, "Truth and Testimony," 63.

24 Laub, "Bearing Witness or the Vicissitudes of Listening," 69.

25 Caruth, *Unclaimed Experience*, 4. See also ibid.

26 Ibid. Extending this idea to the arts is hardly problematic, considering that the conversion of information gleaned from clinical case studies into forms of literature has a long pedigree among mental heath professionals, ranging from Sigmund Freud to contemporary practitioners like Oliver Sacks.

27 Ibid., 8, 24. In *Jerusalem Delivered*, an epic poem by the Italian poet Torquato Tasso, the knight Tancred unknowingly mortally wounds his lover Clorinda and subsequently inflicts another blow by stabbing the tree in which her soul is trapped; at that moment, he hears her ghostly voice moaning that he has wounded her again. For Caruth, both the tale and Freud's use of the motif are metaphors for the way in which psychic trauma entails the repetitive re-enactment of events.

28 Bennett, *Empathic Vision*, 22–23 and 38–39.

29 Young, *The Texture of Memory*, xi–xii.

30 Coser, "Introduction."

31 A noteworthy publication from the late 1990s is Bal, Crew, and Spitzer's edited volume *Acts of Memory* (1999), which incorporates writings on visual art in a cross-cultural, interdisciplinary examination of the production of public and cultural memory, including responses to individual and social trauma.

32 Sturken, *Tangled Memories*, 13.

33 Berger, *Ways of Seeing*, 7.

34 Dissanayake, *Homo Aestheticus*, 39.

35 Lippard, *Mixed Blessings*, 7.

36 Maclear, *Beclouded Visions*, 21.

37 It is a testament to the enduring power of this subject that art dealing with the internment continues to stimulate an ever-expanding body of research, publications, and exhibitions. For instance, a special tribute issue of *Amerasia Journal* (vol. 30, no. 2, 2004) was devoted to the life, art, and work of Miné Okubo. Likewise, there have been important retrospective catalogues and books on individual artists that feature works associated with this theme, such as Lew, ed., *Minidoka Revisited: The Paintings of Roger Shimomura* (2005), and Hill, *Topaz Moon: Chiura Obata's Art of the Internment* (2000). Drawing on two related exhibitions mounted in 1992, "The View from Within" and "Relocations and Revisions," Kristine Kuramitsu's earlier article "Internment and Identity in Japanese American Art" engages in a comparative, intergenerational examination of works by Japanese American artists that either arise from direct, personal experience of the internment, or from its legacy.

38 See Daniels, "The Forced Migration of West Coast Japanese Americans, 1942–1946," 72. Most of the Japanese American population of Hawai'i was spared because of their significant role in the local economy and also because they lived on a relatively isolated island chain that had already been placed under strict martial law for the duration of the war.

39 Daniels, "Incarceration Elsewhere," 132. According to Daniels, there were 125,000 ethnic Japanese living in the continental United States in December 1941; therefore, the vast majority of them were interned.

40 Takaki, *Strangers from a Different Shore*, 391.

41 In spirit, if not in substance, the creation of widely separated federally run camps to confine and police the mainland Japanese parallels the reservation system for Native Americans, which also had as its central purpose the close containment and management of a nonwhite population. Tellingly, Dillon S. Myers, the commissioner of Indian Affairs in 1950, had formerly been in charge of the internment camps. See Debo, *A History of the Indians of the United States*, 351.

42 Dower, "Yelow, Red, and Black Men," 162. Among them, as Dower recounts, were "little yellow men," "yellowbellies," and "yellow monkeys."

43 Ibid., 161.

44 Takaki, *A Different Mirror*, 205.

45 Csikszentmihalyi and Rochberg-Halton, *The Meaning of Things*, 16.

46 Leppert, *Art and the Committed Eye*, 69.

47 Kristine Aono, telephone interview with the author, July 16, 2000.

48 Iwasaki Mass, "Psychological Effects of the Camps on Japanese Americans," 160.

49 Nelly Puiz-Arango Sidoti, "Forgotten Dust Awakens Prayers for Rain."

50 Kristine Aono, interview with the author, March 22, 1990.

51 Kristine Aono, interview with the author, October 1, 1989.

52 Daniels, "Relocation, Redress, and the Report," 4.

53 Marianne Hirsch, "Past Lives," 420, 422.

54 Okihiro, *Cane Fires*, 229–30.

55 Aono, "Artist's Statement," 7. This was an excerpt from notebooks containing statements by the lenders compiled during the course of the exhibition at the Japanese American National Museum (JANM).

56 Oversight for the various types of camps was divided among multiple federal agencies. There were ten War Relocation Authority (WRA) relocation centers (a.k.a. internment camps) set up in Arizona, Arkansas, California, Colorado, Idaho, Utah, and Wyoming. Kristine Aono also included artifacts from the Crystal City, Texas, site, which was one of the Justice Department internment camps. The Justice Department camps, along with two citizen isolation camps, were established for internees who were labeled as troublemakers in the WRA camps, or who lacked U.S. citizenship. Some camps were represented more than once in her installation, which contained fifteen grids.

57 *Relics from Camp* appeared at JANM from January 26 to April 14, 1996. It traveled to two other sites: the National Museum of Women in the Arts, Washington, D.C., and the Harold Washington Library Center, Chicago.

58 Kristine Aono, interview with the author, July 16, 2000.

59 In a more general sense, this object points to how human beings, even in the worst of circumstances, will seek to exercise agency, and surround themselves with what is familiar, rather than becoming paralyzed or passive. For example, in *The Slave Community: Plantation Life in the Antebellum South* (1972), John W. Blassingame outlines how enslaved African Americans maintained a measure of autonomy and self-esteem by carving out private spaces for themselves free from white surveillance, and by drawing upon and preserving aspects of their cultural and religious heritages. While its author was criticized for using slave narratives that are considered historically unreliable by some scholars, his primary focus on the agentive realm within conditions of enslavement was quite influential and likely helped prepare the way for a project like *Relics from Camp*.

60 Eric Hobsbawm, "Introduction," 10.

61 Rosenblatt, "How We Remember."

62 Ibid.

63 Howe, *The Koreans*, 238.

64 Park, *The Korean American Dream*, 29.

65 Yong Soon Min, lecture at Parsons School of Design, New York City, October 25, 1989.

66 Yong Soon Min, interview with the author, December 27, 1990.

67 Ibid.

68 Park, *The Korean American Dream*, 3; Lee "Urban Impressionist," 19.

69 Kim, "A Different Dream," 27. It should be noted that this practice is by no means exclusive to Koreans, as, for instance, the Chinese use "double ten" or 10/10 to refer to the date that marks the outbreak of the Nationalist Revolution (October 10, 1911).

70 This is an alternative spelling of *sa-i-gu*.

71 Alarcon and Kim, Preface to *Writing Self, Writing Nation*, x.

72 Alexander, "The Shock of Arrival," 313.

73 Yong Soon Min, interview with the author, December 27, 1990.

74 Kim and Choi, *Dangerous Women*, 3–4. For this point the editors draw on the essay by Seungsook Moon, "Begetting the Nation: The Androcentric Discourse of National History and Tradition in South Korea."

75 *DMZ XING* was exhibited in 1994 in the Asian American Cultural Center at the University of Connecticut at Storrs.

76 This legislation consisted of the Refugee Act of 1980 and the Amerasian Homecoming Act of 1987.

77 Unlike the Korean DMZ, which is highly militarized, maintained by large contingents of American troops, and remains the de facto boundary between the two Koreas, the DMZ in Vietnam primarily functioned as a diplomatic fiction. While it also served as a boundary between the north and the south, it was never guarded by a permanent foreign presence and was continually bypassed by the north during the war.

78 Yong Soon Min, correspondence with the author, July 27, 2000.

79 Yong Soon Min, telephone interview with the author, May 22, 2000.

80 Keedle, "Twilight Zone."

81 Ibid.

82 Ibid.

83 Ibid.

84 Ibid.

85 Yong Soon Min, interview with the author, May 22, 2000.

86 Min, "Heartland," 14.

87 Reid, "Home and Home Again," 8.

88 Rumbaut, "Vietnamese, Laotian, and Cambodian Americans," 177.

89 Esper and the Associated Press, *The Eyewitness History of the Vietnam War, 1961–1975*, 5.

90 Chan, *Asian Americans*, 155–56.

91 Isaacs, *Vietnam Shadows*, 156.

92 Rutledge, *The Vietnamese Experience in America*, 10.

93 Karnow and Yoshihara, *Asian Americans in Transition*, 23.

94 A telephone poll of four hundred Vietnamese adults living in Orange County, California, conducted between March 20 and April 3, 2000, indicated that only 35 percent would return to live in Vietnam, even if democracy were established there. For details, see Martelle and Tran, "25 Years after the Fall of Saigon, a Vietnamese Enclave Thrives."

95 Thomas, "Introduction," 15. "War and Memory" was presented at Washington Project for the Arts, and "A Different War: Vietnam in Art" was organized by Lucy Lippard for the Whatcom Museum of History and Art, Bellingham, WA.

96 The exception was the artist Tin Ly.

97 "As Seen by Both Sides" and "An Ocean Apart: Contemporary Vietnamese Art from the United States and Vietnam" were both curated by C. David Thomas, the director of the Indochina Arts Project.

98 Isaacs, *Vietnam Shadows*, 10.

99 This memorial was designed with some controversy by the architect Maya Lin, a woman of Asian descent.

100 See Martelle and Tran, "25 Years after the Fall of Saigon, a Vietnamese Enclave Thrives."

101 Hanh Thi Pham, telephone interview with the author, March 2, 1993.

102 Hanh Thi Pham, telephone interview with the author, May 23, 1995.

103 Hanh Thi Pham, telephone interview with the author, November 23, 1992.

104 Hanh Thi Pham, interview with the author, March 2, 1993.

105 Ibid.

106 Lam, "Love, Money, Prison, Sin, Revenge," 86.

107 Hanh Thi Pham, interview with the author, May 18, 1992.

108 For more on Richard Turner's work, see Lucy Lippard's essay "In Country,"

108. As she notes, Turner has long been interested in Asia and has produced several of his own multimedia installations dealing with the Vietnam War period.

109 Hanh Thi Pham, interview with the author, May 18, 1992.

110 Hanh Thi Pham, telephone interview with the author, November 23, 1992.

111 Reisner, "Staging the Unspeakable."

112 Ibid., 5.

113 See Isaacs, *Vietnam Shadows*, 156–57. Here he notes how the lingering psychic wounds of war have had damaging and even fatal consequences for some Southeast Asian refugees. Among them he cites the spontaneous, unexplained deaths of dozens of young men, half of whom were Hmong, in their sleep, as well as the cases of 150 Cambodian women in California who became blind after witnessing the atrocities of the Khmer Rouge reign of terror, despite having no diagnosed eye disease.

114 Hanh Thi Pham, interview with the author, May 18, 1992.

115 Muchnic, "'Street of Knives' Cuts into Fears."

116 Hanh Thi Pham, interview with the author, May 18, 1992.

117 Ibid.

118 This now-iconic image was taken by the Associated Press photographer Eddie Adams.

119 Hanh Thi Pham, interview with the author, May 18, 1992.

120 Ibid.

121 Hobsbawm, *The Invention of Tradition*, 276.

122 Hanh Thi Pham, interview with the author, May 18, 1992.

123 Ibid.

124 Ibid.

125 Suzette Min, "Remains to Be Seen," 231, 237.

126 Kester, *Conversation Pieces*, 118–19. Quoting Jeffrey T. Nealon's conception of the formation of subjectivity through direct, corporeal interchange between people (which builds on the writings of Emmanuel Levinas and Mikhail Bakhtin), Kester states that "our capacity for ethical . . . judgment derives not from the heady vantage point of some transcendent subjectivity but from a given 'dialogical situation in all its concrete historicity and individuality.'" Nealon, *Alterity Politics*, 37.

127 Lippard, *Mixed Blessings*, 168.

128 Lee, "A Peculiar Sensation," 294.

129 See Lewallen, ed., *The Dream of the Audience*. This volume contains essays by Lawrence Rinder and Trinh T. Minh-ha.

130 Kang, "Re-membering Home," 252.

131 As one Japanese American legal scholar writes, the distinction "between citizens and noncitizens and the concept of equality in [U.S] immigration are highly fluid and dynamic notions. As my own family history shows, the line between us and them has never been fixed or impermeable. The question is not just when "we" and "they" are equal, but also when and how "they" become part of "us." Motomura, "Immigration: How 'They Become 'Us,'" B7.

132 The use of assumed identities and fictional life histories reflects how many Chinese migrants sought to bypass the convoluted categories of the Chinese Exclusion Act in order to gain legal admission to the United States. (In effect from 1882, the Chinese Exclusion Act was repealed in 1943 following the United States' anti-Japanese wartime alliance with China). Since wives were excluded, some women entered the United States by claiming to be their husband's sister or mother. Those who could establish U.S. birth, or who were deemed desirable under the exempt-class clause (such as merchants and students) also gained entry for their children and close relatives. Terms like *paper son*, *paper daughter*, and *paper sister* were coined by Chinese Americans to describe those who entered under false papers and who lived continually with the fear and shame that they could be discovered and deported at any time.

133 Florence Oy Wong, e-mail correspondence with the author, August 29, 2006. See also Roth, "A Story In Three Parts." Wong's use of commercial rice sacks (and sometimes the rice they contained) as an iconic sign of sustenance, security, and survival is closely linked to the artist's Asian cultural heritage, family history, and childhood memories of life in Oakland, California's Chinatown. Present in the majority of her assemblages and installations from the late 1970s onward, their personal significance can be traced to a period when the artist's impoverished family subsisted mainly on bags of rice donated by relatives and friends. Further, since rice sacks in Wong's community were commonly "recycled" as dishcloths, or stitched together to serve as sheets and underwear, for the artist they also embody the perseverance and ingenuity of the Chinese immigrant families who by necessity had to make every available resource work to their advantage.

134 Suzette Min, "Remains to Be Seen," 231.

135 Vo, artist's statement.

136 Suzette Min, "Remains to be Seen," 243.

137 Vo, artist's statement.

138 Gumpert, "The Life and Death of Christian Boltanski," 51.

139 Such an approach in the work of Aono and Kabakov can also be seen as related to the concept of *bricolage*, which is employed in several artistic disciplines (and other fields). This French term, popularized by the anthropologist Claude Lévi-Strauss, refers to the creative use and reuse of whatever materials and resources are at hand.

140 Gablik, "Connective Aesthetics," 74–87.

CHAPTER FOUR **Migration, Mixing, and Place**

1 Rogoff, *Terra Infirma*, 8.

2 Appiah, *The Ethics of Identity*, 215.

3 Hall, "The Formation of a Diasporic Intellectual," 490.

4 Weiner, *The Global Migration Crisis*, 2.

5 See Nochlin, "Art and the Conditions of Exile." Nochlin cites the exhibition catalogue *The Golden Door: Artist-Immigrants of America, 1876–1975* (McCabe) as one important account of the impact of European emigration on American art.

6 Chambers, *Migrancy, Culture, Identity*, 5.

7 Alexander, *The Shock of Arrival*, 152–53, 161.

8 Rushdie, *Imaginary Homelands*, 10.

9 Ibid., 12.

10 See Kirshenblatt-Gimblett, "Spaces of Dispersal," 339–344.

11 Axel, "The Diasporic Imaginary," 411–12, 423. Axel's interests concern the Sikh diaspora, particularly how the dissemination of an imagery of martyrdom via modern communication technologies such as the Internet has been instrumental in conceptualizing modern Sikh identity. While his approach intersects with the historical role of social trauma in constructing a dispersed people's sense of identity (and could be applied to groups like the Jews, Armenians, Palestinians, and Kurds), the notion of diaspora as a larger process of identification that transcends places of origin also applies to how the artists discussed in this chapter have conceived of their work.

12 Clifford, *Routes*, 24. In the face of what Stuart Hall has termed the "fashionable postmodernist notion of nomadology," it is necessary to emphasize the importance of examining conceptions of dwelling. See Hall, "Traveling Cultures," 44 (based on a transcript of remarks at the conference entitled "Cultural Studies, Now and in the Future," Champaign-Urbana, Illinois, April 6, 1990).

13 Casey, *Remembering*, 187–88.

14 Wong, *Homebase*, 111.

15 See Pollan, *The Botany of Desire*, xiv.

16 Yau, *The Garden of Earthly Delights*.

17 Ming Fay, interview with the author, January 15, 2004.

18 Obrist, "Conversation with Chen Zhen," 21.

19 Abbas, "Cosmopolitan De-Scriptions," 774.

20 Pomerantz and Topik, *The World That Trade Created*, 62.

21 Ming Fay, correspondence with the author, March 28, 2004.

22 Ming Fay, interview with the author, January 15, 2004.

23 Ming Fay, correspondence with Jonathan Goodman, 2003.

24 Ibid.

25 Ming Fay, in Shields, *Ming Fay*.

26 For a wide-ranging account of the relationship between botany, science, and European imperial expansion, see Drayton, *Nature's Government*.

27 Ming Fay, artist's statement, "Ming Fay: Money Tree & Monkey Pots," exhibition, Montalvo, California, 2004.

28 Zarina, interview with the author, July 17, 2001.

29 Ibid.

30 Zarina, correspondence with the author, December 11, 2005.

31 The figure of fifteen million people was quoted by the New Delhi–based journalist Kai Friese in "Two Uneasy States of Independence."

32 Collins and LaPierre, "The Greatest Migration in History."

33 Zarina, "Zarina Hashmi, Visual Artist, Interviewer," 63.

34 Zarina, unpublished artist's statement, ca. 1996.

35 Zarina, interview with the author, September 22, 1999.

36 Zarina, interview with the author, December 17, 1992.

37 Ranu Samantrai, "Cosmopolitan Cartographies, Art in a Divided World," 171.

38 Bakhtiar, *Sufi*, 25–27.

39 Zarina, interview with the author, December 17, 1992.

40 Naqvi, "Discourse of Intimacy," 131.

41 Zarina, unpublished artist's statement, ca. 1996.

42 Zarina, interview with the author, July 3, 1992.

43 Ibid.; Zarina, in Samantrai, "Cosmopolitan Cartographies, Art in a Divided World."

44 Zarina, interview with the author, July 3, 1992.

45 Zarina, unpublished artist's statement, ca. 1996.

46 Zarina, interview with the author, July 17, 2001.

47 Ibid.

48 DeSouza, "The Flight of/from the Authentic Primitive," 118.

49 Allan deSouza, interview with the author, October 30, 1999.

50 Aretxaga, *Shattering Silence*, 13.

51 Allan deSouza, unpublished slide notes, n.d.

52 Iyer, *The Global Soul*, 42.

53 Allan deSouza, interview with the author, October 30, 1999.

54 Ibid.

55 Ibid.

56 Allan deSouza, interview with the author, June 21, 2001.

57 Ibid.

58 Ibid.

59 Foucault, *Discipline and Punish*; Du Bois, *The Souls of Black Folk*, 45.

60 JanMohamed, "The Economy of Manichean Allegory," 20–21.

61 It could equally be observed that in working class areas of London, South Asians, blacks, and European immigrant groups, like the Irish who preceded them, often tended to occupy similar strata in the social and economic hierarchy. In his study of the impact of globalization in transforming the city of London, John Eade observes, "Black and Asian settlers from former British colonies have played the major part in creating London's multicultural society, but it is they who experience some of the highest levels of poverty and discrimination." See Eade, *Placing London*, 2.

62 Allan deSouza, artist's statement, "Terrible Beauty (a re-Situation of an unnaturally-conditioned Mind, cast upon the treacherously shifting waters between International Style and Nationalist Fervor)," solo gallery exhibition, Susanne Vielmetter Projects, Los Angeles, California, February 2001.

63 Allan deSouza, unpublished slide notes, n.d.

64 Allan deSouza, e-mail correspondence with the author, July 16, 1999.

65 DeSouza, artist's statement, "Terrible Beauty."

66 Y. David Chung, interview with the author, September 24, 1989.

67 Y. David Chung, interview with the author, June 24, 1999.

68 Y. David Chung, e-mail correspondence with the author, September 3, 2001.

69 Ibid.

70 Lippard, *Mixed Blessings*, 151.

71 Y. David Chung, "Seoul on Soul," 20.

72 Y. David Chung, interview with the author, June 24, 1999.

73 Ibid.

74 Y. David Chung, *sites of recollection*, 54.

75 Y. David Chung, "Seoul on Soul," 19–20.

76 Y. David Chung, *sites of recollection*, 52.

77 As Y. David Chung explains, "In the countryside of Korea, they have mask theater productions during festivals. They are very stylized plays, stories with a known plot or even no plot at all. It's more like a dance. The characters are exaggerated and set in individual scenes. We took this as our format and called it an opera because we wanted continuous movement from beginning to end." Chung, *sites of recollection*, 47–48.

78 Ibid.

79 Chung, *Crossroads* interview with Les Gillespie, televised news profile on *Seoul House*, Washington, D.C., March 1988.

80 Y. David Chung, unpublished script, *Seoul House: Korean Outpost.*

81 Ibid.

82 Henry, "Beyond The Melting Pot," 28.

83 Pear, "Racial and Ethnic Minorities Gain in the Nation as a Whole."

84 Y. David Chung, unpublished artist's proposal to Jamaica Arts Center, Jamaica, New York, 1989.

85 Y. David Chung, e-mail correspondence with the author, September 8, 2001.

86 Y. David Chung, unpublished notes from gallery talk, Whitney Museum of American Art at Philip Morris, September 9, 1992, 2.

87 Ibid.

88 Historically, these areas in Central Asia had not previously been nations, but rather were under the feudal control of different Mongol rulers since the thirteenth century, until they came under Russian control in the mid-1500s and were incorporated into the Soviet Union in 1936. Hence, they have long been composite cultures with multiple overlays brought about by conquests over many centuries. Gaining their independence as a result of the breakup of the Soviet Union, they are just now at a point of beginning to construct a sense of national identity or nationalist ethos. It could be said that what Chung is witnessing is a form of social engineering in which there are deliberate efforts, at the governmental level, to create a sense of collective identity through culturalism—i.e., the assertion of language and folk culture, among other means.

89 Y. David Chung, interview with the author, June 24, 1999.

90 Chung, *The Wishing Tree*.

91 Enwezor, "The Black Box," 44.

92 Hayden, *The Power of Place*, 8.

93 Bourriaud, "Relational Aesthetics," 160.

94 Hayden, *The Power of Place*, 9.

95 Komar and Melamid, *Tracing Cultures*, 44.

96 On constructed situations, see Guy Debord, "Towards a Situationist International," 96; on social sculpture, see Joseph Beuys, "I Am Searching for Field Character," 48; and on relational aesthetics, see Bourriaud, "Relational Aesthetics," 160–71.

97 Ibid., 166.

98 Rirkrit Tiravanija, "Rirkrit Tiravanija, March 2006."

99 Such playfully performative explorations of urban surroundings and encounters with modern city life owe a debt to both psychogeography, a concept advanced by Guy Debord in the mid-1950s, and the notion of the flâneur as an observant urban wanderer, a term popularized by Charles Baudelaire in the nineteenth century.

100 Anzaldúa, *Borderlands/La Frontera*, preface, 77.

101 Richard A. Lou, unpublished artist's statement, n.d.

102 Wodiczko, *Critical Vehicles*, 104.

103 Yong Soon Min, "Transnationalism from Below," 10.

104 Min cites Kristeva, *Strangers to Ourselves*.

105 Wallach, "Mixed Signals," 128.

106 In this usage, the term *conceptualism* is not intended to directly link work discussed in this chapter to late 1960s conceptual art, with its countercultural challenges to established authority and anti-commercial emphasis on the idea, rather than on the object, as being of greatest significance. Likewise, it does not refer to more recent conceptually-derived strategies that aspire to expose the ideologies and mechanisms that drive the commodification of art and artists, and the promotion, distribution, circulation, and consumption of contemporary visual culture.

107 Ming Fay, interview with the author, November 11, 1989.

108 As previously cited in chapter 1, see Appiah, *The Ethics of Identity*, 213–72.

109 Yang, "Letting Go," 10. See also Tiravanija, interview with Mary Jane Jacob, 170–77.

110 See Morse, "*Nāu ka wae (the choice belongs to you): A Conceptual Installation by Kaili Chun*," exhibition brochure (Honolulu: Honolulu Academy of Arts, 2006).

Epilogue · Toward an Ongoing Dialogue

1 Papastergiadis, "The Limits of Cultural Translation," 331.

2 Okihiro, *Margins and Mainstreams*, ix.

3 Among recent efforts by contemporary theorists to formulate the role of art as a site of communicative interaction and community formation, see Kester, *Conversation Pieces*, a study of public art practices and cultural activism that proposes a "dialogical aesthetics" in which art is conceived in processual and performative terms, in facilitating dialogue and connections among different communities. He usefully emphasizes the reciprocal relationship between identity and discursive engagement with other living people in forming consensual understandings, drawing on concepts of a "relational aesthetic" (Nicolas Bourriand) and feminist models of a "connective aesthetics" (Suzi Gablik), among other precedents.

4 Becker, "The Artist as Public Intellectual," 389.

5 Ybarra-Frausto, "Transcultural New Jersey," 16–24.

6 Isin and Turner, "Citizenship Studies," 4.

7 Rosaldo, "Cultural Citizenship, Inequality, and Multiculturalism."

8 Bhabha, "The Right to Narrate," *Reflections 2000*.

9 Homi Bhabha, "The Right to Narrate: Interview with Homi Bhabha."

10 Unlike Latinos, the majority of whom share a heritage in Catholicism, the Spanish language, and European colonialism, the sweep of nationalities, ethnicities, and historical experiences that constitute Asian America is of a quite different order of magnitude. European colonization was not total in Asia, and while some East and Southeast Asian groups derive a common ethos from Confucian and Buddhist traditions, others draw upon a range of spiritual traditions and practices, including Christianity, Hinduism, and Islam.

11 Espiritu, *Asian American Panethnicity*, 176.

12 Benmayor, "Testimony, Action Research, and Empowerment," 165.

13 See Sau-ling C. Wong, "Denationalization Reconsidered."

14 Sandoval-Sánchez and Sternbach, *Stages of Life*, 17. They invoke the anthropologist Fernando Ortiz's discussion of transculturation to provide a wide-ranging frame, based on an "accumulation of historical processes" through which diverse performers and audiences can "problematize the multiple strands of their [hybrid] identities simultaneously."

15 Gilroy, *After Empire*; Satya P. Mohanty, *Literary Theory and the Claims of History*, 240.

16 Berlant, "Critical Inquiry, Affirmative Culture," 448, 449; Jameson, "Symptoms of Theory or Symptoms for Theory?" 406.

17 Bhabha, "Statement for the Critical Inquiry Board Symposium," 348.

18 Medina, "Identity Trouble," 657.

19 Min, "The Last Asian American Exhibition in the Whole Entire World," 39. The author's comments are made in response to Jean-Luc Nancy.

20 In her PhD dissertation (2000), Min made this point more emphatically. While she mainly aspires to interrogate the "practice of representation" in order to "present and promote artists of color in complex ways to both an academic and larger public," she does maintain that "the discourse begun with multiculturalism and identity politics needs to continue" if we are to enlarge the "definition of what constitutes valid visual art practices and the description of who can legitimately practice art." Min does not equate inclusion in the arts with "effective political change" but argues nevertheless that "every exhibition, every review, every article promotes core values of Asian American art and Asian American culture that validate and familiarize readers who are not familiar with Asian Americanness and the intersecting issues of race, sexuality, class, and gender." Min, "Creative License," 166, 194–95.

21 This phrasing inverts and reworks Benedict Anderson's well-known formulation of the identity of the modern nation-state in *Imagined Communities*, in which he examines how social collectivity is produced and managed through historical narratives, emblems, maps, anthems, and public spectacles. Whereas Anderson's deconstructive analysis emphasizes the systemic, disciplinary production of social consciousness, my modified usage of this term takes as its point of departure his concern with the role of the imagination in creating a sense of large-scale communities, to instead consider the generative possibilities of individual interventions through visual art and culture in transforming and reworking the aggregation of images by which this society envisions itself. Although I arrived at this formulation independently, I have since recognized that it has also been applied in the field of education studies as a tool for training teachers to work in multicultural classrooms. It appeared in the title of a 2002 paper, "Creating Communities of Cultural Imagination: Negotiating a Curriculum of Diversity," by Janice Huber, M. Shaun Murphy, and D. Jean. Here, however, its use remains limited to its citation in the title. Concerned with learning communities, the authors cite the influence of Susan Florio-Ruane's 2001 book, *Teacher Education and the Cultural Imagination*. In that book, Florio-Ruane calls for engagement with cultural imagination in dealing with a diverse

student body but throughout makes no reference to communities of the cultural imagination.

22 The term *interpretive communities* is commonly associated with Stanley Fish's reception-oriented theory of textual meaning as being produced by "communities" of specialized readers. Fish, *Is There a Text in This Class?*

23 Raven, "Word of Honor," 161.

24 Shohat, "Lynne Yamamoto," 168.

25 Ibid.

26 Genara Banzon, interview with the author, November 28, 1996.

BIBLIOGRAPHY

Published Sources

Abbas, Ackbar. "Cosmopolitan De-Scriptions: Shanghai and Hong Kong." *Public Culture* 12, no. 3 (fall 2000): 769–86.

Abel, Elizabeth. "Mania, Depression, and the Future of Theory." *Critical Inquiry* 30 (winter 2004): 336–39.

Abraham, Ayisha. "Nobody Knows My Name(ing)." *Godzilla: Asian American Art Network* newsletter 3, no. 2 (fall 1993): 2.

Achebe, Chinua. *Home and Exile*. New York: Anchor, 2001.

Adams, Don, and Arlene Goldbard. "Community, Culture, and Globalization." In *Community, Culture and Globalization*, edited by Don Adams and Arlene Goldbard, 7–29. New York: The Rockefeller Foundation, 2002.

Aguilar-San Juan, Karin, ed. *The State of Asian America: Activism and Resistance in the 1990s*. Boston: South End Press, 1994.

Alarcon, Norma, and Elaine Kim. Preface to *Writing Self, Writing Nation: A Collection of Essays on Dictée by Theresa Hak Kyung Cha*, edited by Alarcon and Kim, ix–xi. Berkeley: Third Woman Press, 1994.

Albright, Thomas. *Art in the San Francisco Bay Area: 1945–1980. An Illustrated History*. Los Angeles: University of California Press, 1985.

Alcoff, Linda Martin, Michael Hames-García, Satya P. Mohanty, and Paula M. L. Moya, eds. *Identity Politics Reconsidered*. New York: Palgrave MacMillan, 2006.

Alcoff, Linda Martin, and Satya P. Mohanty. "Reconsidering Identity Politics: An Introduction." In Alcoff, Hames-Garcia, Mohanty, and Moya, *Identity Politics Reconsidered*, 1–9.

Alexander, Meena. "Is There an Asian American Aesthetics?" In Zhou and Gatewood, *Contemporary Asian America*, 627–29.

——. "The Shock of Arrival: Body, Memory, Desire in Asian-American Art." *Women and Performance: A Journal of Feminist Theory* 7, no. 2 (1995): 14–15; 8, no. 1 (1995): 311–24.

——. *The Shock of Arrival: Reflections on Postcolonial Experience*. Boston: South End Press, 1996.

Aletti, Vince. "Playing God." *The Village Voice*, April 23, 1991.

Altshuler, Bruce. *Noguchi*. New York: Abbeville Press, 1994.

American Psychiatric Association. *Diagnostic and Statistical Manual of Mental Disorders*. 4th ed. Washington: American Psychiatric Association.

Amin, Samir. *Eurocentrism*. Translated by Russell Moore. New York: Monthly Review, 1989.

Anderson, Benedict. *Imagined Communities: Reflections on the Origin and Spread of Nationalism*. London: Verso, 1983.

Ang, Ien. *On Not Speaking Chinese: Living between Asia and the West*. London: Routledge, 2001.

Anzaldúa, Gloria. *Borderlands/La Frontera: The New Mestiza*. San Francisco: Aunt Lute Books, 1987.

Aono, Kristine. "Artist's Statement." In *Relics from Camp: An Artist's Installation by Kristine Yuki Aono and Members of the Japanese American Community*. Los Angeles: Japanese American National Museum, 1996.

Apel, Dora. *Memory Effects: The Holocaust and the Art of Secondary Witnessing*. New Brunswick: Rutgers University Press, 2002.

Apostolos-Capadona, Diane, and Bruce Altshuler, eds. *Isamu Noguchi: Essays and Conversations*. New York: Harry N. Abrams in association with Isamu Noguchi Foundation, 1994.

Appadurai, Arjun, ed. *Globalization*. Durham, N.C.: Duke University Press, 2001.

——. *Modernity at Large: Cultural Dimensions of Globalization*. Minneapolis, Minn.: University of Minnesota Press, 1997.

Appiah, Kwame Anthony. *The Ethics of Identity*. Princeton: Princeton University Press, 2005.

——. *In My Father's House: Africa in the Philosophy of Culture*. Oxford: Oxford University Press, 1992.

Appiah, Kwame Anthony, and Henry Louis Gates Jr., eds. *Identities*. Chicago: University of Chicago Press, 1995.

Araeen, Rasheed. *The Other Story: Afro-Asian Artists in Post-War Britain*. London: The South Bank Centre, 1989.

Arai, Tomie. "Artist's statement." In *Tomie Arai: The Way We Remember*. Exh. study guide. New York: Bread and Roses Cultural Project, 1996.

——. *Triple Happiness*. http://www.longwoodcyber.org/Artists/TomieArai/Tripleweb/webimages/splashpage/splashhomepage.html.

Aretxaga, Begoña. *Shattering Silence: Women, Nationalism, and Political Subjectivity in Northern Ireland*. Princeton: Princeton University Press, 1997.

Ashcroft, Bill, Gareth Griffiths, and Helen Tiffin, eds. *Key Concepts in Post-Colonial Studies*. London: Routledge, 1998.

——. *The Post-Colonial Studies Reader*. London: Routledge, 1995.

Ashton, Dore. *Noguchi: East and West*. New York: Knopf, 1992.

Atkins, Robert. *ArtSpeak: A Guide to Contemporary Ideas, Movements, and Buzzwords, 1945 to the Present*. 2nd ed. New York: Abbeville Press Publishers, 1997.

Axel, Brian Keith. "The Diasporic Imaginary." *Public Culture*, 14 no. 2 (spring 2002): 411–28.

Bacalzo, Dan. "Portraits of Self and Other: SlutForArt and the Photographs of Tseng Kwong Chi," *Theatre Journal* 53, no. 1 (March 2001): 73–94.

Bailey, David A., Ian Baucom, and Sonia Boyce, eds. *Shades of Black: Assembling Black Arts in 1980s Britain*. Durham, N.C.: Duke University Press, 2005.

Bakhtiar, Laleh. *Sufi: Expressions of the Mystic Quest*. London: Thames and Hudson, 1976.

Bakhtin, Mikhail. *The Dialogic Imagination*. Edited by Michael Holquist. Translated by Caryl Emerson and Michael Holquist. Austin: University of Texas Press, 1981.

———. *Problems of Dostoevsky's Poetics*. Translated by Caryl Emerson. Minneapolis: University of Minnesota Press, 1984.

Bal, Mieke, Jonathan Crew, and Leo Spitzer, eds. *Acts of Memory: Cultural Recall in the Present*. Hanover: Dartmouth College and University Press of New England, 1999.

Banta, Melissa, and Susan Taylor, eds. *A Timely Encounter: Nineteenth-Century Photographs of Japan*. Cambridge, Mass.: Peabody Museum Press / Wellesley, Mass.: Wellesley College Museum, 1988.

Bari, S. "The Lakshman Rekha: A Fable." In *Contours of the Heart: South Asians Map North America*, edited by Sunaina Maira and Rajini Srikanthm, 214–24. New York: Asian American Writers' Workshop, 1996.

Barrett, Terry. *Why Is That Art? Aesthetics and Criticism of Contemporary Art*. Oxford: Oxford University Press, 2008.

Barthes, Roland. "The Death of the Author." In *Image-Music-Text*, translated by Stephen Heath, 142–48. New York: Hill and Wang, 1977.

Baysa, Koan Jeff. "Longing/Belonging: Filipino Artists Abroad." In *At Home and Abroad: 20 Contemporary Filipino Artists*, 45–56. Exh. cat. San Francisco: Asian Art Museum of San Francisco, 1998.

Becker, Carol. "The Artist as Public Intellectual." *The Review of Education/Pedagogy/Cultural Studies* 17, no. 4 (1995): 385–95.

———. *Zones of Contention: Essays on Art, Institutions, Gender, and Anxiety*. Albany: State University of New York Press, 1996.

Benjamin, Walter. "The Work of Art in the Age of Mechanical Reproduction." In *Illuminations*, edited by Hannah Arendt and translated by Harry Zohn, 217–52. New York: Schocken Books, 1969.

Benmayor, Rina. "Testimony, Action Research, and Empowerment: Puerto Rican Women and Popular Education." In *Women's Words: The Feminist Practice of Oral History*, edited by Sherna Berger Gluck and Daphne Patai, 159–74. New York: Routledge, 1991.

Bennett, Jill. *Empathic Vision: Affect, Trauma, and Contemporary Art*. Stanford: Stanford University Press, 2005.

Bennett, Tony. *The Birth of the Museum: History, Theory, Politics*. London: Routledge, 1995.

Benn Michaels, Walter. *The Shape of the Signifier: 1967 to the End of History*. Princeton: Princeton University Press, 2004.

Berger, John. *The Sense of Sight*. New York: Vintage Books, 1993.

———. *Ways of Seeing*. London: British Broadcasting Company / Penguin Books, 1972.

Berger, Maurice, ed. *The Crisis of Criticism*. New York: The New Press, 1998.

———. *How Art Becomes History: Essays on Art, Society, and Culture in Post–New Deal America*. New York: HarperCollins, 1992.

———, ed. *Modern Art and Society: An Anthology of Social and Multicultural Readings*. New York: HarperCollins, 1994.

Berlant, Lauren. "Critical Inquiry, Affirmative Culture." *Critical Inquiry* 30 (winter 2004): 445–51.

Bernstein, Matthew, and Gaylyn Studlar, eds. *Visions of the East: Orientalism in Film*. New Brunswick, N.J.: Rutgers University Press, 1997.

Beuys, Joseph. "I Am Searching for Field Character." In *Art into Society, Society into Art: Seven German Artists*, edited by Christos M. Joachimides and Norman Rosenthal, 48. London: Institute of Contemporary Arts, 1974.

Bhabha, Homi K. "Dance This Diss Around." In M. Berger, *The Crisis of Criticism*, 41–50.

———, ed. *Narration and Nation*. London: Routledge, 1994.

———. "The Other Question: Stereotype, Discrimination, and the Discourse of Colonialism." In *The Location of Culture*. London: Routledge, 1994.

———. "The Right to Narrate." *Reflections 2000*. http://www.uchicago.edu/docs/millennium/bhabha/bhabha_a.html.

———. "The Right to Narrate: Interview with Homi Bhabha, 3/19/01." By Kerry Chance. http://www.bard.edu/hrp/resource_pdfs/chance.hbhabha.pdf.

———. "Shahzia Sikander Interviewed by Homi Bhabha." In *Shahzia Sikander*, edited by Chillava Klatch, 16–21. Chicago: The Renaissance Society at the University of Chicago, 1999.

———. "Statement for the Critical Inquiry Board Symposium." *Critical Inquiry* 30 (winter 2004): 342–49.

Bhabha, Homi K., Guy Brett, Coco Fusco, et al. "Art and National Identity: A Critic's Symposium." *Art in America* 79, no. 9 (September 1991): 80–3, 142–3.

Blassingame, John W. *The Slave Community: Plantation Life in the Antebellum South*. Rev. ed. New York: Oxford University Press, 1978.

Blinderman, Barry. "He Was a Visitor." In *Tseng Kwong Chi: The Expeditionary Works*, 1–3. Houston: Houston Center for Photography, 1992.

Bolton, Richard, ed. *Culture Wars: Documents from the Recent Controversies in the Arts*. New York: The New Press, 1992.

Borshay, Deann. "The Dilemma of Television Portrayals of Asians." *Asian American Network* (winter/spring 1987): 6–11.

Borum, Jenifer P. "Apocalypse Now: The Ambivalent Allegories of Manuel Ocampo." In *Virgin Destroyer: Manuel Ocampo*. Honolulu: Hardy Marks Publications, 1996.

Bourdieu, Pierre. *The Field of Cultural Production: Essays on Art and Literature*. Edited by Randal Johnson. New York: Columbia University Press, 1993.

———. *The Rules of Art: Genesis and Structure of the Literary Field*. Translated by Susan Emanuel. Stanford: Stanford University Press, 1996.

Bourriaud, Nicolas. "Relational Aesthetics." In *Participation*, edited by Claire Bishop, 160–71. Cambridge, Mass.: MIT Press, 2006.

Brett, Guy. *Through Our Own Eyes: Popular Art and Modern History*. Philadelphia: New Society Publishers, 1987.

Brodsky, Joyce. *The Paintings of Yun Gee and Li-Lan*. Seattle: University of Washington Press, 2008.

Brodsky, Joyce, and Helen Gee. *The Paintings of Yun Gee*. Storrs, Conn.: Willliam Benton Museum of Art / University of Connecticut, 1979.

Brookman, Philip. "The Politics of Hope: Sites and Sounds of Memory." In *Sites of Recollection: Four Altars and a Rap Opera*. Williamstown, Mass.: Williams College Museum of Art, 1992.

Broude, Norma, and Mary D. Garrard, eds. *The Power of Feminist Art: The American Movement of the 1970s, History and Impact*. New York: Harry N. Abrams, 1994.

Brown, Michael D. *Views from Asian California: 1920–1965; An Illustrated History*. San Francisco: Michael Brown, 1992.

Cándida-Smith, Richard. *Utopia and Dissent: Art, Poetry, and Politics in California*. Berkeley: University of California Press, 1995.

Carrier, James G., ed. *Occidentalism: Images of the West*. Oxford: Oxford University Press, 1995.

Caruth, Cathy. *Unclaimed Experience: Trauma, Narrative, and History*. Baltimore: Johns Hopkins University Press, 1996.

Casey, Edward S. *Getting Back into Place: Toward a Renewed Understanding of the Place-World*. Bloomington: Indiana University Press, 1993.

———. *Remembering: A Phenomenological Study*. Bloomington: Indiana University Press, 1987.

Castells, Manuel. *The Power of Identity*. Oxford: Blackwell, 1997.

Cha, Theresa Hak Kyung. *Dictée*. New York: Tanam Press, 1982.

Chadwick, Whitney. *Women, Art, and Society*. London: Thames and Hudson, 1996.

Chaliand, Gérard, and Jean-Pierre Rageau. *The Penguin Atlas of Diasporas*. Translated by A. M. Berrett. New York: Penguin Books, 1995.

Chambers, Iain. *Migrancy, Culture, Identity*. London: Routledge, 1994.

Chan, Sucheng. *Asian Americans: An Interpretive History*. New York: Twayne Publishers, 1991.

———, ed. *Hmong Means Free: Life in Laos and America*. Philadelphia: Temple University Press, 1994.

Chang, Alexandra. "Locating Asian American Art: Redefinitions." *Art AsiaPacific* 41 (summer 2004): 40–41.

Chau, Monica. "Picturing Asian America: Communities, Culture, Difference." In *Picturing Asian America: Communities, Culture, Difference*. Houston: Houston Center for Photography, 1994.

Chavoya, Ondine C. "Customized Hybrids: The Art of Rubén Ortiz Torres and Lowriding in Southern California." *The New Centennial Review* 4, no. 2 (fall 2004): 141–84.

Chen, Suni. "Us Others in the Global Village." *Colors* 4, no. 4 (July–August 1995): 53–58.

Cheng, Anne Anlin. *The Melancholy of Race: Psychoanalysis, Assimilation, and Hidden Grief*. Oxford: Oxford University Press, 2001.

Chiang, Fay. "A Place in Art/History." *Upfront: A Journal of Activist Art* 14/15 (winter/ spring 1987–88): 52–55.

——. *In the City of Contradictions*. New York: Sunbury Press, 1979.

Chiu-Rinaldi, Fabiana. *Mi Familia, Mi Comunidad: Family Pictures from Cuba, Peru and Guatemala*. Exh. brochure. New York: Museum of Chinese in the Americas, 1999.

Chiu, Melissa. "Asian Contemporary Art: An Introduction." *Grove Art Online*. Oxford University Press: 2006. http://www.groveart.com. Accessed February 28, 2008.

Chiu, Melissa, Karin Higa, and Susette S. Min. *One Way or Another: Asian American Art Now*. Exh. cat. New York: Asia Society, in association with Yale University Press, 2006.

Chow, Rey. *Writing Diaspora: Tactics of Intervention in Contemporary Cultural Studies*. Bloomington: Indiana University Press, 1993.

Choy, Philip P., Lorraine Dong, and Marlon K. Hom, eds. *The Coming Man: 19th Century American Perceptions of the Chinese*. Seattle: University of Washington Press, 1994.

Chuh, Kandice. *Imagine Otherwise: On Asian Americanist Critique*. Durham, N.C.: Duke University Press, 2003.

Chuh, Kandice, and Karen Shimakawa, eds. *Orientations: Mapping Studies in the Asian Diaspora*. Durham, N.C.: Duke University Press, 2001.

Chung, Y. David. Interview by Lex Gillespie. *Crossroads*. WAMU. Produced ca. March 1988, aired July 20, 1999.

——. "Seoul on Soul: Asians Take on America." Interview by Margo Machida. In *Cut/ Across*. Exh. cat. Washington: Washington Project for the Arts, 1998.

——. *The Wishing Tree: An Experimental One-Act Opera*. 1998. http://pweb.netcom/ ~ydchung/wishingtree_index.htm.

Clark, Catherine, ed. *Ascending Chaos: The Art of Masami Teraoka*. San Francisco: Chronicle Books, 2006.

Clifford, James. *The Predicament of Culture*. Cambridge, Mass.: Harvard University Press, 1988.

——. *Routes: Travel and Translation in the Late Twentieth Century*. Cambridge, Mass.: Harvard University Press, 1997.

Clifford, James, and George E. Marcus, eds. *The Poetics and Politics of Ethnography*. Berkeley: University of California Press, 1986.

Cockcroft, Eva, John Weber, and Jim Cockcroft, eds. *Toward a People's Art: The Contemporary Mural Movement*. New York: E. P. Dutton, 1977.

Cohen, Warren I. *East Asian Art and American Culture: A Study in International Relations*. New York: Columbia University Press, 1992.

Collins, Larry, and Dominique LaPierre. *Freedom at Midnight*. New York: Simon and Schuster, 1975.

Connerton, Paul. *How Societies Remember*. Cambridge: Cambridge University Press, 1989.

Connor, Celeste. "Pipo Nguyen-duy at Bucheon Gallery." *Artweek* 28, no. 6 (June 1997): 22–23.

Contemporary Art Museum, The. *Then and Now: A Retrospective of Charles E. Higa*. Exh. cat. Honolulu: The Contemporary Museum, 2007.

Cooke, Ariel Zeitlin, and Marsha MacDowell, eds. *Weavings of War: Fabrics of Memory*. Exh. cat. East Lansing: Michigan State University Museum, 2005.

Coombes, Annie E. "The Object of Translation: Notes on 'Art' and Autonomy in a Post-colonial Context." In *The Empire of Things: Regimes of Value and Material Culture*, edited by Fred R. Myers, 233–56. Santa Fe: School of American Research Press, 2001.

Corbey, Raymond. "Ethnographic Showcases, 1870–1930." *Cultural Anthropology* 8, no. 3 (August 1993): 338–69.

Coser, Lewis A. *On Collective Memory / Maurice Halbwachs*. Chicago: University of Chicago Press, 1992.

Creef, Elena Tajima. *Imaging Japanese America: The Visual Construction of Citizenship, Nation, and the Body*. New York: New York University Press, 2004.

Croce, Arlene. "Discussing the Undiscussable." In M. Berger, *The Crisis of Criticism*, 15–29.

Csikszentmihalyi, Mihaly, and Eugene Rochberg-Halton. *The Meaning of Things: Domestic Symbols and the Self*. London: Cambridge University Press, 1981.

Dahbour, Omar, and Micheline R. Ishay, eds. *The Nationalism Reader*. Atlantic Highlands, N.J.: Humanities Press International, 1995.

Daniels, Roger. "The Forced Migration of West Coast Japanese Americans, 1942–1946: A Quantitative Note." In Daniels, Taylor, and Kitano, *Japanese Americans*, 72–74.

———. "Incarceration Elsewhere." In Daniels, Taylor, and Kitano, *Japanese Americans*, 132–33.

———. "Relocation, Redress, and the Report: A Historical Appraisal." In Daniels, Taylor, and Kitano, *Japanese Americans*, 3–9.

Daniels, Roger, Sandra C. Taylor, and Harry H. L. Kitano, eds. *Japanese Americans: From Relocation to Redress*. Salt Lake City: University of Utah Press, 1986.

Davy, Nicholas. "Hermeneutics and Art Theory." In *A Companion to Art Theory*, edited by Paul Smith and Carolyn Wilde, 436–57. Oxford: Blackwell Publishers, 2002.

De Alba, Alicia Gaspar. *Chicano Art Inside/Outside the Master's House: Cultural Politics and the Cara Exhibition*. Austin: University of Texas Press, 1998.

Debo, Angie. *A History of the Indians of the United States*. Norman: University of Oklahoma Press, 1970.

Debord, Guy. "Towards a Situationist International." Translated by Tom McDonough. In *Participation*, edited by Claire Bishop, 96–101. Cambridge, Mass.: MIT Press, 2006.

Dempster, Brian Komei, ed. *Made In USA: Angel Island Shhh*. Exh. cat. San Francisco: Kearny Street Workshop, 2000.

De Certeau, Michel. *The Practice of Everyday Life*. Translated by Steven Rendall. Berkeley: University of California Press, 1984.

De Lauretis, Teresa. "Statement Due." *Critical Inquiry* 30 (winter 2004): 365–68.

Delgado, Richard, ed. *Critical Race Theory: The Cutting Edge*. Philadelphia: Temple University Press, 1995.

Desai, Vishakha N. "Engaging 'Tradition' in the Twentieth Century Arts of India and Paki-
stan." In *Conversations with Traditions: Nilima Sheikh and Shahzia Sikander*, 6–17.
New York: The Asia Society, 2001.

DeSouza, Allan. "The *Coconut Chutney* Series." In *Uncommon Traits: Re/Locating Asia*.
Exh. cat. Buffalo: CEPA Gallery, 1997.

———. "The Flight of/from the Authentic Primitive." In *Memories of Overdevelopment:
Philippine Diaspora in Contemporary Art*, edited by Wayne Baerwaldt, 117–42. Irvine:
University of California / Irvine Art Gallery, 1997.

———. "An Imperial Legacy." In *Crossing Black Waters*, 6–8. London: Working Press,
1992.

———. "Interview." In *Dinh Q. Le: The Headless Buddha*, 4–9. Exh. cat. Los Angeles: Los
Angeles Center for Photographic Studies, 1998.

———. "Name Calling." In *Tradeshow: New Currents in Recent Asian American Art*, 2–5.
Shanghai: c2 Gallery at the Pottery Workshop Shanghai, 2003.

———. "Sushi Deluxe: Star Trek, Oedipus and the Native Informant." *New Observations*,
no. 107 (July–August 1995): 26–27.

Dirlik, Arif. "All the Colors of the Rainbow, and Many Shades in Between: Putting Racism
in Its Place." In "Across the Color Line 2001," special issue of *Amerasia Journal* 26,
no. 3 (2000–2001): 5–19.

Dissanayake, Ellen. *Homo Aestheticus: Where Art Comes From and Why*. Seattle: Univer-
sity of Washington Press, 1995.

Dong, Jim, Zand Gee, and Crystal K. D. Huie, eds. *Texas Long Grain: Photographs by the
Kearny Street Workshop*. San Francisco: Kearny Street Workshop Press, 1982.

Dower, John. "Yellow, Red, and Black Men." In *War without Mercy: Race and Power in the
Pacific War*, 147–80. New York: Pantheon Books, 1986.

Doy, Gen. *Black Visual Culture: Modernity and Postmodernity*. London: I.B.Tauris, 2000.

Drayton, Richard. *Nature's Government: Science, Imperial Britain, and the "Improvement"
of the World*. New Haven: Yale University Press, 2000.

Drescher, Timothy W. *San Francisco Bay Area Murals: Communities Create Their Muses,
1904–1997*. St. Paul: Pogo Press, 1998.

D'Souza, Aruna, ed. *Self and History: A Tribute to Linda Nochlin*. London: Thames and
Hudson, 2001.

Du Bois, W. E. B. *The Souls of Black Folk*. 1903. New York: Signet Classic, 1969.

Duus, Masayo. *The Life of Isamu Noguchi: Journey without Borders*. Translated by Peter
Duus. Princeton: Princeton University Press, 2004.

Eade, John. *Placing London: From Imperial Capital to Global City*. New York: Berghahn,
2000.

Eagleton, Terry, Frederic Jameson, and Edward Said. *Nationalism, Colonialism and Litera-
ture*. Minneapolis: University of Minnesota Press, 1990.

East India Company, The. "The East India Company in North America." www.theeast
indiacompany.com/archives/north_america.html.

Eller, Jack David. "Anti-Anti-Multiculturalism." *American Anthropologist* 99, no. 2 (June
1997): 249–56.

Eng, David L., and David Kazanjian. "Introduction: Mourning Remains." In *Loss: The Politics of Mourning*, edited by Eng and Kazanjian, 1–28. Berkeley: University of California Press, 2003.

Engelhardt, Tom. "Ambush at Kamikaze Pass." In *Counterpoint: Perspectives on Asian America*, edited by Emma Gee, 270–79. Los Angeles: Asian American Studies Center, University of California, 1976.

Enwezor, Okwui. "The Black Box." In *Documenta 11_ Platform 5: Exhibition*, 42–55. Ostfildern-Ruit: Hatje Cantz, 2002.

Esper, George, and the Associated Press. *The Eyewitness History of the Vietnam War, 1961–1975*. New York: Ballantine, 1983.

Espiritu, Yen Le. *Asian American Panethnicity: Bridging Institutions and Identities*. Philadelphia: Temple University Press, 1992.

Fairbrother, Trevor, and Kathryn Potts. *In and Out of Place: Contemporary Art and the American Social Landscape*. Exh. cat. Boston: Museum of Fine Arts, 1993.

Fanon, Frantz. *Black Skin, White Masks*. New York: Grove Press, 1967.

Farris, Phoebe, ed. *Women Artists of Color: A Bio-Critical Sourcebook to the 20th Century Artists in the Americas*. Westport, Conn.: Greenwood Press, 1999.

Farver, Jane. "Inside and Out of India: Contemporary Art of the South Asian Diaspora." In *Out of India: Contemporary Art of the South Asian Diaspora*, 12–21. Exh. cat. New York: Queens Museum of Art, 1997.

Fay, Ming. Artist's statement. In *Ming Fay: Money Trees and Monkey Pots. An Installation of Montalvo Specimens*, edited by Michele Rowe-Shields, n.p. Exh. cat. Saratoga, Calif.: Montalvo, 2004.

Feng, Peter X. *Identities in Motion: Asian American Film and Video*. Durham, N.C.: Duke University Press, 2002.

Ferguson, Russell, Martha Gever, Trinh T. Minh-ha, and Cornel West, eds. *Out There: Marginalization and Contemporary Cultures*. New York: The New Museum of Contemporary Art / MIT Press, 1990.

Finkelpearl, Tom. *Dialogues in Public Art*. Cambridge, Mass.: MIT Press, 2001.

Fischer, Michael J. "Ethnicity and the Post-Modern Arts of Memory." In Clifford and Marcus, *The Poetics and Politics of Ethnography*, 194–233.

Fish, Stanley. *Is There a Text in This Class? The Authority of Interpretive Communities*. Cambridge, Mass.: Harvard University Press, 1980.

Fisher, Jean, ed. *Global Visions: Towards a New Internationalism in the Visual Arts*. London: Kala Press, 1994.

Flores, William V., and Rina Benmayor, eds. *Latino Cultural Citizenship: Claiming Identity, Space and Rights*. Boston: Beacon Press, 1997.

Florio-Ruane, Susan. *Teacher Education and the Cultural Imagination: Autobiography, Conversation, and Narrative*. Mahwah, N.J.: Lawrence Erlebaum Associates, 2001.

Foster, Hal, ed. *The Anti-Aesthetic: Essays on Postmodern Culture*. Seattle: Bay Press, 1983.

———. "The Artist as Ethnographer." In *The Return of the Real: The Avant-Garde at the End of the Century*, 171–204. Cambridge, Mass.: MIT Press, 1996.

———. *Recordings: Art, Spectacle, Cultural Politics*. Seattle: Bay Press, 1985.

Foucault, Michel. *Discipline and Punish: The Birth of the Prison*. Translated by Alan Sheridan. New York: Vintage, 1979.

Freedberg, David. *The Power of Images: Studies in the History of Theory of Response*. Chicago: University of Chicago Press, 1989.

Freud, Sigmund. "Mourning and Melancholia." In *The Standard Edition of the Complete Psychological Works of Sigmund Freud*, 14:239–58. Translated and edited by James Strachey. London: Hogarth Press, 1957.

Friedman, Lester D., ed. *Unspeakable Images: Ethnicity and the American Cinema*. Urbana: University of Illinois Press, 1991.

Friese, Kai. "Two Uneasy States of Independence." *New York Times*, August 15, 2001.

Frisch, Michael. *A Shared Authority: Essays on the Craft and Meaning of Oral and Public History*. New York: State University of New York Press, 1990.

Frueh, Joanna, Cassandra Langer, and Arlene Raven, eds. *New Feminist Criticism: Art, Identity, Action*. New York: HarperCollins, 1994.

Fusco, Coco. "The Other History of Intercultural Performance." In *English Is Broken Here: Notes on Cultural Fusion in the Americas*, 37–64. New York: The New Press, 1995.

Fusco, Coco, and Brian Wallis, eds. *Only Skin Deep: Changing Visions of the American Self*. New York: Harry N. Abrams / International Center of Photography, 2003.

Fuss, Diana. *Essentially Speaking: Feminism, Nature, and Difference*. London: Routledge, 1989.

Gablik, Suzi. "Connective Aesthetics: Art after Individualism." In Lacy, *Mapping the Terrain*, 74–87.

———. *The Reenchantment of Art*. London: Thames and Hudson, 1993.

Gadamer, Hans-Georg. *Truth and Method*. Translated by Joel Weinsheimer and Donald G. Marshall. 2nd ed. New York: Continuum, 1999.

Gagnon, Monika Kin. *Other Conundrums: Race, Culture, and Canadian Art*. Vancouver: Arsenal Pulp Press / Artspeak Gallery / Kamloops Gallery, 2000.

Gagnon, Monika Kin, and Richard Fung. *13 Conversations about Art and Cultural Race Politics*. Montreal: Artextes Editions / Collection Prendre Parole, 2002.

Gangitano, Lia, and Steven Nelson, eds. *New Histories*. Exh. cat. Boston: The Institute of Contemporary Art, 1996.

Gao, Minglu, ed. *Inside Out: New Chinese Art*. San Francisco: San Francisco Museum of Modern Art; New York: The Asia Society Galleries, 1998.

Gates, Henry Louis, Jr. *Race, Writing and Difference*. Chicago: University of Chicago Press, 1985.

Gee, Zand, Bob Hsiang, Crystal K. D. Huie, and Lenny Limjoco, eds. *Pursuing Wild Bamboo: Portraits of Asian American Artists*. San Francisco: Kearny Street Workshop, 1992.

Geertz, Clifford. *The Interpretation of Cultures*. New York: Basic Books, 1973.

———. *Local Knowledge: Further Essays in Interpretive Anthropology*. New York: Basic Books, 1983.

———. *Works and Lives: The Anthropologist as Author*. Stanford: Stanford University Press, 1988.

Gergen, Kenneth. "Social Construction and the Transformation of Identity Politics." Draft copy for New School for Social Research Symposium, April 7, 1995. http://www.swarthmore.edu/SocSci/kgergen1/text8.html.

Gesensway, Deborah, and Mindy Roseman. *Beyond Words: Images from America's Concentration Camps*. Ithaca: Cornell University Press, 1987.

Gibney, Frank. *The Pacific Century: America and Asia in a Changing World*. New York: Charles Scribner's Sons, 1992.

Gilroy, Paul. *After Empire: Melancholia or Convivial Culture?* Oxford: Routledge, 2004.

———. *The Black Atlantic: Modernity and Double Consciousness*. Cambridge, Mass.: Harvard University Press, 1993.

Gluck, Sherna Berger, and Daphne Patai, eds. *Women's Words: The Feminist Practice of Oral History*. London: Routledge, 1991.

Godfrey, Tony. *Conceptual Art*. London: Phaidon, 1998.

Golden, Thelma. *Black Male: Representations of Masculinity in Contemporary American Art*. New York: Whitney Museum of American Art, 1994.

———. *Freestyle*. New York: The Studio Museum in Harlem, 2001.

Gómez-Peña, Guillermo, *Dangerous Border Crossers: The Artist Talks Back*. New York: Routledge, 2000.

———. *Warrior For Gringostroika*. Saint Paul: Graywolf Press, 1993.

Goodrich, L. Carrington, and Nigel Cameron. *The Face of China as Seen by Photographers and Travelers: 1860–1912*. New York: Aperture, 1978.

Grenville, Bruce, with contributing authors Sacha Bronwasser et al. *Home and Away: Crossing Cultures on the Pacific Rim*. Vancouver: Vancouver Art Gallery, 2003.

Guerrilla Girls, The. "Traditional Values and Quality Return to the Whitey Museum." http://www.guerrillagirls.com/posters/whitney/html.

Gumpert, Lynn. "The Life and Death of Christian Boltanski." In *Christian Boltanski: Lessons of Darkness*, 49–86. Chicago: The Museum of Contemporary Art; Los Angeles: the Museum of Contemporary Art; New York: the New Museum of Contemporary Art, 1988.

Gussow, Mel. "The Art of Aftermath, Distilled in Memory: Work Inspired by Sept. 11 May Take Time." *The New York Times*, November 14, 2001.

Habermas, Jurgen. *Postmodernism: A Reader*. Edited by Thomas Docherty. New York: Columbia University Press, 1993.

Hadjinicolaou, Nicos. *Art History and Class Struggle*. London: Pluto, 1978.

Halbwachs, Maurice. *On Collective Memory*. Chicago: University of Chicago Press, 1992.

Hall, Stuart. "Cultural Identity and Diaspora." In *Identity, Community, Culture, Difference*, edited by Jonathan Rutherford, 222–37. London: Lawrence and Wishart, 1990.

———. "The Formation of a Diasporic Intellectual: An Interview with Stuart Hall by Kuan-Hsing Chen." In Morley and Chen, *Stuart Hall*, 484–503.

———. "The Meaning of New Times." In *New Times: The Changing Face of Politics in the 1990s*, edited by Hall and Martin Jacques, 116–34. New York: Verso, 1990.

——. "New Ethnicities." In Morley and Chen, *Stuart Hall*, 441–49.

——, ed. *Representation: Cultural Representations and Signifying Practices*. London: Sage, 1997.

——. "Traveling Cultures." In Clifford, *Routes*, 17–46.

Hall, Stuart, and Paul du Gay, eds. *Questions of Cultural Identity*. London: Sage, 1997.

Hall, Stuart, and Martin Jacques, eds. *New Times: The Changing Face of Politics in the 1990s*. London: Verso, 1990.

Hall, Stuart, and Mark Sealy. *Different: A Historical Context; Contemporary Photographers and Black Identity*. London: Phaidon, 2001.

Hallmark, Kara Kelly. *Encyclopedia of Asian American Artists*. Westport, Conn.: Greenwood Press, 2007.

Hamamoto, Darrell Y., and Sandra Liu, eds. *Countervisions: Asian American Film Criticism*. Philadelphia: Temple University Press, 2000.

Hanhardt, John G. *The Worlds of Nam June Paik*. New York: Guggenheim Museum Publications, 2000.

Harris, Jonathan. *The New Art History: A Critical Introduction*. London: Routledge, 2001.

Harvey, David. *The Condition of Postmodernity: An Enquiry into the Origins of Cultural Change*. Cambridge: Blackwell, 1990.

Hashmi, Zarina. "Zarina Hashmi, Visual Artist, Interviewer: Lisa Liebmann, March 10, 1991." In *Artist and Influence 1992*, vol. 11, edited by James V. Hatch and Leo Hamalian, 63–74. New York: Hatch-Billops Collection, 1992.

Hayden, Dolores. *The Power of Place: Urban Landscapes as Public History*. Cambridge, Mass.: MIT Press, 1995.

Heartney, Eleanor. *Critical Condition: American Culture at the Crossroads*. Cambridge: Cambridge University Press, 1997.

——. *Postmodernism*. Cambridge: Cambridge University Press, 2007.

——. "The Visual Arts: On the Cusp of the New Millennium." *U.S. Society and Values*, USIA Electronic Journal 3, no. 1 (June 1998). http://usinfo.state.gov/journals/itsv/0698/ijse/visarts.htm.

——. "The Whole Earth Show Part II." *Art in America* 77, no. 7 (July 1989): 91–96.

Heidegger, Martin. *Being and Time*. Translated by John Macquarrie and Edward Robinson. London: SCM Press, 1962.

——. "Building, Dwelling, Thinking." In *Martin Heidegger, Basic Writings*, edited by David Farrell Krell, 343–63. Rev. ed. New York: HarperCollins, 1993.

Henry, William A., III. "Beyond The Melting Pot." *Time*, April 9, 1990.

Hertz, Betti-Sue. "Beyond the Borders: Transitional Territories." In *Beyond the Borders: Art by Recent Immigrants*, 11–21. Exh. cat. New York: The Bronx Museum of the Arts, 1994.

Heywood, Ian. *Social Theories of Art: A Critique*. New York: New York University Press, 1997.

Heywood, Ian, and Barry Sandywell, eds. *Interpreting Visual Culture: Explorations in the Hermeneutics of the Visual*. London: Routledge, 1999.

Higa, Karin. *Living in Color: The Art of Hideo Date*. Los Angeles: Japanese American National Museum, 2001.

———. "Origin Myths: A Short and Incomplete History of Godzilla." In Chiu, Higa, and Min, *One Way or Another*, 21–25.

———. *Some Notes on an Asian American Art History*. Exh. cat. San Francisco: Art Department, San Francisco State University, 1995.

———. *The View from Within: Japanese American Art from the Internment Camps, 1942–1945*. Exh. cat. Los Angeles: Japanese American National Museum, 1992.

Higa, Karin, with contributing authors Ian Buruma et al. *Bruce and Norman Yonemoto: Memory, Matter, and Modern Romance*. Exh. cat. Los Angeles: Japanese American National Museum, 1999.

Hill, Kimi Kodani. *Topaz Moon: Chiura Obata's Art of the Internment*. Berkeley: Heyday Books, 2000.

Hilty. Greg. "Thrown Voices." In *Double Take: Collective Memory and Current Art*, edited by Marianne Ryan, 14–19. Exh. cat. London: The South Bank Centre and Parkett Publishers, 1992.

Hirsch, E. D., Jr. *Validity in Interpretation*. New Haven: Yale University, 1967.

Hirsch, Marianne. "Past Lives: Postmemories in Exile." In *Exile and Creativity: Signposts, Travelers, Outsiders, Backward Glances*, edited by Susan Rubin Suleiman, 418–46. Durham, N.C.: Duke University Press, 1996.

Ho, Fred. See *Houn, Fred*.

Hobsbawm, Eric. "Introduction: Inventing Traditions." In *The Invention of Tradition*, edited by Hobsbawn and Terance Ranger, 1–14. Cambridge: Cambridge University Press, 1983.

Hongo, Garrett. *Under Western Eyes: Personal Essays from Asian America*. New York: Anchor, 1995.

Honolulu Academy of Arts. *Reflections of Internment: The Art of Hawaii's Hiroshi Honda*. Exh. cat. Honolulu: Honolulu Academy of Arts, 1994.

hooks, bell. *Art on My Mind: Visual Politics*. New York: The New Press, 1995.

Houn, Fred Wei-han [Fred Ho]. "The Cutting Edge: Asian American Creativity and Change." In Houn, ed., special issue of *East Wind: Politics and Culture of Asians in the U.S.* 5, no. 1 (spring/summer 1986): 2–3.

———. "Revolutionary Asian American Art: Tradition and Change, Inheritance and Innovation, Not Imitation!" In Houn, ed., special issue of *East Wind: Politics and Culture of Asians in the U.S.* 5, no. 1 (spring/summer 1986): 4–8.

Howe, Russell Warren. *The Koreans*. New York: Harcourt Brace Jovanovich, 1988.

Huber, Janice, M. Shaun Murphy, and D. Jean Clandinin. "Creating Communities of Cultural Imagination: Negotiating a Curriculum of Diversity." *Curriculum Inquiry* 33, no. 4 (2003): 343–62.

Hu-DeHart, Evelyn. "From Area Studies to Ethnic Studies: The Study of the Chinese Diaspora in Latin America." In *Asian Americans: Comparative and Global Perspectives*, edited by Shirley Hune, Hyung-chan Kim, Stephen S. Fugita, and Amy Ling, 5–16. Pullman: Washington State University Press, 1991.

Hughes, Robert. *Culture of Complaint: The Fraying of America*. New York: The New York Public Library / Oxford University Press, 1993.

———. *Heaven and Hell in Western Art*. New York: Stein and Day, 1968.

Huntington, Samuel P. *The Clash of Civilizations and the Remaking of World Order*. New York: Simon and Schuster, 1996.

Ignatieff, Michael. *Blood and Belonging: Journeys into the New Nationalism*. London: BBC Books, 1993.

Isaacs, Arnold R. *Vietnam Shadows: The War, Its Ghosts, and Its Legacy*. Baltimore: Johns Hopkins University Press, 1997.

Isin, Engin F., and Bryan S. Turner. *Handbook of Citizenship Studies*. London: Sage, 2002.

Iyer, Pico. *The Global Soul: Jet Lag, Shopping Malls, and the Search for Home*. New York: Vintage, 2000.

Jacob, Mary Jane, ed. *Shigeko Kubota: Video Sculpture*. New York: American Museum of the Moving Image, 1991.

Jacoby, Russell. "America's Professoriate: Politicized, Yet Apolitical." *Chronicle of Higher Education*, April 12, 1996.

Jameson, Fredric. "Symptoms of Theory or Symptoms for Theory?" In *Critical Inquiry* 30 (winter 2004): 403–8.

Jameson, Fredric, and Masao Miyoshi, eds. *The Cultures of Globalization*. Durham, N.C.: Duke University Press, 1998.

JanMohamed, Abdul R. "The Economy of Manichean Allegory." In *The Post-Colonial Studies Reader*, edited by Bill Ashcroft, Gareth Griffiths, and Helen Tiffin, 18–23. London: Routledge, 1995.

Jenkins, Rupert, and Chris Johnson. "Disputed Identities / Photography." *SF Camerawork Quarterly* 17, no. 3 (fall 1990): 5–9.

Jensen, Joli. *Is Art Good for Us? Beliefs about High Culture in American Life*. Lanham, Md.: Rowman and Littlefield, 2002.

Jones, Amelia. *Body Art: Performing the Subject*. Minneapolis: University of Minnesota Press, 1998.

———. "Survey" In *The Artist's Body*, edited Tracey Warr, 18–47. London: Phaidon, 2000.

Joselit, David. "Rings of Fire: Interview with Joe Lewis and Yong Soon Min." *Art Journal* 57, no. 4 (winter 1998): 86–89.

Joseph, May. *Nomadic Identities: The Performance of Citizenship*. Minneapolis: University of Minnesota Press, 1999.

Kang, Hyun Yi. "Re-membering Home." In Kim and Choi, *Dangerous Women*, 249–90.

Kaplan, Louis. *American Exposures: Photography and Community in the Twentieth Century*. Minneapolis: University of Minnesota Press, 2005.

Karnow, Stanley. *Vietnam, a History*. New York: Penguin, 1984.

Karnow, Stanley, and Nancy Yoshihara. *Asian Americans in Transition*. New York: The Asia Society, 1992.

Kearney, Richard, and David Rasmussen. *Continental Aesthetics:* Romanticism to Postmodernism. Oxford: Blackwell, 2001.

Kee. Joan. "Balancing Act: Tension and Tenacity in Asian American Art." *ArtAsiaPacific* 20 (1998): 68–75.

Keedle, Jayne. "Twilight Zone: Asia Meets America in a New Art Installation." *Hartford Advocate*, April 21, 1994.

Kerner, Aaron. *Reconstructing Memories*. Exh. cat. Honolulu: University of Hawai'i Art Gallery, 2006.

Kester, Grant H. *Conversation Pieces: Community + Communication in Modern Art*. Berkeley: University of California Press, 2004.

Kim, Christine Y. "From Dual to Plural: Five Korean American Artists." In *The Korean War in American Art and Culture: Fifty Years Later*, curated by Simon Taylor, 31–35. Exh. cat. East Hampton, N.Y.: Guild Hall of East Hampton, 2000.

Kim, Elaine H. "A Different Dream: Eleven Korean North American Artists." In *Across the Pacific: Contemporary Korean and Korean American Art*, 18–27. Exh. cat. New York: The Queens Museum of Art, 1993.

———. "Interstitial Subjects: Asian American Visual Art as a Site for New Cultural Conversations." In Kim, Machida, and Mizota, *Fresh Talk / Daring Gazes*, 1–50.

Kim, Elaine H., and Chungmoo Choi, eds. *Dangerous Women: Gender and Korean Nationalism*. New York: Routledge, 1998.

Kim, Elaine H., Margo Machida, and Sharon Mizota, eds. *Fresh Talk / Daring Gazes: Conversations on Asian American Art*. Berkeley: University of California Press, 2003.

Kim, Elaine H., and Eui-Young Yu. *East to America: Korean American Life Stories*. New York: The New Press, 1996.

Kim, Hyeonjoo. Review of *Fresh Talk / Daring Gazes*. *Asian Journal of Women's Studies* 10, no. 2 (2004): 120–25.

Kim, Kristine. *Henry Sugimoto: Painting an American Experience*. Exh. cat. Los Angeles: Japanese American National Museum, 2000.

Kim, Sun-Jung, ed. *KOREAMERICAKOREA*. Exh. cat. Seoul: Artsonje Center, 2000.

Kimball, Roger. "Of Chocolate, Lard, and Politics." *National Review*, April 26, 1993.

Kimmelman, Michael. "At the Whitney, Sound, Fury and Little Else," Art View. *New York Times*, April 25, 1993.

King, Anthony D., ed. *Culture, Globalization and the World-System: Contemporary Conditions for the Representation of Identity*. Minneapolis: University of Minnesota Press, 1998.

Kingman, Dong. *Paint the Yellow Tiger*. New York: Sterling, 1991.

Kingsbury, Martha. *George Tsutakawa*. Seattle: University of Washington Press; Bellevue, Wash.: Bellevue Art Museum, 1990.

Kirshenblatt-Gimblett, Barbara. "Spaces of Dispersal." *Cultural Anthropology* 9, no. 3 (August 1994): 339–44.

Klein, Ernest. *A Comprehensive Etymological Dictionary of the Hebrew Language for Readers of English*. New York: Macmillan, 1987.

Komar, Vitaly, and Alexander Melamid. "Artist Portfolios." In *Tracing Cultures*, edited by Michael Read and Steven Jenkins, 44–47. San Francisco: The Friends of Photography, 1995.

Kristeva, Julia. *Strangers to Ourselves*. Translated by Leon Roudiez. New York: Columbia University Press, 1991.

Kruger, Barbara, and Phil Mariani, eds. *Remaking History*. Seattle: Bay Press, 1998.

Kuramitsu, Kristine C. "Internment and Identity in Japanese American Art." *American Quarterly* 47, no. 4 (December 1995): 619–58.

Kwong, Peter. *The New Chinatown*. New York: Hill and Wang, 1987.

LaCapra, Dominick. "Experience and Identity." In Alcoff, Hames-García, Mohanty, and Moya, *Identity Politics Reconsidered*, 228–45.

Lacy, Suzanne, ed. *Mapping the Terrain: New Genre Public Art*. Seattle: Bay Press, 1995.

Lai, Kim Mark, Genny Lim, and Judy Yung. *Island: Poetry and History of Chinese Immigrants on Angel Island, 1910–1940*. Seattle: University of Washington Press, 1991.

Lam, Andrew. "Love, Money, Prison, Sin, Revenge." In *Once upon a Dream . . . The Vietnamese-American Experience*, edited by De Tran, Andrew Lam, and Hai Dai Nguyen, 80–89. San Jose: San Jose Mercury News, 1995.

Laub, Dori. "Bearing Witness or the Vicissitudes of Listening." In *Testimony: Crises of Witnessing in Literature, Psychoanalysis, and History*, edited by Laub and Soshana Felman, 57–74. New York: Routledge, 1992.

———. "Truth and Testimony: The Process and the Struggle." In *Trauma: Explorations in Memory*, edited by Cathy Caruth, 61–75. Baltimore: Johns Hopkins University Press, 1995.

Le, Viet. "How Come Charlie Don't Surf?" In *Charlie Don't Surf: 4 Vietnamese American Artists*. Exh. cat. Vancouver: Vancouver International Centre for Contemporary Asian Art, 2005.

Lee, Anthony W. "The Meanings of Melancholy." *Art Journal* 61, no. 1 (spring 2002): 97–99.

———, ed. *Yun Gee: Poetry, Writings, Art, Memories*. Seattle: University of Washington Press, 2003.

Lee, Helen. "A Peculiar Sensation: A Personal Genealogy of Korean American Women's Cinema." In Kim and Choi, *Dangerous Women*, 291–322.

Lee, Kyung Won. "Urban Impressionist." In Kim and Yu, *East to America*, 1–24.

Lee, Luchia Meihua. *Nexus: Taiwan in Queens*. Exh. cat. New York: Queens Museum of Art, 2004.

Lee, Pamela M., Karin M. Higa, and Jonathan Casely. *Souvenir of SITEseeing: Travel and Tourism in Contemporary Art*. Exh. cat. New York: Whitney Museum of Art, 1991.

Lee, Robert G. *Orientals: Asian Americans in Popular Culture*. Philadelphia: Temple University Press, 1999.

Lee, Rachel C. *The Americas of Asian American Literature: Gendered Fiction of Nation and Transnation*. Princeton: Princeton University Press, 1999.

Lee, Sarah. "Echoes of Our Choice." In *Who's Afraid of Freedom: Korean-American Artists in California*, edited by Lorna Price, 7–13. Newport Harbor, Calif.: Newport Harbor Art Museum, 1996.

Lefebvre, Henri. *The Production of Space*. Translated by Donald Nicholson-Smith. Cambridge, Mass.: Blackwell, 1991.

Leong, Russell, ed. *Asian American Sexualities: Dimensions of the Gay and Lesbian Experience*. New York: Routledge, 1996.

Leppert, Richard. *Art and the Committed Eye: The Cultural Functions of Imagery*. Boulder: Westview Press, 1996.

Lew, William W, ed. *Minidoka Revisited: The Paintings of Roger Shimomura*. Clemson, S.C.: Lee Gallery, Clemson University, 2005. Distributed by University of Washington Press.

Lewallen, Constance M., ed. *The Dream of the Audience: Theresa Hak Kyung Cha. 1951– 1982*. Berkeley: University of California Press, 2001.

Lin, Maya. *Boundaries*. New York: Simon and Schuster, 2000.

Link, Howard A. *Waves and Plagues: The Art of Masami Teraoka*. Honolulu: The Contemporary Art Museum, 1988.

Lippard, Lucy. "In Country." In *A Different War: Vietnam in Art*, 66–87. Seattle: The Real Comet Press, 1990.

——. *Mixed Blessings: New Art in a Multicultural America*. New York: Pantheon, 1990.

——. "Perilous Times." In *Roger Shimomura Stereotypes and Admonitions*, 2–5. Exh. cat. Seattle: Greg Kucera Gallery, 2004.

——. *Six Years: The Dematerialization of the Art Object*. New York: Praeger, 1973.

Liwanag Collective. *Liwanag*. San Francisco: Liwanag Publishing Incorporated, 1975.

Louie, Reagan, and Carlos Villa, eds. *Worlds in Collision: Dialogues on Multicultural Art Issues*. San Francisco: San Francisco Art Institute / International Scholars Publications, 1994.

Louie, Steve, and Glenn K. Omatsu, eds. *Asian Americans: The Movement and the Moment*. Los Angeles: UCLA Asian American Studies Center Press, 2001.

Lowe, Lisa. *Immigrant Acts: On Asian American Cultural Politics*. Durham, N.C.: Duke University Press, 1996.

Luce, Henry R. "The American Century." *Life*, February 17, 1941.

Luke, Timothy W. *Shows of Force: Power, Politics, and Ideology in Art Exhibitions*. Durham, N.C.: Duke University Press, 1992.

Machida, Margo. "Culturalist Conceptualism and the Art of Ming Fay." In *Transcultural New Jersey: Diverse Artists Shaping Culture and Communitie*s, 34–42. New Brunswick, N.J.: Rutgers Office for Intercultural Initiatives / Jane Voorhees Zimmerli Art Museum, 2005.

——. "Margo Machida: An Artist's Perspective." *Upfront: A Journal of Activist Art*, nos. 14–15 (winter/spring 1987–88): 56–57.

——. "Out of Asia: Negotiating Asian Identities in America." In Sternbach and Newland, *Asia/America*, 64–110.

——. "Reframing Asian America." In Chiu, Higa, and Min, *One Way or Another*, 15–20.

——. "Seoul on Soul: Asians Take on America." In *Cut/Across*, 19–21. Exh. cat. Washington: Washington Project for the Arts, 1988.

——. "(dis)Oriented." In *(dis)ORIENTED: Shifting Identities of Asian Women in America*, n.p. Exh. cat. New York: Henry Street Settlement and Steinbaum Krauss Gallery, 1995.

———. "The World as Home." In *Zarina: Mapping a Life, 1991–2001*, 19–27. Exh. cat. Oakland: Mills College Art Museum, 2001.

Maclear, Kyo. *Beclouded Visions: Hiroshima-Nagasaki and the Art of Witness*. Albany: State University of New York Press, 1999.

Macpherson, C. B. *The Political Theory of Possessive Individualism: Hobbes to Locke*. Oxford: Oxford University Press, 1962.

Manalansan, Martin A, IV, ed. *Cultural Compass: Ethnographic Explorations of Asian America*. Philadelphia: Temple University Press, 2000.

———. *Global Divas: Filipino Gay Men in the Diaspora*. Durham, N.C.: Duke University Press, 2003.

Mandle, Julia Barnes. Interview by Y. David Chung. In *Sites of Recollection: Four Altars and a Rap Opera*, 44–55. Exh. cat. Williamstown, Mass.: Williams College Museum of Art, 1992.

Marchetti, Gina. *Romance and the "Yellow Peril": Race, Sex, and Discursive Strategies in Hollywood Fiction*. Berkeley: University of California Press, 1993.

———. "America's Asia: Hollywood's Construction, Deconstruction, and Reconstruction of the 'Orient.'" In *Out of the Shadows: Asians in American Cinema*, edited by Roger Garcia, 37–57. Milan: Edizioni Olivares, 2001.

Marcus, George E., ed. *Cultural Producers in Perilous States: Editing Events, Documenting Change*. Chicago: University of Chicago Press, 1997.

Marcus, George E., and Michael M. J. Fischer. *Anthropology as Cultural Critique: An Experimental Moment in the Human Sciences*. Chicago: University of Chicago Press, 1986.

Marling, Karal Ann. "Imagineering the Disney Theme Parks." In *Designing Disney's Theme Parks: The Architecture of Reassurance*. Montreal: Canadian Centre for Architecture, 1997.

Martelle, Scott, and Mai Tran. "25 Years after the Fall of Saigon, a Vietnamese Enclave Thrives." *Los Angeles Times*, April 28, 2000.

Martin, Richard. "Morning in America: The Monuments, Icons, and Natural Wonders of Tseng Kwong Chi." In *Tseng Kwong Chi*, n.p. Kyoto: Art Random, Kyoto Shoin International Co., 1989.

Mass, Amy Iwasaki. "Psychological Effects of the Camps on Japanese Americans." In Daniels, Taylor, and Kitano, *Japanese Americans*, 159–62.

McEvilley, Thomas. *Art and Otherness: Crisis in Cultural Identity*. Kingston, NY: McPherson and Company, 1992.

McEvilley, Thomas, and Roger D. Denson. *Capacity: History, the World, and the Self in Contemporary Art and Criticism*. Netherlands: G + B Arts International, 1996.

McKee, Sally, ed. *Flo Oy Wong: Whispers of the Past*. Exh. cat. Sacramento: 40 Acres Art Gallery, 2006.

McWillie, Judith. "The Migrations of Meaning." *Visions Art Quarterly*, 3, no. 4 (fall 1989): 4–10.

Medina, José. "Identity Trouble: Disidentification and the Problem of Difference." *Philosophy and Social Criticism* 29, no. 6 (2003): 655–68.

Mercer, Kobena, ed. *Cosmopolitan Modernisms*. Cambridge, Mass.: MIT Press, 2005.

———. *Welcome to the Jungle: New Positions in Black Cultural Studies*. New York: Routledge, 1994.

Milford-Lutzker, Mary-Ann. "Mapping the Dislocations." In *Zarina: Counting 1977–2005*, n.p. New York: Bose Pacia, 2005.

Miller-Lewis, Karin. "Home and the World." In *Home and the World*, edited by Paris Wald, 3–11. Exh. cat. New York: India Center of Art and Culture, 2001.

Millner, Michael. "Post Post-Identity." *American Quarterly* 57, no. 2 (2005): 541–54.

Min, Susette S. "The Last Asian American Exhibition in the Whole Entire World." In Chiu, Higa, and Min, *One Way or Another*, 34–41.

———. "Remains to Be Seen: Reading the Works of Dean Sameshima and Khanh Vo." In *Loss: The Politics of Mourning*, edited by David L. Eng and David Kazanjian, 229–50. Berkeley: University of California Press, 2003.

Min, Yong Soon. "Certain Latitudes." In *Gwangju Biennale 2002, THERE: Sites of Korean Diaspora*, 10–59. Exh. cat. Gwangju, Korea: Gwangju Biennale Foundation, 2002.

———. "Shifting Perceptions." Interview by Betty Phoenix Wan. In *Shifting Perceptions: Contemporary L.A. Visions*, 15–24. Exh. cat. Pasadena: Pacific Asia Museum, 2000.

———. "Transnationalism from Below." In *Xen: Migration Labor and Identity: Yong Soon Min with Allan deSouza*, 4–10. Exh. cat. Seoul, Korea: Samzie Space, 2004.

Mirikitani, Janice, Luis Syquia Jr., Buriel Clay II, et al., eds. *Time to Greez! Incantations from the Third World*. San Francisco: Glide Publications / Third World Communications, 1975.

Mirzoeff, Nicholas. *Diaspora and Visual Culture: Representing Africans and Jews*. New York and London: Routledge, 2000.

———. "Introduction." In Mirzoeff, *The Visual Culture Reader*, 3–13.

———. "Introduction: The Multiple Viewpoint; Diasporic Visual Cultures." In Mirzoeff, *Diaspora and Visual Culture*, 1–18.

———, ed. *The Visual Culture Reader*. New York: Routledge, 1998.

Mohanty, Chandra Talpade. "Feminist Encounters: Locating the Politics of Experience." In *Social Postmodernism: Beyond Identity Politics*, edited by Linda Nicholson and Steven Seidman, 68–86. Cambridge: Cambridge University Press, 1995.

———. "Under Western Eyes: Feminist Scholarship and Colonial Discourses." In *Third World Women and the Politics of Feminism*, edited by Chandra Talpade Mohanty, Ann Russo, and Lourdes Torres, 51–80. Bloomington: Indiana University Press, 1991.

Mohanty, Satya P. *Literary Theory and the Claims of History: Postmodernism, Objectivity, Multicultural Politics*. Ithaca: Cornell University Press, 1997.

Mongia, Padmini, ed. *Contemporary Postcolonial Theory: A Reader*. London: Arnold, 1996.

Morley, David, and Kuan-Hsing Chen, eds. *Stuart Hall: Critical Dialogues in Cultural Studies*. London: Routledge, 1996.

Morley, David, and Kevin Robins. *Spaces of Identity: Global Media, Electronic Landscapes and Cultural Boundaries*. London: Routledge, 1995.

Morse, Marcia. *Nāu ka wae (The Choice Belongs to You): A Conceptual Installation by Kaili Chun*. Exh. brochure. Honolulu: Honolulu Academy of Arts, 2006.

Mosquera, Gerardo, and Jean Fisher, eds. *Over Here: International Perspectives on Art and Culture*. New York: New Museum of Contemporary Art, 2004.

Motomura, Hiroshi. "Immigration: How 'They' Become 'Us.'" *The Chronicle Review*, section B of *The Chronicle of Higher Education*, September 8, 2006, 6–9.

Moy, James S. *Marginal Sights: Staging the Chinese in America*. Iowa City: University of Iowa Press, 1993.

Moya, Paula M. L. "Introduction: Reclaiming Identity." In Moya and Hames-García, *Reclaiming Identity*, 1–26.

Moya, Paula M. L., and Michael R. Hames-García, eds. *Reclaiming Identity: Realist Theory and the Predicament of Postmodernism*. Berkeley: University of California Press, 2000.

Muchnic, Suzanne. "'Street of Knives' Cuts into Fears," review of exhibition at BC Space, Laguna Beach, California. *Los Angeles Times*, March 29, 1985.

Mulvey, Laura, "Visual Pleasure and Narrative Cinema." In *Art after Modernism: Rethinking Representation*, edited by Brian Wallis, 361–74. New York: The New Museum of Contemporary Art, 1984.

Muñoz, José Esteban. *Disidentifications: Queers of Color and the Performance of Politics*. Minneapolis: University of Minnesota Press, 1999.

———. "Feeling Brown: Ethnicity and Affect in Ricardo Bracho's 'The Sweetest Hangover and Other STDS.'" *Theatre Journal* 52 (2000): 67–79.

Munroe, Alexandra. *Japanese Art After 1945: Scream Against the Sky*. New York: Harry N. Abrams, 1994.

Munroe, Alexandra, and Jon Hendricks, eds. *YES Yoko Ono*. New York: Japan Society and Harry N. Abrams, 2000.

Myers, Fred R., ed. *The Empire of Things: Regimes of Value and Material Culture*. Santa Fe: School of American Research Press, 2001.

Naipaul, V. S. *The Mimic Men*. New York: Vintage, 1985.

Napier, David A. *Foreign Bodies: Performance, Art, and Symbolic Anthropology*. Berkeley: University of California Press, 1992.

Naqvi, Akbar. "Discourse of Intimacy." *The Herald* (Karachi, Pakistan), October 2000.

Nealon, Jeffrey T. *Alterity Politics: Ethics and Performative Subjectivity*. Durham, N.C.: Duke University Press, 1998.

Newfield, Christopher, and Avery F. Gordon. "Multiculturalism's Unfinished Business." In *Mapping Multiculturalism*, edited by Avery F. Gordon and Newfield, 76–115. Minneapolis: University of Minnesota Press, 1996.

Nochlin, Linda. "Art and the Conditions of Exile: Men/Women, Emigration/Expatriation." In *Exile and Creativity: Signposts, Travelers, Outsiders, Backward Glances*, edited by Susan Rubin Suleiman, 37–58. Durham, N.C.: Duke University Press, 1998.

Northrup, Joanne. *Tales of Yellow Skin: The Art of Long Nguyen*. Exh. cat. San Jose: San Jose Museum of Art, 2003.

Norton, Ann W. *The Spirit of Cambodia . . . a Tribute*. Exh. cat. Providence: Providence College, 2002.

Norton, William. *Cultural Geography: Themes, Concepts, Analyses*. Ontario: Oxford University Press, 2000.

Oates, Joyce Carol. "Confronting Head-on the Face of the Afflicted." In M. Berger, *The Crisis of Criticism*, 30–40.

O'Brien, Brendan. *A Pocket History of the IRA*. Dublin: The O'Brien Press, 1997.

Obrist, Hans-Ulrich. "Conversation with Chen Zhen." In *Chen Zhen: A Tribute*, 20–25. Exh. cat. New York: P.S.1 Contemporary Art Center, 2003.

O'Doherty, Brian. *Inside the White Cube: The Ideology of the Gallery Space*. San Francisco: Lapis Press, 1986.

Oguibe, Olu. *The Culture Game*. Minneapolis: University of Minnesota Press, 2004.

Okihiro, Gary Y. "African and Asian American Studies: A Comparative Analysis and Commentary." In *Asian Americans: Comparative and Global Perspectives*, edited by Shirley Hune, Hyung-chan Kim, Stephen S. Fugita, and Amy Ling, 17–28. Pullman: Washington State University Press, 1991.

———. *Cane Fires: The Anti-Japanese Movement in Hawaii, 1865–1945*. Philadelphia: Temple University Press, 1991.

———. *Margins and Mainstreams: Asians in American History and Culture*. Seattle: University of Washington Press, 1994.

———. "Is Yellow Black or White?" In Okihiro, *Margins and Mainstreams*, 31–63.

Okihiro, Gary Y., Shirley Hune, Arthur A. Hansen, John M. Liu, eds. *Reflections on Shattered Windows: Promises and Prospects for Asian American Studies*. Pullman: Washington State University Press, 1988.

Okubo, Miné. *Citizen 13660*. 1946. Seattle: University of Washington Press, 1983.

Ong, Aihwa. *Flexible Citizenship: The Cultural Logics of Transnationality*. Durham, N.C.: Duke University Press, 1999.

Ostler, Nicholas. *Empires of the Word: A Language History of the World*. New York: HarperCollins, 2005.

Palumbo-Liu, David. *Asian/American: Historical Crossings of a Racial Frontier*. Stanford: Stanford University Press, 1999.

———, ed. *The Ethnic Canon: Histories, Institutions, and Interventions*. Minneapolis: University of Minnesota Press, 1995.

Papastergiadis, Nikos. "The Limits of Cultural Translation." In Mosquera and Fisher, *Over Here*, 330–47.

Park, Kyeyoung. *The Korean American Dream: Immigrants and Small Business in New York City*. Ithaca: Cornell University Press, 1997.

Pear, Robert. "Racial and Ethnic Minorities Gain in the Nation as a Whole." *New York Times*, August 12, 2005.

Pêcheaux, Michel. *Language, Semantics, and Ideology*. New York: St. Martin's Press, 1982.

Peckham, Linda. "Looking at the West through Reassemblage." *Cinematograph* 2, 1986: 1–5.

Perez, Pilar, ed. *Manuel Ocampo: Heridas de la Lengua, Selected Works*. Santa Monica: Smart Art Press, 1997.

Perry, Gill, and Paul Wood. *Themes in Contemporary Art*. New Haven: Yale University Press / The Open University, 2004.

Pfeiffer, Paul. "Paul Pfeiffer and John Baldessari in Conversation." In *Paul Pfeiffer*, 31–41. Chicago: Museum of Contemporary Art, Chicago, 2003.

Pinder, Kimberly N. *Race-ing Art History: Critical Readings in Race and Art History*. New York: Routledge, 2002.

Pipo. Artist's statement. In *Dialogue*, 26. New York: Asian American Arts Alliance, 1999.

Pollan, Michael. *The Botany of Desire: A Plant's-Eye View of the World*. New York: Random House, 2001.

Pollock, Griselda. *Vision and Difference: Femininity, Feminism, and the Histories of Art*. London: Routledge, 1990.

Pollock, Sheldon, Homi K. Bhabha, Carol A. Breckenridge, and Dipesh Chakrabarty. "Cosmopolitanisms." *Public Culture* 12, no. 3 (fall 2000): 577–89.

Pomerantz, Kenneth, and Steven Topik. *The World That Trade Created: Society, Culture, and the World Economy, 1400 to the Present*. Armonk, N.Y.: M. E. Sharpe, 2006.

Poon, Irene. *Leading the Way: Asian American Artists of the Older Generation*. Wenham, Mass.: Gordon College, 2001.

Portelli, Alessandro. *The Death of Luigi Trastulli and Other Stories: Forming and Meaning in Oral History*. New York: State University of New York Press, 1991.

Poshyananda, Apinan. "Desperately Diasporic." In Mosquera and Fisher, *Over Here*, 182–90.

———. "Roaring Tigers, Desperate Dragons in Transition." In *Contemporary Art in Asia: Traditions/Tensions*, 23–53. New York: The Asia Society Galleries, 1996.

———. "Yellow Face, White Gaze." *Art and Asia Pacific* 2, no. 1 (1995): 30–31.

Prager, Jeffrey. *Presenting the Past: Psychoanalysis and the Sociology of Misremembering*. Cambridge, Mass.: Harvard University Press, 1998.

Prashad, Vijay. *Everybody Was Kung Fu Fighting: Afro-Asian Connections and the Myth of Racial Purity*. Boston: Beacon Press, 2001.

Pratt, Mary Louise. *Imperial Eyes: Travel Writing and Transculturation*. London: Routledge, 1992.

Raven, Arlene. "Word of Honor." In Lacy, *Mapping the Terrain*, 159–70.

Reid, Calvin. "Home and Home Again." In *DMZ XING*, 8–10. Exh. cat. Hartford: Real Art Ways, 1994.

Rindfleisch, Jan. "Art of the Refugee Experience." In *Art of the Refugee Experience*, 7–10. Cupertino, Calif.: De Anza College, 1988.

Robinson, Greg, and Elena Tajima Creef, eds. "A Tribute to Miné Okubo." Special issue of *Amerasia Journal* 30, no. 2 (2004).

Robinson, Jean, and Craig McDaniel. *Themes of Contemporary Art: Visual Art after 1980*. Oxford: Oxford University Press, 2005.

Rogoff, Irit. *Terra Infirma: Geography's Visual Culture*. New York: Routledge, 2000.

Rony, Fatimah Tobing. *The Third Eye: Race, Cinema, and Ethnographic Spectacle*. Durham, N.C.: Duke University Press, 1996.

Rooks, Michael, ed. *Alimatuan: The Emerging Artist as American Filipino*. Exh. cat. Honolulu: The Contemporary Museum, 2006.

Room, Adrian. *Placenames of the World: Origins and Meanings of the Names for over 5000 Natural Features, Countries, Capitals, Territories, Cities, and Historic Sites*. Jefferson, N.C.: McFarland and Company, 1997.

Rosaldo, Renato. "Cultural Citizenship, Inequality, and Multiculturalism." In *Latino Cultural Citizenship: Claiming Identity, Space, and Rights*, edited by William V. Flores and Rina Benmayor, 27–38. Boston: Beacon Press, 1997.

——. *Culture and Truth: The Remaking of Social Analysis*. Boston: Beacon Press, 1993.

Rosenblatt, Roger. "How We Remember." *Time*, May 29, 2000.

Rosenblum, Robert. *Modern Painting and the Northern Romantic Tradition: Friedrich to Rothko*. New York: Harper and Row, 1975.

Roth, Moira. "Cuoc Trao Doi Guia / Of Memory and History: An Exchange between Dinh Q. Lê and Moira Roth, June 1999—April 2003." In *From Vietnam to Hollywood: Dinh Q. Lê*, 8–21. Seattle: Marquand Books, 2003.

——. "The Dual Citizenship of Carlos Villa." *Visions Art Quarterly*, 3, no. 4 (fall 1989): 20–23.

——. "Flo Oy Wong: 'Made In USA'; A Story in Three Parts." In Dempster, *Made In USA*, 15–25.

Rowe-Shields, Michelle. *Ming Fay: Money Trees and Monkey Pots. An Installation of Montalvo Specimens*, curatorial statement in exh. brochure. Saratoga, Calif: Montalvo, 2004.

Rumbaut, Rubén G. "Vietnamese, Laotian, and Cambodian Americans." In Zhou and Gatewood, *Contemporary Asian America: A Multidisciplinary Reader*, 175–206.

Rushdie, Salman. *Imaginary Homelands: Essays and Criticism, 1981–1991*. London: Granta Books, 1992.

Rutledge, Paul James. *The Vietnamese Experience in America*. Bloomington: Indiana University Press, 1992.

Rydell, Robert W. *All the World's a Fair: Visions of Empire at American International Expositions: 1876–1916*. Chicago: University of Chicago Press, 1984.

Said, Edward W. *Orientalism*. New York: Pantheon, 1978.

——. "Orientalism, an Afterword." *Raritan* 14, no. 3 (winter 1995): 32–59.

——. "Orientalism Reconsidered." *Cultural Critique* 1, no. 1 (autumn 1985): 89–107.

——. *The World, the Text, and the Critic*. Cambridge, Mass.: Harvard University Press, 1983.

Sakamoto, Kerri. "The Process of Memory." In *Evidence of Memory: Tomie Arai and Lynne Yamamoto*, 7–14. Exh. cat. Stamford, Conn.: Whitney Museum of American Art at Champion, 1996.

——. "The Process of Memory." In *There to Here: Tomie Arai and Lynne Yamamoto*, 2–13. Exh. cat. Easton, Penn.: Williams Center for the Arts, 1995.

Samantrai, Ranu. "Cosmopolitan Cartographies, Art in a Divided World." *Meridians: Feminism, Race, Transnationalism* 4, no. 2 (2004): 168–98.

Sandoval-Sánchez, Alberto, and Nancy Saporta Sternbach. *Stages of Life: Transcultural Performance and Identity in U.S. Latina Theater*. Tucson: University of Arizona Press, 2001.

Sassen, Saskia. *The Global City: New York, London, Tokyo*. Princeton: Princeton University Press, 1991.

Scholder, Amy, ed. *Sweet Oblivion: The Urban Landscape of Martin Wong*. Exh. cat. New York: New Museum of Contemporary Art, 1998.

Sen, Geeti. "Mapping Boundaries in Space and Time." *The Art News Magazine of India* 5, no. 1 (2000): 32–35.

Senie, Harriet F., and Sally Webster, eds. *Critical Issues in Public Art: Content, Context, and Controversy*. New York: HarperCollins, 1992.

Serwer, Jacquelyn Days. "American Kaleidoscope: Themes and Perspectives in Recent Art." In *American Kaleidoscope: Themes and Perspectives in Recent Art*, 11–25. Exh. cat. Washington, D. C.: National Museum of American Art, Smithsonian Institution, 1996.

Shah, Sonia, ed. *Dragon Ladies: Asian American Feminists Breathe Fire*. Boston: South End Press, 1997.

Shaw, Angel Velasco, and Luis H. Francia, eds. *Vestiges of War: The Philippine-American War and the Aftermath of an Imperial Dream, 1899–1999*. New York: New York University Press, 2002.

Shimakawa, Karen. *National Abjection: The Asian American Body Onstage*. Durham, N.C.: Duke University Press, 2002.

Shohat, Ella. "Lynne Yamamoto: Reflections on Hair and Memory Loss." In Kim, Machida, and Mizota, *Fresh Talk / Daring Gazes*, 167–72.

———, ed. *Talking Visions: Multicultural Feminism in a Transnational Age*. Cambridge, Mass.: MIT Press, 1998.

Shohat, Ella, and Robert Stam. "Narrativizing Visual Culture: Towards a Polycentric Aesthetics." In Mirzoeff, *The Visual Culture Reader*, 27–49.

———. *Unthinking Eurocentrism: Multiculturalism and the Media*. London: Routledge, 1994.

Shukla, Sandhya. *India Abroad: Diasporic Cultures of Postwar America and England*. Princeton, N.J.: Princeton University Press, 2003.

Sibley, David, Peter Jackson, David Atkinson, and Neil Washbourne, eds. *Cultural Geography: A Critical Dictionary of Key Concepts*. London: I.B.Tauris, 2005.

Sidoti, Nelly Puiz-Arango. "Forgotten Dust Awakens Prayers for Rain." *New York Business Women's Calendar* 2, no. 1 (January 1997): n.p.

Silberman, Robert. *Word Views: Maps and Art*. Exh. cat. Minneapolis: University of Minnesota / Frederick R. Weisman Art Museum, 1999.

Sindt, Richard H. "The Vietnamese Diaspora." In *The Forgotten Ones: A Photographic Documentation of the Last Vietnamese Boat People in the Philippines*, 89–102. Westminster, Calif.: Vietnamese American Arts and Letters Association, 2004.

Smith, Paul, and Carolyn Wilde, eds. *A Companion to Art Theory*. Oxford: Blackwell, 2002.

Smith, Roberta. Weekend Arts. *New York Times*, September 8, 2006.

Soja, Edward J. *The Postmodern Geographies*. New York: Verso, 1989.

——. *Thirdspace: Journeys to Los Angeles and Other Real-and-Imagined Places*. Cambridge, Mass.: Blackwell, 1996.

Sokolowski, Thomas W., Kellie Jones, and Sarat Maharaj, et al. *Interrogating Identity*. Exh. cat. New York: New York University / Grey Art Gallery and Study Center, 1991.

Spain, Sharon, ed. *Chang Dai-chien in California*. Exh. cat. San Francisco: San Francisco State University, 1999.

Spivak, Gayatri. "Can the Subaltern Speak?" In *The Post-Colonial Studies Reader*, edited by Bill Ashcroft, Gareth Griffiths, and Helen Tiffin, 24–28. New York: Routledge, 1995.

——. "Resistance That Cannot Be Recognized as Such: Suzana Milevska Interviews Gayatri Chakravorty Spivak." *N.Paradoxa* 15 (2005): 6–12.

Spurr, David. *The Rhetoric of Empire: Colonial Discourse in Journalism, Travel Writing, and Imperial Administration*. Durham, N.C.: Duke University Press, 1993.

Staniszewski, Mary Anne. *Believing Is Seeing: Creating the Culture of Art*. New York: Penguin, 1995.

Sternbach, David, and Joseph N. Newland, eds. *Asia/America: Identities in Contemporary Asian American Art*. Exh. cat. New York: The Asia Society Galleries / The New Press, 1994.

Stewart, John. *Language as Articulate Contact: Toward a Post-Semiotic Philosophy of Communication*. New York: State University of New York Press, 1995.

Stiles, Kristine, and Peter Selz, eds. *Theories and Documents of Contemporary Art: A Sourcebook of Artist's Writings*. Berkeley: University of California Press, 1996.

Sturken, Marita. *Tangled Memories: The Vietnam War, the AIDS Epidemic, and the Politics of Remembering*. Berkeley: University of California Press, 1997.

Sturken, Marita, and Lisa Cartwright. *Practices of Looking: An Introduction to Visual Culture*. Oxford: Oxford University Press, 2001.

Suleiman, Susan Rubin, ed. *Exile and Creativity*. Durham, N.C.: Duke University Press, 1998.

Sullivan, Michael. *The Meeting of Eastern and Western Art*. Berkeley: University of California Press, 1989.

Takaki, Ronald. *A Different Mirror: A History of Multicultural America*. Boston: Little, Brown and Company, 1993.

——. *Strangers from a Different Shore: A History of Asian Americans*. New York: Penguin, 1989.

Tam, Augie, ed. "Is There an Asian American Aesthetics?" In Zhou and Gatewood, *Contemporary Asian America*, 627–35.

Taylor, Charles. *Modern Social Imaginaries*. Durham, N.C.: Duke University Press, 2004.

Taylor, Lucien, ed. *Visualizing Theory*. New York: Routledge, 1994.

Taylor, Simon. "The 'Forgotten War' Remembered." In *The Korean War in American Art and Culture*, 5–29.

———. *The Korean War in American Art and Culture: Fifty Years Later*. Exh. cat. East Hampton, N.Y.: Guild Hall of East Hampton, 2000.

Tchen, John Kuo Wei. "Believing Is Seeing: Transforming Orientalism and the Occidental Gaze." In Sternbach and Newland, *Asia/America*, 12–25.

———. *New York before Chinatown: Orientalism and the Shaping of American Culture, 1776–1882*. Baltimore: Johns Hopkins University Press, 1999.

Tedlock, Barbara. "From Participant Observation to the Observation of Participation: The Emergence of Narrative Ethnography." *Journal of Anthropological Research* 47, no. 1 (spring 1991): 69–94.

Thomas, C. David. "Introduction: Divided by War, United in Peace." In *As Seen by Both Sides: American and Vietnamese Artists Look at the War*, edited by Thomas, 13–15. Exh. cat. Boston: Indochina Arts Project, 1991.

Thompson, John O. "Introduction." In Pierre Bourdieu, *Language and Symbolic Power*, edited by Thompson. Cambridge, Mass.: Harvard University Press, 1991.

Thompson, Paul. *The Voice of the Past: Oral History*. Oxford: Oxford University Press, 1978.

Tiravanija, Rirkrit. Artist's statement. In "Rirkrit Tiravanija, March 2006." Walker Art Center, Minneapolis, http://visual arts.walkerart.org.

———. "Rirkrit Tiravanija." Interview by Mary Jane Jacob. In Jacquelynn Bass and Mary Jane Jacob, *Buddha Mind in Contemporary Art*, 170–77. Berkeley: University of California Press, 2004.

Torgovnick. Marianna. *Gone Primitive: Savage Intellects, Modern Lives*. Chicago: University of Chicago Press, 1990.

Trinh, Minh-ha T. *Framer Framed*. New York: Routledge, 1992.

———. *Woman, Native, Other: Writing Postcoloniality and Feminism*. Bloomington: Indiana University Press, 1989.

Tsai, Eugenie. "Between Heaven and Earth." In *Threshold: Byron Kim 1990–2004*, 15–24. Exh. cat. Berkeley: University of California / Berkeley Art Museum / Pacific Film Archive, 2004.

Tsutakawa, Mayumi, ed. *They Painted from Their Hearts: Pioneer Asian American Artists*. Exh. cat. Seattle: Wing Luke Asian Museum, 1994.

Tsutakawa, Mayumi, and Alan Chong Lau, eds. *Turning Shadows into Light: Art and Culture of the Northwest's Early Asian/Pacific Community*. Seattle: Young Pine Press / Asian Multi-Media Center, 1982.

Turner, Victor. *From Ritual to Theatre: The Human Seriousness of Play*. New York: PAJ Publications, 1982.

Uba, Laura. *Asian Americans: Personality Patterns, Identity, and Mental Health*. New York: Guilford Press, 1994.

Um, Nancy. "Commentaries and Demarcations: Asian American Art." Review of *Fresh Talk / Daring Gazes*. *Art Journal* 64, no. 2 (summer 2005): 101–2.

United States Census Bureau. *We the People: Asians in the United States*. Census 2000 Special Reports. Prepared by Terrance J. Reeves and Claudette E. Bennett. Washington: U.S. Census Bureau, 2004.

Vega, Marta Mareno, and Cheryll Y. Greene, eds. *Voices from the Battlefront: Achieving Cultural Equality*. Trenton, N.J.: Africa World Press, 1993.

Villaveces-Izquierdo, Santiago. "Art and Media-tion: Reflections on Violence and Representation. In *Cultural Producers in Perilous States: Editing Events*, edited by George E. Marcus, 233–54. Chicago: University of Chicago Press, 1997.

Vo, Khanh. Artist's statement. http://kvostudio.org.

Võ, Linda Trinh, and Marian Sciachitano, with Susan H. Armitage, Patricia Hart, and Karen Weathermon, eds. *Asian American Women: The Frontiers Reader*. Lincoln: University of Nebraska Press, 2004.

Wallach, Amei. "Mixed Signals: Nuance and the Reading of Immigrant Art." *American Art* 20, no. 2 (summer 2006): 126–33.

Wallis, Brian. "Selling Nations." *Art in America*, 79, no. 9 (September 1991): 80–91.

Wallis, Brian, Marianne Weems, and Philip Yenawine, eds. *Art Matters: How the Culture Wars Changed America*. New York: New York University Press, 1999.

Warr, Tracey, ed. *The Artist's Body*. London: Phaidon, 2000.

Warren, Kenneth W. *So Black and Blue: Ralph Ellison and the Occasion of Criticism*. Chicago: University of Chicago Press, 2003.

Wechsler, Jeffrey, ed. *Asian Traditions / Modern Expressions: Asian American Artists and Abstraction 1945–1970*. New York: Harry N. Abrams, in association with the Jane Voorhees Zimmerli Art Museum, Rutgers, The State University of New Jersey, 1997.

Weglyn, Michi. *Years of Infamy: The Untold Story of America's Concentration Camps*. New York: Quill / William Morrow, 1976.

Wei, William. *The Asian American Movement*. Philadelphia: Temple University Press, 1993.

Weiner, Myron. *The Global Migration Crisis: Challenge to States and to Human Rights*. New York: HarperCollins, 1995.

Weintraub, Linda, Arthur Danto, and Thomas McEvilley, eds. *Art on the Edge and Over: Searching for Meaning in Contemporary Society, 1970s–1990s*. Litchfield, Conn.: Art Insights, 1996.

Williams, Raymond. *Drama from Ibsen to Brecht*. New York: Oxford University Press, 1969.

———. *Marxism and Literature*. New York: Oxford University Press, 1977.

———. *The Sociology of Culture*. Chicago: University of Chicago Press, 1995.

Willis, Deborah. *Family History Memory: Recording African American Life*. New York: Hylas Publishing, 2005.

Wilson, Judith. "Stereotypes, or a Picture Is Worth a Thousand Lies." *Prisoners of Image: Ethnic and Gender Stereotypes*. Exh. cat. New York: Alternative Museum, 1989.

———. "What Are We Doing Here? Cultural Difference in Photographic Theory and Practice." *SF Camerawork Quarterly*, 17, no. 3 (fall 1990): 27–30.

Wilson, Rob, and Wimal Dissanayake, eds. *Global/Local: Cultural Production and the Transnational Imaginary*. Durham, N.C.: Duke University Press, 1996.

———. "Introduction." In Wilson and Dissanayake, *Global/Local*, 1–18.

Winther-Tamaki, Bert. *Art in the Encounter of Nations: Japanese and American Artists in the Early Postwar Years*. Honolulu: University of Hawai'i Press, 2001.

Wodiczko, Krzysztof. *Critical Vehicles: Writings, Projects, Interviews*. Cambridge, Mass.: MIT Press, 1999.

Wolff, Janet. *The Social Production of Art*. 2nd ed. New York: New York University Press, 1993.

Wollheim, Richard. *The Mind and Its Depths*. Cambridge, Mass.: Harvard University Press, 1993.

Wong, Sau-ling C. "Denationalization Reconsidered: Asian American Cultural Criticism at a Theoretical Crossroads." *Amerasia Journal* 21, nos. 1–2 (1995): 1–27.

Wong, Shawn. *Homebase: A Novel by Shawn Wong*. New York: I. Reed Books, 1979.

Wong, William. "Angel Island Immigration Station." In Dempster, *Made In USA*, 9–13.

Wu, Frank H. *Yellow: Race in America beyond Black and White*. New York: Basic Books, 2002.

Wye, Deborah. *Committed to Print: Social and Political Themes in Recent American Printed Art*. New York: The Museum of Modern Art, 1988.

Xing, Jun. *Asian America through the Lens: History, Representations, and Identity*. Walnut Creek, Calif.: AltaMira Press, 1998.

Yang, Alice. "Why Asia?" In *Why Asia? Essays on Contemporary Asian and Asian American Art*, edited by Jonathan Hay and Mimi Young, 103–6. New York: New York University Press, 1998.

Yang, Jeff, Dina Can, Terry Hong, and the staff of A. Magazine. *Eastern Standard Time: A Guide to Asian Influence on American Culture from Astro Boy to Zen Buddhism*. Boston: Houghton Mifflin, 1997.

Yau, John. *The Garden of Earthly Delights: The Work of Ming Fay*. New York: The Whitney Museum of American Art at Philip Morris, 1998.

Ybarra-Frausto, Tomás. "Transcultural New Jersey: Conocimiento (Knowledge), Confianza (Trust), Convivencia (Living Together)." In *Transcultural New Jersey: Diverse Artists Shaping Culture and Communities*, edited by Marianne Ficarra, Isabel Nazario, and Jeffrey Wechsler, 16–24. New Brunswick, N.J.: Rutgers Office for Intercultural Initiatives / The Jane Voorhees Zimmerli Art Museum, 2004.

Yee, Lydia. "Extending Families and Imagining Communities." In *Tomie Arai: Double Happiness*. Exh. cat. New York: The Bronx Museum of the Arts, 1998.

Yohn, Tim, ed. *Bad Girls*. Exh. cat. New York: The New Museum of Contemporary Art, 1994.

Yoshimoto, Midori. *Into Performance: Japanese Women Artists in New York*. New Brunswick, N.J.: Rutgers University Press, 2005.

Young, James E. *The Texture of Memory: Holocaust Memorials and Meaning*. New Haven: Yale University Press, 1993.

Young, Linda W. L. *Crosstalk and Culture in Sino-American Communication*. Cambridge: Cambridge University Press, 1994.

Young, Louis, ed. *The Decade Show: Frameworks of Identity in the 1980s*. Exh. cat. New

York: Museum of Contemporary Hispanic Art / New Museum of Contemporary Art / Studio Museum in Harlem, 1990.

Young, Robert J. C. *Colonial Desire: Hybridity in Theory, Culture and Race*. New York: Routledge, 1995.

Yu, Henry. *Thinking Orientals: Migration, Contact, and Exoticism in Modern America*. New York: Oxford University Press, 2001.

Zhou, Min, and James V. Gatewood, eds. *Contemporary Asian America: A Multidisciplinary Reader*. New York: New York University Press, 2000.

Zia, Helen. *Asian American Dreams: The Emergence of an American People*. New York: Farrar, Straus and Giroux, 2000.

Ziff, Trisha, ed. *Hidden Truths: Bloody Sunday 1972*. Santa Monica: Smart Art Press, 1998.

Zolberg, Vera L. *Constructing a Sociology of the Arts*. Cambridge: Cambridge University Press, 1990.

Unpublished Sources

Note: Copies of all unpublished sources are in the author's personal collection.

Anonymous visitor's commentary. Guest book for "Asia/America: Identities in Contemporary Asian Art," exhibition, The Asia Society, New York, February 16 to June 26, 1994.

Arai, Tomie. Unpublished artist's proposal to Jamaica Arts Center, Jamaica, New York, 1989.

——. Unpublished artist's statement, 1991.

——. Unpublished artist's statement, 1993.

——. "Seoul House: Korean Outpost." Unpublished script, n.d.

DeSouza, Allan. "The Flight of/from the Authentic Primitive." Revised unpublished manuscript, March 1998. Originally published in Baerwaldt, *Memories of Overdevelopment*.

——. Artist's statement from "Terrible Beauty (a re-Situation of an unnaturally-conditioned Mind, cast upon the treacherously shifting waters between International Style and Nationalist Fervor)." Exh. Susanne Vielmetter Projects, Los Angeles. February 2001.

Lou, Richard A., unpublished artist's statement, n.d.

Manalansan, Martin F., IV. "Remapping Frontiers: The Lives of Filipino Gay Men in New York." PhD dissertation, University of Rochester, 1997.

Min, Susette S. "Creative License: Walking Through Asian American Cultural Productions." PhD dissertation, Brown University, 2000.

Reisner, Steven. "Staging the Unspeakable: A Report on the Work of Theater Arts against Political Violence in New York City and the Associazione Culturale Altrimenti in Pris-

tina, Kosovo." Paper presented at the International Trauma Studies Program, New York University, spring 2000.

Tchen, John Kuo Wei. "The New York Asian/Pacific American & Asian Documentation Project: Building a Living Archive of Local and Transnational Cultural Movements." Proposal to the Creativity and Culture Division, Rockefeller Foundation, New York, June 2001.

Zarina, unpublished artist's statement, ca. 1996.

Oral Sources

Aono, Kristine. Interview with the author. Washington, October 1, 1989.

——. Interview with the author. Silver Spring, Md., March 22, 1990.

——. Telephone interview with the author. July 16, 2000.

Arai, Tomie. Interview with the author. New York, November 30, 1989.

——. Interview with the author. New York, February 13, 1991.

——. Lecture at Parsons School of Design, New York, February 13, 1991.

——. Interview with the author. New York, May 25, 1995.

——. Interview with the author. New York, April 2, 1997.

——. Interview with the author. New York, July 27, 2001.

——. Interview with the author. New York, August 8, 2001.

Banzon, Genara. Interview with the author. November 28, 1996.

Chiang, Fay. Interview with Taiyo Takeda Ebato, Simone Fujita, Siddhartha Joag, and Margo Machida, Project Reach, New York, November 20, 2001.

Chung, Y. David. Interview with the author. Washington, September 24, 1989.

——. Interview with the author. Washington, April 27, 1993.

——. Interview with the author. McLean, Va., June 24, 1999.

DeSouza, Allan. Interview with the author. New York, October 30, 1999.

——. Interview with the author. New York, June 21, 2001.

Dong, Jim. Telephone interview with the author. May 23, 2003.

Fay, Ming. Interview with the author. New York, November 11, 1989.

——. Interview with the author. New York, June 24, 1999.

——. Interview with the author. Brooklyn, N.Y., January 15, 2004.

Fuentes, Marlon. Interview with the author. Washington, March 24, 1990.

——. Telephone interview with the author. July 8, 1991.

——. Telephone interview with the author. January 1, 1993.

——. Telephone interview with the author. May 22, 1996.

——. "Bontoc Eulogy," unpublished artist's statement. Ca. mid-1990s.

Khandelwal, Madhulika. Interview with the author. New York, December 23, 1992.

Min, Yong Soon. Lecture. Parsons School of Design, New York, October 25, 1989.

——. Interview with the author. New York, December 27, 1990.

——. Interview with the author. New York, August 21, 1991.

———. Telephone interview with the author. May 22, 2000.

Pham, Hanh Thi. Interview with the author. Los Angeles, May 18, 1992.

———. Telephone interview with the author. November 23, 1992.

———. Telephone interview with the author. March 2, 1993.

———. Telephone interview with the author. May 23, 1995.

Pipo. Interview with the author. New York, August 29, 1997.

———. Interview with the author. New York, June 23, 2000.

———. Interview with the author. New York, July 19, 2001.

Zarina. Interview with the author. New York, July 3, 1992.

———. Interview with the author. New York, December 17, 1992.

———. Interview with the author. New York, September 22, 1999.

———. Interview with the author. New York, July 17, 2001.

INDEX

Page numbers in italics refer to illustrations

MARGO MACHIDA

is an associate professor of art history and Asian
American studies at the University of Connecticut.
She is the coeditor of *Fresh Talk, Daring Gazes:
Conversations on Asian American Art* (with Elaine
H. Kim and Sharon Mizota) and the author of the
curatorial essay in *Asia/America: Identities in
Contemporary Asian American Art.*

LIBRARY OF CONGRESS
CATALOGING-IN-PUBLICATION DATA

Machida, Margo.
Unsettled visions : contemporary Asian
American artists and the social imaginary /
Margo Machida.
p. cm. — (Objects/histories)
Includes bibliographical references and
index.
ISBN 978-0-8223-4187-1 (cloth : alk. paper)
ISBN 978-0-8223-4204-5 (pbk. : alk. paper)
1. Asian American art—20th century—
Themes, motives. I. Title.
N6538.A83M37 2008
704.03'95073—dc22 2008028959